THE
ICON

THE ICON

Kurt Weitzmann, Gaiané Alibegašvili,
Aneli Volskaja, Manolis Chatzidakis, Gordana Babić,
Mihail Alpatov, and Teodora Voinescu

EVANS BROTHERS LIMITED
LONDON

First published in Great Britain, 1982, by Evans Brothers Limited,
Montague House, Russell Square, London WC1B 5BX

English translation © 1982 Arnoldo Mondadori Editore

Original edition first published in Italy under the title *Le Icone*
by Arnoldo Mondadori Editore, Milan

© 1981 Arnoldo Mondadori Editore and Mladinska Knjiga for the international edition

© 1981 Arnoldo Mondadori Editore for the Italian edition

Printed at Officine Grafiche di Verona,
Arnoldo Mondadori Editore, Verona, Italy
ISBN 0 237 45645 1

CONTENTS

INTRODUCTION
The Origins
and Significance
of Icons

 Kurt Weitzmann

I N classical antiquity the veneration of the gods found artistic expression mainly in the cult statue within the temple. For private worship, the cult figurine—copied in smaller form in bronze or terra-cotta—was placed in a separate niche in the corner of a room. However, in late antiquity a more spiritual concept of deity developed, and the statue in the round gradually went out of fashion, to be replaced first by rather flat relief sculpture and then by painting. This tendency is most noticeable in the mystery religions, in which a transcendental outlook found more appropriate expression for the Deity in the dematerialized rendering of the human body. We can follow the process clearly in the art of Mithraism: here the cult image, *Mithras Slaying the Bull,* is sculpted in the round in examples of the second century, appears in rather flat relief in the third, and finally is seen painted in fresco in the Mithraeum of Dura. A parallel development can be seen in the Isis cult, in which by the third century *Serapis and Isis* are painted in encaustic technique on a triptych with folding wings (p. 4).

Christianity, obviously influenced by the Second Commandment of its Judaic roots, initially objected to representational art in general and to images of the Deity in particular. The opposition continued for quite some time, although after Christianity became Hellenized in the second and third centuries, representational art did establish itself. In the fourth century, bishops such as Eusebius of Caesarea and Epiphanius of Salamis speak of icons of Christ, the Virgin, the Apostles, and the Archangel Michael. However, it must be emphasized that holy images as such were not an invention of Christianity; as mentioned before, the Isis cult and others already had them. And, like the mystery cults, Christianity had holy images in both forms: the monumental, appropriate for the cultroom, and the small for private veneration. Yet the literary sources make it quite clear that small-scale portable icons proliferated at a time when the Church still had to overcome resistance to placing icons in the sanctuary. The zealous Epiphanius of Salamis tore down a holy image painted on a curtain, expressing in this way his opposition to what he considered idolatry. This

Serapis and Isis
Encaustic, wing of triptych, each wing 40 x 19 cm. (15¾ x 7½ in.); Egypt, third century; J. Paul Getty Museum, Malibu.

passage is of particular importance because the icon in question was a piece of weaving, thus proving that from the very beginning the icon was not limited to a particular medium. A tapestry of this era, which only recently came to light and is now in the Cleveland Museum, depicts the *Virgin Enthroned,* obviously an iconic image (p. 5).

When in A.D. 726 the issue of the veneration of images led to an outbreak of iconoclasm, it shook the foundations of the Byzantine Empire. The church fathers who defended the images had to find convincing formulations to prove that icon worship was not idolatry. The key to their reasoning is the Doctrine of the Incarnation and the Dogma of the Two Natures of Christ. Early in the iconoclastic period, John of Damascus wrote his *Defense of Holy Images* in Palestine—then under Muslim rule—where he was safe from the persecution of the Byzantine emperor. He argued: "It is not divine beauty which is given form or shape, but the human form which is rendered by the painter's brush. Therefore, if the Son of God became man and appeared in man's nature, why should his image not be made?" Somewhat later, Theodore of Studios defined the relationship between the image and its prototype as relations of

identity ("Man himself is created after the image and likeness of God; therefore there is something divine in the art of making images") and *necessity* ("As perfect man Christ not only can but must be represented and worshipped in images: let this be denied and Christ's economy of the salvation is virtually destroyed"). It was this theory of necessity which, after the final triumph of icon-worship in 835, gave the holy image its preeminent position in the life of the Orthodox worshipper.

The icon can take many forms. Some of the earliest icons have sliding lids, for protection when they were taken along on their owners' travels. Another form, the diptych, was invented as a writing tablet. It preserved this function in the well-known ivory consular diptychs of the fifth and sixth centuries, and the practical usage still survives today in the Eastern Church, when the deacon reads the prayer of intercession from a diptych. After the diptych ceased to be used primarily as a writing tablet, the relief decoration was moved from the outside to the inside, which provided protection for the holy images. The sixth-century ivory diptych in Berlin, showing Christ and the Virgin Enthroned, is a splendid example (p. 7). It is probably the product

Virgin Enthroned, Ascension, and Medallions with the Twelve Apostles Tapestry, 179 x 100 cm. (70½ x 39⅜ in.); Egypt, sixth century; Cleveland Museum of Art, Cleveland.

of a Constantinopolitan atelier. Protection is equally well achieved in the triptych, which, to judge from the fairly numerous early fragments at Sinai, exceeded the diptych in popularity. With its natural focal point in the central plaque, and wings to which subordinate figures could be relegated, the triptych automatically permitted display of a hierarchical order.

Soon the iconostasis (the screen dividing the sanctuary from the main body of an Eastern Orthodox church) became the focal point for the display of important icons. Usually four in number, they depicted Christ, the Virgin, and St. John the Baptist forming the "Deesis" (Supplication), and lastly the patron saint of the church. Not until the middle Byzantine period (853–1204) were large icons placed above the marble parapet of the iconostasis and between the pillars supporting the architrave. From the tenth century on, a beam was placed above the architrave, decorated with representations of the liturgical feasts, replacing an earlier tradition of saints' busts or medallions. Finally, the Royal Doors,

through which the priest enters the sanctuary, were decorated with an *Annunciation*, of which the earliest surviving example—at Sinai—dates from the thirteenth century.

In Eastern Orthodox churches, the icon of the day is displayed on a special lectern, the *proskynetarion*, which stands in the nave. The church's often considerable collection of small icons hangs on the walls of the aisles or the sanctuary, or is kept in a storeroom. Elsewhere are installed the icons of special veneration, such as images of the Virgin painted (according to tradition) by St. Luke himself, or the *acheiropoietes*, those not made by human hand. These are pilgrim attractions, adorned with votive gifts of all kinds. Most churches also possess bilaterally painted processional icons, to which special veneration is likewise due. In the past, these were sometimes carried into battle by the army.

The widely accepted notion that an icon must be a painted panel derives from the enormous number of images preserved from the late and post-Byzantine periods when, indeed, the painted panel prevailed. But this is not true for the earlier periods, especially the time of the Macedonian dynasty (867–1056), the second golden age of Byzantium, when a great variety of media was used. Gold and silver were widely employed to enhance the splendor of small-scale mosaic icons, as were precious stones and highly prized ivory. Marble and ivory sculpture once again played a prominent role, although a rather flat relief was usually preferred, in order to subdue the impression of pronounced corporeality. One medium in particular now far surpassed its earlier use: cloisonné enamel, which because of its two-dimensionality and translucence appealed to artists trying to render a dematerialized body. The revival of these diverse media, chiefly in the tenth century, was part of a conscious renascence of the first golden age of Byzantium, the era of Justinian.

From the early Byzantine period on, to judge from the literary sources as well as the recently discovered icons at Sinai, the main subjects were, as might be expected, the figures of Christ, the Virgin, the Apostles, the popular saints, and the great festivals of the ecclesiastical year. Christ and especially the Virgin often appear with epithets, which in most cases denote a general quality rather than a specific type. The epithet *Eleousa*, the Virgin of Tenderness, is a term that had become popular through hymns and other poetry, and occurs in connection with many different Virgin types. Other epithets indicate

the church to which the icon belongs, such as the *Blachernitissa*, from the Church of the Blachernae in Constantinople.

In the middle Byzantine period, art became increasingly liturgical in character, as is most clearly visualized in the *Deesis*, or Prayer of Intercession. This composition shows Christ in the center flanked, in order of rank, by the Virgin and St. John the Baptist as chief intercessors, and then by Archangels, Apostles, and saints. The Grand Deesis is usually placed on the beam of the iconostasis, which often also holds depictions of the great feasts. These feasts had already existed individually in the Early Christian Chuch, but now a set of twelve developed that achieved canonicity during the middle Byzantine period.

Calendar icons, in which the saints of every day of the year were depicted in long rows, became popular in the eleventh century, after Symeon Metaphrastes had compiled the "Lives of the Saints" in ten volumes. By the end of the twelfth century, the saints were often framed on all sides by narrative scenes from their own lives. The late Byzantine period, while it added comparatively few new subjects, tended to elaborate the traditional compositions by including large crowds of bystanders. In the *Death of the Virgin*, which in the middle Byzantine period confined the mourners to the twelve Apostles and three bishops, the number of attendants grew vastly in later representations: a heavenly host surrounded Christ and mourning women occupied the balconies of flanking buildings. However, from about the fifteenth century the Russian artists became iconographically creative, inventing on an impressive scale dogmatic, liturgical, and even historical subjects which, based largely on mystical literature, often became exceedingly complex.

Of the early period of icon production we know very little. We will never know the whole story because of the widespread destruction of icons during the war waged over image-worship. Until fairly recently, only four examples from the period before the outbreak of iconoclasm (726) were known. These came from Sinai, and are now in Kiev. Only within the past twenty-five years, when the Sinai collection itself has been investigated, have we been able to establish a small group of first-rate icons as works of Constantinopolitan ateliers: a bust of *Christ* (p. 9), a bust of *Peter*, and a *Virgin Enthroned Between Soldier Saints*. A somewhat larger group of early Sinai icons was, we believe, produced

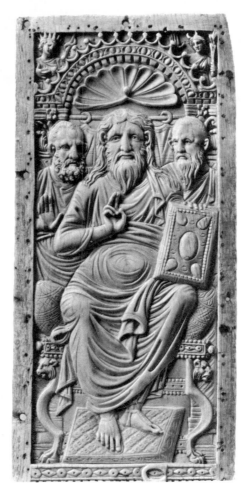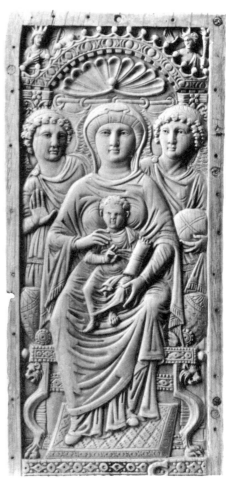

Christ Between St. Peter and St. Paul;
Virgin Between Two Archangels
Ivory diptych, each tablet approx. 29 x
13 cm. (11⅜ x 5⅛ in.); Constantinople,
sixth century; Staatliche Museen,
Preussischer Kulturbesitz, Berlin.

in Palestine, the province in which St. Catherine's Monastery is located. There are icons of a later date in the same collection that have Syriac and Arabic inscriptions and a style of their own.

We still have very little evidence about icons painted in such important centers as Alexandria, which must have been Greek in character and distinct from the Coptic style. A few early Coptic icons are known, but their systematic study has not yet been attempted. Surely Antioch must have been an influential center of icon-painting, but this is still a complete gap in our knowledge. Moreover, icons were certainly produced in pre-iconoclastic Georgia, yet here too only very few have survived. There is every reason to believe that in the early Byzantine period there was no unified style, but rather, each important metropolis and surrounding province had its own tradition, colored by the influence of indigenous and often anti-classical trends. A few very important early encaustic icons have come to light even in Rome; they are quite distinct from the

Eastern images, and less painterly in style.

A group of Sinai icons which we would like to assign to the eighth or ninth century is evidence that icon-painting did not come to a complete halt upon the outbreak of iconoclasm. Production certainly continued beyond the boundaries of the Byzantine Empire, for example, in Palestine, then under Muslim domination. It was not until the second golden age, when under the Macedonian dynasty the Empire expanded again, that Constantinople became the undisputed artistic center of the eastern Mediterranean and developed a distinct style, with a consequent impact felt in all neighboring countries, east, west, north, and south.

During the Comnenian period (1081–1185), the high standards of Constantinopolitan art continued, although the classical element receded to some degree in favor of a style that emphasized a more dematerialized rendering of the human body. This tendency should not, however, be interpreted as anti-classical, but rather as an attempt to effect a

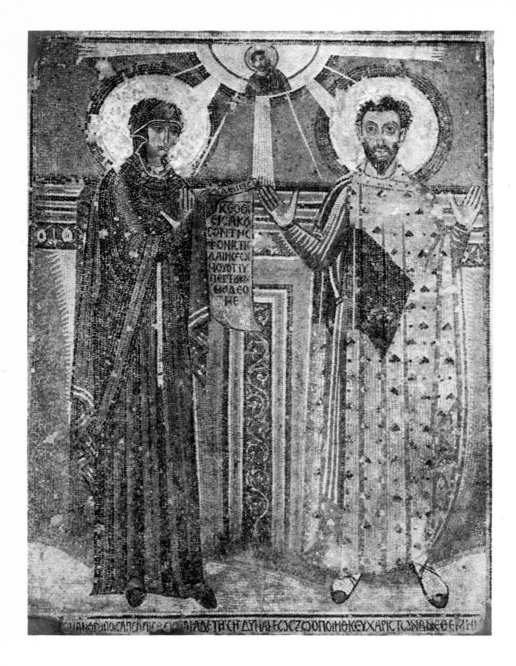

Virgin and St. Theodore Stratelate
Mosaic; c. seventh century; Church of
St. Demetrius, Thessalonike.

synthesis between the earthbound classical and the spiritual. The more ascetic style developed in an era of revitalized monasticism, with its emphasis on mysticism, as represented by Simeon, the New Theologian. A perfect harmony was achieved between two trends—a harmony that remained the very essence of Byzantine art.

One result of the tendency to dematerialize the human body was the increasing dominance of painting and the corresponding decline of sculpture, although the use of two-dimensional media such as mosaic and cloisonné continued unabated.

Not only was the art of Constantinople exported to all the neighboring countries, but the artists themselves (especially mosaicists) were much in demand in other cities, Islamic as well as Christian, such as Venice, Palermo, Kiev, Damascus, and Cordova. In Greece, Thessalonike (since Early Christian times a great rival of Constantinople) was a center of the highest artistic standards, to judge from the votive icons in wall-mosaic in the Church of St. Demetrius (p. 8); but the rest of Greece had to wait until the middle Byzantine period for economic recovery and the revitalization of art and icon-painting. After the Christianization of the Balkans and Russia, images were imported to those areas from Constantinople and imitated by local artists.

Where Orthodoxy was accepted, artistic imitation was a natural process; but in the Latin West, the situation was quite different. Although strong

waves of Byzantine influence reached all Western countries, especially in the twelfth and thirteenth centuries, and icons like the *Virgin of Spoleto* were highly appreciated, enjoying special veneration, nonetheless the very meaning of the icon and its integration into the liturgy were not understood. In the West the venerable image was ensconced on the altar, whereas in Orthodox culture only chalice, paten, and Gospelbook were admitted within the sanctuary.

Byzantine art and icon-painting continued in the thirteenth century, despite the founding of the Latin Kingdom in Constantinople and the settlement of the Crusaders in Syria and Palestine. There was a mutual interpenetration of Byzantine and Western iconography, and Western style did have some impact on Eastern art, although the main current of influence flowed from East to West. During this period Byzantine art was vital enough to exert its strongest influence on the Western world, especially in Italy, where the Byzantine style was called the "maniera greca" or "maniera bizantina." Equally strong was the influence on Slavic countries, where many Greek artists apparently took refuge.

In the Palaeologan period (1261–1453), which began with the reconquest of Constantinople, reaction against Western influence set in. A conscious harking back to Constantinople's own past, chiefly the Justinian and Macedonian eras, determined the forms of icon-painting and art in general. New formulae for the mixture of classical and spiritualizing elements were found, with the latter gradually predominating. The sculptural media were all but abandoned, and painting became virtually the exclusive medium for icons.

As the Empire shrank, the impact of Byzantine art beyond its borders also diminished. The Slavic countries in the north developed a style of their own, never losing sight of their Byzantine roots but reducing the Hellenic component in order to achieve greater abstraction. In Russian icon-painting especially, the dematerialization of the human figures went far beyond the Greek models. Bodies became over-elongated, and a loose and fleeting brush technique gave them at times a phantom-like appearance, emphasized by the use of glowing mystical colors.

During this period, for an opposite reason, the influence of Byzantine art on the Latin West declined altogether. While the East sought greater abstraction, western European art, from the very beginning of the Gothic period, developed in the

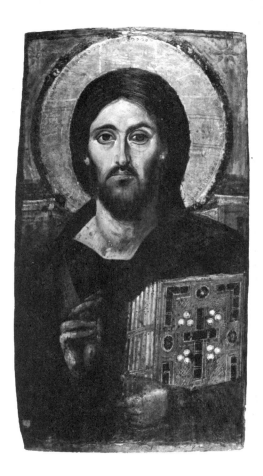

Christ
Encaustic; Constantinople, sixth century; St. Catherine's Monastery, Sinai.

direction of a naturalism that was incompatible with the spiritual concept of the icon.

After the fall of Constantinople in 1453, Byzantine icon-painting continued mainly in the monasteries of Mount Athos, which enjoyed a certain degree of autonomy under Turkish rule, and on Crete, then under Venetian domination. Produced in great quantities, and often very competent technically, the early Cretan icons displayed a high degree of conservatism, stylistic as well as iconographic. However, as time went on, close contact with Venice brought about an infusion of Western elements, and in the later mixed style we sense a dissolution of the spiritual values that are the raison d'être of the icon.

For far more than a millennium, the icon has been central to the life of the Orthodox believer. Its wide acceptance has rested upon the ability of artists to mix tradition and innovation. Subject matter, whether dictated by the Church or developed as illustration of popular beliefs, has always remained

understandable to the masses. At the same time, a sufficient measure of artistic freedom existed to allow the development not so much of a personal style—although the individual note is by no means missing—as of a style conditioned by the structure of society and the various classes that commissioned individual icons. Moreover, icons are endowed with aesthetic values, which are expressed in harmonious design and carefully calculated color distributions. For all of these reasons, icons are loved and admired today all over the world.

THE ICONS OF CONSTANTINOPLE

Kurt Weitzmann

ICONOCLASM, Venetian looting in 1204, and the sack by the Turks in 1453 are the main reasons why only very few icons have survived in Constantinople proper. It may seem daring, therefore, to write an entire chapter on the icons of the capital. Yet the situation is not quite so hopeless as might appear at first glance. Icons existed not only as panel paintings but also as frescoes and wall-mosaics, some of which have emerged from layers of whitewash to give an undiluted impression of the highest achievements of Constantinopolitan art. The capital was so widely recognized as the chief center of mosaic production that her artists, highly trained artisans working in well-organized shops, were invited to work in every Orthodox Christian and Islamic country. This virtual monopoly extended to the delicate small-scale mosaic icons, most of which show a very high artistic level. As there is every reason to believe that almost all of these were produced in Constantinople, we have included several in this study.

The art of Constantinople excelled in other precious media, particularly during the Macedonian dynasty (867–1056), when we notice an almost ostentatious display of splendor. Gold, silver, and ivory, widely used in the "sumptuous arts" of the early Byzantine period, were now employed again. While most of the gold and silver was melted down in later ages—the two *Archangel* icons in Venice are exceptions (pp. 42–43)—a very considerable number of ivories survived. Ivory icons from this second golden age are so abundant that several ateliers can be distinguished and their development traced in detail. In precious metals as well as ivory carvings, Constantinople had few rivals besides Georgia in the East and the Carolingian and Ottoman empires in the Latin West.

We are well aware that there is no stringent method for determining in each individual case the Constantinopolitan origin of a work of art. An artist from the capital may have migrated to another place, or an artist from the provinces may either have been trained in Constantinople or have imitated in his homeland the style of the capital. Moreover, not every product of the capital was necessarily

of the highest quality. A sharp line between a product made in Constantinople and one made under her direct influence cannot always be drawn; consequently, the term "Constantinopolitan style" must be used in a wider sense.

The church portal was a favorite place for icons of special protective value. The outbreak of iconoclasm was marked by the episode of the Chalke Gate, whose *Christ* icon was removed by the order of Leo III in or shortly after 726—an action that caused extremely serious rioting. The original Chalke *Christ* icon was detachable, as was its successor, put up by Empress Irene around 800. (When the image was replaced a third time, in 843, it was executed as a fixed mosaic.)

Of the several surviving portal icons in mosaic, the *Christ Enthroned* over the Imperial Door of Hagia Sophia is the earliest (p. 25). Representing the penitent emperor Leo VI prostrate before Christ enthroned, with the Virgin as intercessor, it was probably executed after the emperor's death in 912. The majestic, powerfully built figure of Christ, with its Zeus-like head, suggests a high degree of corporeality, emphasized by the garments pressing against the body. The closest parallels to such a classical concept of the body are the miniatures of the well-known Paris Psalter, the most outstanding work of the Macedonian Renaissance.

Under Leo's successor, the scholar-artist Constantine VII Porphyrogennetos, the classical revival movement reached its height. A great collector of relics, in 944 he had the *mandylion,* the towel bearing the imprint of Christ's face, brought in a triumphal procession to Constantinople from Edessa, where it had been a detachable portal icon. An encomium celebrating this occasion is attributed to him. A triptych wing at Sinai (p. 28) depicts a messenger bringing the *mandylion* to Abgarus, King of Edessa, who had asked for a likeness of Christ. The face of King Abgarus has the unmistakable portrait features of Emperor Constantine Porphyrogennetos, evidence that the icon could only have been made after 944. The figure of the emperor-king shows bulging garments over a strongly built body, very similar to the Christ in the Leo mosaic (p. 25). However, the artistic quality is not the highest, which raises the unanswerable question whether the icon, iconographically so closely tied to Constantinople, was indeed made there.

The dearth of painted icons from the tenth century is abundantly compensated by icons in ivory. Of the more than two hundred Byzantine ivory plaques in existence, the large majority are tenth-century icons, which with few exceptions were made in Constantinople in several clearly definable ateliers. One group, called the "painterly," depends, as the term suggests, on painted models. The relatively small size of the plaques and the sensitivity of their execution make it more than likely that the models were miniatures. One of the finest ivories (now in Munich) represents the *Dormition of the Virgin* (p. 26). The dense sharp lines of the drapery imitate brushstrokes. True to the aesthetic of the Macedonian Renaissance, the artist combines painterly quality with sculptural values by maintaining a rather shallow surface of the figures, but cutting very deeply into the background around their edges, giving in this way the illusion of considerable plasticity. This ivory plaque was once the center of a triptych, but when it came to the Latin West, its function as a portable icon was no longer understood. As in many similar cases, it was taken apart; and the central plaque was used to decorate the luxurious Gospelbook of the German emperor Otto III (983–1002).

Ivory inspired the carving of delicate but somewhat less precious steatite. One of the earliest steatite icons, probably executed in the tenth century, is a plaque with the *Dormition* (p. 27), now in Vienna. While the faces are very expressive, the drapery is not quite as elegant and as classical as in the ivory, suggesting that artists of higher quality worked only in the latter medium. Steatite, moreover, was technically unsuitable for the complicated mechanism of a triptych. This *Dormition* plaque was most likely set into a wooden case surrounded by a metal frame (cf. p. 80).

An ivory *Crucifixion* of the highest quality (p. 29), now in the Metropolitan Museum, probably also was originally the center of a triptych. With great skill the carver applies two distinct modes side by side, preferring a rather stiff pose for the Virgin and a more realistic, relaxed stance for St. John, to distinguish the divine from the human. The deep undercutting is most effective in the figure of Christ on the Cross, which appears almost detached from the ground. The classical tradition asserts itself in many details, most noticeably in the figure of Hades stabbed by the Cross, inspired by a classical river or mountain god.

One of the few complete triptychs of the painterly group, now in Leningrad, represents in the

center the *Forty Martyrs of Sebaste and Soldier-Saints* (pp. 30–31). The writhing poses of some of the martyrs, who froze to death in an icy lake, may well have been inspired by the dying giants of a gigantomachy, as known from ancient floor-mosaics. But while the ivory carver copied the extraordinary agility of the figures from his antique model, at the same time he subdued their muscularity by over-elongating the bodies, emphasizing their nervous sensibility. The balance of classical realism and Christian spirituality is reflected in the contrast between the restlessness in the central plaque and the hieratic poses of the soldier-saints on the wings.

Single soldier-saints are the subject of individual icons like that of *St. Demetrius* (p. 32), now in the Metropolitan Museum. Slightly more mannered in pose and drapery, this ivory may represent a somewhat later phase, still within the tenth century, of the painterly group. Being of a stately size, the plaque was certainly mounted into a wooden core and surrounded by a metal frame, creating a general effect not unlike that of the *St. Demetrius* icon in steatite (p. 80).

The cross-fertilization of media worked both ways. Not only were the ivories of the painterly group dependent upon painted models, but the influence of ivories on painting can be observed in the Sinai icon of *St. Philip* (p. 34), in which the treatment of the folds, imitating incised grooves, clearly reflects the carving technique of the painterly ivory group (pp. 26, 29, and 32). Among the very few tenth-century painted icons known today, we would like to ascribe the *St. Philip* to Constantinople because of its refinement and dignified restraint in posture.

The most aristocratic ivories are those which can be considered imperial commissions. These are the so-called Romanos group, named after an ivory in the Louvre in which Christ crowns an emperor and empress, probably Romanos IV (1068–1071) and Eudocia. This group was begun before the middle of the tenth century. One of the earliest examples extant is a triptych now in Rome (pp. 32–33), which has an inscription on the central plaque referring to Christ's promise to Constantine that he will bestow all power on him. This Constantine can be no other than Constantine VII Porphyrogennetos (919–953). The focal point of the icon is the *Deesis* in the upper center, which features the unusual placement of St. John the Baptist (whose head relic enjoyed a particular veneration by the emperor) at

the right of Christ. Below are five of the twelve Apostles, those who were connected with the great bishoprics: Peter and Paul with Rome, James with Jerusalem, John with Ephesus, and Andrew with Constantinople. On the wings are placed, in correct order of rank, the church fathers and soldier-saints. The ivory reflects the liturgical setting of the all-important prayer of intercession, the program that dominates the decoration of the iconostasis. The models—especially of the Apostles—were apparently early Byzantine reliefs, perhaps also of ivory or possibly of marble. The normal proportions, the firm stances, and the comparatively high relief give the figures a sense of physical reality, surpassing that of almost any other Byzantine ivory.

The desire to make use of every conceivable precious material for the production of icons led to a revival of late antique glyptics. The Kremlin possesses a colorful heliotrope of a *Standing Christ* making the gesture of benediction (p. 35), apparently inspired by a contemporary ivory of the Romanos group and seemingly reflecting a most popular and celebrated icon, the *Christ* of the Chalke Gate. Although the pose of Christ's right arm varies slightly from the types inscribed "Chalkotes," this gem may be considered a variant of that famous image.

In the Treasury of San Marco there is a unique *Crucifixion* group in solid gold on a disc of lapis lazuli. Gold on lapis lazuli had been used in late antiquity and is known from pieces ascribed to Egypt. Like the Kremlin cameo (p. 35), the disc is vivid testimony to the revival of the sumptuous arts in tenth-century Constantinople. In style, it is related to the early phase of the Romanos ivories (pp. 32–33), equaling them in the high degree of plasticity and the natural proportions of the figures.

The Romanos group is not the only one that is related to the imperial court. In the Church of San Francesco in Cortona there is an ivory icon of noble dimensions, *Deesis and Saints* (p. 36), which includes a relic of the Holy Cross and which was made at the time of Emperor Nicephoros II Phocas (963–969). Stephanos, the treasurer of the Great Church of Wisdom, gave this icon to the monastery that had raised him, probably the Studios monastery. Although a relic is usually kept in a casket, the mounting of a particle of the Cross on an icon is not unknown. The theme of the upper part of the ivory is once more the *Deesis,* this time including two Archangels but omitting the Apostles. John the Evangelist at the lower right and Longinus below

relate to the Crucifixion, and the medallions of Constantine and Helena to the finding of the Holy Cross; Stephanos is there as the namesake of the donor. This ivory is the key piece of the so-called Nicephoros group, whose production was as prolific as that of the Romanos group and, at least in the best pieces, of the same high quality. However, the bodies are more corporeal, the faces round and fleshy, and the eyes large. This makes the figures appear slightly less severe and more human than those of the more aristocratic Romanos group.

There is evidence that the plaques with a standing *Christ* and a standing *Virgin* in Bamberg (p. 37) are the result of an imperial commission. They belong to a set that includes *Peter and Paul,* the *Archangel Gabriel,* and the *Presentation in the Temple.* Four of the plaques became book covers for the prayerbooks of the German emperor Henry II (1002–1012) and his wife Kunigunde, after Henry acquired the imperial treasure of Otto III, son of Otto II and the Byzantine princess Theophano; but the whole set had probably originally decorated the iconostasis beam of Theophano's private chapel. Comprising perhaps more than thirty plaques of stately size, including the Grand Deesis and the liturgical feast cycle, this beam must have been one of the greatest and costliest enterprises undertaken by ivory carvers. The style of the hieratic figures is that of the Romanos group, although the execution is more summary than usual, perhaps because they were made to be placed at a height at which details could not be distinguished by the naked eye.

In Early Christian icon art the diptych played a significant role, often displaying on its wings Christ and the Virgin enthroned. The ivory diptych in Berlin (p. 8), a Constantinopolitan product of the time of Justinian, is a most striking example.

The cycle of the Twelve Feasts of the ecclesiastical year, formulated in the tenth century, appeared first on an iconostasis beam, but immediately became a subject for every conceivable medium. At first, a few feasts were still interchangeable: an ivory diptych in Leningrad, one of the earliest examples of the cycle of the *Twelve Feasts* (p. 38), includes the *Visitation* and the *Incredulity of Thomas,* replaced in later examples by the *Raising of Lazarus* and the *Death of the Virgin.* This ivory belongs to the Nicephoros group, although its style, because of the small figure-scale, is not as explicit as in other pieces. The draperies are more sketchily treated and the proportions of the figures more elongated—an indi-

cation that it was executed at the very end of the tenth or beginning of the eleventh century.

It is in ivory that we have the earliest icon with a representation of the *Last Judgment.* In a plaque in London from the turn of the tenth–eleventh century (p. 39), we notice an Early Christian Christ-type with a gesture that suggests the separation of the sheep from the goats, placed in a composition which has its parallels in several frescoes and the Torcello mosaic. Although the figures on this plaque are reduced in size and many details are omitted, they nevertheless reflect the complex composition of a large-scale model, especially in the figures of the Apostles, the angels behind them, and the choirs of the saved below. Characteristic features of the Nicephoros style are recognizable, though they are mixed with those of another Constantinopolitan ivory group, the so-called "frame" group.

Cloisonné enamel, the great rival of ivory as a medium for icons, achieved its most perfect realization in Constantinople during the middle Byzantine period. The translucence of its colors was particularly suited to the icon's spiritualized rendering of the human body. The pair of enamel plaques in the Treasury of San Marco depicts *Christ on the Cross,* draped in the *colobium,* on one side and a *Virgin Orant* on the other, both surrounded by medallions with saints' busts. The plaques show the rather simple design of the early stage of cloisonné enamel; stylistically, they can be closely related to those of a votive crown in San Marco made for Leo VI (886–912). The enamels are surrounded by strings of pearls and an outer frame of cut-glass pieces in a kind of *opus sectile* technique. These plaques, now set on a Latin evangelistary of the ninth century (for the use of the Cappella Ducale of San Marco), shared the fate of many ivories that were mounted on book covers when they came to the West, where their original purpose as icons was not understood. A number of enamels and pearls are missing from the rear cover, the side which lies on the altar table.

Another pair of enamel plaques in the Treasury of San Marco (pp. 40–41) was also used to cover a Venetian Gospelbook, the rear cover again showing greater damage than the front in the loss of pearls and stones. With a standing *Virgin Orant* on what was originally the left wing of a diptych, and a standing *Christ* on the right, we have here a more normal iconography for this type of icon. The slender figures are of great elegance and show a sure handling of the design, with gold threads marking

the folds, and striped garments in the medallions providing great decorative effect.

Enamel, which achieved its effects by a decorative surface design and partly translucent colors, had its counterpart in marble intarsia, which used colored marbles, pastes, and glass. Like other two-dimensional media, marble intarsia was much in vogue from the fourth to the sixth century, and was revived along with other techniques in the tenth century. Although many fragments have survived in Constantinople, only one is preserved in almost perfect condition. It represents St. Eudocia, the wife of Theodosius II, in imperial vestments whose jewels and adornments were particularly suitable for the intarsia technique (p. 44). The rosiness of the flesh resembles the translucence of enamel. Created at the end of the tenth or perhaps the beginning of the eleventh century, the icon was discovered in the Fenari Isa Camii.

Enameled terracotta was another popular icon medium. The shiny surface of the tiles is eminently effective for the rendering of immaterial, saintly bodies. A whole group of such tiles was found in a suburb of Constantinople and is now divided between the Louvre and the Walters Art Gallery in Baltimore. It is interesting to note that all the saints' busts, including the *Virgin with Child* of the Nikopoios type (p. 42), are in medallion form. Scenes of iconoclasts whitewashing images, which appear in the margins of ninth-century psalters, render every icon as a roundel—a form derived from the *clipeus* of classical antiquity (cf. p. 44).

No unified style dominates the icons ascribed to the tenth century; rather, two almost contradictory trends can be discerned. The classical revival style flourished in the ivories, mosaics (p. 25), and painted panels (p. 28); but at the same time the comparatively more abstract tendencies that had prevailed in the eighth and ninth centuries continued to develop, especially in enamels (pp. 40–41) and marble intarsia (p. 44). The contrast between the two trends was resolved in the eleventh century by the harmonious fusion and balance that characterize Comnenian art (1081–1185).

AMONG THE MOST STRIKING surviving works of Byzantine art are two icons now in San Marco, carried off by the Venetians in the looting of 1204, which display an extraordinary combination of the most delicate techniques and precious materials. One is a bust of the *Archangel Michael* (p. 42), in which the face, hands, and forearms are executed in embossed gilded silver, while the *loros* (ceremonial imperial garb) is made of stones, glass paste, pearls, and filigree, and the wings and sleeves of the tunic of the most delicate cloisonné enamel. The extremely hieratic appearance of the Archangel makes it difficult to decide whether the icon dates from the tenth or the eleventh century.

The second enamel icon in San Marco also portrays the *Standing Archangel Michael* (p. 43), holding, very realistically, a sword in his outstretched right hand and a little orb decorated with delicate enamel in his left. One can only marvel at the inventiveness with which different techniques are combined. In contrast to the first *Michael,* the sculptured face and neck are covered with flesh-colored enamel. For the wings, the artist employs gold instead of enamel, although in general he uses enamel much more profusely. Every scale of the plate armor is a separately worked segment of enamel; nimbus and background are richly patterned, and the unusually large pieces of the inner lining of the mantle show an intricate plant design. The frame of this icon is contemporary, with medallions of saints at the top and bottom and pairs of full-length soldier-saints at the sides, arranged as they are on the triptych wings of ivories (cf. p. 31). The date of the icon is once again difficult to establish on stylistic grounds—the figures are stiff and almost lifeless, and no comparable object exists—but we propose the first half of the eleventh century. It staggers the imagination to think, on the basis of these two survivors, how much must have been destroyed and melted down in 1204. The large number of metal relief icons still preserved in Georgia, where they escaped large-scale destruction, give us an indication of what has been lost elsewhere.

For information about eleventh-century icons we have to rely heavily on the ivories, although toward the end of the century an economic recession reduced production to a trickle in all the sumptuous arts. It seems that during the Macedonian Renaissance only one ivory carver attempted to create a freestanding statuette—a sizable full-length *Virgin Hodegetria* (p. 44), now in London. Uniquely in Byzantine art, the artist cut around the figure and modeled the back by sculpting a smooth drapery clinging to the body. And yet, looking at this figure from the front, one is unaware of this three-dimensionality, shallow as it is. It is a free, but not a round,

sculpture. Because of the slender proportions and the inclination toward straight, dematerialized folds, we ascribe this statuette of the Romanos group to the first half of the eleventh century.

To the latest phase of this group belongs the central part of a triptych now at Dumbarton Oaks, which represents the *Virgin Hodegetria Between St. John the Baptist and St. Basil* (p. 45). The high quality as well as the iconography—both saints were much venerated by Byzantine emperors—speak for an imperial commission, as does the close stylistic relationship to the Coronation ivory of Romanos IV and Eudocia in the Louvre. Compared with the London *Virgin* (p. 44), the dematerialization of the body has progressed still further. We have reached the stage where painting can more fully satisfy the desire for spiritualism.

The influence of the Romanos ivories can be traced in several media. In London, there is a roundel bust of the *Virgin Orant* executed in a spotted dark green serpentine (p. 44). The face and the characteristic design of the drapery, with its dense and sharply cut folds, leave no doubt about a close connection with ivory *Virgins* like that at Dumbarton Oaks (p. 45). The inscription around the rim invokes the aid of the Mother of God for Emperor Nicephoros III Botaneiates (1078–1081), which indirectly confirms the redating of some Romanos ivories around and after the middle of the eleventh century.

Also dependent upon ivories of the Romanos group is a triptych in cast and gilded bronze in London which represents the *Virgin Enthroned with Child,* flanked, on the wings, by the stately figures of Gregory of Nazianzus and St. John Chrysostom. Indeed, so close is the relationship that one could imagine the figures having been cast from matrices made from ivories. We would like to ascribe this triptych to the same period, the second half of the eleventh century, although the cast may have been made somewhat later.

When ivory production declined in Constantinople toward the end of the eleventh century, a substitute was found in steatite, which has a beautiful creamy and sometimes greenish color. It has only one disadvantage: softer than ivory, its surface is more easily rubbed. Very few steatites have survived in pristine condition. Here, too, with a few exceptions from an earlier period (p. 27), it was the late Romanos group that exerted the strongest influence.

Because idolatry was closely associated in the minds of the Byzantines with marble statues, it is hardly surprising that monumental sculpture was a relatively minor art. One outstanding piece is the relief of a *Virgin Orant* (p. 46), which was found in front of the Church of St. George in the Mangana quarter of Constantinople, near a palace built by Constantine Nonomache (1042–1055). The hands of the Virgin are perforated, indicating that the relief once served as a fountain for holy water. The marble sculptors did not develop a style of their own, but took their inspiration from the ivories: the relative plasticity of the body (especially of the legs) and the designing of the folds in grooves were apparently inspired by works of the painterly group (cf. p. 26), and the hieratic pose and straight folds of the mantle by the advanced Romanos group.

The Latin West, in contrast to the Byzantine East, embarked on a full-scale revival of monumental sculpture at the beginning of the early Romanesque period. When they plundered Constantinople, the Venetians brought home as much marble sculpture as they could carry, to decorate the interior and exterior walls of San Marco and other churches. Such an import is the *Virgin Orant* in the Church of Santa Maria Materdomini (p. 46), which is nearly contemporary with the Mangana *Virgin*. A *clipeus* (roundel) with a youthful Christ is suspended before her breast—a type known as the *Platytera;* her perforated hands indicate that she, too, was a *Zoodochos Pege* (Lifegiving Spring), a fountain for holy water. The grooving of the folds recalls once more the ivories of the painterly group, while their softer modeling and the fleshiness of the Virgin's face agree more with the Nicephoros style.

Also in San Marco are three marble plaques that together form a *Deesis* (p. 47). They were probably set into a marble iconostasis in the first half of the eleventh century, before painted icons on wooden iconostases became the norm.

DURING THE COMNENIAN PERIOD (1081–1185), the desire for a more ascetic style led to the virtual abandonment of sculpture in favor of painting and mosaic. Deities and saints withdrew into the heavenly sphere, and the distance between them and the beholder increased. This severe style lasted from the middle of the eleventh century without a serious break until the middle of the twelfth, that is, through most of the Comnenian period, and it is often difficult to decide whether an icon dates from

the second half of the eleventh or the first half of the twelfth century. A Sinai icon of the *Deesis and Saints* (p. 49) makes the change of style quite apparent, the swaying posture of Christ conveying the notion of a dematerialized body. The figure of St. John the Baptist is also less corporeal than the tradition demanded. Slenderness is even more strongly emphasized in the figures of *St. John the Almoner* (*Eleemon*) and *St. John Climacus* in the narrow frame.

Another Sinai icon, of related style, depicts a straddling Christ Child trying to steady himself by grasping the Virgin's veil while his right hand accepts a scroll (the *logos*) from the Virgin's hand (p. 48). This image is a copy of a famous *Virgin* icon which, according to tradition, was painted by St. Luke himself, and sent, in 1082, by the emperor Alexios Comnenos to the Monastery of Kykko on Cyprus. We cannot know whether the Sinai replica of the *Kykkotissa* was painted in Constantinople before 1082 or afterwards at Cyprus by a Constantinopolitan painter. The center with the Virgin enthroned is surrounded by a wide frame, with figures of Prophets and saints and scenic representations in a very minute figure style, suggesting that this is the work of an artist who was both icon- and miniature-painter—a frequent combination in the eleventh century.

The minute figure style was widely used for calendar icons in which a saint—and occasionally more than one—was depicted for each day of the ecclesiastical year. These came into fashion in the eleventh century, after Symeon Metaphrastes compiled the "Lives of the Saints" in ten volumes. Sinai possesses the earliest sets of such calendar icons, including one from the second half of the eleventh century: four panels, each containing the saints of three months either as frontal standing figures or in a narrative scene—most frequently, of course, the scene of their martyrdom. The first panel (p. 50) comprises the *Saints of September–November,* beginning in the upper left with *Symeon Stylites.* In the same row, for September 6, there is a particularly beautiful representation of the *Miracle of St. Michael at Chone* (p. 57). In some of the luxuriously illustrated menologia of Symeon Metaphrastes, we find at the beginning of each month full-page miniatures in which the saints are lined up in rows exactly as in the icons. It is more than likely that in many cases the same artists executed both.

Churches tried to collect saint icons for each day to display on the *proskynetarion,* the lectern

placed in the nave. Where none was available, they could always fall back on the collective calendar icon for an image. Moreover, saints were sometimes grouped together on individual icons, not necessarily in the sequence of the calendar but according to their associations. One icon at Sinai (p. 51) unites three soldier-saints: St. Procopius (July 8) with SS. Demetrius and Nestor (both October 26). The delicate execution of their stiff poses, their immaterial bodies, and their unapproachability are all hallmarks of the early Comnenian style.

In Constantinople proper only two mosaic icons of the Comnenian period have survived, in the Greek Patriarchate (p. 52). Unfortunately, both were cut at the bottom and badly restored in the nineteenth century, so that their quality can no longer be fully appreciated. One icon represents a frontal standing *St. John the Baptist,* pointing at a medallion that originally must have contained a bust of Christ but was restored as an angel. The kneeling donor at the Baptist's feet, now thoroughly distorted by the restorer, may well have been the emperor John II Comnenos (1118–1143), who probably was the founder of the Church of the Virgin Pammakaristos, whence these icons came. The stern, ascetic face of the Baptist is calm, showing none of the signs of physical strain so marked in late Byzantine art (cf. p. 68). The *Virgin* is of the *Hodegetria* type, so familiar in Constantinople (cf. pp. 44–45).

Wherever Constantinopolitan icons were sent, they were highly appreciated and treated with special veneration. Around 1131, an image of the *Virgin* was sent to Kiev; thence to Vladimir, where it received the toponym *Vladimirskaja;* and finally to the Kremlin in 1315 (p. 55). As a type, it has been called *Eleousa,* the Merciful. Only the face and hands are old; the garments, which suffered under a metal covering (*oklad*), have been repainted. The close relation, cheek to cheek, between Virgin and Child is characteristic, although the Virgin's face expresses more melancholy than maternal affection, as if she were anticipating the Passion of her son. Her almond-shaped eyes, the narrow ridge of her nose, and other dematerializing features are similar to those of the contemporary *Pammakaristos Virgin* (p. 52).

Toward the end of the twelfth century, the German emperor Frederic Barbarossa gave another Comnenian *Virgin* icon (p. 52), which he had acquired from a Crusader named Petrus of Alipha, to the Cathedral of Spoleto, where it was held in high

esteem and became a center of pilgrimage. Like all such venerated icons, it was enriched not only by its metal covering (*oklad*) but also by a jewel-studded nimbus and other adornments. The Spoleto *Virgin* is of the *Paraclesis* (Supplication) type, holding an open scroll with the prayer of intercession in her hand, and showing the same sensitive facial features as the previous two icons.

The *Virgin Paraclesis* can be seen in the Church of the Martorana in Palermo as a monumental mosaic (p. 53). Here she has a specific function: to intercede for George of Antioch, the admiral of the Norman fleet (1143–1151), who lies prostrate at her feet. The Martorana mosaic is the work of first-generation Greek immigrants who had been trained in Constantinople.

In the execution of *Christ* icons, artists followed closely the accepted conventions of relatively few types, which often makes it difficult to assign dates. A mosaic icon in West Berlin (p. 54), with a *Christ* whose facial expression is bare of human emotion, fits well into the spirit of Comnenian art. Its date could not be far from that of the *Christ* who crowns King Roger II, the companion piece to the *Paraclesis Virgin* in the Martorana in Palermo. Its stately size makes it seem quite probable that—like the mosaic icons in the Greek Patriarchate (cf. p. 52)—it was made to be placed on an iconostasis beam, in which case one would have to assume that it once formed a *Deesis* with flanking icons, now lost, of the *Virgin* and *St. John the Baptist*.

Of even slightly larger dimensions is an icon in the Hermitage depicting the half-figure of *St. Gregory Thaumaturgos*, the miracle worker (p. 56), which was probably also intended for an iconostasis. Compared with the aloof *Christ* of the Berlin icon, the focused glance of St. Gregory, his carefully combed hair and trimmed beard, and the tufts of hair between his contracted brows are individualizing features that point to a Constantinople provenance in a later phase of the Comnenian style.

The Comnenian artists' great elegance, refinement, and versatility in the simultaneous use of different modes is nowhere more clearly demonstrated than in the Sinai icon that portrays the *Miracle of St. Michael at Chone* (p. 57). We are told that the Archangel saved the hut of the monk Archippus, which the Devil had tried to inundate by diverting a stream. The artistic effect is built on the contrast between the very slender emaciated body of the ascetic monk, on the one hand, and the powerful figure of the Archangel on the other, indicating the reality of the angel's presence on earth, though the fluent folds of his garments and his tiptoe stance emphasize his weightlessness. The contrast between the dark sober colors in the monk's garments and the lighter tints of the angel's robe also stress Michael's ethereal quality. The arching of the stream gives to the composition a balanced, firm structure, but a note of caprice is introduced by the rendering of the poor monk's hut as a sumptuous marble building.

Sinai possesses a unique series of iconostasis beams from the Comnenian period, which usually comprise the cycle of the Twelve Feasts, the *Dodecaorton*, interrupted in the center by a dominating Deesis. By now the selection of the feasts was fixed, as was not yet the case in the earlier example in ivory (cf. p. 38). Also the individual feast pictures had become more or less standardized iconographically, as may be seen in the *Raising of Lazarus* on a twelfth-century iconostasis beam of which only the central part has been preserved (p. 58). Followed by the Apostles, Christ faces Lazarus standing upright in the entrance of a cellar-like tomb, flanked by one man who holds the marble plaque that had closed the tomb and by another who unwinds the shroud. The predetermined measurements of the beam suggest that the artist worked on the spot, in the Sinai monastery. Although the quality is not quite as high as that of the icon of *St. Michael at Chone*, we believe that the painter of the beam may very well have come from Constantinople. It must be kept in mind that iconostasis beams were not designed to be seen at close range, but from below at a considerable distance, which explains the rather summary treatment of the figures. We saw the same kind of treatment on the ivory plaques in Bamberg (p. 37), which we believe to be parts of an iconostasis beam.

In the Comnenian period, a goodly number of icons were still produced in media other than panel-painting, though far fewer than in the Macedonian period. In the tenth and most of the eleventh century, ivory predominated; but during the eleventh and increasingly in the twelfth century, cloisonné enamel took the lead because of its greater effectiveness in abstracting and dematerializing the human body. One of the most ambitious projects of enamel art was an iconostasis beam of which only the second half, with the feasts of the *Entry into Jerusalem* and the *Koimesis* (*Entombment*, p. 59), has survived. These six plaques were brought to Venice

and mounted on top of the Pala d'oro in San Marco, and a plaque with the *Archangel Michael* (from an earlier period) was placed in their midst. The *Koimesis* clearly reveals the specific problems of the enamelist working in a comparatively large format: the dense gold lines in the figures of the Apostles result in a patternization and greater abstraction than in any other medium. The vast gold ground and the golden walls of the buildings enhance the unearthly appearance of this scene, the style of which points to a date in the second half of the twelfth century.

Several examples of the combination of icon and Holy Cross relic, comparable to that in ivory in Cortona (cf. p. 36), exist in enamel. One of them—preserved in Esztergom (Grau) in Hungary (p. 60)—is stylistically related to the beam plaques of the Pala d'oro, although its quality is uneven. At the top are represented two hovering angels common to Crucifixion scenes; below are Constantine and Helena, whose rich imperial costumes were a delight to the enamel worker; and at the bottom are two Passion scenes. The plaque is surrounded by a frame with embossed metal reliefs of about the fourteenth century, which may well replace an earlier enamel frame that included a Deesis, a subject which, as in the Cortona ivory, would well suit the liturgical program of such a relic icon.

Additions and replacements are very common in Byzantine icons. These should not always be judged as repairs but as a process of growth whereby, particularly in the case of much-venerated icons, additions of metal reliefs, filigree plaques, stone settings, and the like were made to enhance their beauty. A delicate *Crucifixion* enamel (p. 61), now in Leningrad, in the style of the feast plaques of the Pala d'oro, is almost drowned by its setting, which contains two enamel plaques with bishop-saints in a different scale and fourteenth-century metal reliefs also of different figure sizes. It is quite likely that the *Crucifixion* originally had a narrower and more delicate frame. We must remember that icons were made primarily for veneration, and that every generation of worshippers felt free to enhance their religious significance and material splendor.

In the late Comnenian period, just as the representation of the human figure threatened to become rigid and stereotyped, reaction set in. Without necessarily emphasizing the corporeality of the body,

artists began to endow it with a greater agility and to infuse a keen observation of human behavior. Emotion, heretofore incompatible with the hieratic concept of Byzantine art, was belatedly added as a new mode of pictorial expression. Until fairly recently, this emotional style had only been known from frescoes such as those at Nerezi (1162) and—in a somewhat mannered form—Kurbinovo (1191), both in Yugoslavia; and at Laghoudera on Cyprus (1192). The first known Constantinopolitan work to reflect the new style in its highest quality is an icon of the *Annunciation* at Sinai (p. 62). The Virgin—not the stately woman of the past, but a frail figure with an expression of anxiety on her sad face—is approached by the angel Gabriel, who is rendered in a contorted pose simultaneously expressing onrush and arrest. To achieve this complex motion, the artist recalled the dancing maenads of antiquity, who were portrayed in similar twirling poses. The delicacy of this icon is enhanced by the grisaille-like treatment of the angel, the ground, and the throne. Only the dark blue and purple garments of the Virgin give a saturated color effect.

Even the face of Christ, which was less susceptible to change than that of any other figure, was affected in a very subtle way in the trend toward emotionalism. Whereas the *Christ Eleemon* in Berlin (p. 54) does not display any facial characteristics that could connote human feeling—the Byzantine artist's way of expressing divinity—the *Christ* on a mosaic in Florence (p. 64) looks stern, a Christ to be faced on Judgment Day.

The agitated late Comnenian style did not come to an abrupt halt with the end of that dynasty or the end of the twelfth century. We ascribe to the turn of the century one of the most refined mosaic icons, now in the Louvre (p. 65), for which a Constantinople provenance must surely be assumed. Depicting the *Transfiguration*, it displays the Comnenian style in the cascading, crumpled folds of St. John's mantle, and in the agitated poses of the kneeling Peter and James, while replacing the contrasting enamel-like colors preferred in the Comnenian period (cf. p. 58) with more subdued and delicately shaded colors, imitating painterly brushstrokes. The artist has used the tiniest of cubes, which at a certain distance can hardly be recognized as such, thus actually achieving the effect of a painting executed in a subtle brush technique.

Starting at the turn of the century, a new style developed whereby the artist tried to express by

painterly means what the Comnenian artist had achieved by linear design. Striking examples of this new style are found at Sinai, where we can trace the activities of a quite individualistic artist in great detail. First he collaborated with two other painters who still worked in the late Comnenian style on an iconostasis beam depicting, among other scenes, the *Nativity of Christ* (p. 63). The painterly quality is most obvious in the landscape setting, to which he gives greater importance than was traditional. The licking flames on the inner contour of the cave, and the palette of ochre and orange, used quite unrealistically for emotional effect, are new expressive elements. After his participation in what we have called the "Three Master Beam," he executed a whole beam by himself, in which his painterly style matured. Then, apparently as the head-master, he was involved in a huge project: twelve monumental calendar icons. He must have come from Constantinople, probably after 1204, and worked in the monastery itself.

Early in the thirteenth century yet another style developed, which tried to achieve a more solid, monumental human figure by linear means. We ascribe to the beginning of the thirteenth century one of the finest mosaic icons in existence, a gift from Constantinople to the Sinai monastery. It represents the *Virgin Hodegetria*, a variation on the original type in that the Christ Child is carried on the right arm, a *Dexiokratousa* (p. 64). For the flesh in particular very tiny cubes were used, while larger ones were employed in the drapery for the very pronounced straight golden highlights that give to the *paenula* its distinct decorative splendor. The background has a pattern which imitates cloisonné enamel—a clear example of the mutual influences of the media.

We also ascribe to the first half of the thirteenth century a Sinai icon with the *Virgin Enthroned*, flanked by two angels who place their hands on the throne (p. 66). Here the gold striation is an even more conspicuous feature, which has an abstracting as well as a luminous effect. This technique was particularly popular in the thirteenth century, when relations with the West and especially with Italy were very close (cf. p. 227).

In the cathedral of Freising in Bavaria there is an icon of the *Praying Virgin* that dates from the period when Constantinople was under Latin domination (1204–1261). It is overpainted and will need cleaning before its style can be judged more precisely;

but its importance lies in the fact that it is surely datable, and that it is one of the relatively few cases in which the painted panel and its richly decorated frame (with medallion busts of saints in enamel) are still intact and contemporary. The frame also contains an extensive inscription in delicate enamel, which mentions as donor a certain Manuel Disykatos, Bishop of Thessalonike between 1235 and 1261. This does not, however, necessarily mean that the icon was executed in the capital of Macedonia. The bishop may well have commissioned it in Constantinople, the main center for the production of cloisonné enamels.

In the course of the thirteenth century the iconostasis reached a greater height, and larger individual icons, rather than continuous beams, were placed on the architrave. The bust of the *Archangel Gabriel* at Sinai (p. 66) is a good example. The body's massive form suggests the influence of monumental painting. It is true that no such frescoes have survived from this period in Constantinople, but their influence can be seen in those of the Church of St. Mary in Studenica, Yugoslavia, dated 1209.

At about the same time a whole series of huge icons with saint figures was commissioned at Sinai, to be placed in the saints' own chapels. The earliest, made for the chapel of St. Nicholas, which no longer exists, represents this father of the Church in half-figure (p. 67). The other, even larger icons depict *St. Panteleimon* and—as full figures—*St. John the Baptist*, *St. George*, and *St. Catherine*. The frames of these icons all have cycles of scenes from the saints' lives. There is an obvious contrast between the central saint figures, rendered in the new monumental style, and the narrative scenes, more painterly in manner. These narrative scenes seem to have been executed by lesser artists, about whose Constantinople training we cannot be sure.

WHEN THE PALAEOLOGAN DYNASTY established itself in the reconquered capital in 1261, artistic production was resumed on a large scale. One of the early imperial commissions is the large mosaic icon of the *Deesis* in the South Gallery of Hagia Sophia (p. 68). It is clearly not the product of a new beginning, but a mature work that stands in the line of an uninterrupted tradition. Yet there is an increasing emphasis on intensified observation of human sentiments. Christ has a tired look, the Virgin's face expresses a touch of melancholy, and that of St. John the Baptist

physical pain. Palaeologan art developed along these lines.

The first half of the fourteenth century saw the high point of Palaeologan art: the mosaics and frescoes of the Kariye Camii, the former monastery of the Chora, whose donor was the great humanist Theodore Metochites (d. 1335). The mosaics, in particular, constitute the most extensive of several church decoration programs executed in the capital during the last flowering period of this noble technique. Among the mosaics of the Kariye Camii are several that stand out as individual icons. This is particularly true for the *Bust of Christ* (p. 68) in the lunette over the entrance from the outer to the inner narthex. Inscribed around the figure is the toponymical epithet *Chora ton Zonton* (Land of the Living), a reference to the name of the monastery. The face is immobile and expressionless in the Comnenian tradition, but the attitude of the left hand, holding the Gospelbook with widely spread fingers, is typical of Palaeologan mannerism.

A second portal icon, located over the entrance from the inner narthex into the nave, depicts *Christ Enthroned*, with Theodore Metochites, the donor, at his feet. Two more mosaics flank this entrance, representing *St. Peter* and *St. Paul* set in frames of precious colored marble revetment (pp. 70–71). Here we see the fully developed Palaeologan style. The over-elongated figures are draped in garments that bulge slightly, giving the impression of detachment from the frail bodies underneath. The sweeping folds and fleeting highlights are testimony to the power of the revived classical tradition, but these elements are confined to the surface treatment and do not much affect the physicality of the figures, whose swaying poses rather convey the impression of dematerialized bodies.

SS. Peter and Paul also appear on a portable icon at Sinai (pp. 70–71), united and facing each other. This icon is contemporary with, or perhaps a little later than, the mosaics of the Kariye Camii. It displays the same characteristics of drapery style, which, particularly in the end of Peter's mantle, has a metallic quality. A scroll, normally grasped by its center, is held upright in Peter's hand and slightly opened at the top, while Paul unconventionally holds a codex with both hands. Both these details are typical of Palaeologan mannerism.

There were also icons in fresco in the Kariye Camii. Beneath the arch of the beam were two, one with *Christ,* now lost, and the other with the *Virgin*

turning to the right (p. 69). That this Virgin was actually venerated as an icon is proved by the slight damage caused by the smoke of a votive lamp. As a portable icon, the figures of Christ and the Virgin would have formed a diptych; but, as in the *Peter* and *Paul* mosaics (pp. 70–71), in the scheme of the wall decoration they became separated from each other. The Virgin holds the Christ Child high up in her arms so that the heads are close to each other, cheek to cheek. The style is the same as that of the mosaics, and the quality is equally high. At first glance, the Virgin figure appears very massive; but looking more closely one realizes that the very slender body, hidden under the bulky drapery, does not stand firmly on the feet, which are placed so far to the left that part of the garment seems to support the figure.

While, unfortunately, no important icons of this period survived in Constantinople, there exist at least a few outside the borders of the Byzantine Empire that can be traced to the capital. The two bilateral icons of outstanding quality in Ohrid were sent there from the Constantinopolitan Monastery of the Virgin with the epithet "Savior of Souls." The abbot of this monastery at the time of Emperor Andronicus II (1282–1328) was a certain Galaktion of Ohrid; it must have been he who sent these icons. The *Christ* on one icon and the *Virgin* on the other are both inscribed "Savior of Souls," so there can be no doubt that they came together from the monastery of this name and that they date from the early fourteenth century. On the back of the *Virgin* icon is a representation of the *Annunciation* (p. 72), which displays all the characteristics of the mature Palaeologan style. The angel, making a hasty step forward, is dressed in an inflated mantle, the end of which juts out like a stiff piece of metal. The Virgin recoils in such a way that the organic structure of the over-elongated body is endangered: the legs are out too far to the left and the left arm extends too far down. In the interplay of forces, the architecture plays a vital role: the top of the baldachin is jutting out to the left, counter-balancing the thrust of the angel.

When the Orthodox Church celebrates the *Synaxis of the Twelve Apostles* on June 30, an icon with that subject is placed on the *proskynetarion*. In an icon in Moscow (p. 73) on which the Apostles are inscribed, the four in the front row are marked most prominently. Among them John, the second from the right, is singled out as the oldest and most dis-

tinguished of the four, to whom Peter and Matthew turn reverently, while James stands aside at the left. Among the Apostles in the second row Andrew, individualized by his disheveled hair, is given slightly more space than the others because he was, according to legend, the first Bishop of Constantinople. In spite of their slightly bulging garments, these Apostles are endowed with a relatively greater corporeality than the figures of the Kariye Camii. Therefore, we are inclined to date the Moscow icon somewhat earlier, to the very beginning of the fourteenth century.

FROM THE FOURTEENTH CENTURY ON, the number of surviving icons increases immeasurably. Constantinople set high standards, although other centers like Thessalonike, never denying their close dependence on the capital, competed successfully. To distinguish the style of the capital from that of other centers, not only in Greece but also in the Balkan countries, poses difficult problems that at times have led to heated controversies. In an attempt to define what was most probably produced in Constantinople proper, it has seemed prudent to concentrate on the highly refined mosaic icons. Given the capital's worldwide reputation for mosaic production, the assumption that the majority of these icons were made there seems justified.

To the early fourteenth century also must be ascribed the much-venerated icon in Rome which is enshrined in the Church of Santa Croce in Gerusalemme, in a reliquary triptych, and which a local (untenable) tradition has connected with Pope Gregory the Great. It represents the *Man of Sorrow* (also called *Christ of the Passion*) in front of the Cross (p. 76). Christ's head with closed eyes has fallen on his shoulder, and his hands are crossed, prominently displaying the stigmata. Although claimed by a long tradition as a product of Western art, there can be no doubt that this is the work of a Constantinopolitan master. Recent restoration revealed on its back a fourteenth-century painted figure of St. Catherine, in the style of many Sinai icons. It is very likely indeed that the icon had been at Sinai before it was brought to Italy in the fourteenth century and deposited in the Church of Santa Croce. The highly stylized design of the body, the strong inclination of the head, and the expression of sorrow in the face denote emotional qualities typical of Palaeologan art.

A very similar and contemporary mosaic icon, also with the *Man of Sorrow,* survives on Orthodox soil in Greece, in the Monastery of Tatarua in Eurythania. There is still another, painted, in the Monastery of the Transfiguration at Meteora, which can be dated somewhat later in the fourteenth century. Here the *Man of Sorrow* forms the wing of a diptych whose other half depicts the mourning *Virgin* turning toward Christ. The two wings have such iconographic as well as stylistic unity that one may well ask whether the two mosaic icons of the *Man of Sorrow* were also originally wings of diptychs.

In the second half of the fourteenth century, Palaeologan painting became increasingly mannered, exaggerating the slenderness of the figures and their contorted poses, emphasizing still further the metallic effect of the draperies, and creating a sense of restlessness by zigzagging fleeting highlights. All these characteristics are very pronounced in a mosaic diptych of the *Twelve Feasts* (pp. 74–75), now in the Opera del Duomo in Florence. This mannered style imparts a great deal of dynamic energy to the human figures and also to the landscape, as in the vigorous hillcrests around the cave of the Nativity. In the *Baptism,* the stormy advance of St. John is eye-catching, and so are the contorted poses of the three Apostles on the ground, blinded by the light of Tabor, in the *Transfiguration.* In the *Raising of Lazarus* we notice the precariously tilted mummy, and in the *Pentecost,* the agitated gesture of Paul in the midst of otherwise calm Apostles.

In London, there is a mosaic icon of the *Annunciation* (p. 77) that may very well be a product of the same workshop as the Florentine diptych. The angel advances cautiously, but because of the somewhat larger scale of this scene, the crumpling of the folds and the inner restlessness that goes with it are even more intensified. Moreover, the garments are no longer bulging as in earlier Palaeologan art. The artist stresses still further the frailty of the bodies, especially that of the Virgin who has just risen from her throne. She recoils slightly, looking apprehensively at the angel. These mosaic icons share with enamel art an inclination to patternize certain areas of the surface: the nimbi, the floor, and also the writing of the inscriptions on separate panels.

At Sinai there is a tetraptych (pp. 78–79), which—typical of Palaeologan art—has expanded the cycle of the Twelve Feasts and added three more scenes, the *Leading of Christ to Calvary,* the *Deposition from the Cross,* and the *Bewailing,* with the soldier-

saints George and Demetrius at the very end. On a reduced scale, this is the program of an iconostasis beam; but in this small format, the eccentricity of the figures' behavior seems less disturbing. The weightlessness of the almost puppet-like figures is emphasized not only by their proportions but also, in the case of the *Deposition,* by the suspension of St. John and the Virgin in mid-air. The flamelike mountains and trees take part in the dynamic effect. A few new iconographic elements have enriched the otherwise traditional compositions, as when Nicodemus, in the *Bewailing,* puts his head through the rungs of the ladder. It seems more than likely that in this case, as had often happened in the eleventh century (cf. p. 50), an artist was at work who was at the same time a miniaturist.

We will conclude our study of small-scale Constantinopolitan mosaic icons with one that depicts *St. John Chrysostom* (p. 81); it comes from the Monastery of Vatopedi on Mount Athos and is today in the Dumbarton Oaks Collection. In the eleventh century, artists had begun to give this church father an ascetic, highly intellectual appearance. During the Palaeologan period, his features became over-accentuated: the size of the forehead increased abnormally, its furrows and the sunken cheeks became excessively emaciated. This icon shows the degeneration of the saint's features almost to the point of caricature. The mannerism of Palaeologan art has reached its final stage.

It seems obvious that in a period which expressed itself best by fleeting brushstrokes, relief sculpture could no longer play an important role. It is true that only very few ivories seem to have been manufactured at this period; steatite icons alone survive in quantity. One of the Palaeologan steatites, now in Moscow, represents *St. Demetrius on Horseback* (p. 80). According to tradition, this steatite, which has a beautiful soft green surface, was a gift of the Byzantine emperor to the grand duke Dimitrij Donskoj. While this cannot be confirmed, we are convinced of the icon's Constantinopolitan origin. The egg-shaped head, with hair combed onto the face, and the stylized, stiffly billowing mantle are clues to a fourteenth-century date contemporary with the metal frame with which the image forms a unity. We must assume that similar metal frames were made for other small mosaic icons (cf. pp. 76, 77, and 81), and we realize that without them the intended aesthetic effect is impaired and the iconographic program disrupted.

The minuteness and agility of the human figures in so many creations of Palaeologan painting are not to be seen in the great traditional "despotic" icons. This is particularly true of the *Christ Pantocrator* (pp. 82–83), now in the Hermitage, which can be firmly dated by the tiny figures of the donors in the frame, Alexios the Grand Stratopedarch and John the Grand Primicerios, founders of the Pantocratoros Monastery on Mount Athos in 1363. The hieratic frontal pose, the conventional gestures, and the inexpressive face have changed comparatively little over the centuries (cf. pp. 54, 64, and 68). Yet even here features characteristic of the advanced Palaeologan style can be discerned in the stylized, sharply hatched highlights on the flesh. Although here applied rather moderately, in later works these hatched highlights cover the whole figure, imparting a phantom-like appearance.

UNTIL THE FALL OF CONSTANTINOPLE in 1453, the fifteenth century showed signs of artistic exhaustion even though, in its best creations, the general level remained high. For more than half a millennium—from the late ninth century to the fourteenth—the icon had been paramount in Byzantine art because it was the focus of religious observance in the liturgy as well as in daily life, and in all these centuries no material splendor was begrudged it. Stylistic changes in all major branches of Byzantine art were always reflected immediately in icons, because many of the very finest and most acclaimed artists devoted their energies to the most highly prized objects in Byzantine culture.

For centuries Constantinople had set the artistic standard, not only within the Byzantine Empire but beyond its frontiers. The Balkan countries and Russia had thoroughly absorbed the Byzantine style since the tenth century. Even as national elements began to assert themselves, the influence and legacy of Constantinople were never denied. But while the art of the capital began to show signs of weariness, the Slavic countries were displaying great vigor and inventiveness. As one might have expected, Byzantine icon-painting continued, in the later fifteenth and the sixteenth centuries and even longer—not in Constantinople itself, which lost the preeminence it had held for a remarkably long time, but in Crete and other parts of the Orthodox world.

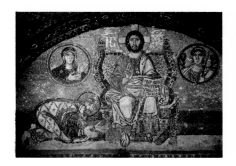

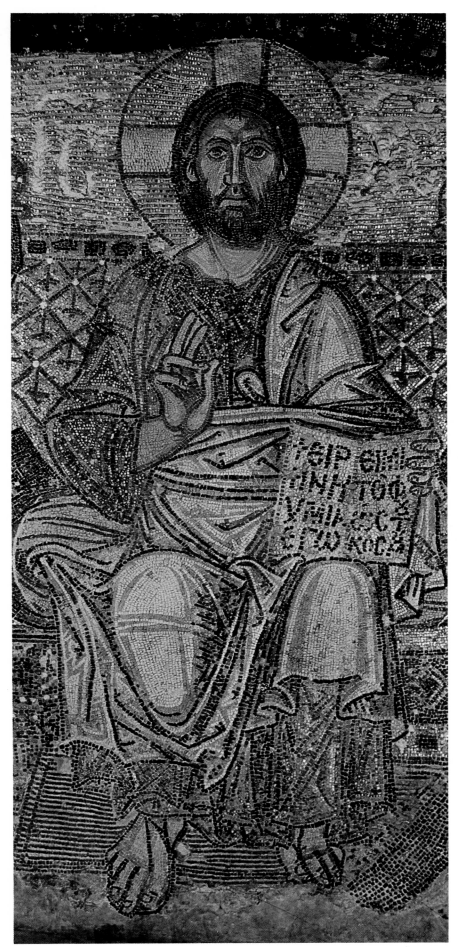

Above:
Leo VI Prostrate Before Christ Enthroned
Mosaic, after 912; above the central
door of the narthex, Hagia Sophia,
Istanbul.

Right:
Detail: Bust of Christ

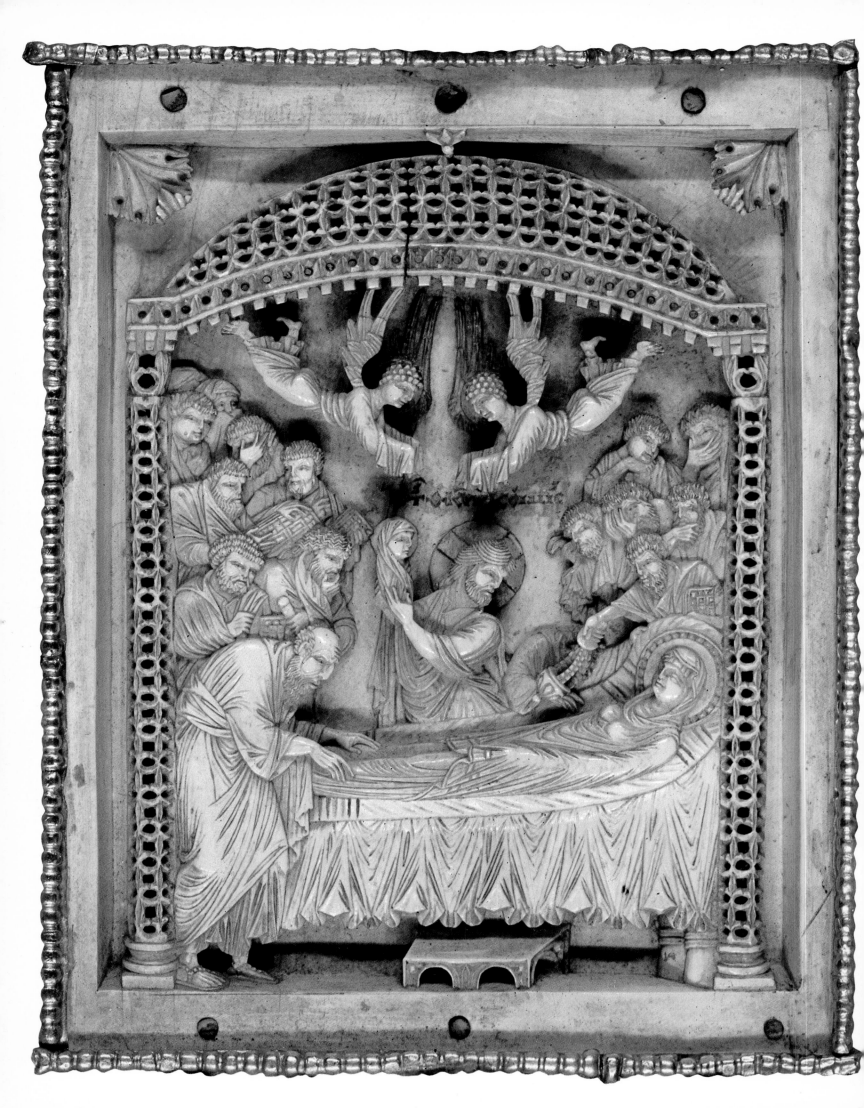

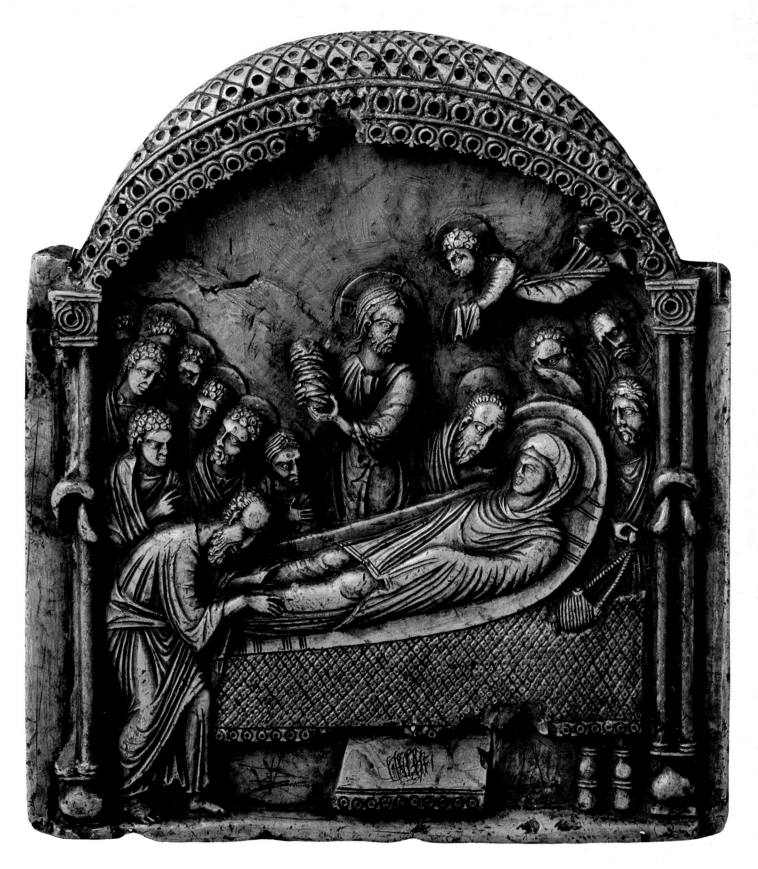

Opposite:
The Dormition of the Virgin
Central plaque of an ivory triptych used for the front
cover of the Cod. Monac. lat. 4453, Cim. 58; 14.5 x 11
cm. (5¾ x 4⅓ in.); Constantinople, tenth century;
Staatsbibliothek, Munich.

The Dormition of the Virgin
Steatite plaque, originally mounted into a wooden
core; 13.1 x 11.3 cm. (5⅛ x 4½ in.); Constantinople,
tenth century or slightly later; Kunsthistorisches
Museum, Vienna.

King Abgarus Receiving the Mandylion
Constantinopolitan painter (?)
Upper part of a right triptych wing, tempera on wood;
after 944; St. Catherine's Monastery, Sinai.

Opposite:
Crucifixion
Central plaque of an ivory triptych, 12.7 x 8.8 cm. (5
x 3½ in.); Constantinople, tenth century; Metropolitan
Museum of Art, New York.

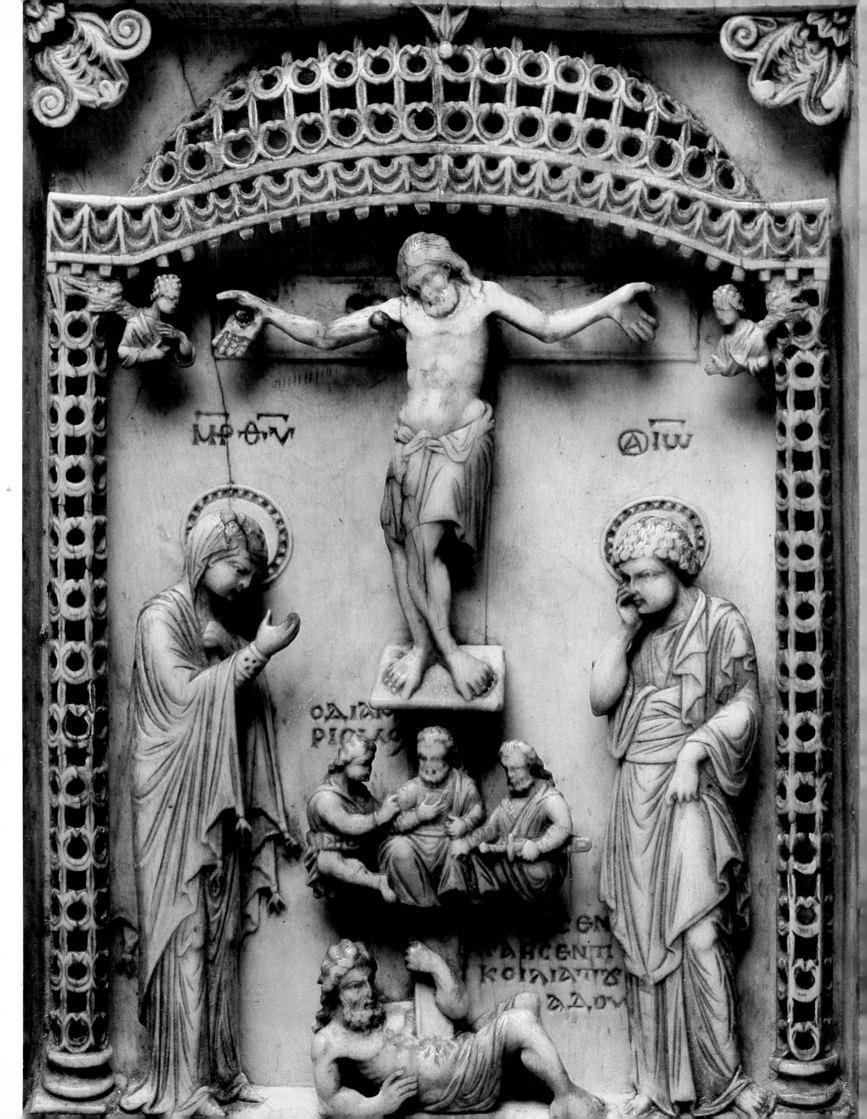

The Forty Martyrs of Sebaste and Soldier-Saints
Ivory triptych, center: 18.7 x 12 cm. (7⅜ x 4¾ in.),
each wing: 16.8 x 5.9 cm. (6⅝ x 2⅜ in.);
Constantinople, tenth century; Hermitage, Leningrad.

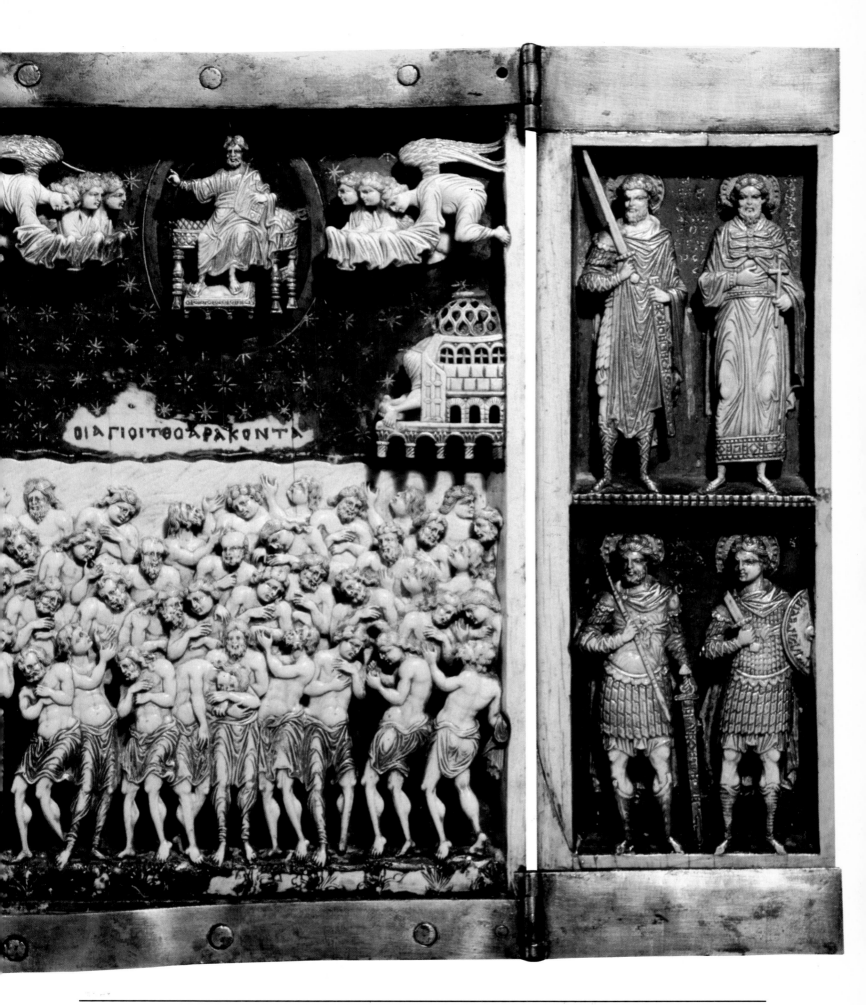

OIΔΓΙΟΙΤΕΘΔΡΔΚΟΝΤΔ

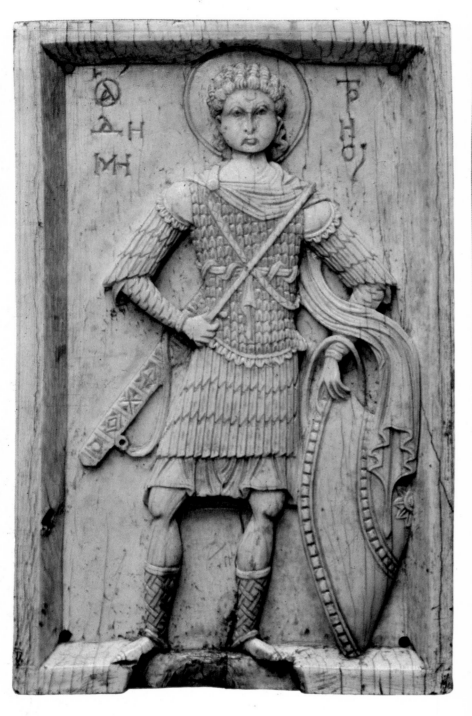

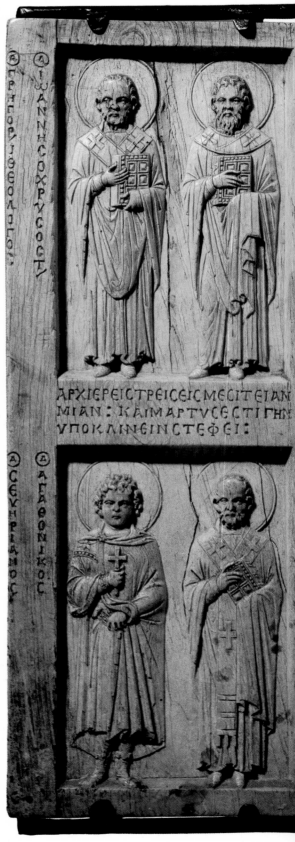

Above:
St. Demetrius
Ivory, 19.5 x 12.5 cm. (7⅝ x 4⅞ in.); Constantinople,
late tenth century; Metropolitan Museum of Art, New
York.

Right:
Deesis and Saints
Ivory triptych, center: 24 x 14.5 cm. (9½ x 5¾ in.),
each wing: 21 x 7-7.2 cm. (8¼ x 2¾-2⅞ in.);
Constantinople, mid-tenth century; Museo di Palazzo
di Venezia, Rome.

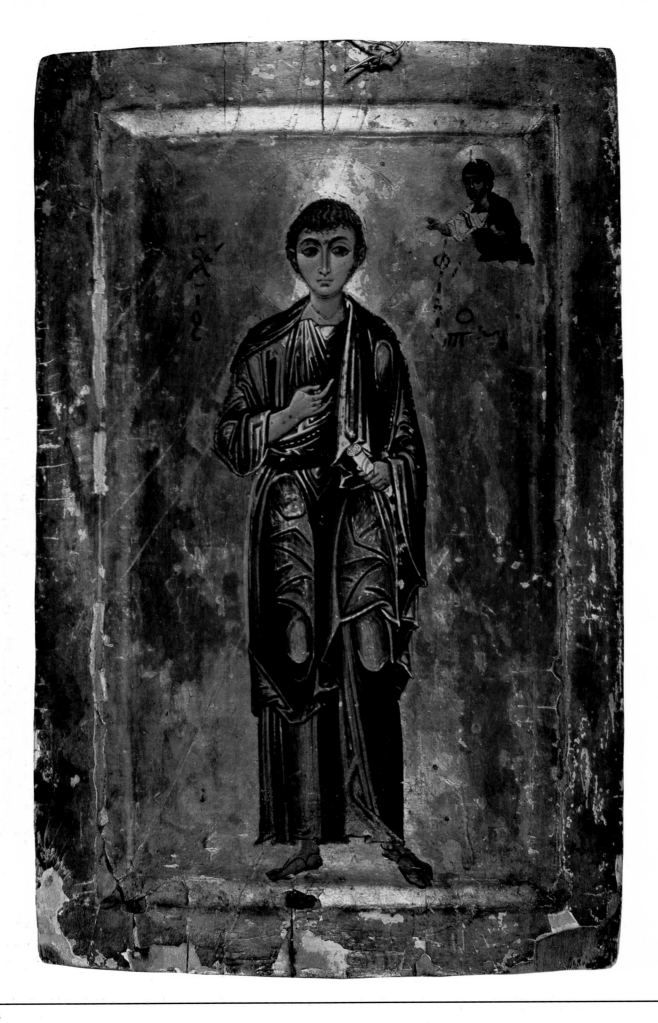

34

Opposite:
St. Philip
Panel in tempera, 32.8 x 20.2 cm. (12⅞ x 8 in.);
Constantinople, 950–1000; St. Catherine's Monastery,
Sinai.

Standing Christ
Chalcedony mounted in a later frame, 12 x 8.2 cm.
(4¾ x 3¼ in.), 8.8 x 5 cm. (3½ x 2 in.) without
mounting; Constantinople, c. tenth century; Armory,
Kremlin, Moscow.

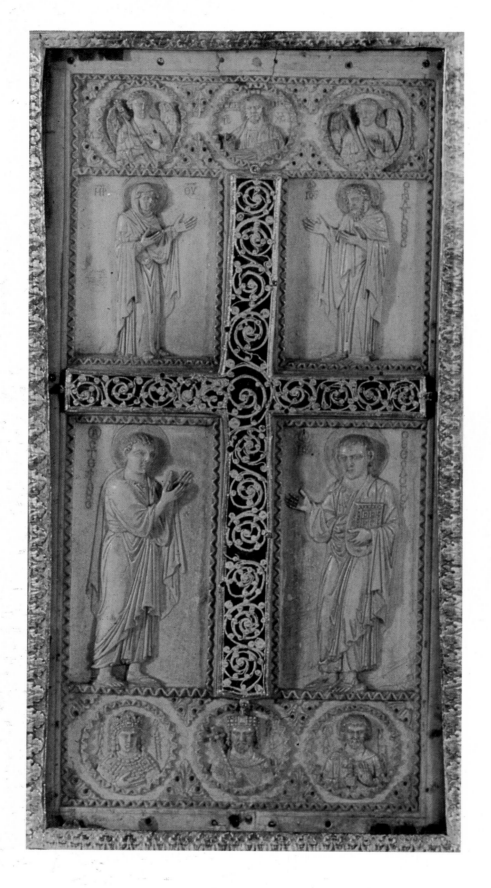

Deesis and Saints
Ivory, containing a relic of the Holy Cross; 31 x 17.4
cm. (12¼ x 6⅞ in.); Constantinople, 936–69; Church
of S. Francesco, Cortona.

Opposite:
Christ and the *Virgin*
Ivory plaques, originally decorating an
iconostasis beam, re-used as book covers
of prayerbooks; each plaque 27.9 x 11.3
cm. (11 x 4½ in.); Constantinople, end
of tenth century; Staatsbibliothek,
Bamberg.

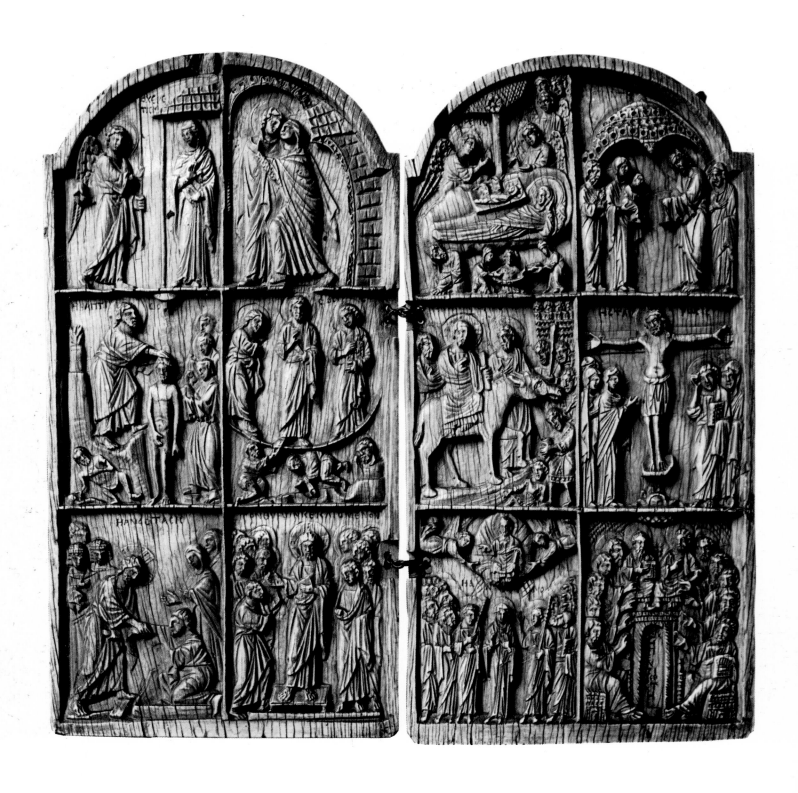

The Twelve Feasts
Ivory diptych, each wing 26.4 x 13.2 cm. (10⅜ x 5¼
in.); Constantinople, c. 1000; Hermitage, Leningrad.

The Last Judgment
Ivory, 15.5 x 21.5 cm. (6⅛ x 8½ in.); Constantinople,
c. 1000; Victoria and Albert Museum, London.

Virgin Orant and Christ and Saints' Busts
Enamel diptych, each plaque 29 x 21 cm. (11⅜ x 8¼
in.); Constantinople, tenth century; Treasury of San
Marco, Venice.

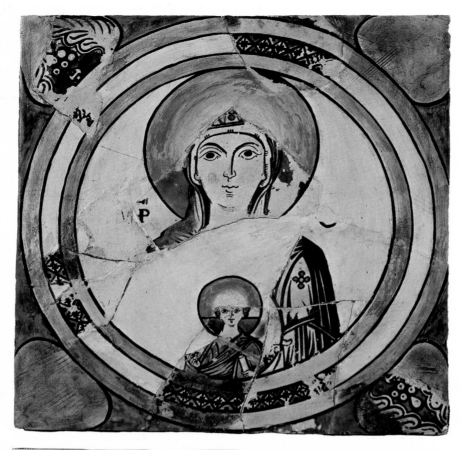

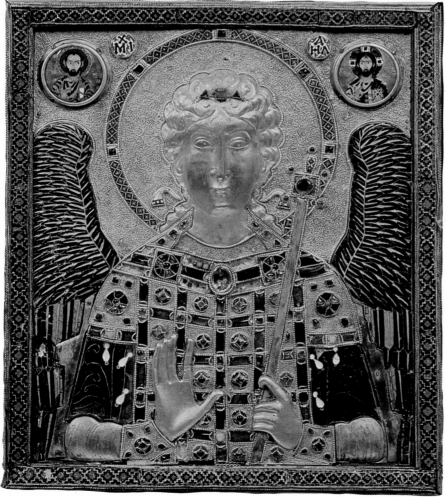

Above left:
Virgin Nikopoios
Enameled terracotta, 30 x 30 cm. (11¾ x 11¾ in.); Constantinople, tenth or eleventh century; Musée du Louvre, Paris.

Left:
Bust of Archangel Michael
Enamel in a thirteenth-century frame with some earlier pieces, 33 x 22 cm. (13 x 8⅝ in.); Constantinople, second half of tenth or early eleventh century; Treasury of San Marco, Venice.

Opposite:
Standing Archangel Michael
Enamel, 46 x 35 cm. (18⅛ x 13¾ in.); Constantinople, c. 1000–1050; Treasury of San Marco, Venice.

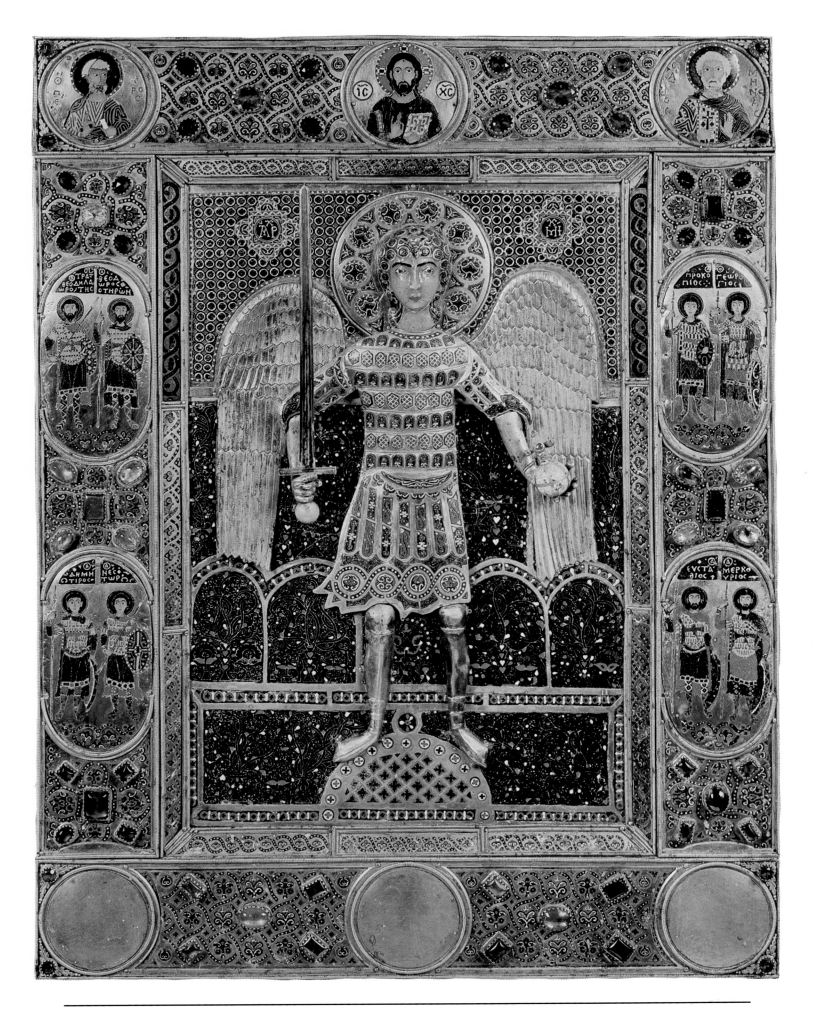

THE ICONS OF CONSTANTINOPLE

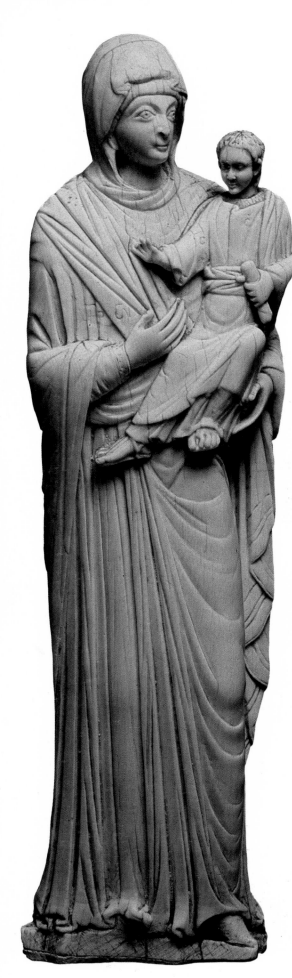

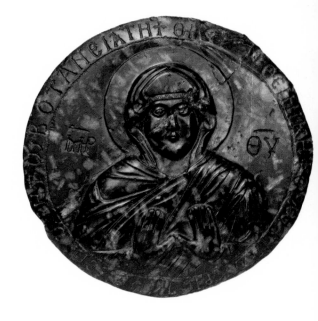

Left:
Standing Virgin Hodegetria
Ivory, 32.1 cm. (12⅝ in.);
Constantinople, c. 1000–1050; Victoria
and Albert Museum, London.

Above right:
Virgin Orant
Green serpentine, diameter 17.9 cm. (7
in.); Constantinople, 1078–81; Victoria
and Albert Museum, London.

Right:
St. Eudocia
Marble intarsia, 57.5 x 27 cm. (22⅝ x
10⅝ in.); Constantinople, c. 1000;
Archaeological Museums, Istanbul.

Opposite:
*Virgin Hodegetria Between St. John the
Baptist and St. Basil*
Central part of an ivory triptych with
the background cut out, 16.2 x 10.6
cm. (6⅜ x 4⅛ in.); Constantinople,
mid-eleventh century; Dumbarton
Oaks Collection, Washington, D.C.

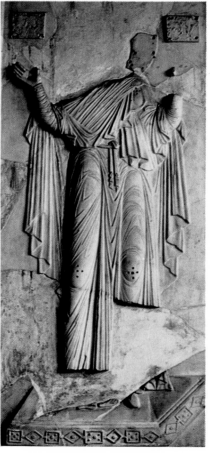

Virgin Platytera
Marble, 136 x 76 cm. (53½ x 29⅞ in.); Constantinople,
mid-eleventh century; Santa Maria Materdomini,
Venice.

Virgin Orant
Marble, 200 x 99 cm. (78¾ x 39 in.);
Constantinople, mid-eleventh century;
Archaeological Museums, Istanbul.

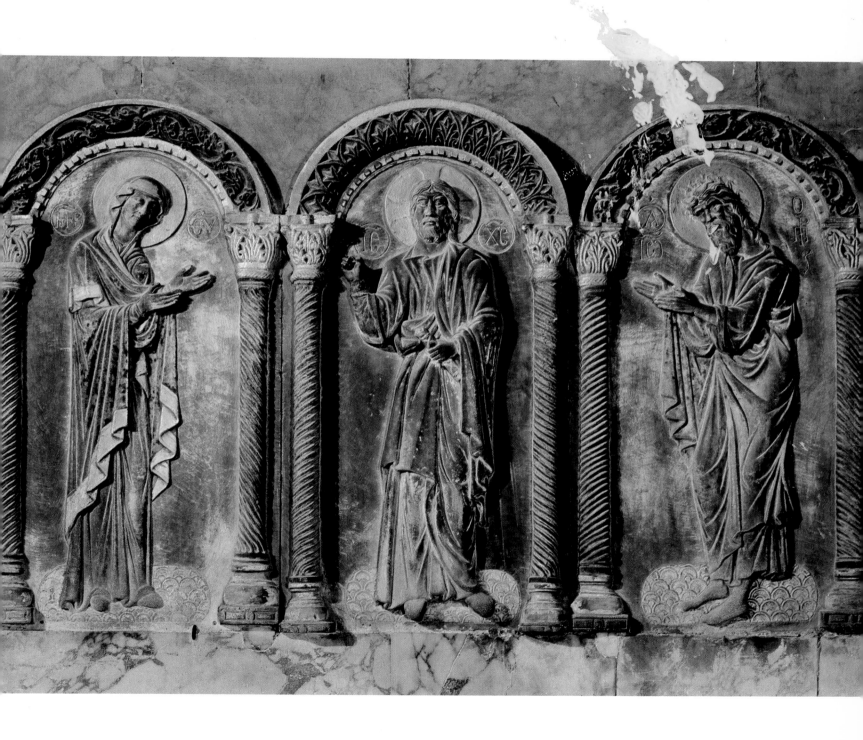

Deesis
Marble, from an iconostasis; 111 x 177 cm. (43¾ x 69⅝
in.); Constantinople, c. 1000–1050; Cathedral of San
Marco, Venice.

THE ICONS OF CONSTANTINOPLE

47

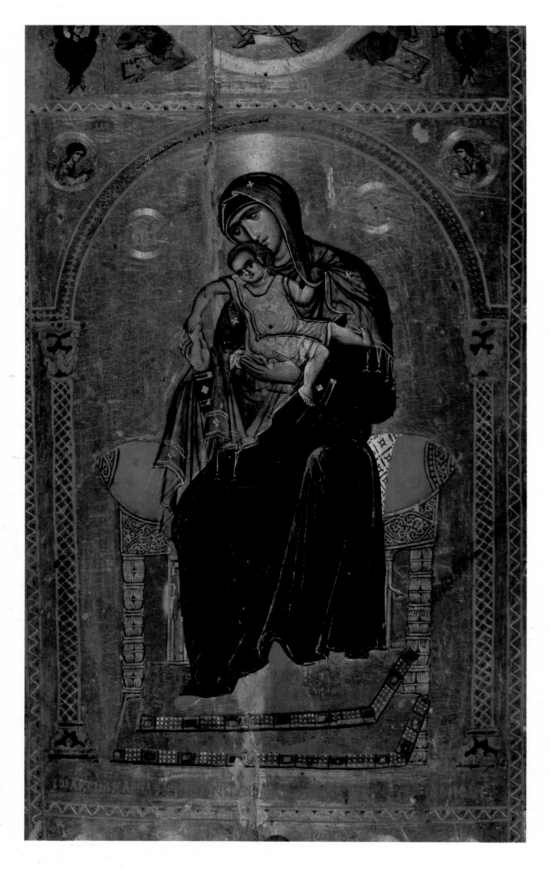

Virgin with Child, called *Kykkotissa,* Detail
Central part of an icon painted in tempera with figures
of saints and narrative scenes in the frame; total
measurement 48.6 x 39.8 cm. (19⅛ x 15⅝ in.);
Constantinople, 1050–1100; St. Catherine's Monastery,
Sinai.

Opposite:
Deesis with Saints in the Frame
Tempera, 36.2 x 29.1 cm. (14¼ x 11½ in.);
Constantinople, late eleventh century; St. Catherine's
Monastery, Sinai.

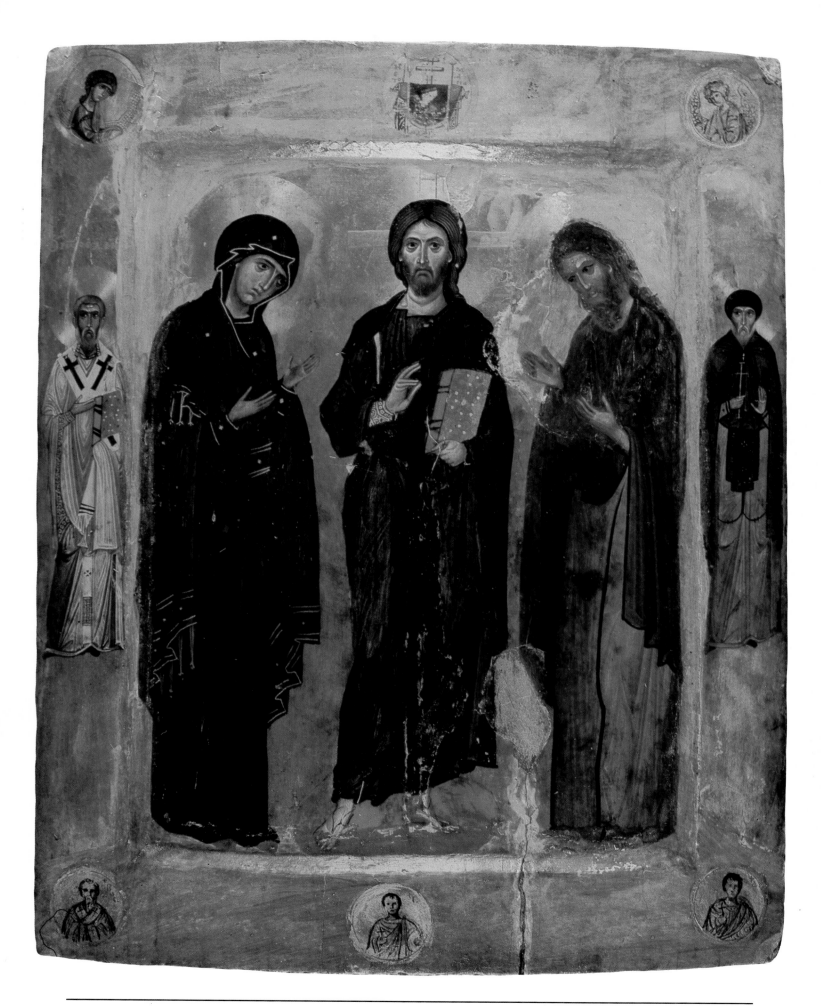

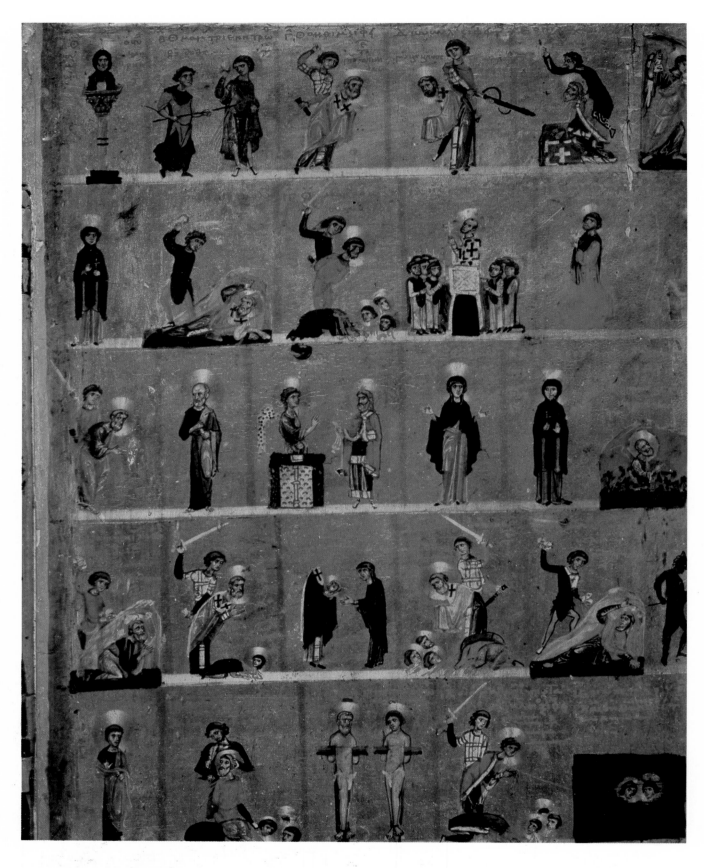

The Saints of September–November
One of a set of four calendar icons painted in tempera,
48.1 x 36.8 cm. (19 x 14½ in.); Constantinople,
1050–1100; St. Catherine's Monastery, Sinai.

Opposite:
SS. Procopius, Demetrius, and Nestor
The icon is cut at the sides
Tempera, 28.5 x 18.2 cm. (11¼ x 7⅛ in.);
Constantinople, 1050–1100; St. Catherine's Monastery,
Sinai.

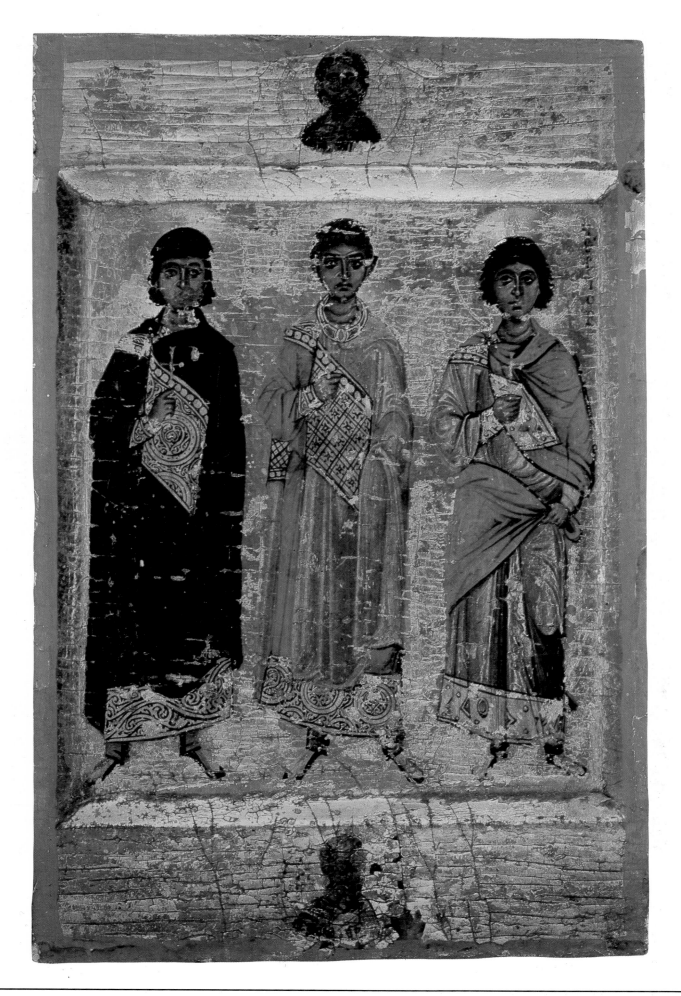

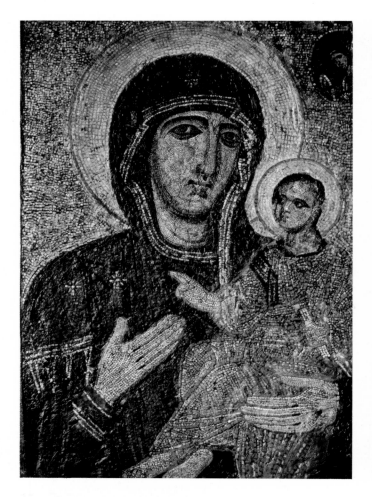

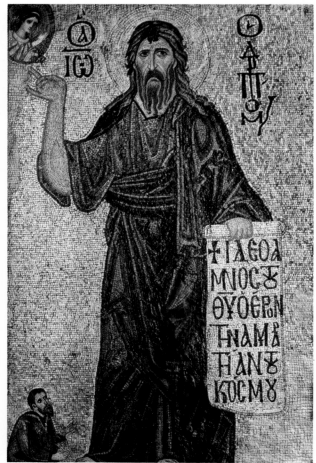

Above left:
Virgin Hodegetria
Mosaic, 17.2 x 16.5 cm. (6¾ x 6½ in.); Constantinople, probably between 1118 and 1143; Greek Patriarchate, Istanbul.

Above:
St. John the Baptist
Mosaic, 20.3 x 19.5 cm. (8 x 7⅝ in.); Constantinople, probably between 1118 and 1143; Greek Patriarchate, Istanbul.

Left:
Virgin Paraclesis
Tempera; Constantinople, 1100–1150; Cathedral, Spoleto.

Opposite:
Virgin Paraclesis with George of Antioch
Constantinopolitan artist working in Sicily
Mosaic; 1143–51; Church of the Martorana, Palermo.

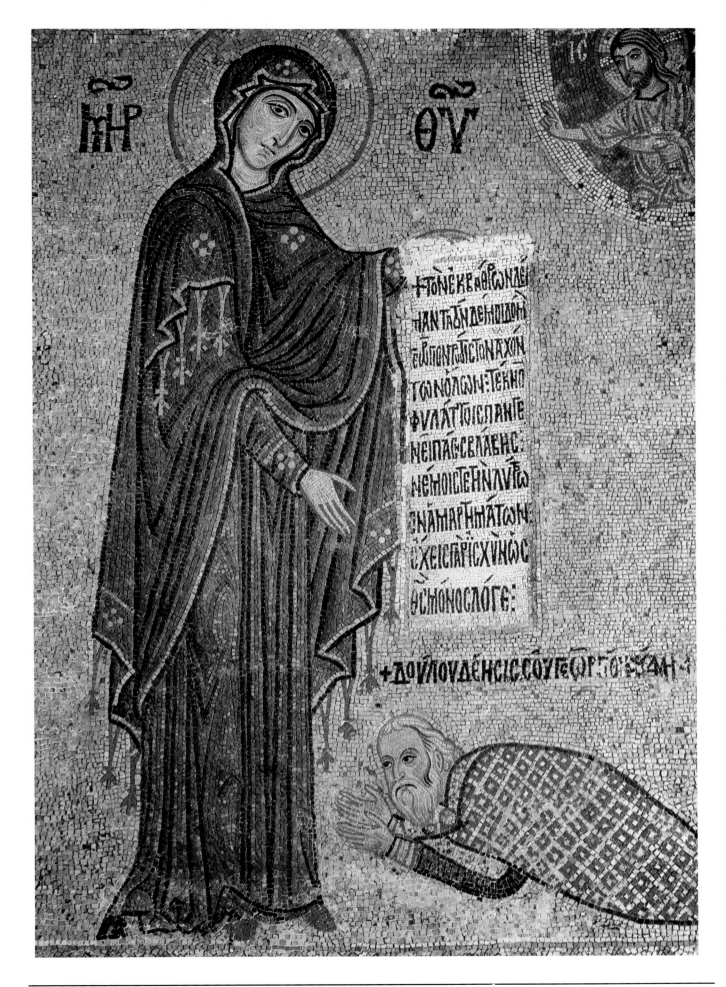

Christ Eleemon
Mosaic, 74.5 x 52.5 cm. (29⅜ x 20⅝ in.);
Constantinople, 1100–1150; Staatliche Museen,
Preussischer Kulturbesitz, Berlin.

Opposite:
Virgin of Vladimir
Tempera, 104 x 69 cm. (41 x 27⅛ in.); Constantinople,
c. 1131; Tretyakov Gallery, Moscow.

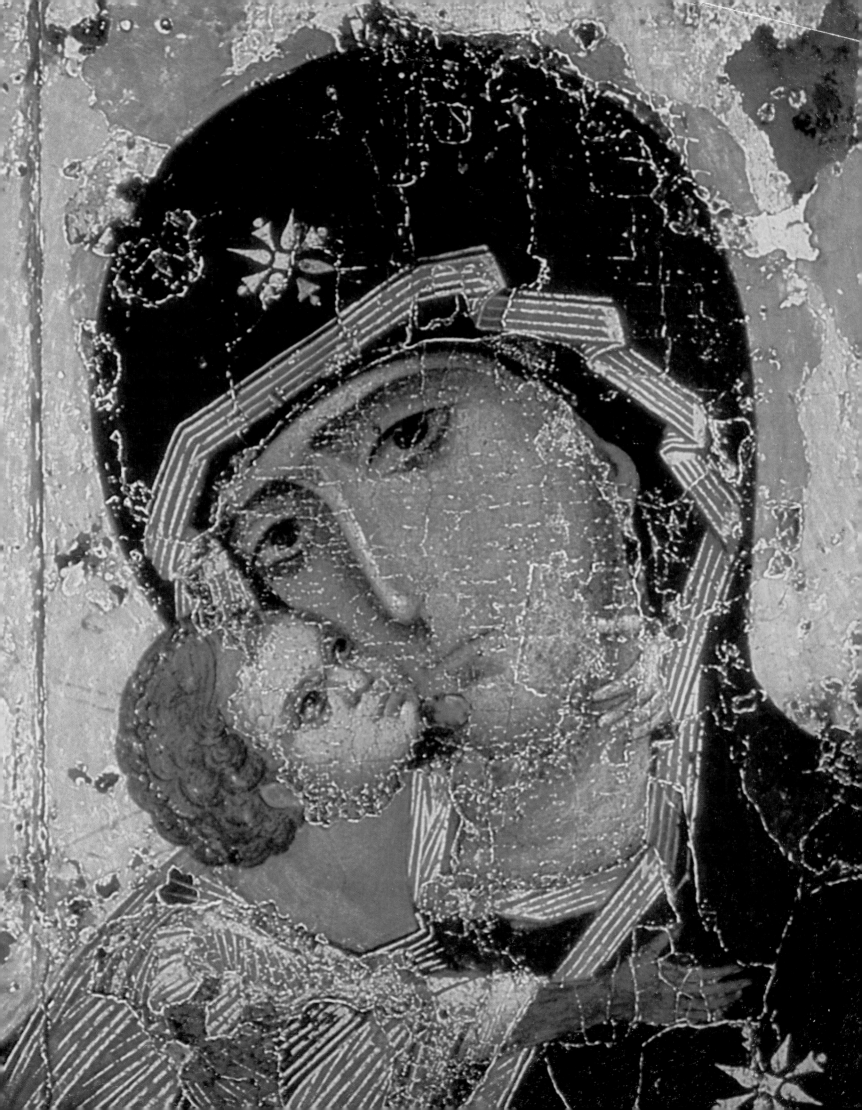

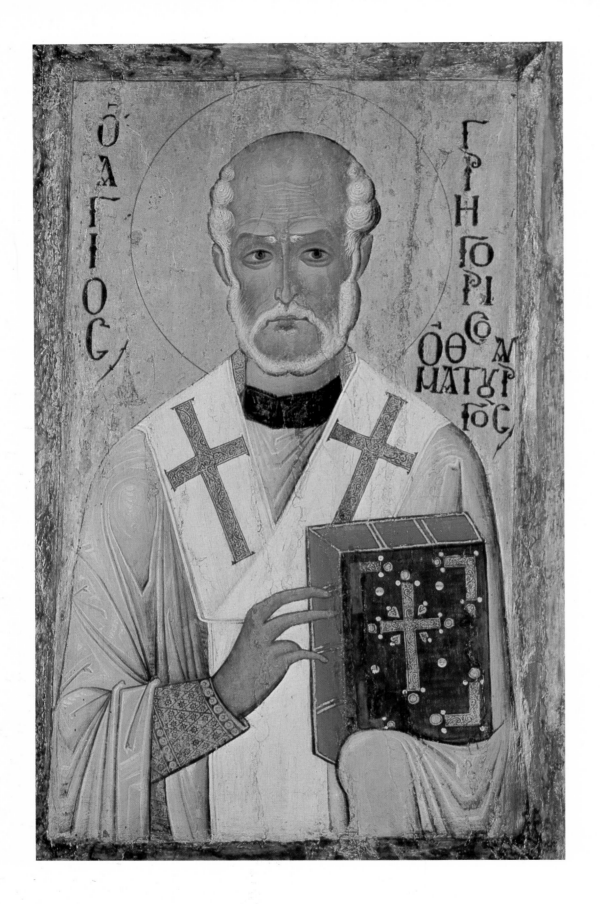

St. Gregory Thaumaturgos
Tempera, 81 x 53 cm. (31⅞ x 20⅞ in.);
Constantinople, 1150–1200; Hermitage, Leningrad.

Opposite:
Miracle of St. Michael at Chone
Tempera, 37.5 x 30.7 cm. (14¾ x 12⅛ in.);
Constantinople, 1100–1150; St. Catherine's Monastery,
Sinai.

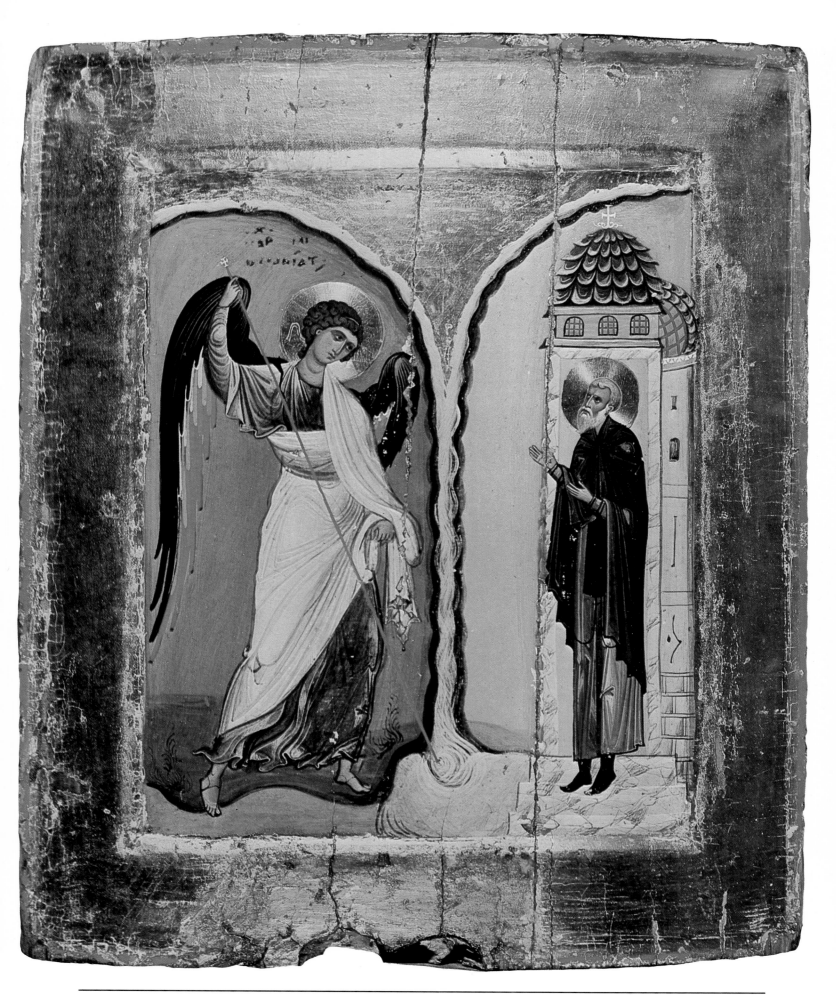

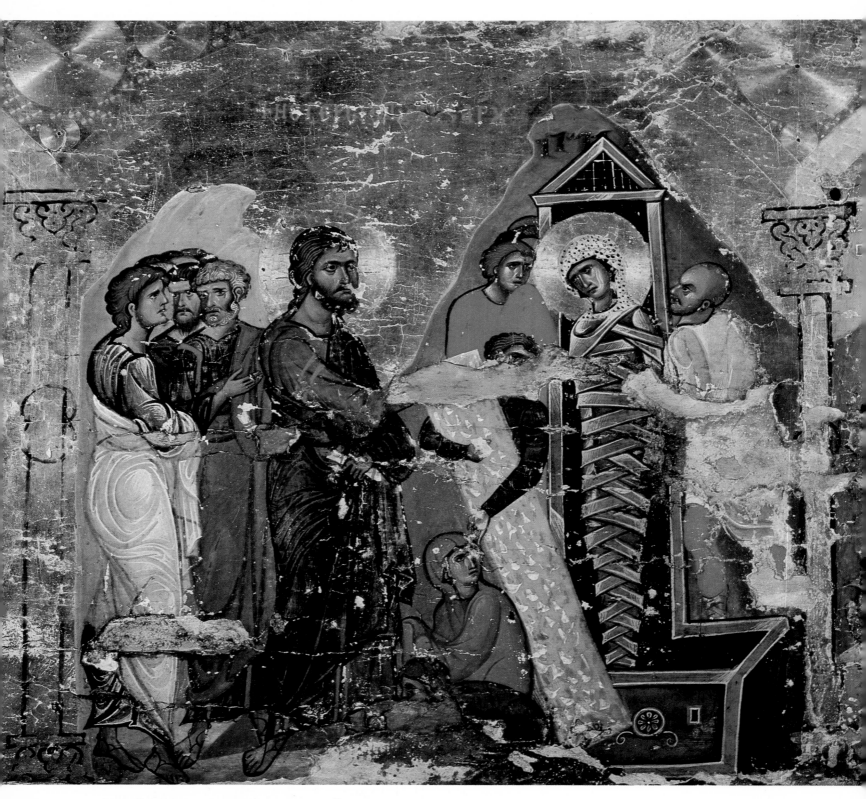

Raising of Lazarus
Detail: Central section of an iconostasis beam
comprising the *Deesis* and four feast scenes
Constantinopolitan artist working at Sinai
Total measurement 41.5 x 159 cm. (16⅜ x 62⅝ in.);
mid-twelfth century; St. Catherine's Monastery, Sinai.

Opposite:
Koimesis
Part of a dismantled iconostasis beam, reassembled on
the Pala d'oro
Cloisonné enamel, 30.7 x 30 cm. (12⅛ x 11¾ in.);
Constantinople, 1150–1200; Cathedral of San Marco,
Venice.

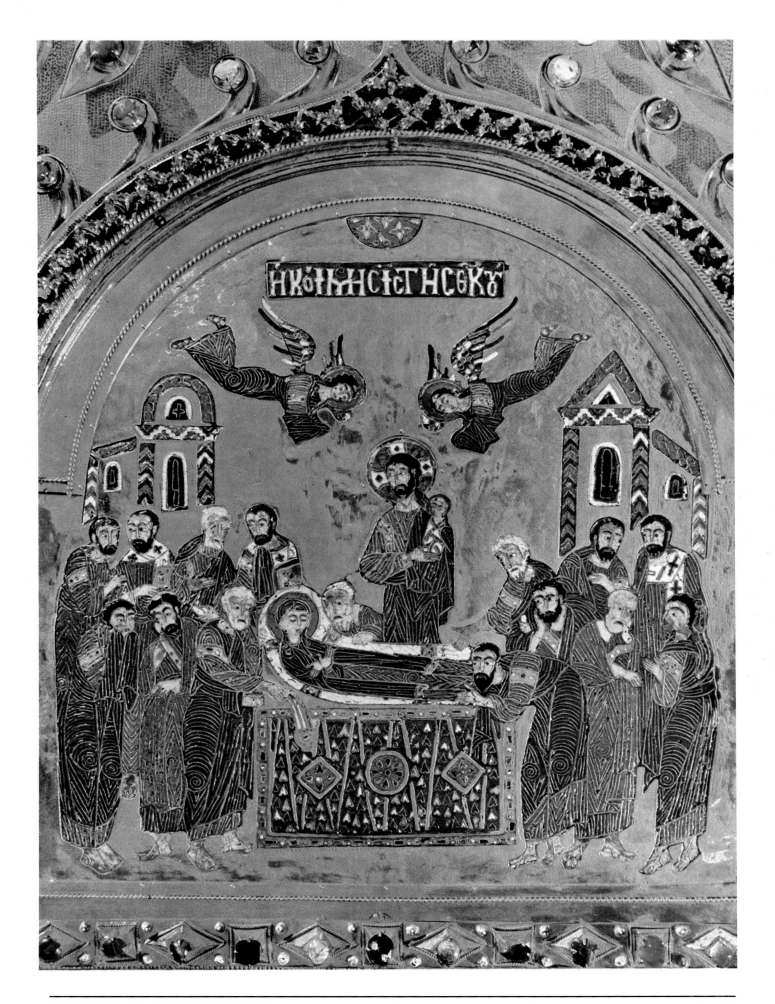

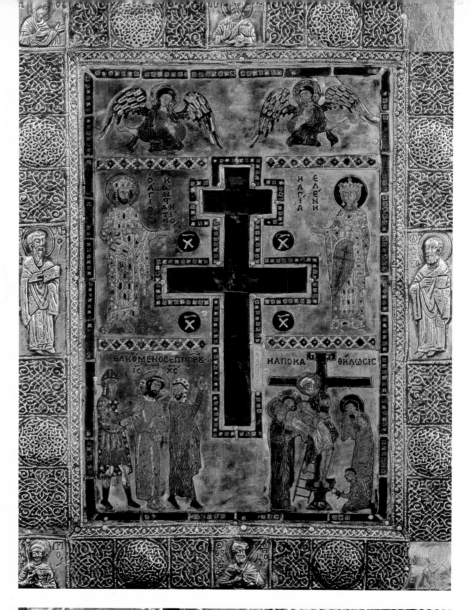

Above left:
Cross Reliquary with Constantine and Helena and *Two Scenes from the Passion*
Cloisonné enamel, 35 x 25 cm. (13¾ x 9⅞ in.); Constantinople, 1150–1200; Christian Museum, Esztergom, Hungary.

Opposite:
Crucifixion and Saints
Enamel and metal, 34.3 x 32.5 cm. (13½ x 12¾ in.); Constantinople, twelfth century; Hermitage, Leningrad.

Left:
Crucifixion and Saints, Detail

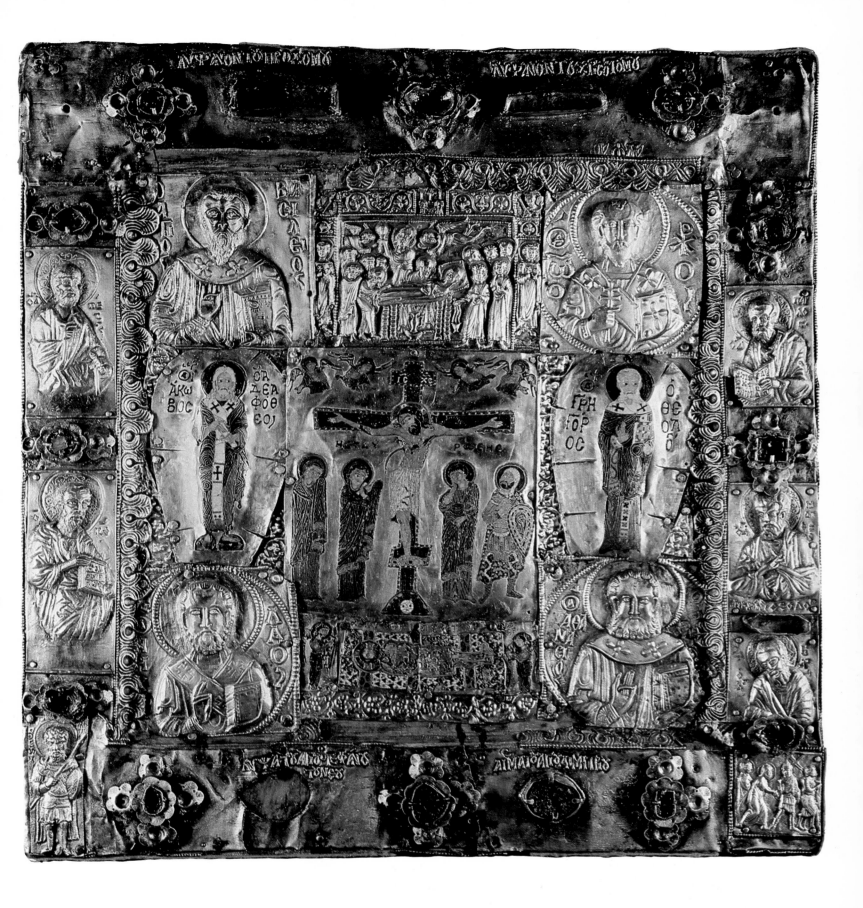

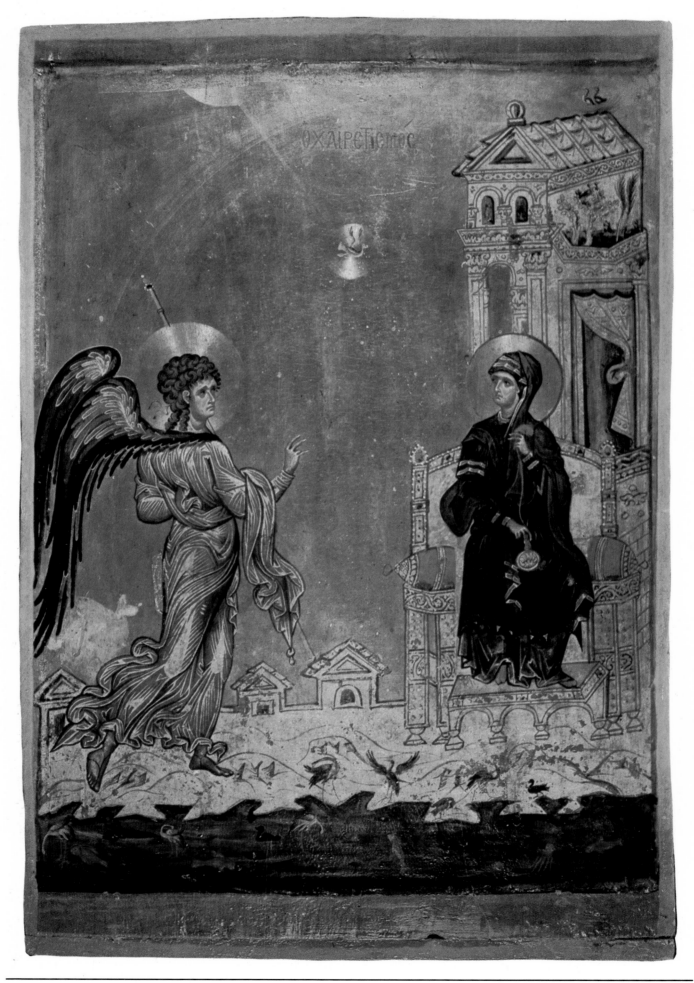

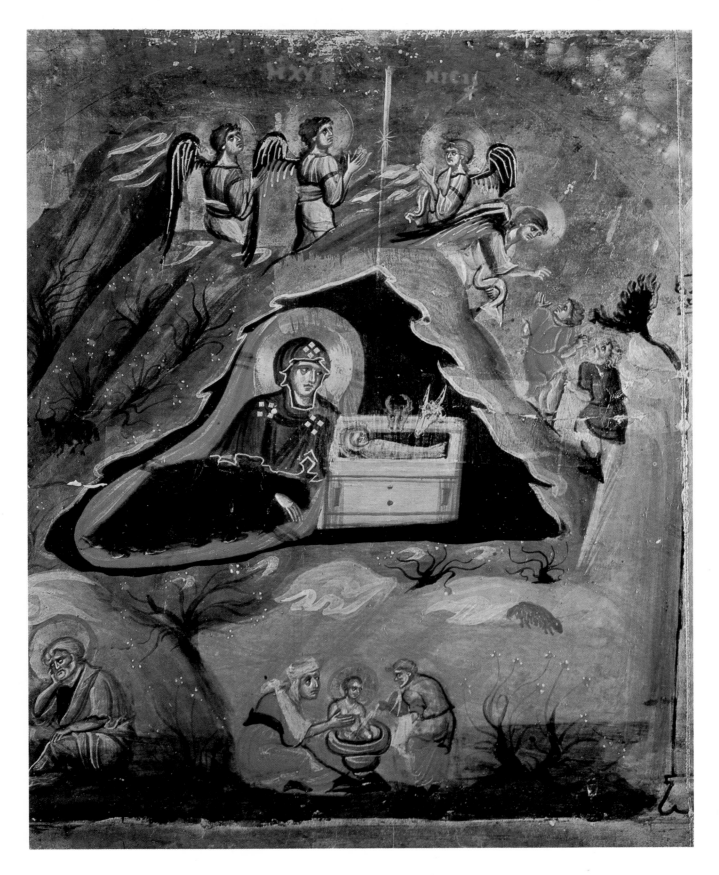

Opposite:
Annunciation
Tempera, 61 x 42 cm. (24 x 16½ in.); Constantinople,
end of twelfth century; St. Catherine's Monastery,
Sinai.

Nativity of Christ
Section of an iconostasis beam with the feast cycle
Constantinopolitan artist probably working at Sinai
Tempera, 38 x 50.3 cm. (15 x 19¾ in.), including
"Presentation in the Temple"; c. 1200; St. Catherine's
Monastery, Sinai.

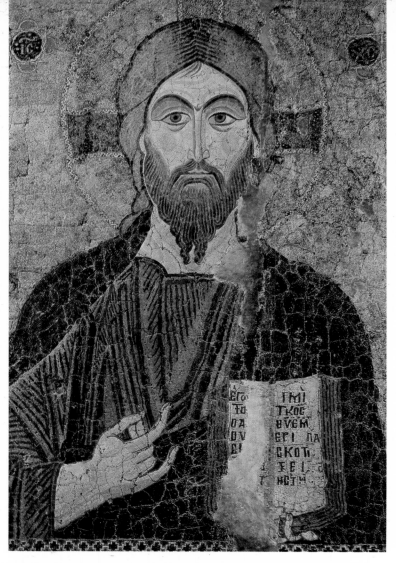

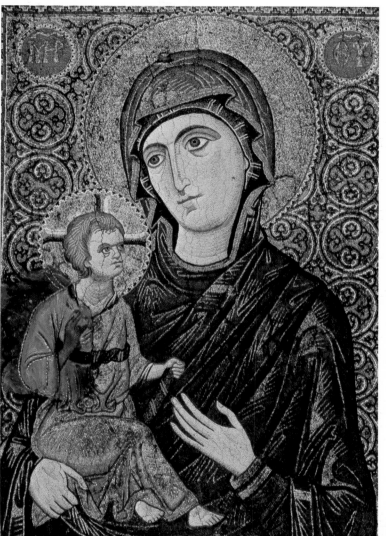

Above left:
Christ
Mosaic, 54 x 41 cm. (21¼ x 16⅛ in.);
Constantinople, 1150–1200; Museo del
Bargello, Florence.

Left:
Virgin Hodegetria
Mosaic, 44.6 x 33 cm. (17½ x 13 in.)
(34 x 23 cm. [13⅜ x 9 in.] without
frame); Constantinople, early thirteenth
century; St. Catherine's Monastery,
Sinai.

Opposite:
Transfiguration of Christ
Mosaic, 52 x 36 cm. (20½ x 14⅛ in.);
Constantinople, c. 1200; Musée du
Louvre, Paris.

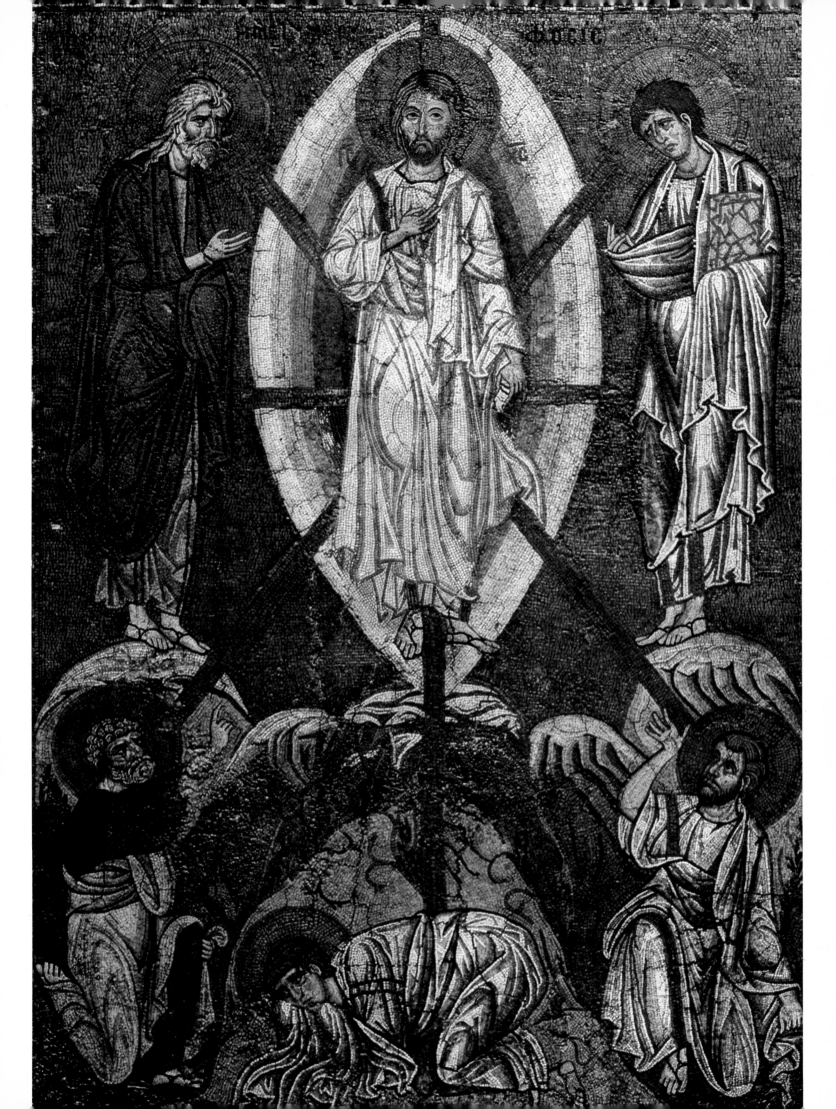

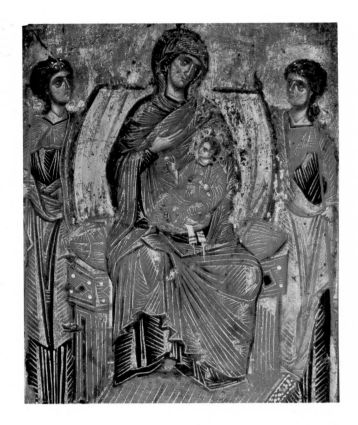

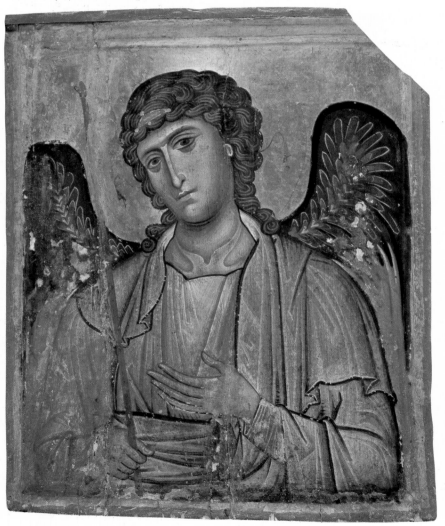

Above:
Virgin Enthroned
Tempera, 34.5 x 26 cm. (13⅝ x 10¼
in.); Constantinople, 1200–1250; St.
Catherine's Monastery, Sinai.

Left:
Archangel Gabriel
Constantinopolitan artist working at
Sinai
55.6 x 45.5 cm. (21⅞ x 17⅞ in.);
1200–1250; St. Catherine's Monastery,
Sinai.

Opposite:
St. Nicholas
Constantinopolitan artist working at
Sinai
82 x 56.9 cm. (32¼ x 22⅜ in.); early
thirteenth century; St. Catherine's
Monastery, Sinai.

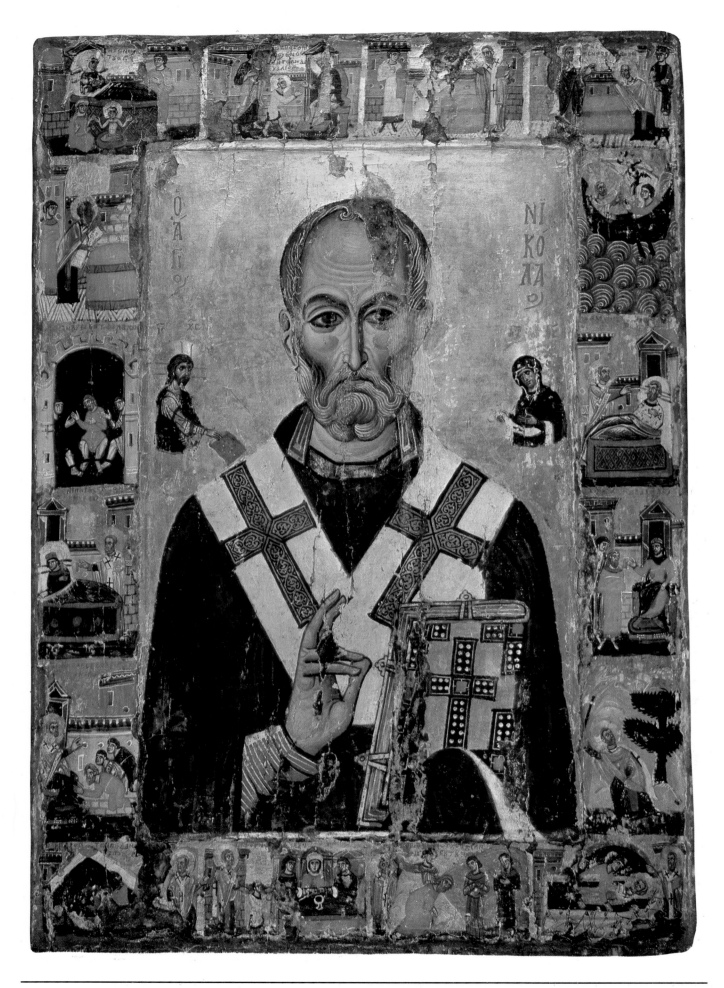

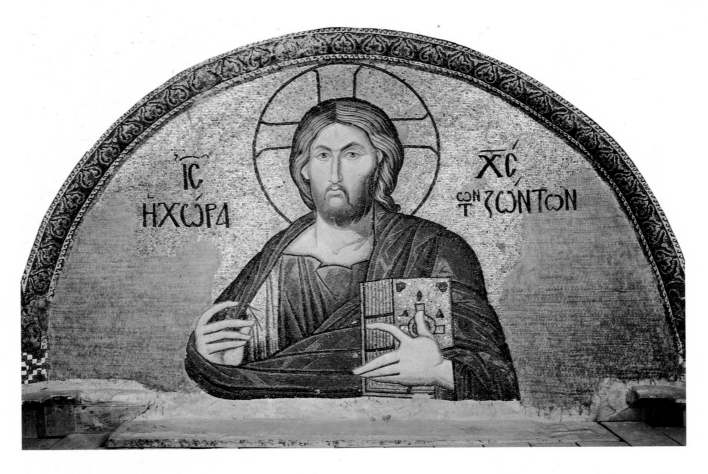

Top:
Bust of Christ
Portal icon in mosaic over entrance into narthex, 215 x
363 cm. (84⅝ x 142⅞ in.); Constantinople, before
1335; Kariye Camii, Istanbul.

Above:
Deesis
Mosaic; Constantinople, end of thirteenth century;
South Gallery, Hagia Sophia, Istanbul.

Opposite
Virgin Glykophilousa
Fresco, 229 x 156 cm. (90⅛ x 61⅜ in.);
Constantinople, before 1335; Kariye Camii, Istanbul.

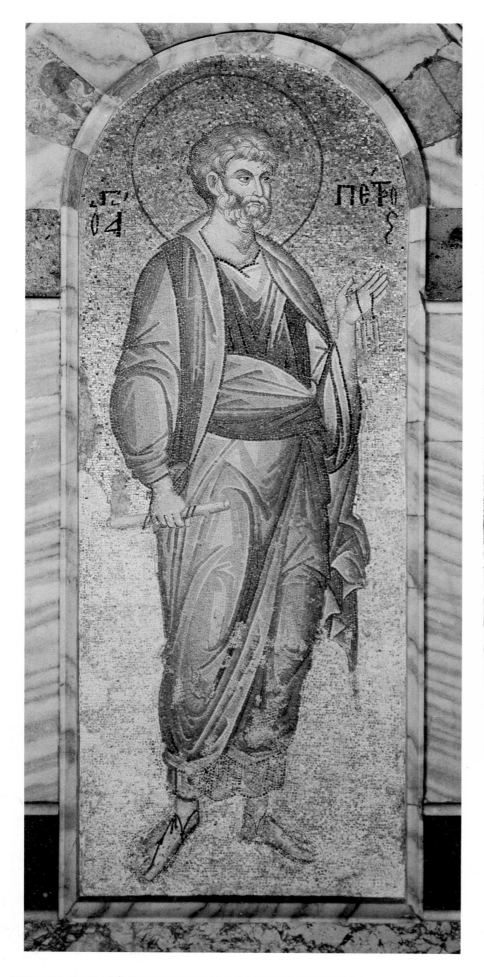

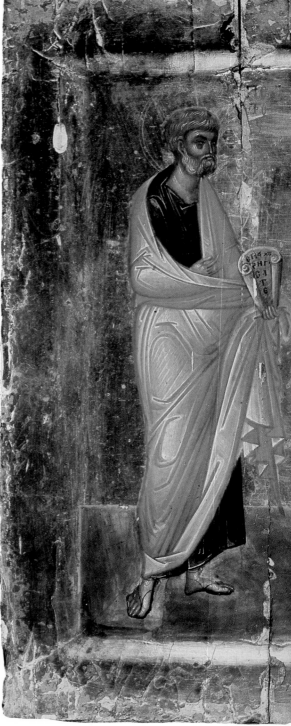

Above:
St. Peter and St. Paul
Tempera, 25 x 20.8 cm. (9⅞ x 8¼ in.);
Constantinople, fourteenth century; St.
Catherine's Monastery, Sinai.

Left and opposite:
St. Peter and *St. Paul*
Mosaics flanking the entrance into the
nave, Peter: 205 x 76 cm. (80¾ x 29⅞
in.), Paul: 205 x 72 cm. (80¾ x 28⅜
in.); Constantinople, before 1335;
Kariye Camii, Istanbul.

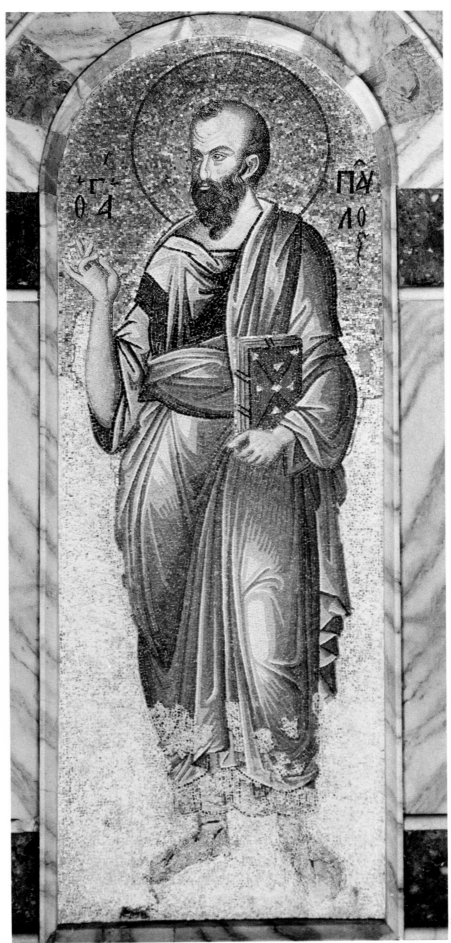

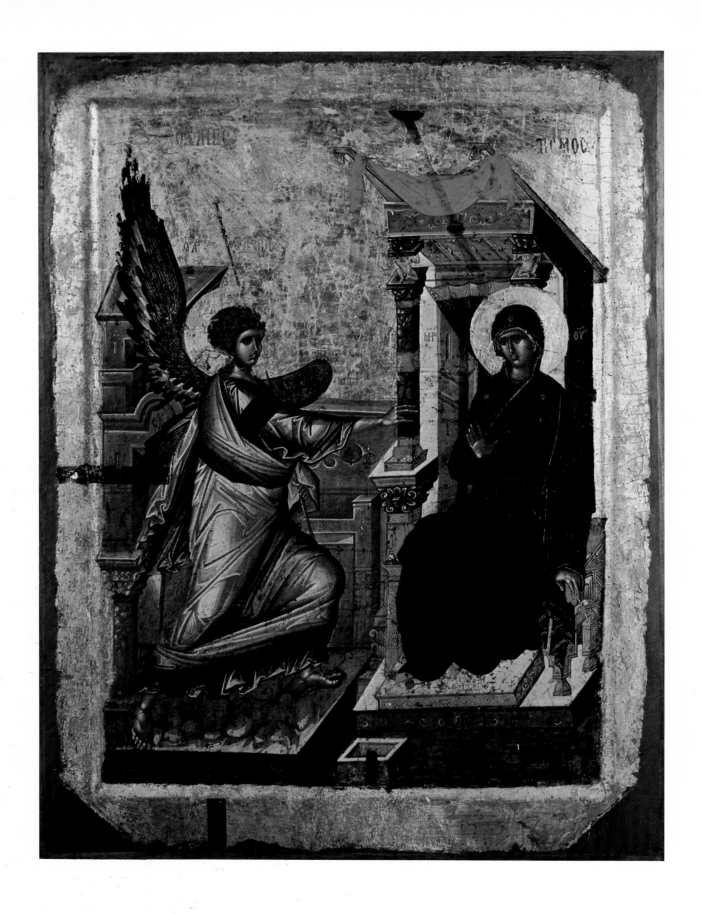

Annunciation
Bilateral icon painted in tempera, 94.5 x 80.3 cm. (37¼
x 31⅝ in.); Constantinople, early fourteenth century;
National Museum, Ohrid.

Opposite:
Synaxis of the Twelve Apostles
Tempera, 38 x 34 cm. (15 x 13⅜ in.); Constantinople,
early fourteenth century; Pushkin Museum, Moscow.

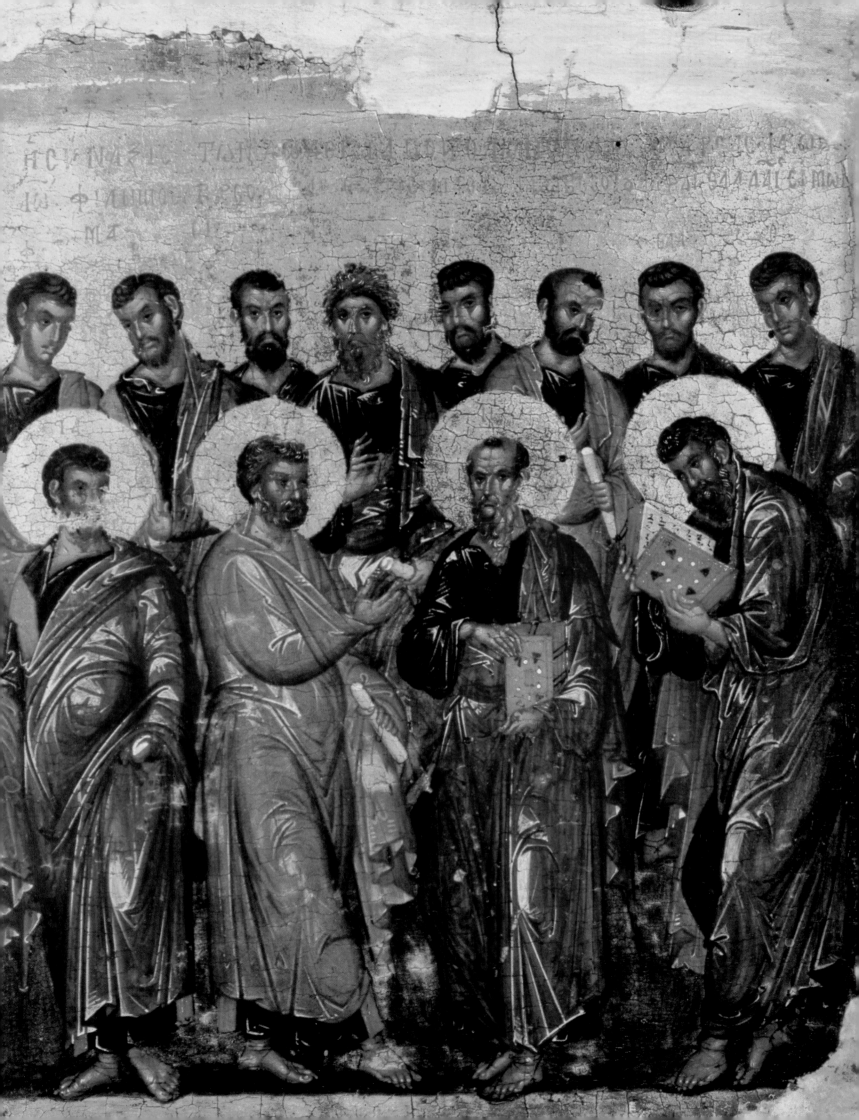

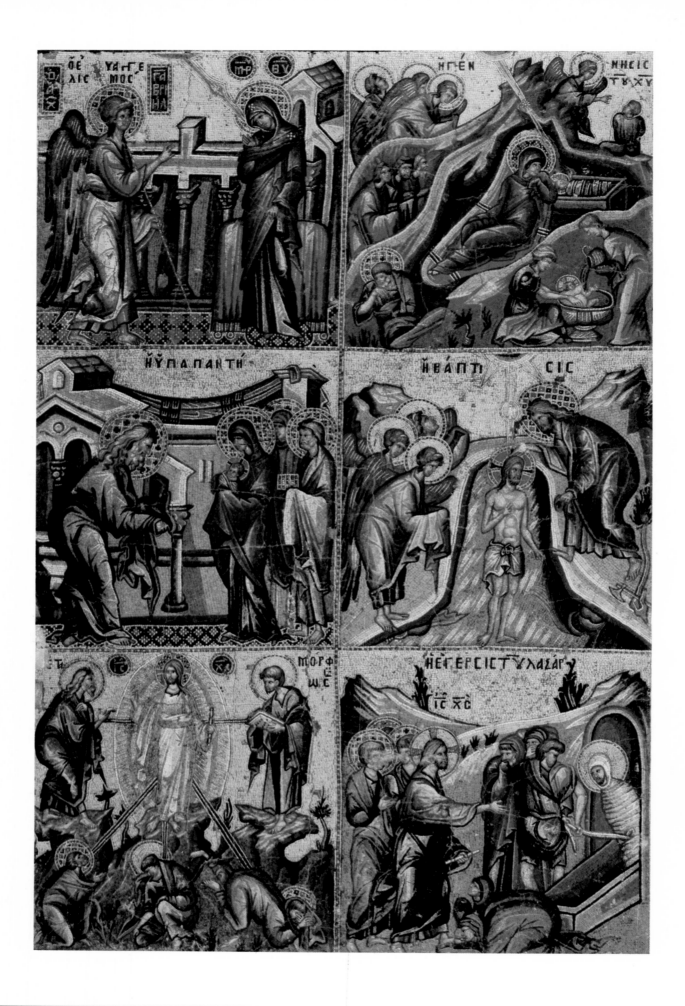

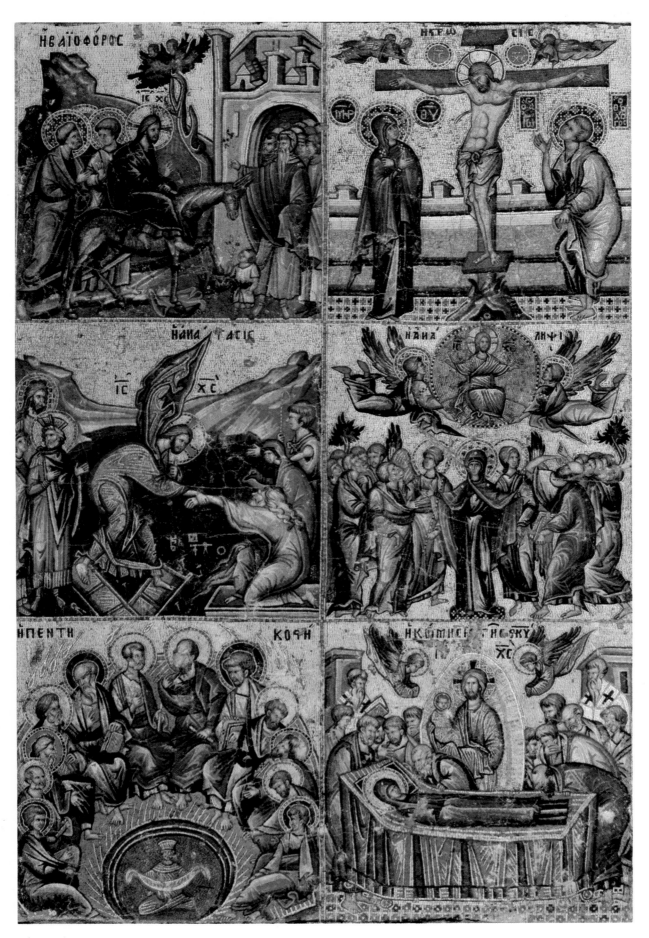

The Twelve Feasts
Mosaic diptych, 27 x 17.7 cm. (10⅝ x 7 in.) without
frame; Constantinople, 1350–1400; Museo dell'Opera
del Duomo, Florence.

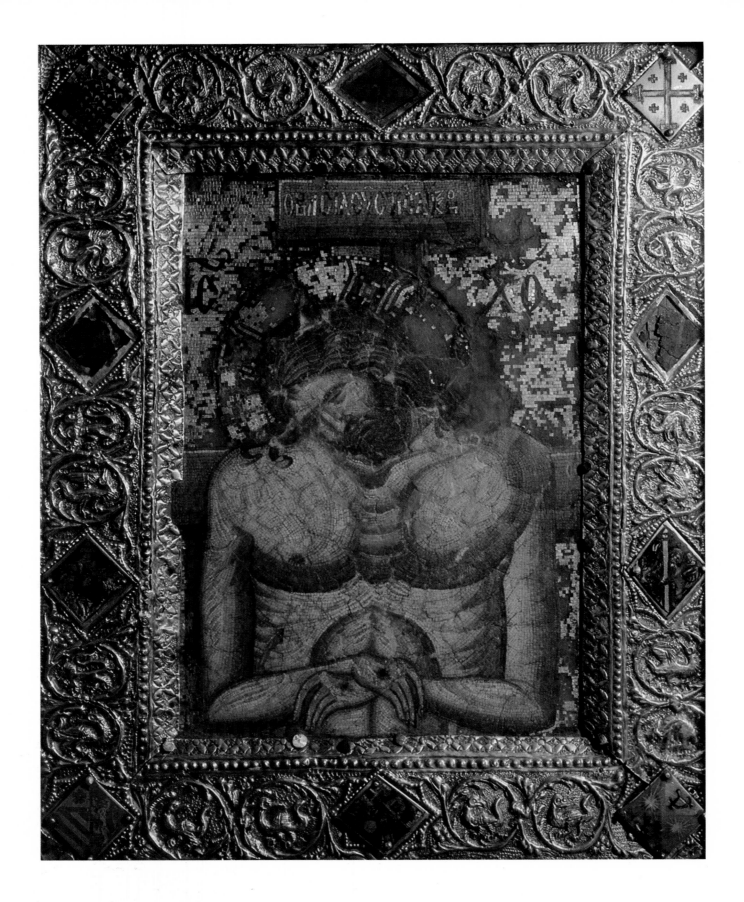

Man of Sorrow
Mosaic mounted in a reliquary, 28 x 23 cm. (11 x 9 in.) (19 x 13 cm. [7½ x 5⅛ in.] without frame); Constantinople, early fourteenth century; Santa Croce di Gerusalemme, Rome.

Opposite:
Annunciation
Mosaic, 13.3 x 8.4 cm. (5¼ x 3¼ in.); Constantinople, 1350–1400; Victoria and Albert Museum, London.

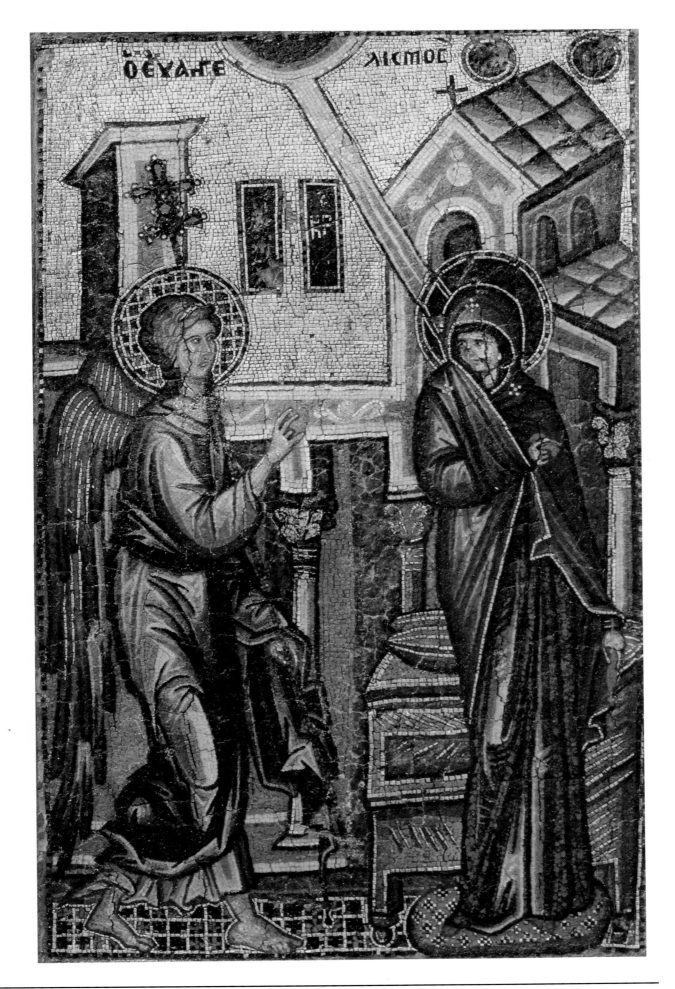

Ο ΕΥΑΓΓΕ ΛΙCΜΟC

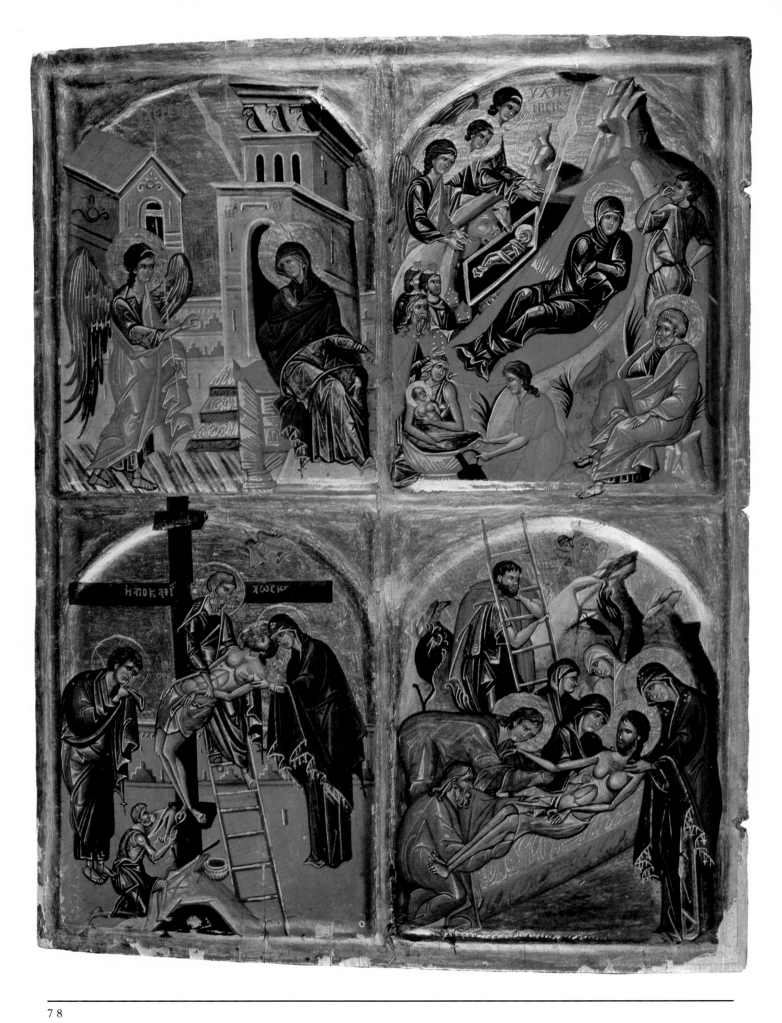

Both chased and painted Svanian icons of the twelfth and thirteenth centuries reflect the artists' admiration for certain compositional patterns and facial types. In the Ipari *Archangel* (late thirteenth century; p. 119), the soft, subdued colors (a combination of grayish-blue and light ochre) and the decorative elements (pearls, the ornamental design of the garments) together create a festive impression. The very large eyes, the small mouth, the exaggerated long and fleshy nose, the shoulders somewhat too narrow for the size of the head, and the shortened arms with small hands, all betray the work of a provincial artist. The draftsmanship, however, is fine and remarkably expressive.

During the thirteenth century, the decorative tendency apparent in Svanian icons can also be detected in those created by other provincial schools. The linear style can be seen in an image of *Christ Enthroned* from the village of Matskhvarishi, and in icons from Imereti portraying the *Presentation in the Temple*, the *Ascension*, and the *Descent of the Holy Ghost on the Apostles* (p. 121). The light color scheme, the harmony of blue, green, lilac, and brown, makes these icons very different from those painted in Svaneti. The system of highlights and shades appears as a graphic transformation of the pictorial designs of early Palaeologan art, which, conjoined with the clear brown strokes of the drawing, determines the overall decorative effect. These icons evoke associations with miniature painting; it is indeed likely that some local artists painted both kinds of images, sacred and secular. The similarity of the icon of *Christ Enthroned* (p. 123) from the village of Khé to a composition in the Church of St. Barbara has led researchers to ascribe both the mural and the icon to the same master.

The arched parallel lines drawn on the chests of the *Two Archangels* in the Matskhvarishi icon (p. 120) seem to be a formal repetition of three-dimensional models that have here lost all plastic expressiveness. The clear-cut lines of shade outlining the face in the Svanian icon of *St. George* (p. 124) are perceived as a graphic interpretation of a "painterly"

molding of forms; the same effect is produced by splashes of color on the cheeks and neck. The features, the shape of the hands and their gesture, are typical of the fourteenth and fifteenth centuries.

Many icons displaying the high professional skills of local artists and vividly demonstrating the features of the Palaeologan style were created in Georgia. Three icons from Bkhotrera—half-figures of the *Savior*, an *Archangel*, and the *Apostle Paul*—give no convincing evidence of their local origin; on the other hand, the Georgian provenance of two large triptychs from Ubisi (p. 122) is corroborated by the inscriptions they bear in *asomtavruli*, the Georgian uncial script. Stylistic features of these triptychs prove that they come from the same workshop. One represents the *Dormition of the Virgin*, with attending Prophets and evangelists; the other, *Scenes from the Life of the Virgin and the Old Testament* (p. 122). (The scenes from the life of the Virgin are exact replicas of those we find in the fourteenth-century frescoes at Zarzma.) The organization of the many-figured composition, the broken lines of drawing contrasting with splashes of green, lilac, and vermilion on the robes, are typical features of the Palaeologan style in fourteenth-century Georgian painting.

Works of later centuries present a complex picture. In Svaneti, there is an abundance of low-quality material in which features of the epoch are scarcely discernible. The style has degenerated; the work is mediocre. The post-Byzantine style can be seen in such icons as the half-figure of the *Savior* from Alaverdi (p. 127), encased in a rich chased frame. On the whole, icons of this period reveal an artistic eclecticism. An Oriental (Iranian) influence is evident, as are the conventions of Russian painting. The many icons of Russian origin still preserved in Georgia possess a certain historical interest, however, as additional material for studying the period when Georgian painting was overcoming retrospective and Oriental tendencies and seeking a new path of development along the lines of Russian and western European art.

Opposite:
Transfiguration
Silver gilt (faces were painted), 131.5 x 74 cm. (51¾ x
29⅛ in.); Zarzma, 886; Georgian State Art Musuem,
Tiflis.

Overleaf left:
Virgin with Child Attended by Archangels
Encaustic tempera, 60 x 40 cm. (23⅝ x 3½ in.);
Tsilkani, ninth century, partially repainted in
thirteenth century (hair, robes, background, and
inscriptions); Georgian State Art Museum, Tiflis.

Overleaf right, above:
Deesis Triptych
Cloisonné enamel, silver gilt; 8 x 9 cm. (3⅛ x 3½ in.);
Martvili, ninth century; Georgian State Art Museum,
Tiflis.

Overleaf right, below:
Dormition of the Virgin
Central panel of an ivory triptych, 13 x 12.6 cm. (5⅛
x 5 in.); Nikortsminda, tenth century.

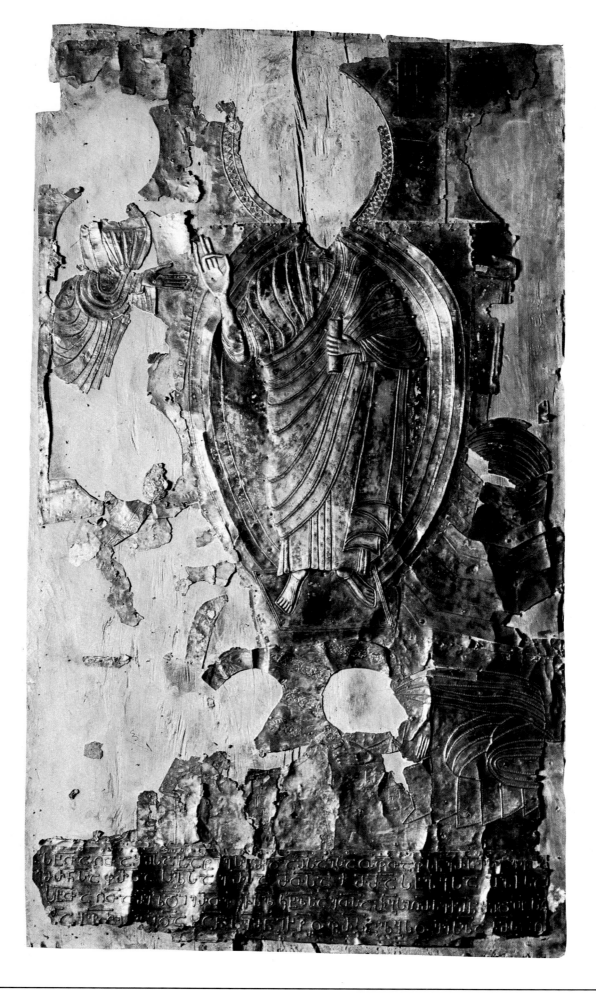

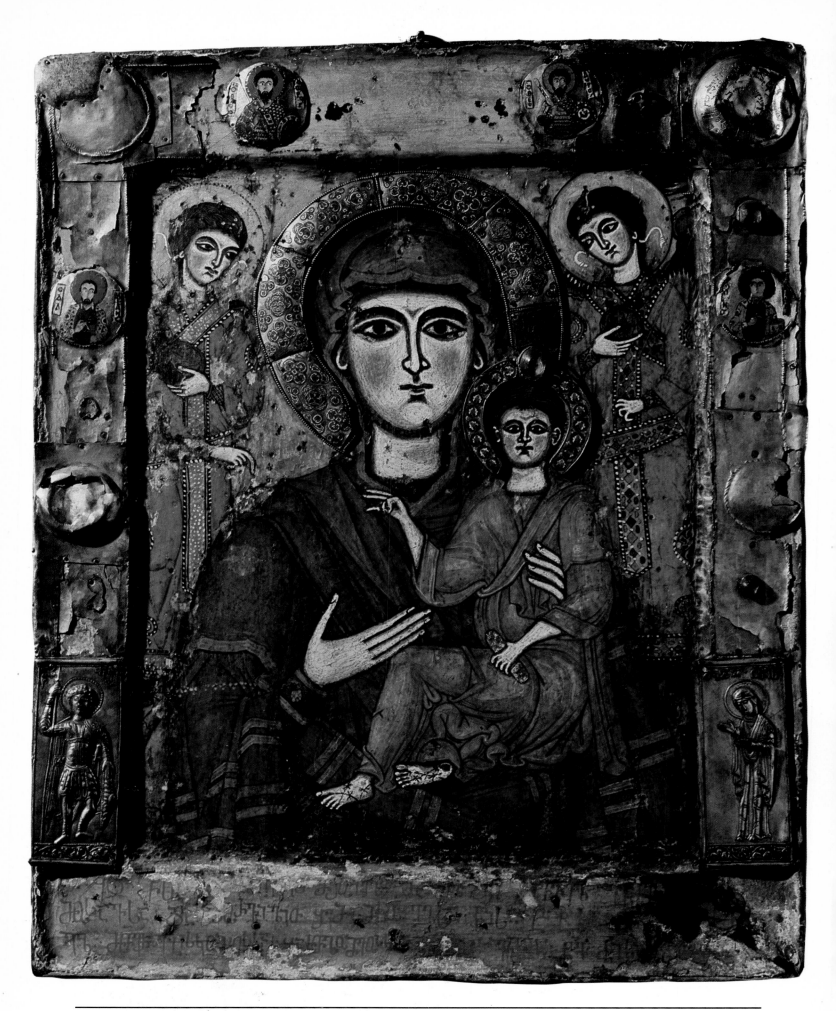

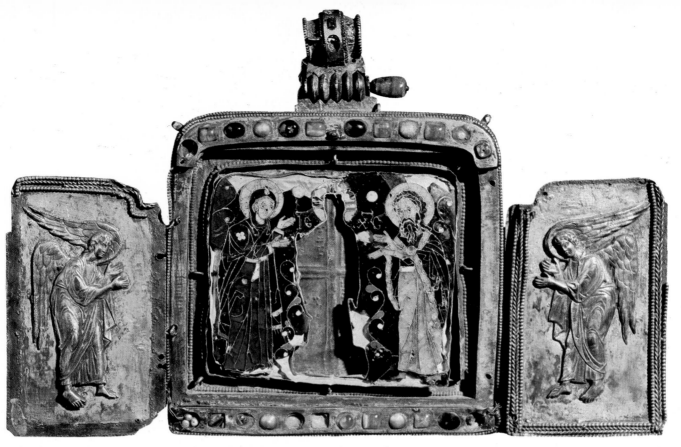
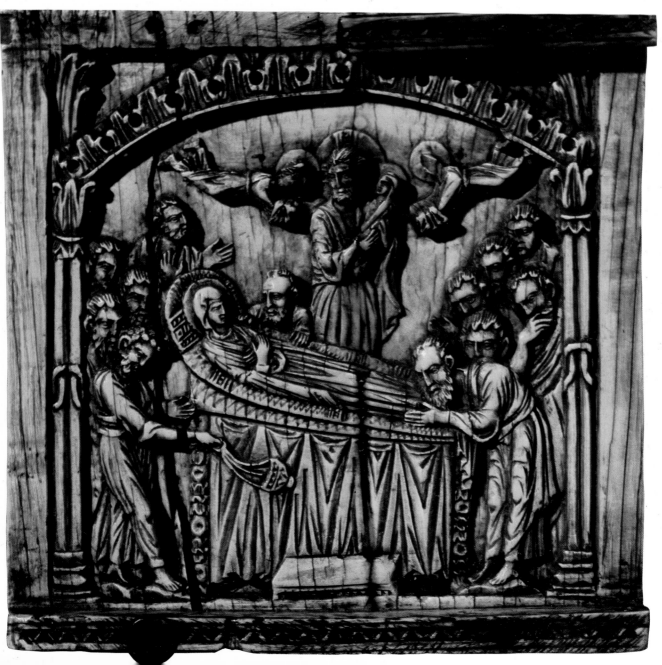

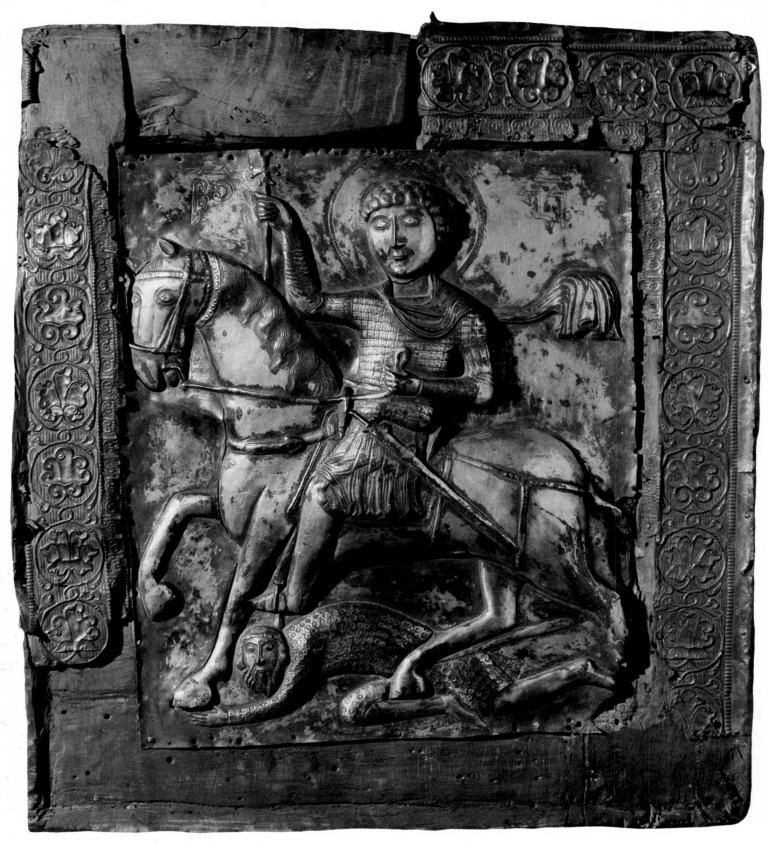

St. George on Horseback
Silver gilt, 38.5 x 35 cm. (15⅛ x 13¾ in.); Sakao, end
of tenth century; Georgian State Art Museum, Tiflis.

Opposite:
Virgin
Silver gilt, cloisonné enamel, precious stones; 55 x 43
cm. (21⅝ x 16⅞ in.); Khobi, second half of tenth
century; the face of the Virgin is of a later date; the
inscription on the bevel of the border mentions King
Leon, 957–67; Georgian State Art Museum, Tiflis.

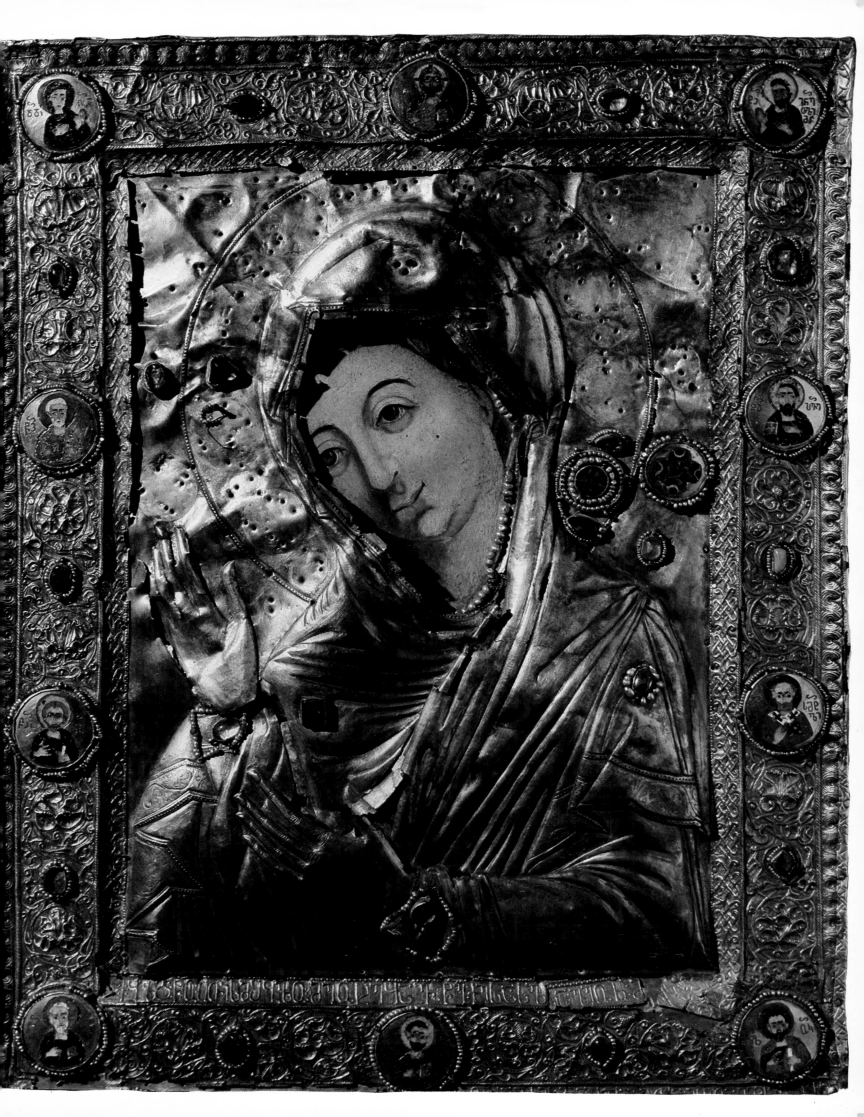

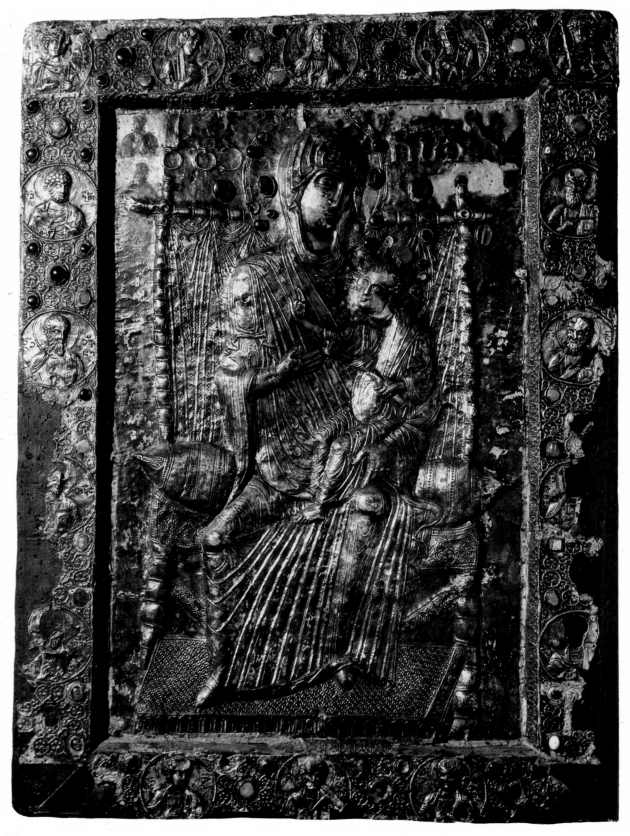

Virgin Enthroned with Child
Silver gilt, 106 x 75 cm. (41¾ x 29½ in.); Tsageri,
early eleventh century; Georgian State Art Museum,
Tiflis.

Opposite:
Virgin Hodegetria with Child
Gold (central part) and silver gilt (frame), cloisonné
enamel; 27.6 x 15.1 cm. (10⅞ x 6 in.); Martvili, tenth
or eleventh century; precious stones around the figure
of the Virgin were added later; Georgian State Art
Museum, Tiflis.

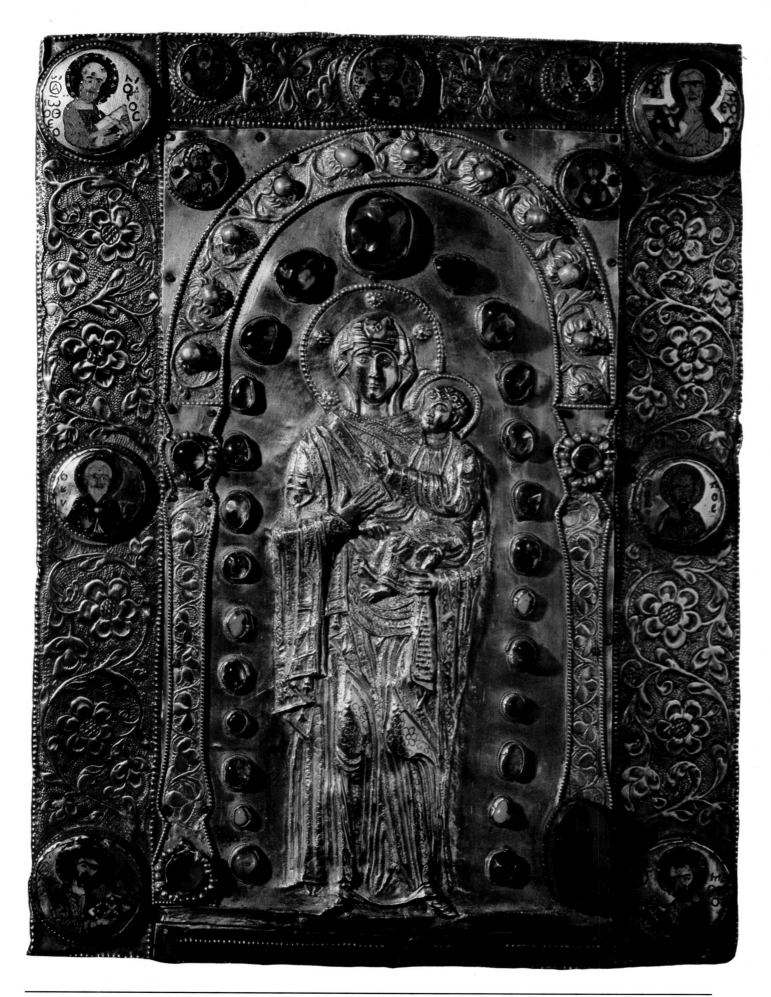

THE ICONS OF GEORGIA

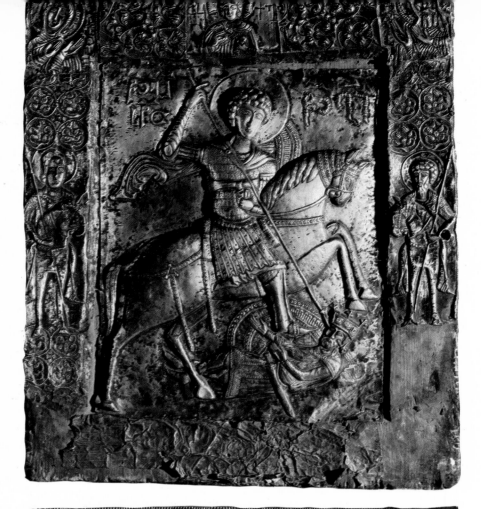

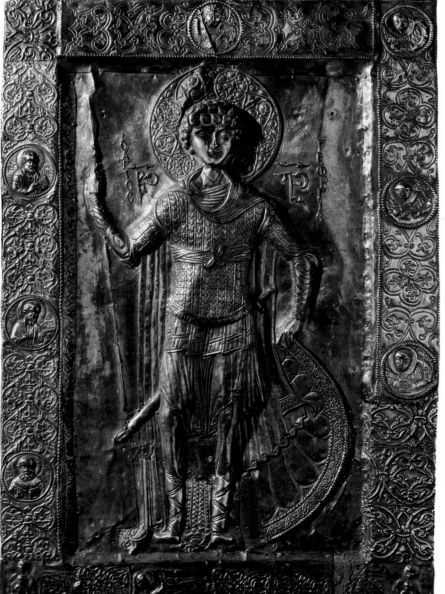

Above left:
St. George on Horseback
The background is silver; the figures of
St. George and the king, reins and
hoofs (but not the horse), are gilt; 53 x
64 cm. (20⅞ x 25¼ in.); Seti, tenth or
early eleventh century; State Museum
of History and Ethnography of Svaneti,
Mestiya.

Below left:
St. George
Silver gilt; Sujuna, eleventh or twelfth
century; part of the background and
the legs below the knee are much later;
preserved at Sujuna.

Opposite:
St. George "of Ipari"
Goldsmith Asan; donated by Marushi
Silver gilt; Nakipari, eleventh century;
preserved at Nakipari.

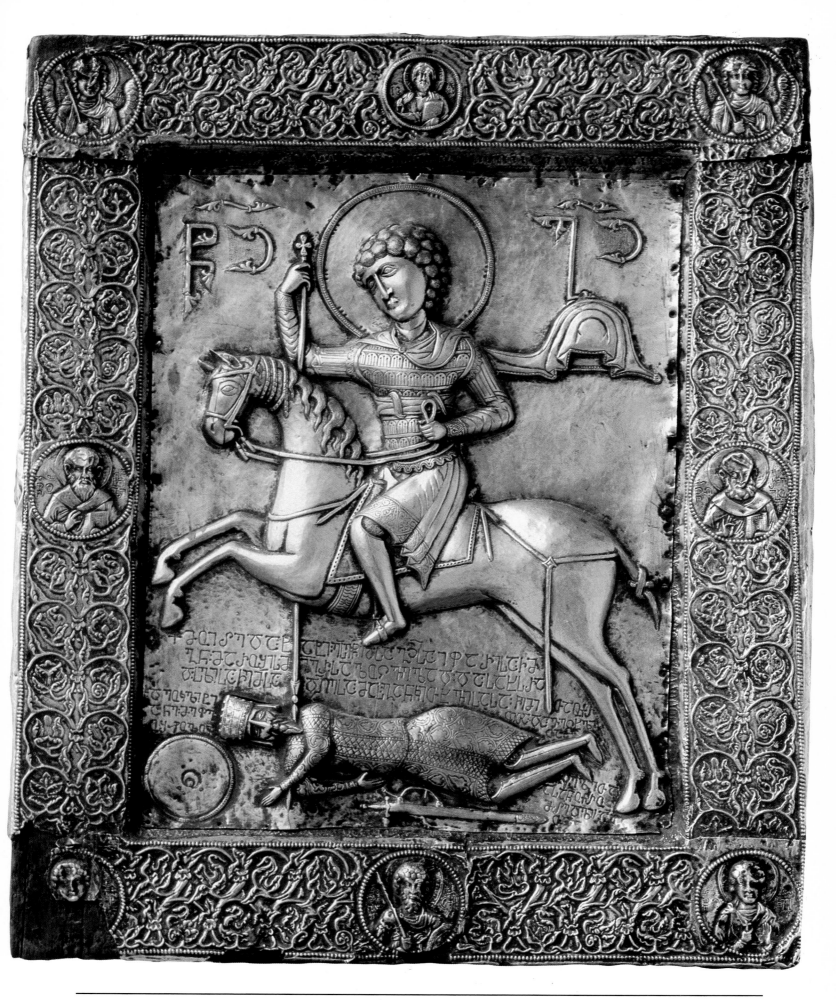

Above:
St. Simeon Stylites
Below left: the donor Anton, Bishop of Tsageri
Goldsmith Philip
Silver gilt, 35.3 × 23 cm. (13⅞ × 9 in.);
Lagami, 1020–30; Georgian State Art Museum,
Tiflis.

Left:
St. Simeon (fragment of an icon of the *Presentation*)
Silver gilt, height 75.5 cm. (29¾ in.); Lailashi, 1020–30;
Georgian State Art Museum, Tiflis.

Opposite:
Virgin Eleousa with Child
Scenes from lives of the Virgin and Christ on the
frame; inscriptions mention members of the noble
family Laklakidze (faces of the Virgin and Christ
originally painted, at present photographic
reproductions)
Silver gilt, 80 x 64 cm. (31½ x 25¼ in.); Zarzma,
1000–1025; Georgian State Art Museum, Tiflis.

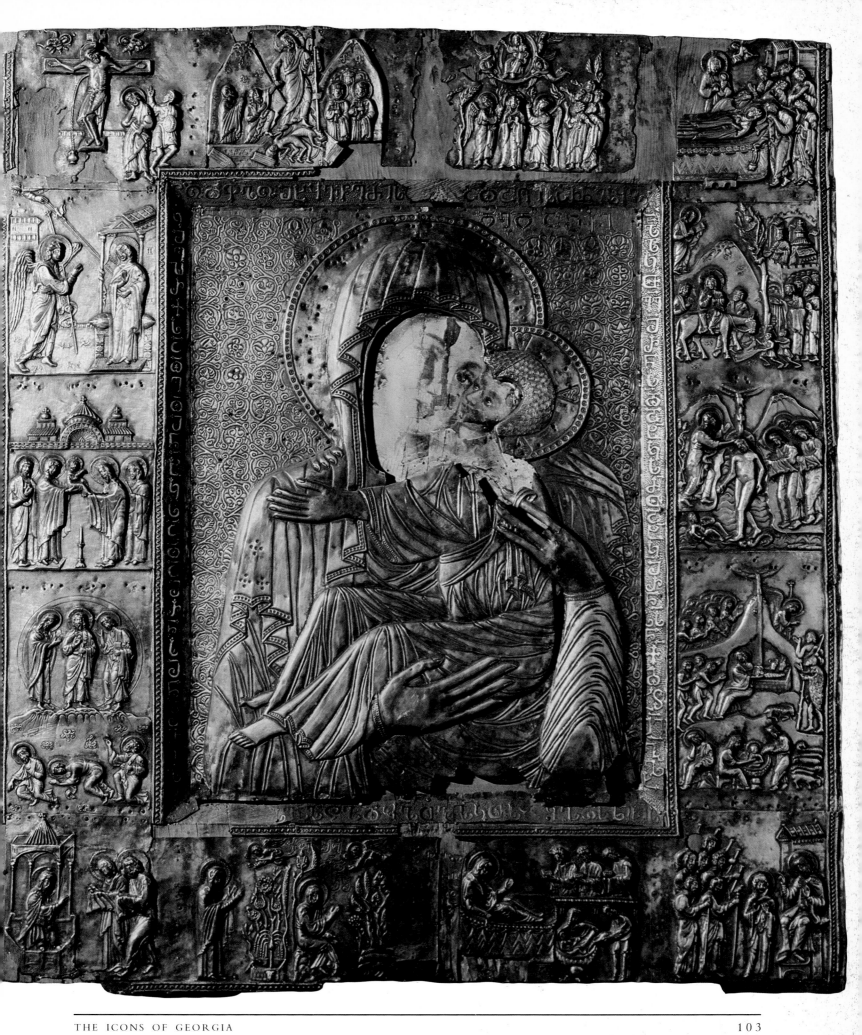

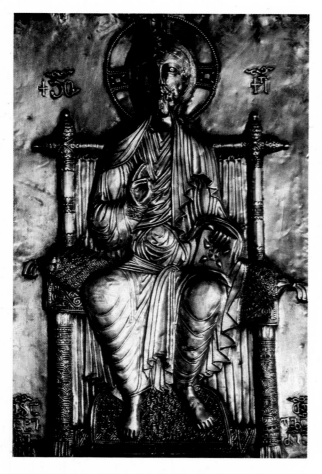

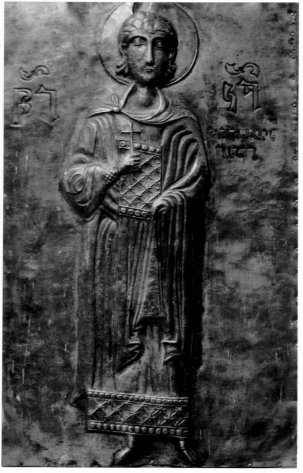

Above left:
Christ Enthroned
Goldsmith Tydor Gvazavaisdze; commissioned by
Ioanné Borohvelasdze
Silver gilt, frame missing; 35 x 26.3 cm. (13¾ x 10⅜
in.); Ieli, 1030–40; State Museum of History and
Ethnography of Svaneti, Mestiya.

Below left:
St. Kviriké of Gverula
Silver gilt, 67.5 x 47.5 cm. (26⅝ x 18¾ in.); Lagurka,
1030–40; preserved at Lagurka.

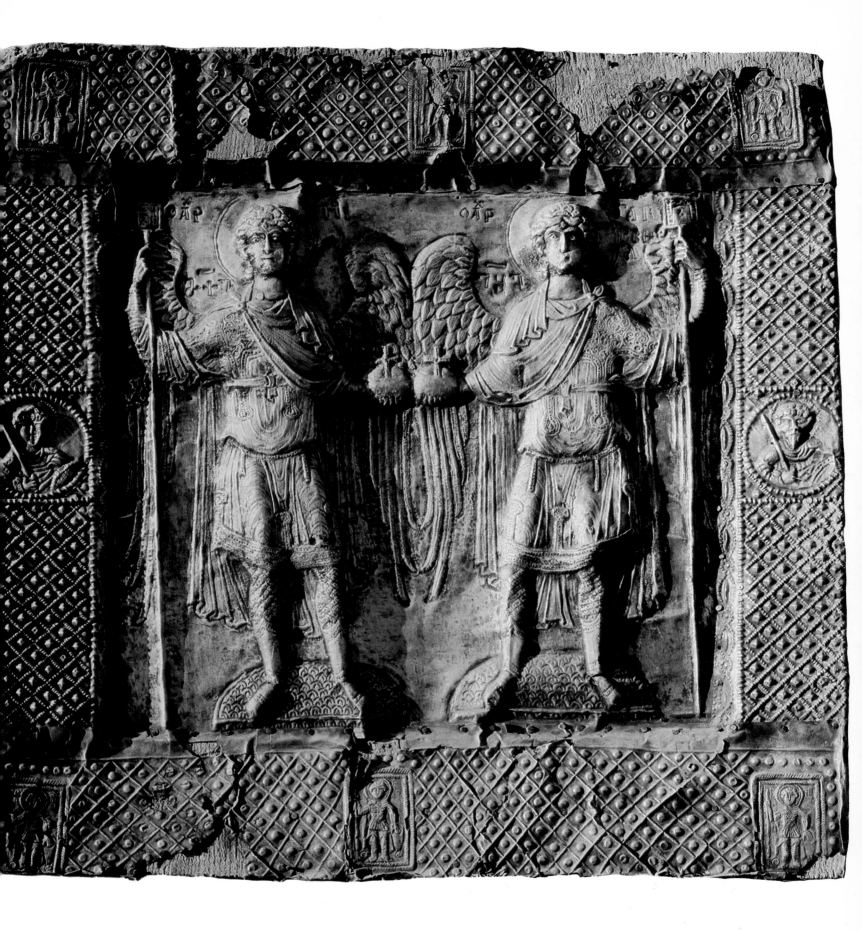

Archangels Michael and Gabriel in Armor
Silver, 44 x 43.5 cm. (17⅜ x 17⅛ in.); Tsvirmi,
eleventh century; preserved at Tsvirmi.

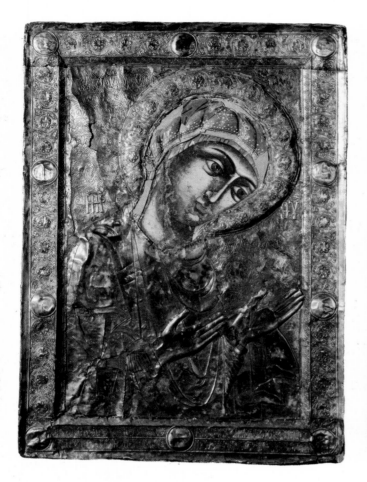

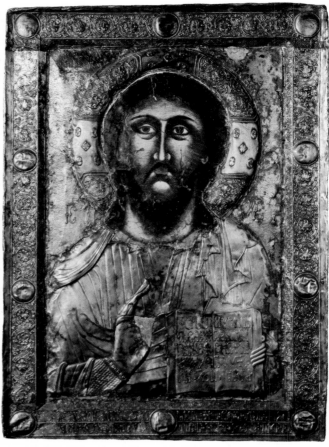

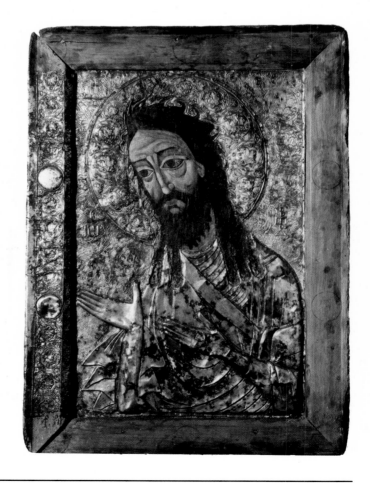

Deesis
Above left: the Virgin
Above right: the Savior
Right: St. John the Baptist
Opposite: detail of the Virgin
Chased metal: the Virgin, 87 x 61 cm. (34¼ x 24 in.);
the Savior, 87 x 62 cm. (34¼ x 24⅜ in.); St. John the
Baptist, 87 x 62 cm. (34¼ x 24⅜ in.); Mgvimevi,
eleventh century; Georgian State Art Museum, Tiflis.

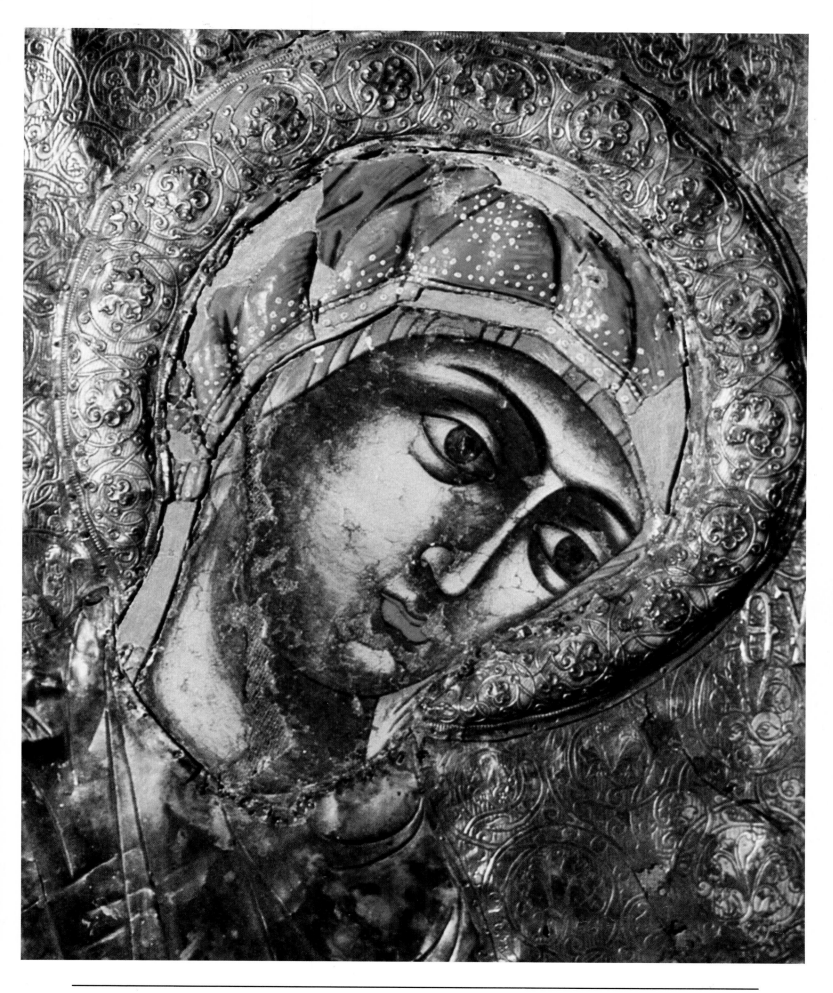

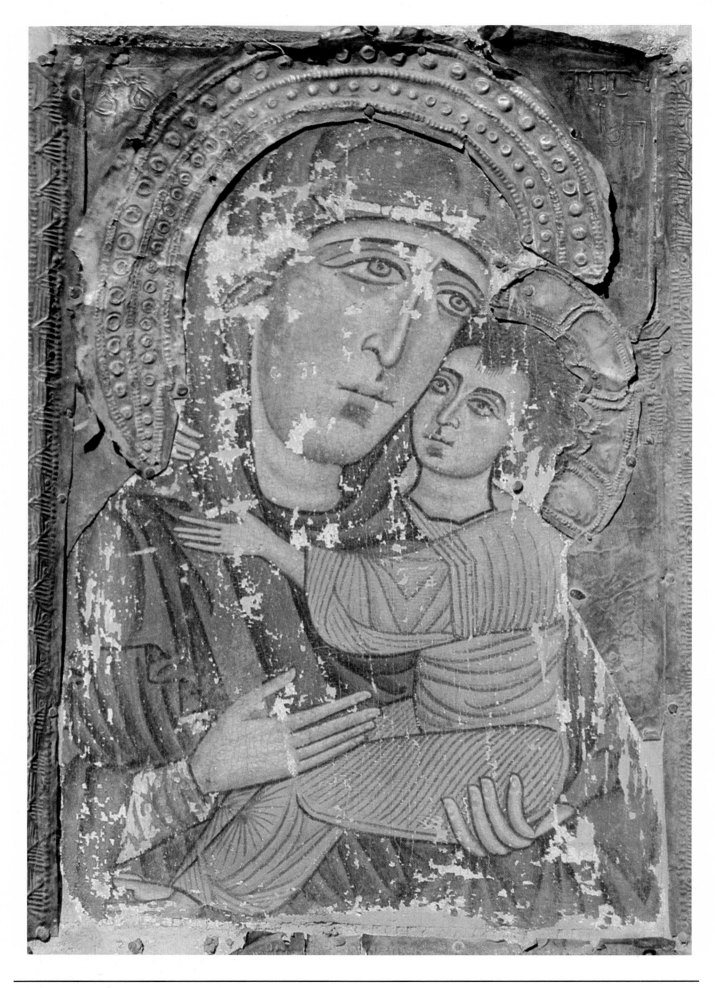

Opposite:
Virgin Eleousa with Child
Tempera on wood, 33 x 25 cm. (13 x
9⅞ in.); Lagurka, eleventh century;
preserved at Lagurka.

Above right:
Deposition and Lamentation
Tempera on wood, 48.5 x 40 cm. (19⅛
x 15¾ in.); Church of SS. Kviriké and
Ivlita, Lagurka, eleventh century;
preserved at Lagurka.

Right:
St. George
Mosaic, 27 x 17 cm. (10⅝ x 6¾ in.);
Matskhvarishi, eleventh or twelfth
century; Georgian State Art Musuem,
Tiflis.

Below left:
Archangel Michael
Wood, canvas, tempera; 72 x 47 cm. (28⅜ x 18½ in.);
Church of SS. Kviriké and Ivlita, Lagurka, c. 1100;
preserved at Lagurka.

Below right:
Crucifixion
Tempera on wood, frame in repoussé silver; 28 x 21
cm. (11 x 8¼ in.); twelfth century; State Museum of
History and Ethnography of Svaneti, Mestiya.

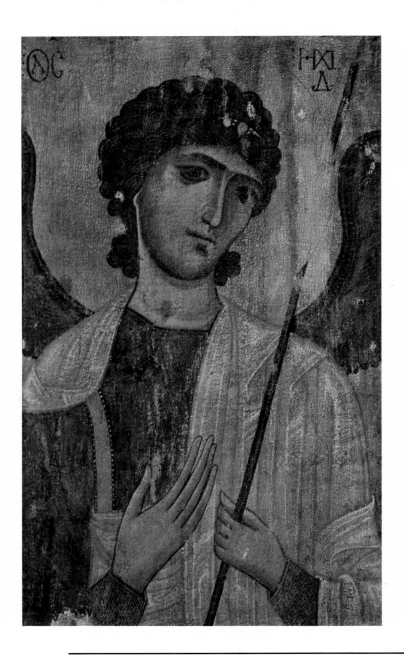

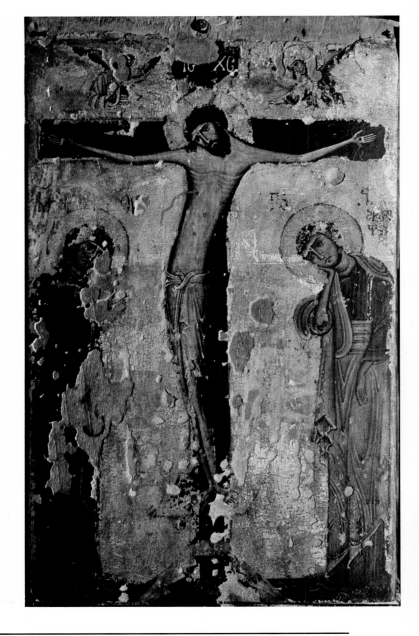

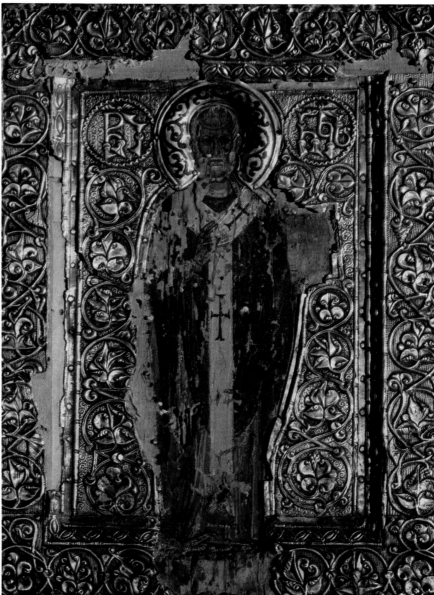

Above right:
Khakhuli Virgin
Donated by King David the Builder
(1089–1125) and his son Demetre I
(1125–54)
Triptych: gold central part, silver gilt
wings, adorned with Georgian and
Byzantine cloisonné enamel from
eighth to twelfth century; 147 x 202
cm. (57⅞ x 79½ in.); Georgian State
Art Museum, Tiflis.

Right:
St. Nicholas
Silver gilt, painted face; 23.5 x 17 cm.
(9¼ x 6¾ in.); Mestiya, twelfth
century; State Museum of History and
Ethnography of Svaneti, Mestiya.

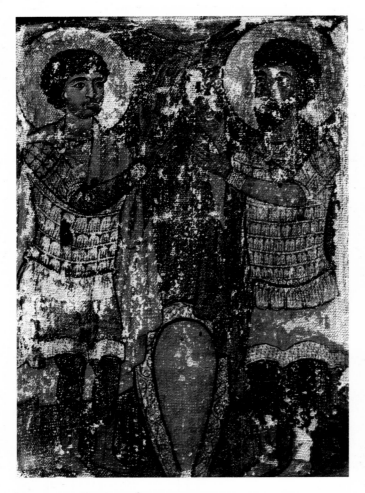

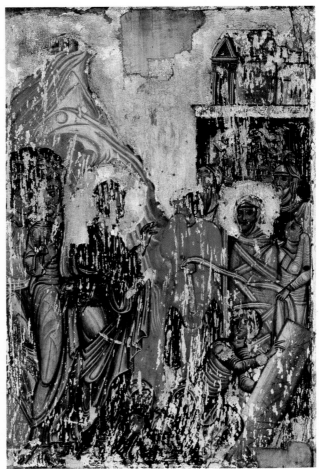

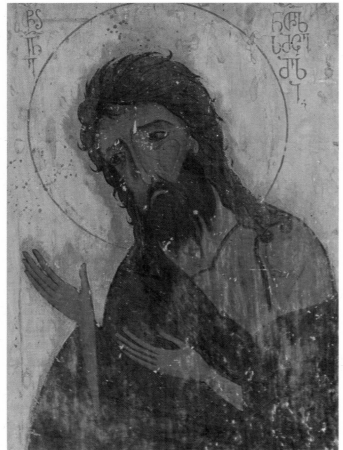

Above left:
SS. George and Theodore
Tempera on canvas, wooden base not preserved; 43 x
31 cm. (16⅞ x 12¼ in.); Nakipari, twelfth century;
State Museum of History and Ethnography of Svaneti,
Mestiya.

Above:
Raising of Lazarus
Wood, canvas, tempera; 65 x 46.5 cm. (25⅝ x 18¼
in.); twelfth century; State Museum of History and
Ethnography of Svaneti, Mestiya.

Left:
St. John the Baptist
Tempera on wood, 52 x 41 cm. (20½ x 16⅛ in.);
Matskhvarishi, twelfth century; preserved at
Matskhvarishi.

Opposite:
Forty Martyrs
Tempera on wood, 68.5 x 53 cm. (27 x 20⅞ in.);
twelfth century; State Museum of History and
Ethnography of Svaneti, Mestiya.

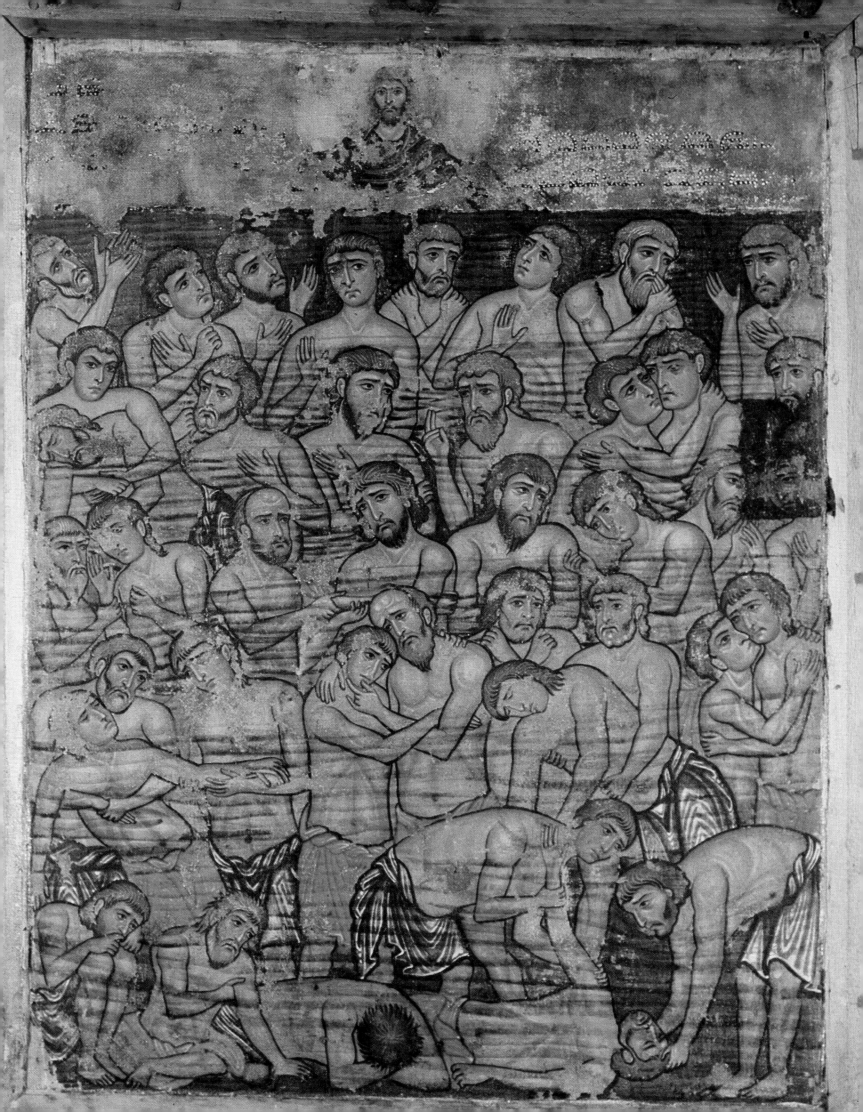

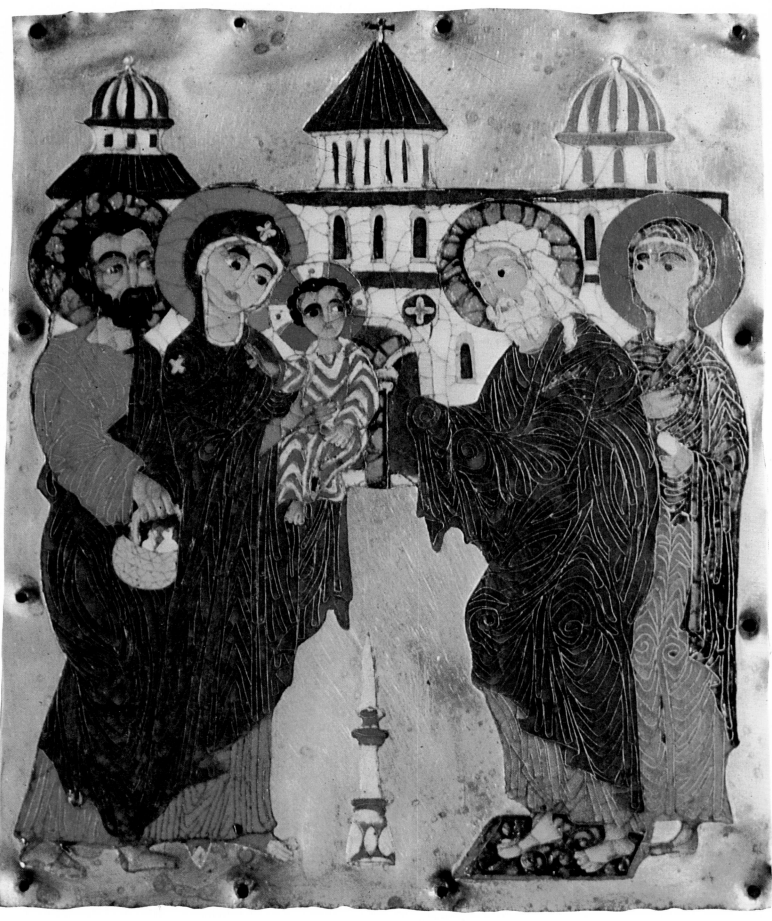

Presentation in the Temple
Cloisonné enamel, 13 x 10 cm. (5⅛ x 4 in.); c. 1200;
Georgian State Art Museum, Tiflis.

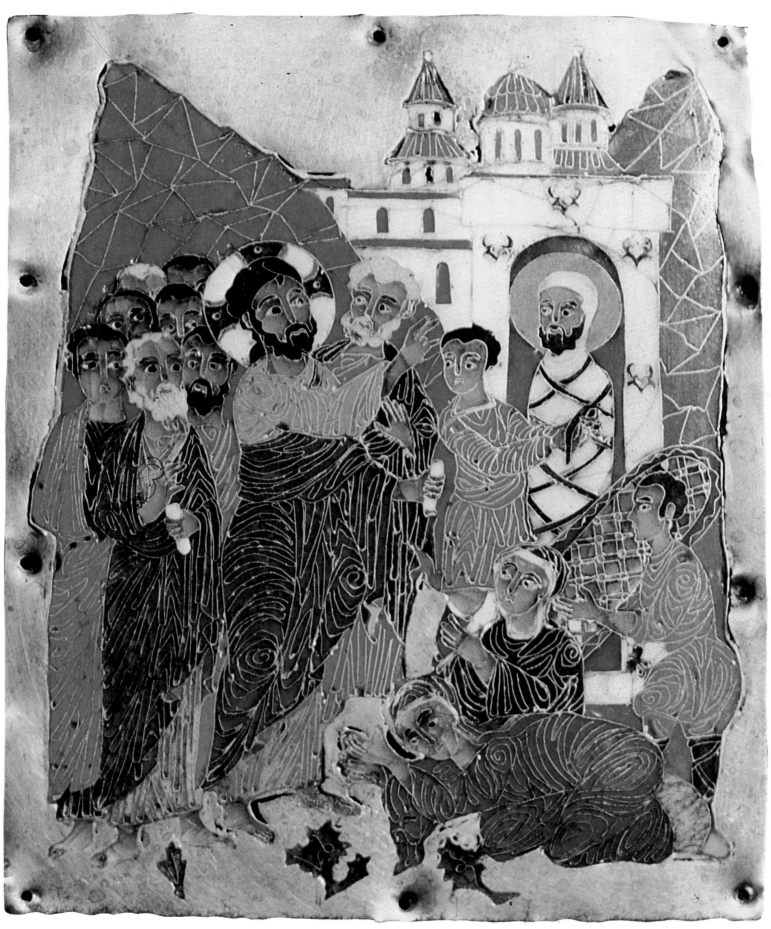

Raising of Lazarus
Cloisonné enamel, 12.5 x 10.4 cm. (4⅞ x 4⅛ in.);
c. 1200; Georgian State Art Museum, Tiflis.

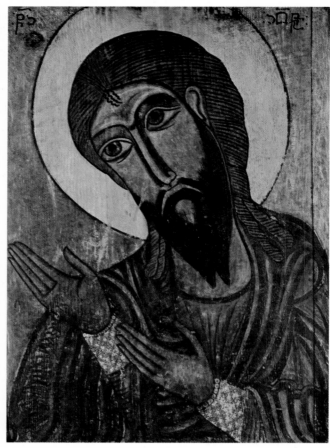

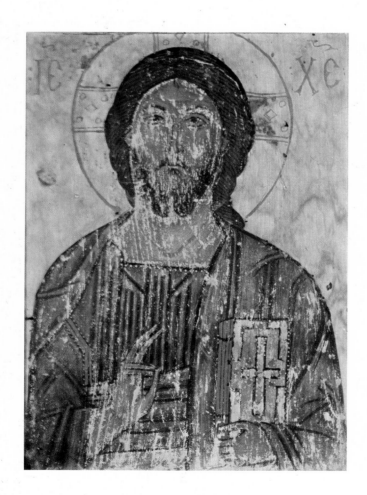

Above left:
St. George
Tempera on wood, 58 x 38 cm. (22⅞ x 15 in.);
Nakipari, thirteenth century; State Museum of History
and Ethnography of Svaneti, Mestiya.

Above:
St. John the Baptist
Tempera on wood, 79 x 59 cm. (30¾ x 23¼ in.);
c. 1200; State Museum of History and Ethnography of
Svaneti, Mestiya.

Left:
Christ the Savior
Tempera on wood, 40.5 x 30 cm. (16 x 11¾ in.);
Tsvirmi, twelfth or thirteenth century.

Opposite:
Christ the Savior, Detail
Tempera on wood, 59 x 51 cm. (23¼ x 20⅛ in.); State
Museum of History and Ethnography of Svaneti,
Mestiya.

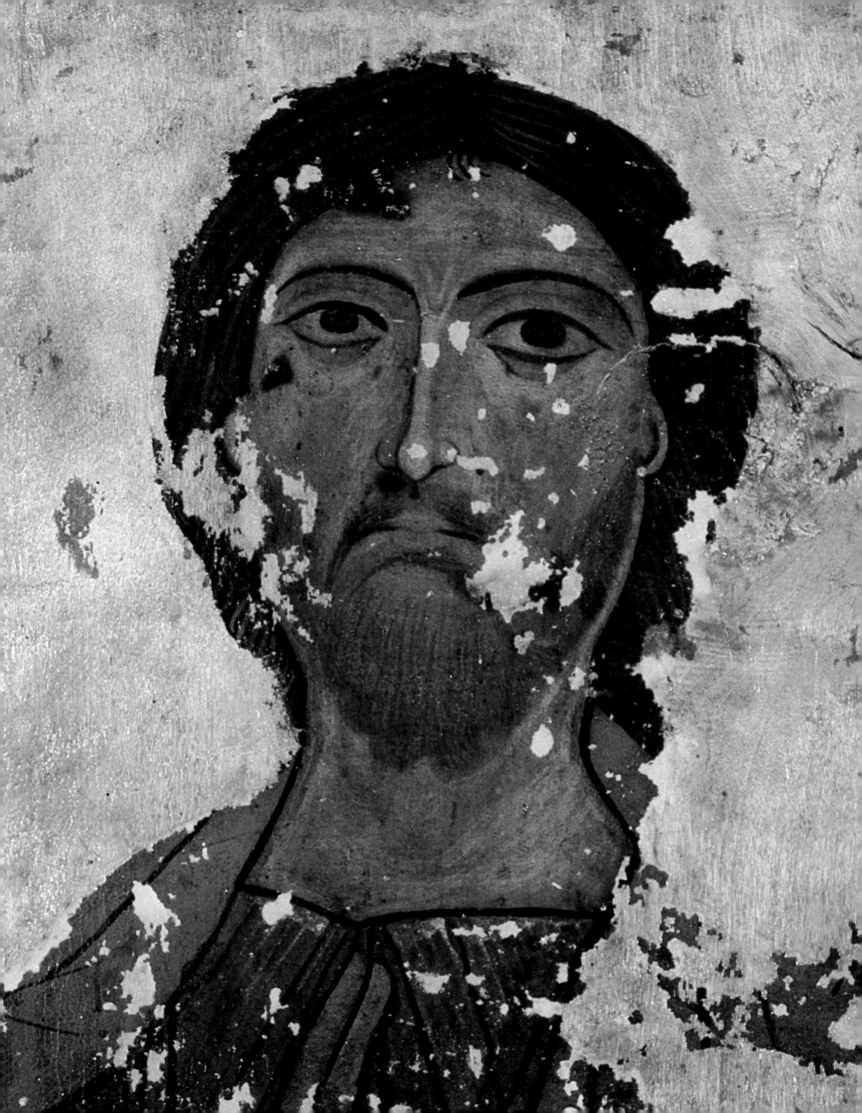

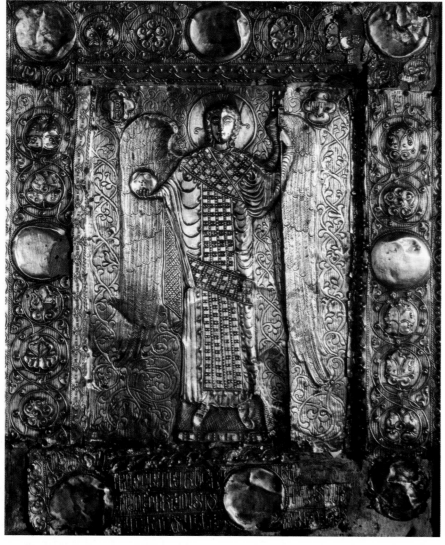

Above left:
The Anchi Triptych
Gold (frame of the central panel) and silver gilt, 148 x 156 cm. (58¼ x 61⅜ in.); Tiflis, end of twelfth century (central section—work of Beka Opizari); fourteenth century (reliefs on the inner faces of the wings and the upper semicircle); 1686 (reliefs on the outer faces of the wings, work of the goldsmith Bertauka Loladze); State Museum of History and Ethnography of Svaneti, Mestiya.

Left:
Archangel
Tavdidisdze
Silver gilt, 35 x 45 cm. (13¾ x 17¾ in.); Mestiya, thirteenth century; State Museum of History and Ethnography of Svaneti, Mestiya.

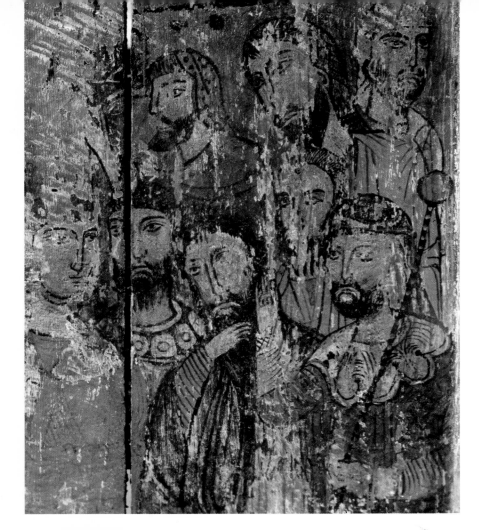

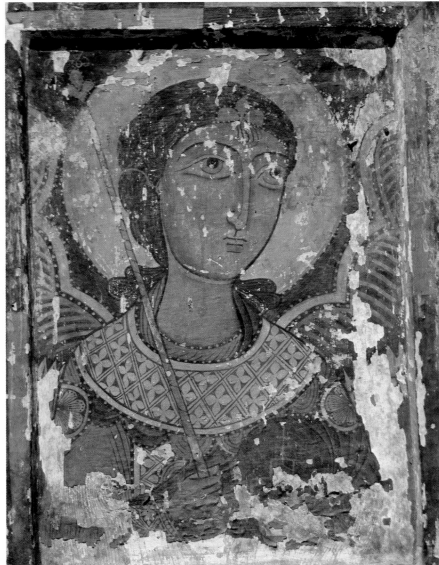

Above right:
Crucifixion
Tempera on wood, total measurement
157 x 101 cm. (61¾ x 39¾ in.);
Matskhvarishi, thirteenth century;
preserved at Matskhvarishi.

Right:
Archangel
Tempera on wood, 90 x 66.5 cm. (35⅜
x 26⅛ in.); Ipari, thirteenth century;
preserved at Ipari.

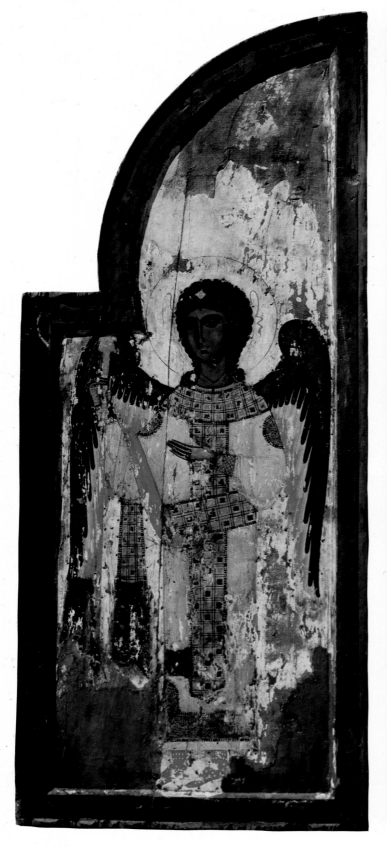
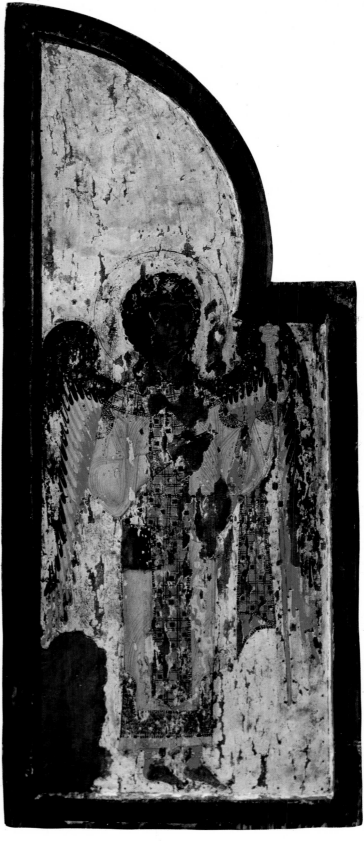

Two Archangels
Wings of a triptych
Tempera on wood, 104–68 x 43 cm. (41–66⅛ x 16⅞
in.); Matskhvarishi, second half of thirteenth century;
preserved at Matskhvarishi.

Opposite:
Descent of the Holy Ghost on the Apostles
Tempera on wood, 48 x 34 cm. (18⅞ x 13⅜ in.);
Imereti, thirteenth century; Georgian State Art
Museum, Tiflis.

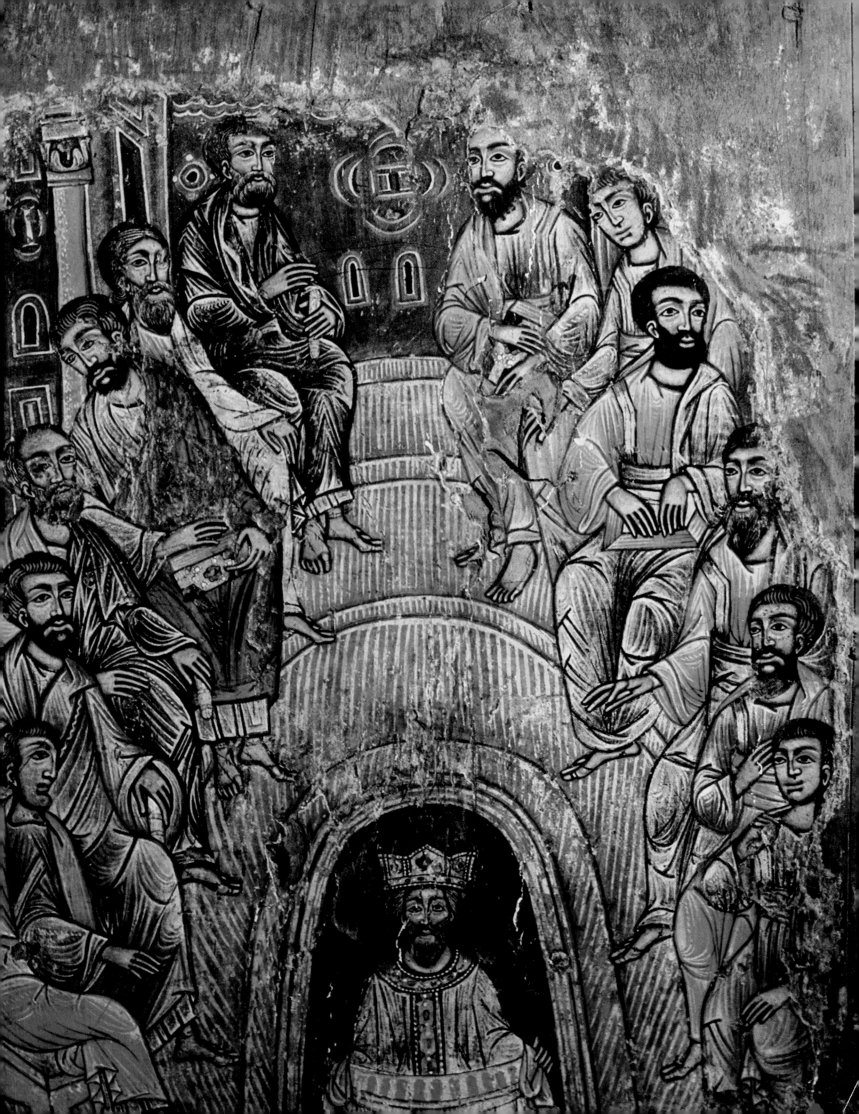

Triptych with Scenes from the Life of the Virgin and the
Old Testament
Tempera on wood, 133 x 176 cm. (52⅜ x 69¼ in.);
Ubisi, fourteenth century; Georgian State Art Museum,
Tiflis.

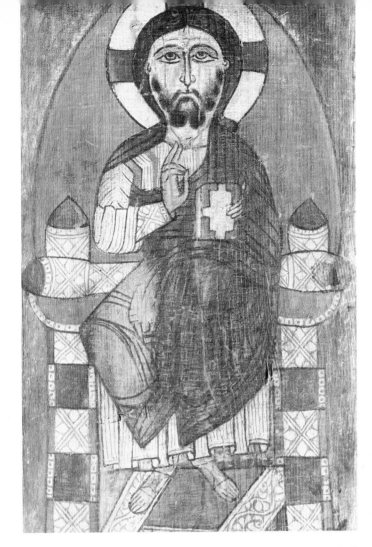

Above right:
Christ Enthroned
Tempera on wood, 88 x 58 cm. (34⅝ x 22⅞ in.); Khé,
thirteenth century; St. Barbara's Church, Khé, Svaneti.

Right:
SS. George, Theodore, and Demetrius
Wood, canvas, tempera; 125 x 75 cm. (49¼ x 29½
in.); Nakipari, thirteenth century; preserved at
Nakipari.

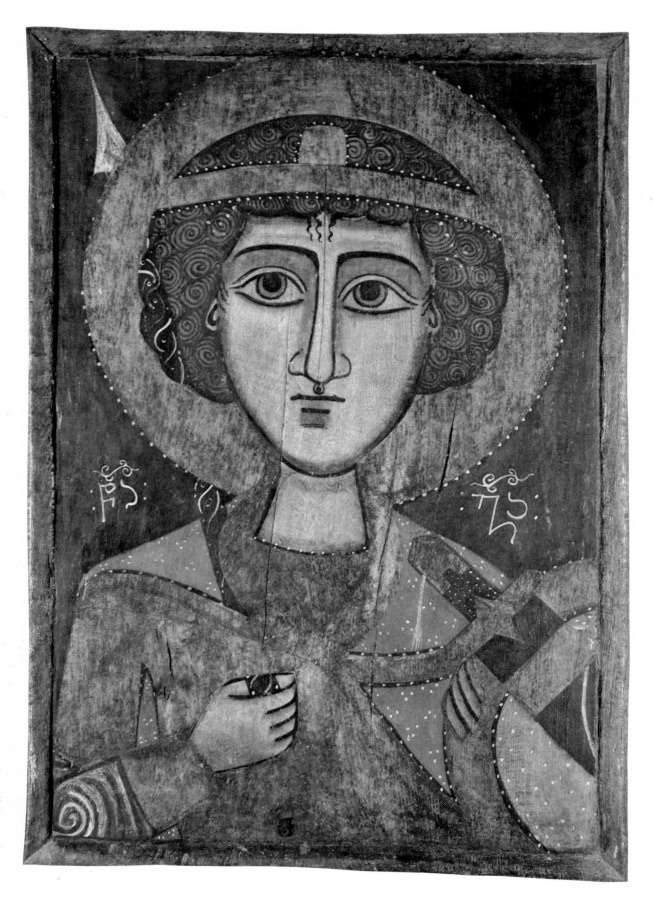

St. George
Tempera on wood, 80 x 58 cm. (31½ x 22⅞ in.);
Mestiya, fourteenth or fifteenth century.

Opposite:
St. George Mounted
Cloisonné enamel, 14.5 x 11.6 cm. (5¾ x 4⅝ in.);
fifteenth century; Georgian State Art Museum, Tiflis.

Above left:
Virgin with Child
Donated by Queen Tinatin, wife of
Leon, King of Kakheti (1520–74)
Gold, painted face, richly adorned with
precious stones (rubies, turquoises,
pearls); 49 x 41 cm. (19¼ x 16⅛ in.);
Shuamta, 1550–1600; Georgian State
Art Museum, Tiflis.

Left:
Prophets
Detail: The donors Levan II Dadiani
(1611–1657) and his wife
Nestan-Daredjan
Silver gilt, total measurement 65 x 47
cm. (25⅝ x 18½ in.); Kortskheli, 1640;
Georgian State Art Museum, Tiflis.

Opposite:
Christ the Savior
Gold, painted face richly adorned with
precious stones; 58 x 41 cm. (22⅞ x
16⅛ in.); Alaverdi, sixteenth century;
Georgian State Art Museum, Tiflis.

THESSALONIKE

THESSALONIKE, the second most grand and populous city in the Byzantine Empire, contained a number of ecclesiastical buildings, some of the most splendid in the Empire, within the strong fortification walls that still encircle the old city. A bulwark against the Slav and Bulgar invasions, it was the crossing point of routes converging from all directions, from both land and sea. The Via Egnatia, which linked Constantinople with the Adriatic Sea at Dyrrachium, ran a little north of the town. During the fifth and sixth centuries several large basilica-type churches were built and at least one impressive late Roman building, the Rotunda, was converted into a church that can still be seen. Two of the most important basilicas still stand: the great martyrion of St. Demetrius, which throughout the Byzantine period was an extremely popular shrine, and the Acheiropoietos, probably the first cathedral. All the churches were embellished with pavements and revetments of multicolored marble, with mosaic decoration on both walls and arches, and with carefully finished column capitals, relief closure slabs, and other sculpture. They housed portable icons, amongst them the miracle-working images mentioned in contemporary sources. Despite the damage inflicted by earthquakes, the passage of time, the hand of man, repairs and renovations, these churches, as well as a number of Byzantine buildings of a later period, nevertheless preserve better than any others (except those in Constantinople) the true grandeur and perfect elegance that distinguishes the architecture of the period.

During the Byzantine period and the Ottoman occupation, Thessalonike held a commanding position amongst the cities of the Balkans, Byzantine Italy, Greece and its islands. The Byzantine monuments of this great city served beyond question as models for most of the works of art found in Macedonia, the region which came under its immediate influence, and for at least the most important paintings of Greece farther south. We can also assert that many works of art found in both northern and southern Greece were the work of ateliers or artisans from Thessalonike itself. The extent of this artistic activity, to which

THE ICONS OF THE BALKAN PENINSULA AND THE GREEK ISLANDS (1)

 Manolis Chatzidakis and Gordana Babić

both literary sources and the study of the works testify, has established Thessalonike as an artistic center of high standards and vast influence.

This does not necessarily mean that new approaches and methods were formulated in Thessalonike, independent of those emanating from the capital. At an artistic level there was close contact between the two cities. Anyone who studies the medieval art of the region must distinguish, in each object, which of the styles employed, the iconographic concepts expressed, the figures and events depicted, and the manners of presentation can be attributed to Thessalonike and which to Constantinople.

The task is not easy. Anyone who undertakes to establish, however summarily, the output of icons from Thessalonike faces many obstacles because the number of portable icons whose provenance is unquestionable is very small. To some extent this difficulty can be sidestepped by saying that to the Byzantine mind the meaning of the word "icon" was very broad. The proof of this lies in the fact that the Iconoclastic Controversy was concerned with all representations of saints and devotional scenes in every medium (painting, marble, metal, ivory, or precious stones), by whatever means of artistic expression, and on whatever scale, from the largest monumental mosaic figures to the smallest coins, and not only with portable icons painted on wood.

No example of work in precious materials is yet known from Thessalonike; but in monumental art—mosaics and wall-paintings—many portrayals of holy figures and biblical scenes of high quality have survived. Furthermore, the ateliers known to have existed in and around Thessalonike probably produced both portable icons and murals, so we can assume that the portable icons of the period would not have differed in any important way from the examples of mosaic and wall-paintings that can be identified. At that time the painters of portable icons borrowed techniques and style either from monumental painting or from miniature illustration, according to size.

It should be noted here that in earlier centuries miracle-working icons had been known in Thessalonike: for example, the *Virgin Hodegetria,* the *Acheiropoietos,* the *Kataphyghe,* and others. Only in the surviving mosaic decoration of St. Demetrius, which consists of autonomous dedicatory panels ascribed to the seventh century, do we find figures of St. Demetrius standing between the donors, repeated many times in almost identical fashion. He is portrayed full-length and frontally, his hands raised in prayer.

We believe that this figure provides the iconographic model for the lost devotional icon of the church. This is suggested by the repetition of the stance and details, such as the gold nobleman's chlamys and the gilded hands. It is perhaps the oldest known example of the sheathing of a portable icon in metal. There must also have existed—though perhaps at an earlier date—icons of the saint seated, portrayed as a nobleman and not as a warrior.

We know of few tenth-century icons from Thessalonike from the period following the Iconoclastic Controversy. There is a small marble slab now in the Byzantine Museum, Athens, depicting three *Apostles* full-length in raised linear relief; the depressed surfaces are filled with painted material. It must have formed part of an iconostasis beam, with full-size representations of the Twelve Apostles on either side of the three-figure Deesis. Its recent re-dating to the tenth century seems plausible. Two other rather larger stone icons have been found in Thessalonike—a full-length *Virgin* in prayer (Byzantine Museum, Athens) and a *St. David* (Museum, Thessalonike) displaying the same technique of execution—which reinforce the attribution of the slabs to Thessalonike. Stylistically, these three stone icons, which would have been built into a wall, belong to the anti-classicizing tendencies of the age. A fourth relief icon of the *Virgin* has strongly emphasized classical elements, recalling the aristocratic ivories of the Romanos group of the same period, and is therefore more closely related to the art of Constantinople. In monumental painting there is no easy point of reference for icons. The most important work of this period at Thessalonike, the large-scale *Ascension* in the dome of St. Sophia (? 880), is closely related to some mosaics of the great church of Constantinople.

In this same Thessalonikan church, the murals preserved on the inner face of the vaults of the narthex depict pairs of saints shown frontally, their hands in the conventional gestures of martyrs (p. 145). These paintings should be considered representative of the local style of the first half of the eleventh century; but they must also be regarded as a variation on the art of the capital. The blue ground, the expressive faces whose emphasized features combine linear drawing with elaborate plasticity, are found in murals of other churches in Thessalonike such as the Panaghia Chalkeon, after 1027. We shall also find these elements in the oldest layer of paintings at St. Sophia, Ohrid, founded by Leo, the first archbishop to come from Constantinople (1037–1056).

We could define this stylistic tendency, which in general has an anti-classical twist, as the manifestation of aristocratic art, not only because we meet it in lavishly embellished churches or monasteries but also because of the perfect exactness of its execution, the range of technical skills it displays, and its universality. These qualities preclude any dismissive labeling of this art as "peasant," "monastic," "hieratic," or "local." The style is dominant during most of the eleventh century, both within the Byzantine Empire and beyond its frontiers, albeit only in major institutions with high standards. We find it in St. Sophia at Kiev, where Byzantine craftsmen are known to have worked for the Russian ruler, and much farther south in the larger of the two monastic churches of Hosios Loukas in Boeotia, in the mosaics of both nave and narthex and in the wall-paintings of the side chapels and crypt.

As we now know, this great church, despite its rich decoration, was not an imperial establishment, but was founded by an abbot, Philotheos, a member of the local landowning class of Thebes. It was natural for him to employ artisans from Thessalonike to embellish his foundation. The program of mosaic decoration for the church, which housed the miracle-working marble reliquary containing the relics of Hosios Loukas, is dominated by representations of saints. There are at least 144 of them, whereas the evangelical scenes are relatively few. It is not strange, therefore, that we find here two variants of the icon of the *Virgin Hodegetria* (p. 146), a type known from innumerable portable icons, both contemporary and later. It is not even coincidence that these two icons of the Virgin are placed on high, close to the iconostasis, as they are also in St. Sophia, Ohrid (p. 149). Moreover, there is clearly a relationship, in the shape and expression of the faces, with the corresponding figures in the murals of the Panaghia Chalkeon in Thessalonike.

More portable icons have survived from the twelfth century. This may be related to the development of the *templon*, which created the need for a greater number of icons of a new kind. The gradual alteration in the nature of the sanctuary barrier, the development of the *templon* into the iconostasis, had begun at the time of the Macedonian dynasty. At first, icons of several kinds were placed above the iconostasis beam: a marble slab like that depicting the Apostles described above, or painted panels of wood representing a multifigured *Deesis,* perhaps with a second row containing the scenes of the Twelve Feasts or the life of the saint to whom the church was dedicated. Frequently, the *Deesis* and the other scenes unfolded in the same row.

Icons so placed did not impede the congregation's view of the religious services performed in the sanctuary, because the spaces between the small columns of the *templon* were closed by curtains that could be raised. This means that by the eleventh century certain iconographic conventions already reflected definite ideas about the role of the *templon*. The *Deesis,* referring to the Second Coming, is sometimes found carved on the stone iconostasis beam from an earlier age. The iconographic program of the *templon* was gradually amplified, with large icons emphasizing worship placed in the middle row, but not conforming to any predetermined set of rules. Eventually a standard *Deesis* was to emerge: the figure of Christ placed between those of the Virgin and St. John the Baptist, combined with the figures of the titular saint of the church and the Archangel. Thus the *templon* took on the appearance of a solid wall, divided into decorative panels, as a eurythmic architectural facade capable of supporting two or even three rows of icons—the *templon* became the iconostasis. But the liturgy then became something secret, removed from the gaze of the faithful.

This development from *templon* to iconostasis began in answer to a devotional need to place the icons of Christ and the Virgin in front of the sanctuary for worship. Thus, on the pilasters that flank the *templon* we find full-length icons of Christ and the Virgin, either mosaic or painted, for example, at Ohrid as early as the eleventh century (p. 149), in the thirteenth century at Trikkala in Thessaly (pp. 164–165), and in a host of other places. It was not difficult to integrate these images into an expanded iconographic program on the iconostasis itself, framed by the pilasters.

In this case, the supposedly austere and inflexible art of Byzantium manipulated its themes with great freedom, thereby putting the twentieth-century Byzantinist in a difficult position because he has conferred on it the rigidity and severity of his logical conceptions. For example, on the two pilasters of St. Sophia, Ohrid, there are two different representations of the *Virgin* and none of *Christ;* similarly at Hosios Loukas, where there are no pilasters, two icons of the *Virgin* border the *templon* (p. 146). In the Church of St. Panteleimon at Nerezi, near Skoplje, founded by Alexios, grandson of the emperor Alexios Comnenos, after 1164, the pilasters bear the icons of the *Virgin*

and of *St. Panteleimon* (p. 148) within a skillfully executed frame. St. Panteleimon, his gentle face suffused with a fine spirituality, is portrayed as a lissome aristocratic young man wearing the formal dress of a doctor. The long mauve apron hangs down in front; with its edge he covers his delicate hands to hold his medical instruments.

St. Panteleimon is one of a number of icons providing a focal point in the development of Comnenian painting after the middle of the twelfth century. For the first time in European art the attempt is made in certain scenes to convey the fullest expression of pain and suffering. The tall figures of saints acquire an aristocratic elegance and an affectation in their proportions, because the lower part of the body is often elongated in an unnatural way. The painterly modeling, especially in the youthful faces, is achieved by a sophisticated mesh of brushstrokes of warm colors on the cheeks, contrasted with cold green shadows. Similar methods were employed for the faces of the imperial portraits in St. Sophia in Constantinople—those of John Comnenos and his family. It is not impossible that the talented painter of Nerezi came from Thessalonike, since an identical style and standards are to be found in murals at the Monastery of Latomou in Thessalonike.

The later development of painting in the Balkans testifies to the importance of the paintings at Nerezi, because here are found the originals on which artists of the ensuing epochs worked their stylistic variations. For example, in the Church of SS. Cosmas and Damian (the *Anargyroi*) at Kastoria, the paintings of the two lower rows—scenes of the Passion and full-length warrior-saints, which must be the work of a gifted and "modern" painter—display a keen appreciation of the vital contribution the element of exaggeration can make to a composition. *SS. George and Demetrius* (p. 150), depicted full-length as soldiers, have rather short bodies. Here the emphasis is expressed in the wealth of detail rendered not only in the composition but also in the decoration of each military uniform—parade dress. St. George wears a close-fitting cuirass of scales. It is, however, slightly unnatural for a cuirass in that it falls in folds and has a leafy pattern. Furthermore, applied gold embroidery adorns the knee-length, long-sleeved mauve tunic with intricate, well-designed arabesque patterns. The long red chlamys with double rows of pearls on the borders billows out at the bottom as though lifted by the puff of a breeze. St. Demetrius' chlamys hangs straight, his tunic falls to his feet, and the scales of his

cuirass are larger. The supple bodies, the somewhat affected stances, the thin necks supporting relatively large heads leave the impression that the artist intended to depict untried aristocratic youths, not seasoned campaigners. Everything combines to express a certain mannerism that characterizes late Comnenian painting. Because of their close affinities with other pictures in Cyprus and in Kurbinovo (Yugoslavia, dated 1191), the murals of the *Anargyroi* (Holy Physicians) should be ascribed to the last twenty years of the twelfth century.

The evolution of the *templon* into the iconostasis had far-reaching consequences for the painting of portable icons. New shapes were invented, such as the long narrow icons for the iconostasis beam and, in larger churches, the rows of icons depicting the Apostles and scenes from the Twelve Feasts, and the rows of great despotic icons of uniform size and shape. The result was increased production of icons in all these categories.

The mosaic icon of the *Virgin Hodegetria* in the Monastery of Chilandari on Mount Athos (pp. 146–147) may have been intended for the *templon;* its dimensions do not exclude this possibility. The symmetry of the features framed by the regular folds of the *maphorion,* the almost sculptural plasticity created by sharply defined shadows, the curved eyebrows crowning large eyes, and the thin elongated nose, recall the characteristics of a classical model. These points all suggest that the style of this icon should be assigned to the branch of Comnenian painting that we might call the Academic; this school existed earlier at Nerezi and continued parallel with the dynamic style which we saw, for example, at Kastoria (p. 150) toward the end of the century. In the same icon, the figure of the Christ Child has a more expressive face, more freely drawn, and the shifting folds of the chestnut brown *himation* are relieved by gold highlights. Certain weaknesses, such as the unarticulated fingers and the blank gaze, suggest that this work should be classed among the products of Thessalonike, with which the Serbian princes who founded the monastery were closely associated.

Some of the icons that decorated iconostasis beams have survived, and a few of these can be assigned to Thessalonike. Four large oblong icons come from the iconostasis beam of the Monastery of Vatopedi. From elsewhere on Mount Athos we have two of a row of the *Twelve Feasts,* originally composed from a number of small icons. One, a *Transfiguration,* is now in the Hermitage; the other, a *Raising of La-*

zarus (p. 154), is in a private collection in Athens. The painting of this second small icon, whose style is related to miniatures, preserves a monumental character in its composition—the figure of Christ standing on his own, isolated and dominant among the sedate spectators in small, sparsely dispersed groups. A red ground, rare in icons, replaces the more common gold. The style suggests a date toward the end of the twelfth century.

During the Frankish occupation of Thessalonike, which ended in 1224, artistic creativity did not dry up, at least as far as portable icons are concerned. Clues to the style of these works may be detected in murals, whether in Thessalonike, such as that of the *Forty Martyrs* in the Acheiropoietos, or beyond the city, for example, from the Church of Episkopi in Eurythania, in the Despotate of Epiros, of which Thessalonike was part until at least 1244. In the more recent strata of paintings surviving the destroyed Church of Episkopi, among the lower rows of standing saints is *St. Cosmas the Healer* (p. 152). His handsome face expresses nobility and intense spirituality, and the modeling, where red tints and highlights make smooth transitions, is taut. He wears formal medical dress. We may reckon that the high artistic level of these paintings, which were created in what was probably a rather poor and isolated district, represents an evolution of the Academic style we noted in the twelfth century. One might say that the minute execution proper to the portable icon also developed in large-scale mural painting. But other figures from this same church, like the soldier *St. Orestis* (p. 153), are executed in a totally different way, entirely free of the influence of the twelfth century. The modeling here is more painterly, showing hasty brushstrokes; the expression is more violent, the stance somewhat less steady. This all succeeds in emphasizing the heroic character of the warrior. From the twelfth century survives the love of carefully rendered garments (cf. p. 150), but now the details of pattern are absent.

Relief icons in stone are not uncommon in the Byzantine Empire, and we have already noted some that date from the earlier period. Painted relief icons on wood first appeared in the thirteenth century. The largest, some 10 feet (3 meters) tall, is at Omorphoklesia (Galista) near Kastoria; its high relief sculpture depicts *St. George* the warrior in a frontal position. From the Ohrid region comes a similar icon of the local saint, *St. Clement,* rather more naively executed. A high standard of painting is displayed in the two-sided icon of *St. George* (p. 155) from the same Kastoria, now in the Byzantine Museum, Athens. It shows the warrior-saint, the only relief figure on the icon, with both hands raised in prayer, facing left toward the small painted figure of Christ. At his feet, in the bottom left corner, the donor, a nun, is painted in miniature in an attitude of prayer. In the upper border, two angels revere the Preparation of the Throne, and on either side are twelve scenes from the life of the saint, seven of which are still visible. On the reverse, considerably damaged, are two holy women, shown full-length facing each other, praying to the tiny figure of Christ in the center above.

The provenance of this elaborate icon has generated much discussion. In the relief area, Frankish elements are obvious: the shape and decoration of the shield, the battle dress with a cuirass probably of leather, the knee-length, long-sleeved blue tunic that has a red border with gold pseudo-cufic letters, and finally the rigidity of the ungainly stance. All these bear witness to close contacts with the western European world, as much in the realistic details as in the artistic manner, which appears to be more Romanesque than Gothic. The painted sections are quite clearly Byzantine in style; however, in the miniature scenes in particular the Gothic buildings provide added testimony to the emergence during the thirteenth century of certain influential centers of taste between East and West. Thus places as far apart as Constantinople, Arta, Kastoria, Cyprus, and even St. Catherine's Monastery at Sinai have been advanced as candidates for the icon's provenance. At the present stage of our knowledge it is not possible to supply a definite answer. The rich iconographic motifs and the variety of styles must be exhaustively studied before any conclusion can be reached beyond our conviction that this is the work of a center of some importance in the mid-thirteenth century.

The number of icons attributed to the thirteenth century is much greater than those preserved from the twelfth, and the works that are thought to date from the second half of the thirteenth century are greater again than those that can be assigned to the first half. This difference should not be ascribed only to fortuitous survival. As can also be observed in monumental painting, it may be due to the favorable circumstance of the liberation of Thessalonike from Frankish rule in 1224, even though the city then slipped from the grasp of the Greek Despot of Epiros into the hands of another Greek ruler, the king of Nicaea. The efflorescence of artistic creativity and production that fol-

lowed the reestablishment of Constantinople as the capital of the Byzantine Empire in 1261 was not confined to that city alone, and certainly in the last decades of the thirteenth century and during the fourteenth century—the Palaeologan period—Thessalonike emerged as a dynamic artistic center of religious painting. Around 1300, three and perhaps four important ateliers are known to have been producing murals in the city. Among the names of the master painters who established them are the eminent citizen Georg Kaliergis, who signed murals in the Church of Christ at Veroia (1315) and may have executed the murals of St. Blaise in the same town; Michael Astrapas and Eutychios, a prolific pair; and Manuel Panselinos, whose name is traditionally associated with the wall-paintings of the Protaton on Mount Athos.

A considerable number of murals by anonymous painters also survive, such as those at Arilje (1296), where the evidence suggests that the artists came from Thessalonike. Other examples are to be found at Omorphoklesia (Galista) 1286–87; at the Metropolitan churches of Veroia and Edessa; at the monastery church of Elassona; on Mount Athos (at Vatopedi, 1312, Chilandari, 1320, and in various chapels); and in Thessalonike itself at St. Panteleimon (? 1300), St. Euthymios (1303), St. Aikaterini (? 1300), St. Nicholas Orphanos (1320–30), and others. We omit the Church of the Holy Apostles, the mosaics and paintings of which we believe to be the works of a Constantinopolitan atelier. We also omit important unsigned murals in Serbia, at Gračanica, Žiča, Studenica, Peć, and elsewhere, of which a number may be attributed to Thessalonikan painters.

The existence of so many distinguished mural-paintings—whether executed by known or unknown hands certainly attributable to Thessalonikan workshops—is an indication that these studios must have been fairly numerous and of considerable merit. It is not easy to distinguish the individual qualities of each, but a typical example of the range of stylistic variation and evolution is the stylistic development of the atelier of Michael Astrapas and Eutychios, where during a period of about twenty-five years (c. 1295–1320) a series of murals was created under the patronage of King Milutin and of Greek and Serbian nobles. Their variety is such that had the dedicatory inscriptions not survived, it would be impossible for anyone to believe that these works were all executed by the same artists.

There is no doubt that portable icons partook of this artistic flowering, both in their diversity and in the stylistic development observable in the murals. Unfortunately, only a few icons have survived, either in the city itself or in other areas. When we consider that building records and other documentary evidence name at least fifty churches and forty monasteries in Thessalonike, we realize that the number of icons once to be found in the city must have been immense, especially if we add all those in the possession of smaller ecclesiastical foundations, *metochia,* shrines, and private houses. Among the icons that have survived is one of particular distinction—a large painted image in the Church of the Virgin Peribleptos (now St. Clement's) at Ohrid, showing the *Evangelist Matthew* full-length and turning to his left (p. 168).

As far as we know, this somewhat Baroque style died out, for after 1300 painting turned toward more classical concepts, lighter and more elegant figures, and Thessalonikan artists followed the fashion. The portable icons that most typically represent Palaeologan art after 1300 are those of the *Twelve Feasts* that have survived from the Church of the Virgin Peribleptos, Ohrid (pp. 169–172). These are works of very high quality, freed from the restrictions of the voluminous style, which show great originality of composition, achieved by the infusion of familiar schemes with a new element of imagination and grace.

Signed works of Michael Astrapas and Eutychios survive in the Church of St. George at Staro Nagoričino, restored by King Milutin in 1313. The murals, dated 1316–18, consist of many iconographic cycles, each scene being of small dimensions similar to those of the portable icon. The tendency to multiply the iconographic cycles, to increase the scenes in every cycle and the number of figures in every scene so that everything diminished in size, is a widespread phenomenon of the age, related to the burgeoning of a new kind of religious feeling. The consequence is that the technical execution of wall-paintings frequently resembles the highly elaborate technique of the portable icon. This mild confusion in the use of the media is also expressed in the iconographic decoration of the masonry *templon* used even in such relatively large churches as St. George. Here the large wooden despotic icons are replaced by mural figures—*St. George the Tropaiophoros and Diassoritis* and the *Virgin Pelagonitissa* (pp. 174–175); the latter is a type unusual in the *templon* but beloved in the region. *Christ Eleemon* and the *Virgin of Pity* are depicted full-length on the front surfaces of the neighboring pilasters.

In the despotic icons of the *templon*, whether portable or murals, the style is always more conservative because certain older models are repeated. On the other hand icons of the *Twelve Feasts*, becoming more and more rare, usually display freer composition. Thus in the despotic icons of the *templon* of St. George, the most personal stylistic signatures of the painters are not reflected, although we can see them clearly in the murals of the same church.

One characteristic of the Thessalonikan style in the first two or three decades of the fourteenth century is the tendency toward a more realistic rendering of facial features, more expressive stances and gestures in every scene, and a feeling for space that is noticeable in the increase of plasticity. This tendency is manifested on the one hand in an evident avoidance of idealized natural beauty, of quiet and gracious poses and noble gestures, an avoidance, that is, of the classical tradition; on the other hand it is declared in the sincere preference for faces frankly ugly, animated by an expression perhaps coarse or common, with all the characteristics of portraiture. This anti-classicizing tendency, evident throughout the fourteenth century, is not confined to one region; it can be seen even in some of the mosaics in the Monastery of Chora (Kariye Camii) in Constantinople.

There are some portable icons from Thessalonike, representative of this style, which are now in the Byzantine Museum, Athens. The large figure of *Christ as the "Wisdom of God"* (p. 192) has a broad face, flowing hair, a thick neck, and a nimbus plastically rendered; but the right hand, which is relatively small, conveys a certain elegance in its gesture of benediction or speech. This impressive figure with its somewhat common features commands the forgiveness of Man in the words of the Bible (Matthew 6: 14–15).

The sulky-faced *Virgin with Child* (p. 179), rather ill at ease with the Child reclining in her arms, is a lady of rank with a supple neck and the melancholic expression so often to be found in the murals of the period. Another icon of the *Virgin with Child* (p. 178) is of the same type, although it comes from Asia Minor. The technical means by which the modeling is rendered are different, so that the face with its sharp shadows becomes more expressive and its irregularity more apparent. The small Christ Child, with its big head, protuberant cheeks, large nose, and pudgy hand raised in benediction, expresses no particular spirituality. One would say, however, that the exaggerated

ugliness of the faces in these icons is deliberate. It recalls the words of the Prophet, "he hath no form nor comeliness" (Isaiah 53:2), and may express the desire to stress the earthly aspect of the incarnation of the Lord.

The first thirty years of the fourteenth century were a creative period when various styles of painting were elaborated and reached maturity. In the following decades artistic standards remained high, but there was little stylistic evolution, while in the last decades of the century both muralists and icon-painters returned to earlier models, showing a very clear contrast between survivals of the "voluminous" style (e.g., the set of the *Apostles* at the Monastery of Chilandari; pp. 188–192) and the much more elegant and painterly style seen in the two-sided icon from Poganovo (now in the Museum of Icons, Sofia), which must have been made in Thessalonike at the end of the century.

In the small towns and provinces of the Balkan interior, often laid waste by war and depredation, artistic activity was frequently interrupted. Few Byzantine icons from the eleventh and twelfth centuries survived these ravages. The existence of icons and the esteem in which they were held are evident, however, in the written records: monastery inventories and rules, wills, and records of deposits by wealthy people who placed their icons and valuables in treasuries for safekeeping in troubled times. Many old icons are also mentioned in the biographies of donors, who presented them to their foundations when the latter were being equipped and beautified.

The preserved *Typikon* (rules) of the Monastery of Bačkovo (1083), the inventory of the Monastery of St. John the Evangelist on Patmos (1200), and many other sources refer to icons and reliquaries set in silver and gold, ornamented with pearls and precious stones. An inventory of the valuables of the Monastery of Xilourgos (1143) on Mount Athos also gives a picture of the *templon*, the upper part of the altar screen, which from the eleventh century on supported icons of the Twelve Feasts set above the architrave and the main row of icons depicting Christ, the Virgin, the titular saint of the church, and some other specially venerated saints. The inventory of 1499 of the Monastery of the Virgin Eleousa, founded in 1080 in the vicinity of Strumica, mentions some forty icons, not one of which has survived.

In the larger towns, where artistic activity continued for a longer period, some of the holy images have been preserved. The churches of Ohrid, Kostur,

and Veroia still contain valuable icons, created in local workshops or sent as gifts from Constantinople and Thessalonike.

OHRID

IN THE CITY OF OHRID on the lake of the same name, where Clement and Naoum, the disciples of Cyril and Methodius, lived and worked, art and literature began to flourish as early as the ninth century. The earliest icons, however, date from the period 1037–56, when many artists came to Ohrid to work on the restoration of the archiepiscopal church of St. Sophia. In addition to the numerous icons imported from Constantinople and Thessalonike, two locally made images painted in fresco are still partially preserved on the pillars of the former altar screen of the large church (p. 149), representing two different types of the *Virgin with Child*.

Local painters' workshops seem to have been more active in Ohrid and western Macedonia toward the end of the twelfth century, to judge from the frescoes in St. George's Church at Kurbinovo on the shores of Lake Prespa (1191), the churches of the Holy Physicians (*Anargyroi*) and St. Nicholas tou Kasnitzi at Kastoria, and the Church of St. Elijah in the village of Grnčari in Macedonia (early thirteenth century). The anonymous painter of the Kastoria processional icon of the *Virgin with Child*, with the *Dead Savior* on the reverse (late twelfth century), was a more sensitive colorist and more restrained in showing the pain and foreboding of the Virgin foreseeing her son's end, than the principal Kurbinovo master, who was responsible for the frescoes in St. George's and the large fresco-icon portraying *Christ and the Virgin of Intercession* (*Paraclesis*).

During the thirteenth century, local painters were ever more frequently employed by the clergy of Ohrid and prominent Byzantine officials in Epiros and Thessaly. Thanks to the Greek inscription on the reverse of the icon of *Christ Pantocrator* in the collection of St. Clement's Church, Ohrid (p. 159), we know that it was painted in Ohrid in 1262–63, at the time of Archbishop Constantine Cavasilas. It was created by a painter trained in an artistic milieu with a lengthy tradition, where as early as the thirteenth century the desire to present the human form three-dimensionally encouraged the adventurous to attempt modeling effects with tones both warm and cold, and to abandon the pronounced linearism of the Com-

nenian epoch. This anonymous master's successfully painted *Pantocrator* is modeled with delicate transitions from the dark olive shadows of the oval face to the rosy cheeks and the pale radiance of the high, intellectual forehead. The artist also made skillful use of gold, highlighting the purple *chiton* and dark blue *himation,* whose folds, however, still emphasize the regular rhythm of the composition rather than the curves of the body. From his approach to the material and modeling of Christ's garments, it is clear that the artist retained much that was traditional in his work.

In the icon of *St. George* at Struga (p. 158), commissioned by a great art lover, the deacon and referendary Jovan of the Archbishopric of Ohrid, and painted in 1266–67 by an artist of the same name, the old stylistic concepts are completely dominant. The figure of St. George has a stiff, ceremonial pose. Much more attention is paid to his accoutrements, his weapons and the ornamentation on his chain-mail tunic, than to the volume of his body. According to the inscription, the painter Jovan followed a model proposed by the donor: "The gift of thy servant, the humble deacon, Jovan, who had the rank of referendary. After I, filled with awe, drew your holy countenance, Jovan, who possessed the gift of coloring, painted this icon. . . ." The same deacon supervised the frescoes in the Church of St. Nicholas at Moriovo (1271). He had traditional tastes in art, delighting in the models of the Comnenian age. Neither in the Church of St. Nicholas nor in the Ohrid icon did his chosen artist copy the innovations of recently restored Constantinople, where a new style was born after the victory over the Franks in 1261.

In the revival of Byzantine painting during the reign of Michael VIII Palaeologus (1261–1282), Constantinople's leading artists resorted to the stylistic models of the ninth and tenth centuries. The modeling of flesh by the use of contrasts of complementary colors, pink and green, warm and cold, painted in transparent layers over ochre, was adapted in the 1260s from the works of acknowledged masters of the Macedonian epoch. The frescoes of Sopoćani Monastery in Serbia, the icons of Christ and the Virgin at Chilandari Monastery on Mount Athos, following the famous *Deesis* of Hagia Sophia in Constantinople, all illustrate the development of this style. In the 1260s and 1270s, the founders and benefactors of the monasteries of Sopoćani and Chilandari employed highly trained artists familiar with developments in the capital. The Sopoćani frescoes and the icons of the *Virgin with Child* and *Christ the Savior* on the altar screen of

the main church at Chilandari (pp. 160, 161) rank among the most beautiful works of this period. The origins of their creators are unknown because of the modesty of the artists, who before the early fourteenth century very rarely signed their names.

Around 1300, more painters from Thessalonike came to work in both the Ohrid area and Serbia. In 1296, Arilje, founded by King Dragutin of Serbia, was painted with frescoes by artists from the city who introduced many innovations in working method and choice of color. The standing figure of Christ in the composition showing the Serbian rulers, the Nemanjićs, as humble monks, is painted almost entirely in tints of ochre and brown. The subtle shading in one color gives a powerful three-dimensional impression.

The anonymous painter of the icon of the *Evangelist Matthew* (p. 168) in the collection in St. Clement's Church, Ohrid, was an even better draftsman and a much more sensitive colorist. The principles of tonal modeling displayed at Arilje are also employed here. The painters of late thirteenth-century icons showed too a preference for athletic bodily contours, as seen in the Protaton frescoes. The powerful temperament and great talent of the *Evangelist Matthew* master can best be judged by comparison with the frescoes on the pilasters of the altar screen of St. John's Church in the hamlet of Kaneo (Ohrid). The Kaneo icons are the work of a somewhat earlier and less educated provincial painter, but the St. Matthew master ranks among the best of his time.

When the Church of the Virgin Peribleptos in Ohrid was decorated with icons in 1295, thanks to the Byzantine general, Progon Zgur, it must also have received many icons as gifts. The Thessalonikan artists Michael Astrapas and Eutychios came to Ohrid at that time to paint the church's frescoes, and probably also did some icons on wood. The examples that come closest to their style are the *Ascension* (p. 169) and the *Baptism of Christ* (p. 170), preserved in the church collection.

As we saw earlier, being eminent painters already celebrated in Thessalonike, Michael and Eutychios were also invited to work in Serbia, where over a twenty-year period they decorated many churches founded by King Milutin. This was the era of the closest artistic ties between the Serbian Kingdom, Thessalonike, and Mount Athos. The influence of Constantinople was felt almost simultaneously in these three lively artistic centers, where icon-painting was intensively fostered in local workshops.

GREECE IN THE THIRTEENTH CENTURY

RECOGNIZING THAT THESSALONIKE and its hinterland came under the direct cultural influence of Constantinople, we consider Greece south of Mount Olympus, together with the islands, as forming a different unit, governed at least partly by indigenous traditions, debatable though it is whether these could confer any particular stamp on local art. Because the geographical boundaries were only relative and not reinforced by closely guarded frontiers, the interplay of ideas and artistic manners was constant.

The southern part of this region was one of the most turbulent in the Empire, partly because of its geographical position. Hence its artistic output was always modest if not downright impoverished in terms of materials and style. Neither the lavish buildings with polychrome marble floors, marble-faced walls, and mosaic decoration (for example, at Hosios Loukas, Nea Moni, Chios, and Daphni) nor the individual mosaics (*Paregoritissa—the Virgin of Consolation—*at Arta, and the *Holy Apostles* at Thessalonike) can be regarded as the products of local workshops.

Portable icons of some merit on wooden panels or of more precious materials (other than stone) have not yet been identified. We shall therefore limit our remarks to mural icons of the thirteenth century, so that we may look closely for the existence of traditions and concepts common to all of Greece. The mural icons in a remote cave on the island of Cythera are instructive in this regard. We ought first to explain that they did not decorate a masonry *templon*, but rather the western face of a wall, virtually the only surviving part of a small chapel dedicated to St. Sophia, which was constructed in the large cave. The register of saints includes the tenth-century local figure, *Theodore of Cythera,* and a three-figure *Deesis.* To the right of the small entryway is a bust of *St. Nicholas* (p. 167). The contours of the figure, the large expressive eyes and arched brows, the firm mouth and broad forehead, are rendered with a free hand. This linear style, which may be regarded as a somewhat simplified continuation of that already seen in the eleventh-century murals at St. Sophia, Thessalonike (p. 145), has led some scholars to attribute these Cytheran murals to the eleventh century. The gar-

ments, however, display the rich decoration of the Comnenian period (Kastoria; p. 150). The painter Theodoros, not a monk but a family man, who signed these so-called monastic paintings, may not have been very strong on spelling, but he was a very skillful draftsman in the style that prevailed in the islands and in Crete throughout the thirteenth century.

We are led to central Greece by two mosaic icons (pp. 164–165) on the pilasters of the Church of the Porta Panaghia near Trikkala, Thessaly, the monastery founded by John Comnenos Angelos Doukas, illegitimate son of the Despot of Epiros, Michael II (c. 1285). Bordered in the usual way with relief colonnettes, these two full-length icons flanking the *templon* are not positioned traditionally. Here the *Virgin* is placed to the left of *Christ,* that is, on the southern pilaster, evidence of the artist's failure to understand the dogmatic significance of this image. The very poverty of the material is also striking; the mosaic is of stone and does not contain a single gold, or even glass, cube.

The unnaturally proportioned tall figures characteristic of twelfth-century art are still in evidence; the drapery is rather stiff, the clothes cling to the bodies, and the relatively small heads possess little facial expression.

The faces and other parts of the bodies are firmly drawn, although the plasticity is undiminished. We should note that these mosaic icons were in existence before the murals of the sanctuary (probably created by the same atelier), although they display affinities with only a small group of these, distinguished by the same conservative characteristics. There is, moreover, a significant difference between the materials, artistic quality, and technique of these mosaics and those of the *Paregoritissa* of Arta (the capital of Epiros), only some ten years later, which are regarded as Constantinopolitan works.

From the Frankish-held region of Euboea, there are two examples of mural icons (c. 1300). Among the wall-paintings in the small transverse-vaulted Church of the Transfiguration in the village of Pyrghi, which can be dated to 1296, is the mural icon of *St. Theodore Tiron* (p. 166). Here we see a different aspect of the painting of the period. The virile figure of the soldier-saint, with its almost square face and small mustache, belongs to a kind of portraiture untouched by the Western influence common in more northerly regions. The vivid modeling of the face is achieved without lines, simply by various shades that render light and shadows very clearly, sharpening the expression of profound sentimentality. St. Theodore is related to the most progressive group of wall-paintings in the Porta Panaghia—those that do not resemble the mosaics. The work at Pyrghi is distinguished, however, by the flat linear style in which the sumptuous clothing—always parade dress—is rendered. From this idiosyncrasy we can recognize a local workshop.

Also in Euboea, the somewhat later wall-paintings of St. Thekla include a row of interesting medallions depicting saints in half-figure. *St. Barbara* (p. 166), with her distinctive headdress, expresses the same tendency toward an emphasized facial expression with a slanting gaze, but here the painterly means have become a little harsher, the light and shadow more aprupt. The time interval between Pyrghi and St. Thekla (? 1310) cannot be very long.

These few examples would seem to confirm that the hope of defining characteristics common to all Hellenic art, at least in the thirteenth century, is a vain one.

SERBIA

THE OLDEST ICONS in Raška (Rascia), Zeta, and Hum have vanished without a trace; not even written descriptions have come down to us. It is therefore unclear when certain distinctive features of subject or style began to appear—features that would indicate the evolution of a society desirous of declaring its own value through artistic achievement or by promoting the cult of local saints.

The importance of building up special local cults was fully grasped by the founders and benefactors of the Serbian monasteries. The Grand Zhupan Stephen Nemanja (later the monk Simeon) and his son, the monk Sava of Mount Athos, chose the Virgin Mary—universally recognized protectress of the human race—when deciding on the dedication of the main church of Chilandari at the end of the twelfth century. Simeon Nemanja breathed his last in his Mount Athos foundation in 1199, just after Sava had brought to him an icon of the *Virgin,* to whom he commended his soul. During his journeys and campaigns, Nemanja frequently invoked the aid of St. Nicholas and St. George; he erected churches dedicated to these saints in his own country, and sent valuable gifts to the famous Church of St. Nicholas at Bari (Italy),

which kept the relics of the saint. In the fourteenth century, King Stephen Dečanski of Serbia also sent an icon to this church (p. 157).

In the oldest preserved icons painted in fresco in the Church of the Holy Virgin at the Monastery of Studenica (1208–09), notable prominence was given to the patron saints of the Nemanjić dynasty. Beside the Virgin and Christ, who were probably represented on the altar screen, there were paintings of St. Nicholas and St. Stephen the First Martyr, bordered by very decorative painted frames. Highly venerated at the Byzantine court, St. Stephen the First Martyr was also chosen as the patron of the Nemanjić rulers, who were all to bear his name for two centuries. A little way from the altar screen, in the nave, there were frescoes of *St. John the Forerunner* (p. 151) and *St. Sabbas of Jerusalem,* protector of Nemanja's sons, who were responsible for the decoration of their father's foundation. Even in their earliest commissions, the royal patrons introduced distinctive features into the iconography of Serbian wall-painting by choosing new patron saints and giving more space to their images and the depiction of their lives. Following the old Byzantine custom, "new" icons were also created in Serbian churches by the addition of special epithets to the older iconographic types. A replica of the celebrated Constantinople image of the *Virgin Nikopoios* appeared in a fresco at Studenica, but with an epithet connecting it with this region: the "Studenica Virgin" (*Bogorodica Studenička*). At Chilandari, too, there seems to have been a "Chilandar Virgin," a copy of this icon having been preserved in a fourteenth-century fresco at the Monastery of Konča; in the church dedicated to the Virgin at Prizren (*Bogorodica Ljeviška*), there is a representation of Christ as the "Protector of Prizren"; at Matejič, the "Virgin of Montenegro"; and so on.

Before the mid-thirteenth century, there was no sign in Serbia of groups of painters working together on a number of monuments under the supervision of the same master. A lengthy period of development had to pass, during which Serbian patrons and benefactors endeavored to find native artists capable of executing their ideas, before Serbia could produce works that differed in style from those of other Byzantine cultural centers. Early in the thirteenth century, Sava Nemanjić obtained icons in Thessalonike, and seems to have brought in painters from Constantinople as well to work for the Nemanjić rulers. The mosaic icon of the *Virgin with Child* at Chilandari (pp. 146–147) was not executed in Serbia, where this

ancient Byzantine technique never took root. The Studenica fresco-icons display stylistic similarities to works preserved in the Byzantine provinces, which emulated Constantinopolitan art, for example, those at Sinai, Cyprus, and Eurythania in Greece.

The next step in the development of distinctive local features in Serbian icon-painting was prompted by the Nemanjićs' desire for the independence of Church and state. They were quick to exploit the opportunity offered by the Latin conquest of Constantinople (1204), by shrewd diplomatic activity and the fostering of local religious cults. Depicted first in portraits in his foundations, Simeon Nemanja was soon proclaimed *Myroblitos* (holy personage) and celebrated in icons too. Buried at Chilandari in 1199, his remains were transferred to Studenica as saintly relics seven years later. Within the next twenty years, liturgical and artistic evidence shows a cult of St. Simeon flourishing in Serbia. Offices were composed, his "Life" was written, and the most important episodes were painted in the south chapel of the Church of the Holy Virgin at Studenica, which like the exonarthex was added by Nemanja's grandson, King Radoslav (1234–1235). The Serbian state, independent from 1217, and the Serbian Church, autocephalous from 1219, needed the cult of a local saint from the royal family, which would thereby gain enormously in prestige. The cult of St. Simeon Nemanja was celebrated by the Nemanjić church builders, who had their holy ancestor painted as their protector on the church walls or on portable icons. One of these images is mentioned in an inventory including some twenty other icons deposited in Dubrovnik in 1281 by Zhupan Desa and his mother, the former Serbian queen, Beloslava. This icon was embellished with a silver setting and small plaques of mountain crystal.

The earliest preserved representations of St. Simeon, in frescoes at the Monastery of Mileševa (before 1228) and in Radoslav's chapel at Studenica, fully accord with the descriptions of his appearance to be found in contemporary Serbian literature (the "Life of St. Sava," the "Life of St. Stephen the First-Crowned," and offices). The model for writers and painters was the oldest portrait of Nemanja, painted above his grave at Chilandari. According to his biographer, holy myrrh emanated from this Chilandari portrait: "And myrrh came not only from the holy relics but also from the dry stone where the visage of the holy man was inscribed on the rock. . . ." As in the case of the famous Thessalonikan saints, Demetrius, Theodora of Thessalonike, and others, the emanation

of myrrh was considered a sure sign of a miracle and the consecration of the person interred. Anyone whose portrait was once marked with the flowing of myrrh was subsequently venerated as a holy personage (*myroblitos*), and the image was copied on portable icons.

It was only in the early fourteenth century that St. Simeon began to be portrayed with his son, St. Sava, the first Serbian archbishop (1219–1235). Joined in liturgical verse of the early fourteenth century and in frescoes of that period, their cults were pictorially co-celebrated in wooden icons of the fifteenth and sixteenth centuries, which were carried to all parts of the Orthodox world (p. 198). The mighty Serbian King Milutin (1282–1321) offered prayers for salvation to SS. Simeon and Sava when preparing a campaign against the Byzantines; King Stephen Dečanski also invoked their aid before the decisive Battle of Velbužd (1330) in which he defeated Emperor Michael of Bulgaria (pp. 346–347).

Carrying out the commissions of Serbian rulers, archbishops, and local bishops, painters both in the interior and along the coast had recourse to a variety of styles, depending on the environment in which they had grown up or were working. Even when consciously imitating the iconography and manner of Byzantine painters, the artists of the coastal towns introduced features that reveal their equal familiarity with Latin iconographic or stylistic traditions. The robust *Crucifixion* (p. 163), with a crown of thorns, rough-faced and thickly bearded Christ, and no cross in the nimbus, recalls the work of a "Greek painter," which was what the people of Kotor and Dubrovnik called the artists who could paint icons of Byzantine type with Greek inscriptions.

An icon with busts of the *Apostles Peter and Paul* and portraits of the Serbian donors (p. 156) was probably by a "Greek painter" from the Serbian coast who was able to adapt his style to suit the immediate purpose and the donors' wishes. Intending the icon as a gift to the Catholic Church, it is very likely that the donors deliberately chose an artist who could execute their commission in a manner that would be well received in a Catholic environment. Brought up on Byzantine painting of the Comnenian epoch, the artist still relied to a considerable extent on line to suggest the volume of the saints' heads and bodies, draped in the customary robes, the *chiton* and *himation*. The historical figures are given summary treatment, with no proper attempt at portraiture; the figure of St.

Nicholas, to whom one king bows, has all the features of the Latin iconographic tradition with its robes, mitre, and sceptre.

Queen Helena of Anjou, whose sons Dragutin and Milutin shared the Serbian throne from 1282, is known to have donated huge sums for the beautification of her foundations, particularly the mausoleum-church she had built for herself at Gradac (by 1276). The Archbishop of Serbia, Danilo II, states in Helena's biography that she presented to the church at Gradac icons in beautiful gold frames set with magnificent pearls and precious stones, containing many relics of saints, as well as curtains of cloth-of-gold, books, and liturgical vessels. There is no longer any trace, however, of any of the church's priceless icons, the most venerated of which were the despotic icons of the altar screen. One of these was seen and revered by King Dragutin, when he visited the tomb of his mother in 1314–15.

At that time, there was a miraculous icon of the Virgin in the metropolitan church of Belgrade, which was revered by Queen Simonis of Serbia during a visit to her brother-in-law, King Dragutin, and his court some time before 1316. King Milutin also procured many icons for the churches he founded throughout Serbia and Eastern Christendom, but little is known about these. Archbishop Danilo II states that King Milutin gave the Monastery of the Holy Virgin at Treskavac (near Prilep) icons set in gold and ornamented with pearls. These, like so many others, were taken from the churches and destroyed. Two frescoes have been preserved, however, on the altar screen of St. George's Church at Staro Nagoričino (near Kumanovo), which King Milutin restored. As we have seen, in 1316–18 the famous Thessalonikan painters Michael Astrapas and Eutychios painted new frescoes in this eleventh-century church for the king. The openings between the small columns and the architrave on the altar screen were filled in and decorated with frescoes of *St. George the Tropaiophoros and Diassoritis*, and the *Virgin Pelagonitissa* (pp. 174–175). Since the cult of the Virgin flourished in the Pelagonian plain as early as the thirteenth century, it is believed that all later icons repeated the image of the Virgin with a playful Christ Child originally depicted on an ancient miraculous icon from this region.

Michael Astrapas and Eutychios worked in several of King Milutin's churches. In Serbia they were the representatives of the true "classical" style of the Palaeologan age, which had discovered new oppor-

tunities for more complex expression in scenes of small size with many figures, strongly modeled by the play of light and shadow, and placed in a setting with greater depth. These qualities of the new style are visible in the mural of St. George's Church at Staro Nagoričino and in the icons on the altar screen (p. 174). The strongly emphasized relief of Christ's body in movement, and the volume of the busts, confidently conveyed by the relationship of light and dark colors, are qualities that prevailed in the most progressive art of both Byzantium and Serbia in this period.

Some remarkable icons of the great feasts of the Church, for example, the *Nativity of Christ* (p. 172), the *Baptism of Christ* (p. 173), and the *Harrowing of Hell* (p. 170), display the finest qualities of this early fourteenth-century style, which quickly spread among artists in the Balkans. The Gates of Heaven held open by angels, neophytes leaping into the waves of the Jordan, personifications of river and sea—all these attractive details were also known in Comnenian painting of the eleventh and twelfth centuries; but it was not until the early fourteenth that these and other motifs were used to deepen space, portray the hilly landscape, and balance the composition. The multiplicity of figures giving an impression of lively movement and realism, the resonant and pure colors applied with very fine brushstrokes, and the deft drawing of the human body in movement (particularly in the outstanding icon of the *Harrowing of Hell*, with its striking diagonal composition), are the qualities that mark these icons as masterpieces of their time.

Only the *Presentation of the Virgin in the Temple,* preserved in the main church at Chilandari, can equal these in artistic quality (p. 176). Wholly traditional iconographically, this image radiates a realism rarely expressed so powerfully in the creations of other artistic centers. The exceptional grace of the young Virgin's companions, their studied movements and the attempt of one of them to shield her candle-flame from a breath of wind, are extraordinarily lifelike and convincing, qualities much sought after in early fourteenth-century painting. Probably painted in 1321, when King Milutin restored the old Serbian monastery on Mount Athos, the *Presentation of the Virgin* testifies to the great skill of the masters he employed. Many gifted artists besides Michael and Eutychios worked for him. They have remained anonymous; however, the icons which they painted reveal the king's familiarity with contemporary artistic trends and his ability to engage the best painters of his time, whether from Thessalonike, Constantinople (where he restored and made gifts to several churches), or his own realm.

The painters of the court workshops were the most expert and closest to the ideas of Constantinople. Other less skilled but still sought-after artists satisfied the tastes and requirements of local feudal lords. The painter of the frescoes in the White Church at Karan (near Užice) was a local man, who had no opportunity to acquire a real classical training. The iconostasis (1342) bore icons chosen by the founder, Zhupan Brajan, and other donors. At the wish of a nun, the cult of the *Virgin with Three Hands* (*Tricheiroussa*) was perpetuated (p. 181). This cult had been brought to Serbia via Skoplje, where King Milutin restored a church with the same dedication at the end of the thirteenth century, when he captured the city. The *Virgin Tricheiroussa* was venerated at Chilandari as well, but no other images of this type have come down to us.

Artists of varying ability worked in Serbia in the fourteenth century, at the behest of a growing number of benefactors from diverse social classes with different degrees of wealth and education. The icon of the *Virgin with Christ* at Čajniče, the *Virgin Hodegetria* in the Church of St. Nicholas in Prizren (p. 187), the *Virgin with Child* in the Church of St. George in Prizren (p. 187), and the *Virgin with Child* in Dečani (p. 180)—all from this period—demonstrate that, though not lacking in originality, the work of local painters' workshops was very uneven in quality.

At this time the town of Prizren became a flourishing artistic center. In addition to the Thessalonikan master Michael Astrapas, who was responsible for the frescoes in the Church of the Virgin (*Bogorodica Ljeviška;* 1307–13), several local painters worked in the city and surrounding churches founded by feudal lords. The best among them executed a small icon that has the feast of the *Annunciation* on one side (p. 185) and the *Meeting of Joachim and Anne* on the reverse (p. 184). The well-rendered architecture in the background of the latter, with its Gothic windows and gables, is reminiscent of contemporary forms seen in Raška, while the wonderful modeling of the Archangel Gabriel in the *Annunciation* reveals a painter who had learned from the best masters of the classical style. The integration of old and new dates the icon to the middle of the fourteenth century.

At Dečani in the same period (c. 1340–50), the icons for the altar screen were painted by a local artist whose powerful temperament and excellent training are revealed in the convincing, natural relationship of the *Virgin with Child* (p. 180). In the tenth and eleventh centuries, the Constantinopolitan image of the Virgin of Tenderness had been highly esteemed. It was later copied nearly everywhere from Cappadocia to the Balkans, and at Dečani it was this type, which emphasizes the feelings of the holy personages, that was chosen for the iconostasis. All five of the icons on the Dečani altar screen are successful works of art. The attenuated, slender figures, well drawn and modeled, show familiarity with the use of parallel brushstrokes in light ochre to achieve roundness of the face, neck, and arms. By a play of light lines, relief is given to beards, cheeks, and noses; but it is the treatment of the *Archangel Gabriel's* forehead that is most unusual (pp. 180–181). The regular oval face is enlivened by quite asymmetrical lines. The painter was seeking to give character to the figures, both in the youthful face of the Archangel, and in the wrinkled visages of St. John the Baptist and St. Nicholas.

Several icons of large size were painted for the iconostases of the churches of Ohrid in the mid-fourteenth century, commissioned by Archbishop Nikola of Ohrid and the local lord, Kyr Isaac Ducas. The feudal lords who supported King Dušan—who incorporated Ohrid into the Serbian state in 1334—demonstrated their high social stature by making valuable gifts to churches. They bestowed two large icons, framed in gold with silver plaques, on the Church of the Virgin Peribleptos in Ohrid. On the frame of the icon of *Christ the Savior of Souls (Psychosostis)*, an inscription has been preserved mentioning Kyr Isaac as donor; the one on the frame of the *Virgin Psychosostria with Child* (p. 186) identifies the portrait embossed on a thin metal plaque as Archbishop Nikola.

A number of local painters were at work in Ohrid at this time, but the most talented was a Greek, John Theorianos. In his work, the old classical traditions gave way to new stylistic models, and a certain monumentality of large figures was sought, even in icons.

The classical beauty of proportion and emotional realism so evident in the best works of the first half of the century did not, however, satisfy the wishes of devout donors in Serbia during the 1360s. In holy figures they usually looked for idealized heroes of robust build and spiritual strength, exceptional personalities endowed with superhuman powers. Surviving works on Mount Athos (pp. 188–191)—the standing figures of huge dimensions in the *Deesis* of the Pantocrator monastery (c. 1363), the icons of Vatopedi, or the *Megali Deesis* with busts at Chilandari (c. 1360)—indicate the direction taken by a certain group of painters. By increasing the size of the holy personages, and through powerful modeling of the large bodies and exceptional characterization of the faces, they conveyed their vision of the heroic defender of the faith. Refined contrasts of darker colors in the clothing, most frequently deep blue and purple, and the shading of the flesh with a somewhat darker ochre, are characteristic of an exceptional painter, whose work has only been preserved at Mount Athos.

There were other gifted artists whom the monks brought to paint on Mount Athos, such as the one responsible for depicting the five martyrs of Sebaste (pp. 176–177) on an icon preserved at Chilandari. It would seem that these painters were engaged in Constantinople and Thessalonike, where they had received their training and made their names, to come to Mount Athos to carry out particular commissions.

Icons by Constantinopolitan and Thessalonikan artists of the 1360s and 1370s show the same disposition toward monumentality and athletic build of holy figures as those from Mount Athos and Serbia. These new forms were a reflection of new times. The icon of *Christ* in the Hermitage (1363) and the icon of *Christ*, with *St. John the Theologian* on the reverse, now on Lesbos, are works of the highest quality from that period, similar in their soft treatment of the flesh. These large busts are painted with very careful regard to detail. In the icon of the *Archangel Michael* in the Byzantine Museum in Athens, in the somewhat smaller icon of *St. Gregory Palamas* in Moscow (Pushkin Museum), and in many other works of the seventh and eighth decades of the fourteenth century, the large figures are modeled with exceptionally fine lines of light ochre, highlighting the curves of face and body, a treatment familiar to artists working in Serbia in the same period or somewhat later. In the fresco of *St. Nicholas* at Psača (1365–71), the huge bust of the saint shows the same kind of highlighting, by rays of tiny white lines. The painter of the *Virgin Hodegetria with Child* at Lesnovo (p. 193) worked in a similar manner, and was very successful in suggesting relief. Further examples can be found in the frescoes of Melentija, Ravanica, and other Serbian churches.

The best-known late fourteenth-century artist, both by name and by work, was the Metropolitan Jovan. A native of the Prilep region, he was an associate of the last kings of the Mrnjavčević family, Vukašin and Marko, and a descendant of the monk German, founder of the Monastery of Zrze in the mid-fourteenth century. For his family foundation, Jovan painted an icon of *Christ the Savior and Giver of Life* in 1394 (p. 192). His style is original, but nevertheless incorporates all the qualities of earlier trends: the monumentality of athletic figures, the detailed treatment of the flesh with tiny lines of light ochre, and the darker purple and blue tones of Christ's clothing. His frescoes in St. Andrew's at Treska (1389), with a considerably brighter harmony of colors, show the Metropolitan's ambition to revive the finest traditions of Serbian monumental painting. Undoubtedly acquainted with the great Byzantine masters of his age, Jovan created these large athletic figures by the slow methods of the icon-painter even when he was painting frescoes. His idealized holy figures were to help painters of the next generation along the path to stylized forms, with the emphasis on robustness giving way to attenuated faces with large eyes in softly molded flesh.

Jovan's brother Makarije painted the icon of the *Virgin Pelagonitissa with Child* in 1421–22 (p. 197), respecting the iconographic type of this long-venerated saint, but giving her a fresh appearance, neglecting volume while paying special attention to line and the decorative effect of the garments. Makarije worked in Serbia, painting frescoes at Ljubostinja in the early years of the fifteenth century, but later he returned to his native region and undertook the ornamentation of the altar screen in his ancestor's foundation in Zrze. Besides the *Virgin Pelagonitissa*, he left several icons of the *Grand Deesis* on the *templon* of the iconostasis.

At the time when the downfall of the Christian states appeared imminent, surrounded as they were by victorious Turkish armies, the need for spiritual beauty overshadowed the fear of inevitable death. The finest icons of the early fifteenth century in Serbia, few of which have been preserved (p. 198), must have resembled the frescoes of Resava and Kalenić, bathed in golden radiance. In all likelihood, the fresco-painters of the Morača churches created images for the iconostases, monumental figures with a noble, serene, and classical beauty. In the states ruled by despots—the Lazarevićs and Brankovićs in the north, and King Marko in the south—strenuous efforts were made in the late fourteenth and early fifteenth centuries to preserve the local church organizations and to demonstrate the legitimacy of these heirs to authority previously held by the Serbian kings and emperors. With the demise of King Marko in 1395, painting in the Prilep and Ohrid regions died out for a considerable period. It was not until the 1430s, it seems, that the churches in these regions were repaired and endowed, thanks to an improvement in the position of the local clergy. The old cults of local saints, Clement and Naoum, attracted fresh benefactors. The thoughtful faces of their icons (pp. 194–195) are illuminated with a gentle radiance, and their huge foreheads suggest the superhuman nature of the saints, from whom the people of the region never ceased to expect protection. The painters' aspirations toward the complete idealization of holy figures evolved at this time into the new style of the fifteenth century.

After the fall of Smederevo to the Turks in 1459, the last rulers of Serbia, the despots of the Branković dynasty, vanished from the scene. With them, for some time, went any notable artistic activity in local workshops. Thus ended a fruitful period in the artistic life of the Serbian state, which from the mid-twelfth to the mid-fifteenth century had intensively fostered icon-painting as a reflection of devotion to Eastern Orthodoxy.

Turning back to Thessalonike, we see that the portable icon of the *Virgin with Child* (p. 183) from the Church of St. Nicholas Orphanos, metochion of the Monastery of Vlatadon, should be dated to the fifteenth century. Cleaning has revealed the characteristics of an ungraceful style, with a marked expressionistic character, continuing the anti-classical tendency of the preceding century. This attribution is supported by the mural icon of similar style, *St. Joasaf*, on a pilaster in the Church of St. Demetrius. The saint is portrayed full-length protecting the smaller St. Gregory Palamas. During the Hesychast Controversy this hierarch, leader of the Hesychasts, enjoyed the protection of the emperor John Cantacuzenos, who later took the habit as the monk Joasaf. That the style of these two Thessalonikan works had a certain influence is clear from the murals of the school of Morava, in chapels at the Monastery of Vatopedi and elsewhere, but it was to be the final offshoot of artistic activity in Thessalonike.

Thessalonike and Constantinople were for centuries the most important centers from which art

spread into the Slavic lands of the Balkan interior (although Mount Athos, especially in the early fourteenth century, also played a significant role, transmitting cultural influences and models from the Greek to the Slavic world). When these cities fell under Latin rule and artistic creativity was at a minimum, the Serbian kings revived the ancient art in their own country, accepting Byzantine models but adapting them to their own ideology as rulers, stressing local saints. Regardless of individual differences in the specific characteristics of venerated saints, and of the differences in painting style that are ushered in by every new age, over the extensive area of the Balkans the same iconographic language was spoken, and the same respect accorded to the Byzantine artistic ethos, comprehensible to every medieval person born into the Orthodox Christian tradition.

Ὁ ΑΓΙΟC ΟΚΥΝΟΒΗ...

St. Theodose the Cenobiarch and an Unidentified Saint
Fresco; 1000–1050; narthex of the Church of St. Sophia,
Thessalonike.

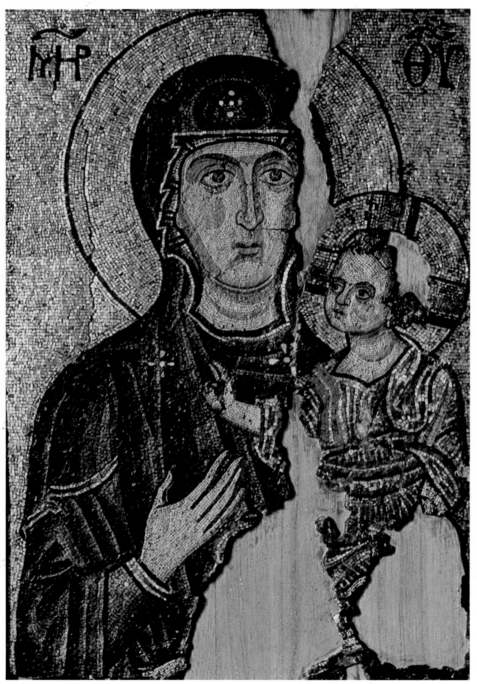

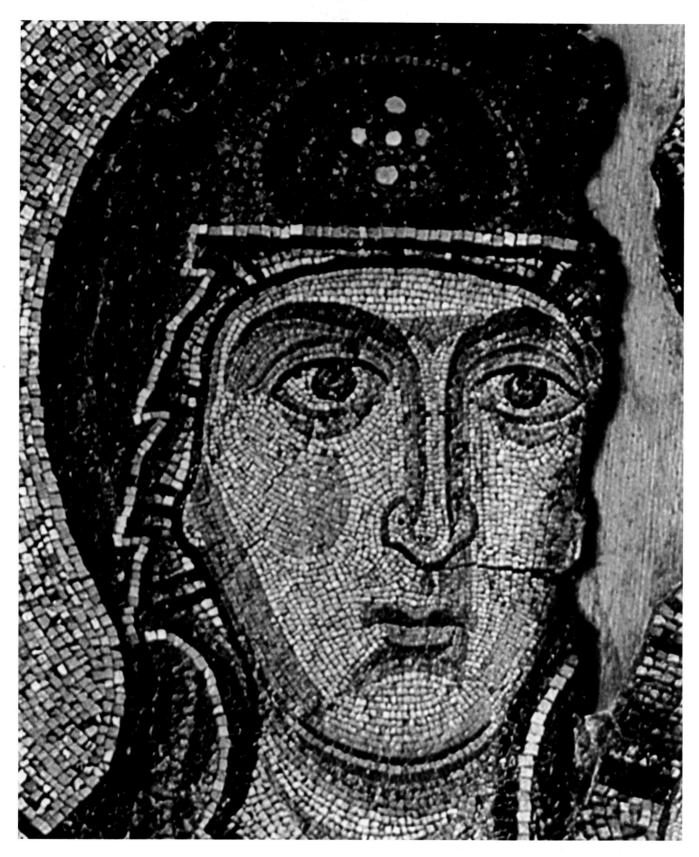

Opposite above:
Virgin with Child
Mosaic; Monastery of Hosios Loukas, Phocis, 1030–50;
preserved at St. Loukas.

Opposite below:
Virgin Hodegetria with Child
Greek painter
Mosaic, 57 x 38 cm. (22½ x 15 in.); end of twelfth
century; Chilandari Monastery, Mount Athos.

Above:
Virgin Hodegetria with Child, Detail

St. Panteleimon
Greek painter from Constantinople
Fresco; 1164; Church of St. Panteleimon at Nerezi,
near Skoplje; decorating the pillar of the altar screen.

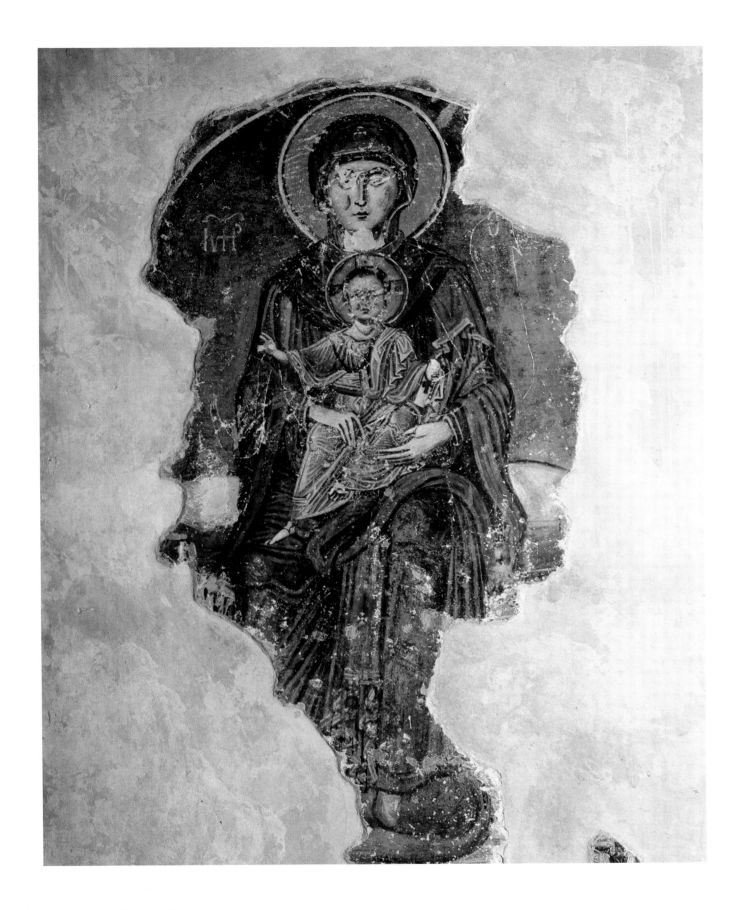

Virgin Enthroned with Child
Greek painter probably from Thessalonike
Fresco; mid-eleventh century; Church of St. Sophia at
Ohrid, Macedonia; decorating the pillar of the altar
screen.

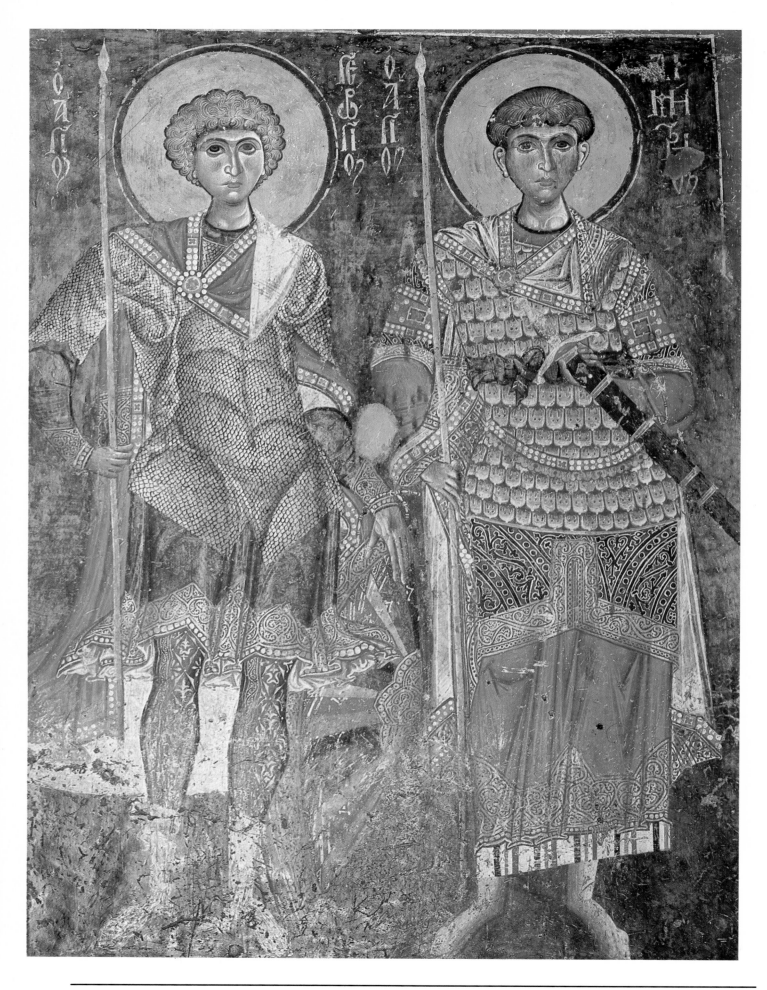

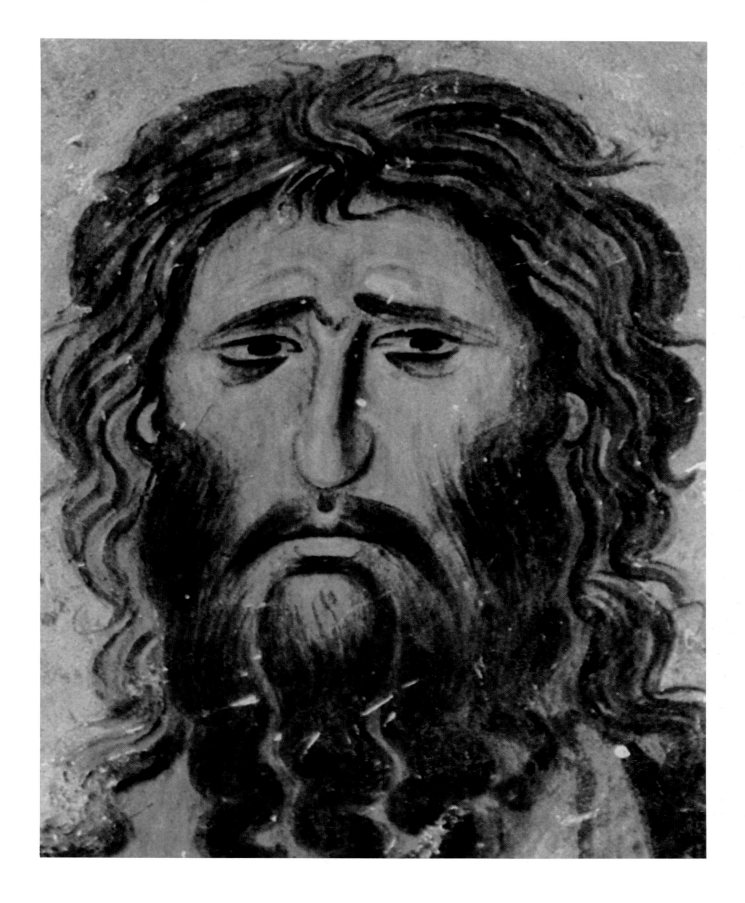

Opposite:
SS. George and Demetrius
Mural, egg tempera; 1180–1200; Church of SS. Cosmas
and Damian, Kastoria.

St. John the Forerunner (Prodromos), Detail
Probably a Greek painter from Constantinople
Fresco; 1208–09; Church of the Virgin, Monastery of
Studenica, Serbia; on the pillar of the north wall of the
nave.

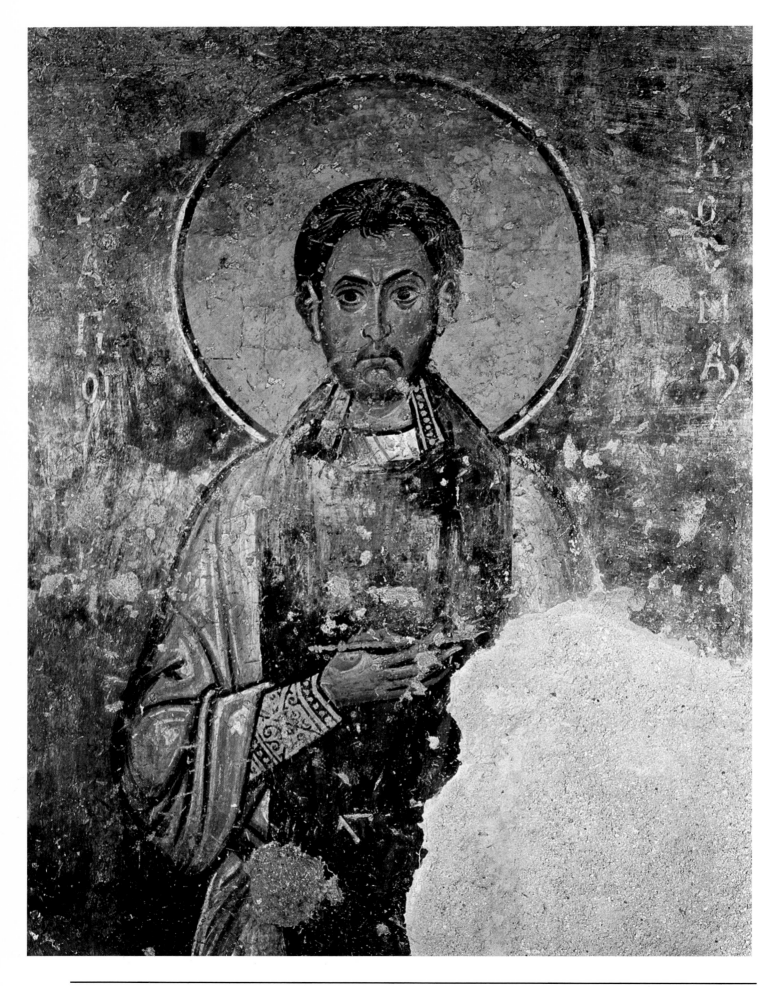

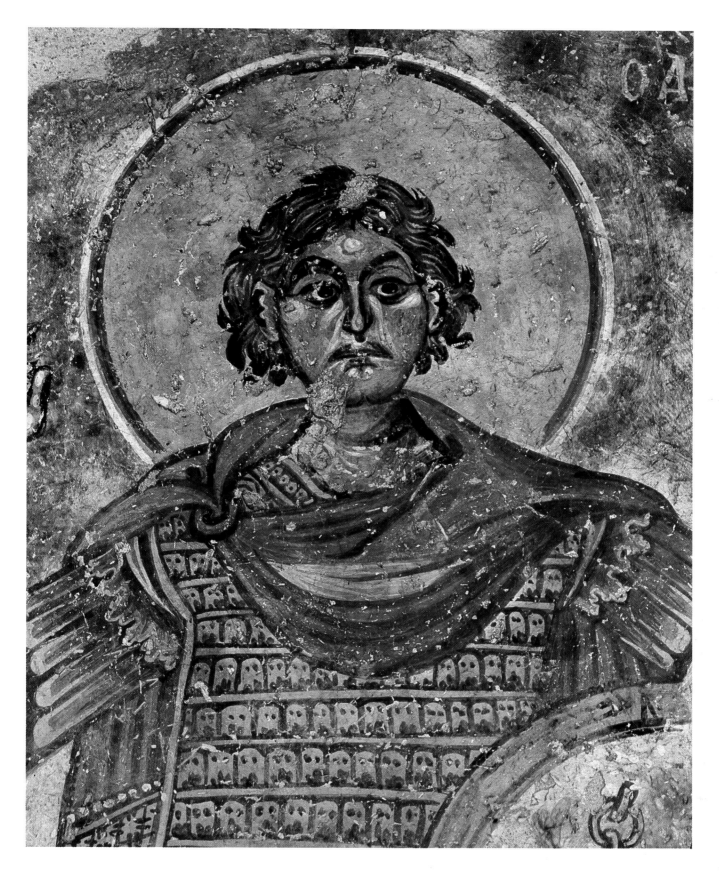

Opposite:
SS. Cosmas and Damian
Detail: St. Cosmas
Fresco and egg tempera; Church of Episkopi
(destroyed), Eurythania, 1200–1250; Byzantine
Museum, Athens.

St. Orestis
Fresco and egg tempera; Church of Episkopi
(destroyed), Eurythania, 1200–1250; Byzantine
Museum, Athens.

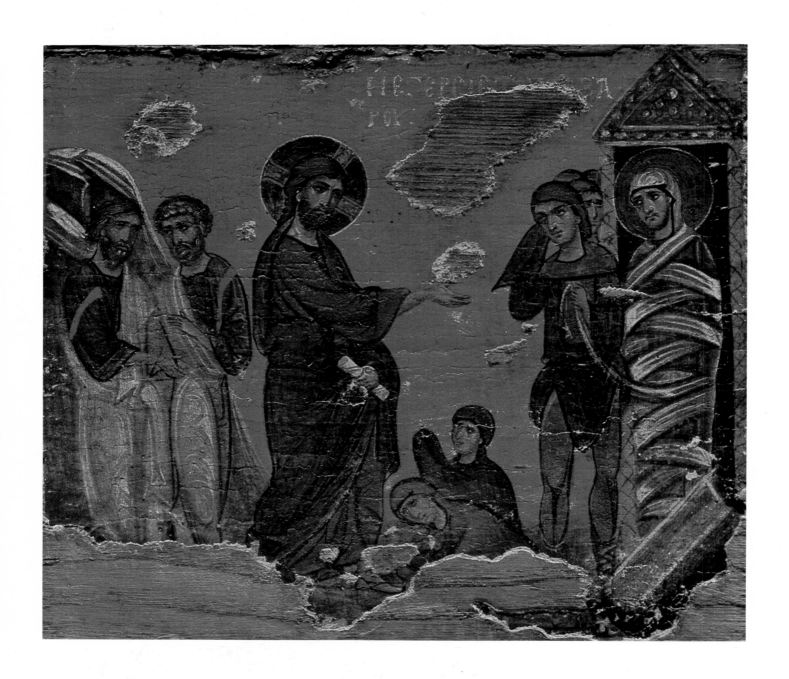

Raising of Lazarus
Egg tempera on wood, 21.5 x 24 cm. (8½ x 9½ in.);
Thessalonike, c. 1200; private collection, Athens.

Opposite:
St. George
Wooden relief, 109 x 72 cm. (42⅞ x 28⅜ in.); East
Mediterranean (?), thirteenth century, formerly in
Kastoria; Byzantine Museum, Athens.

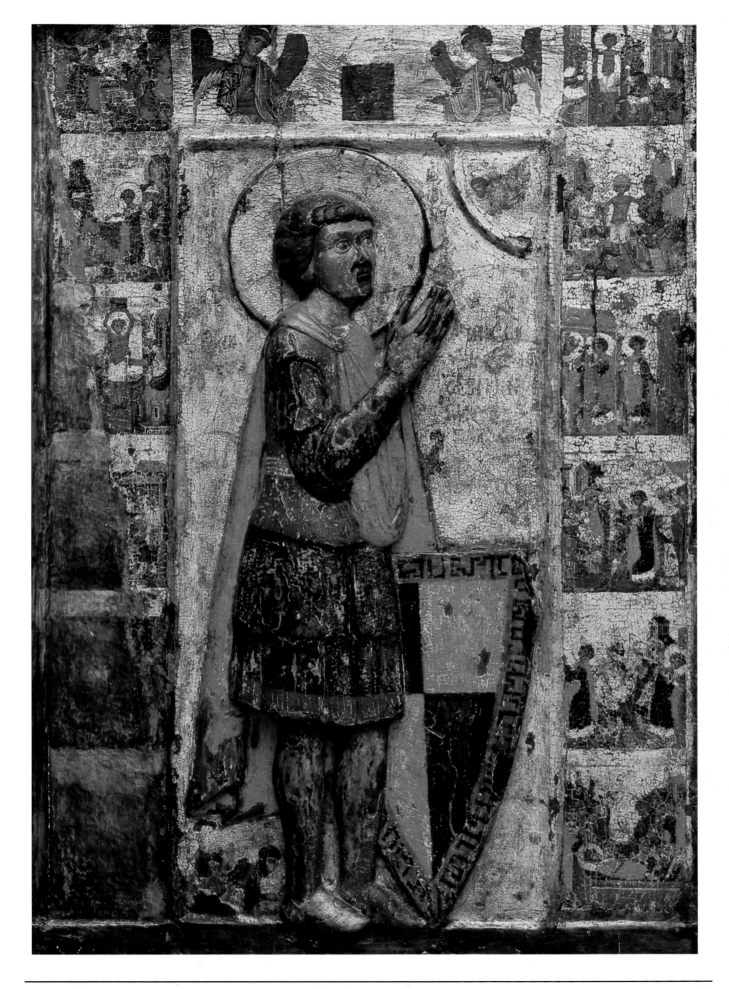

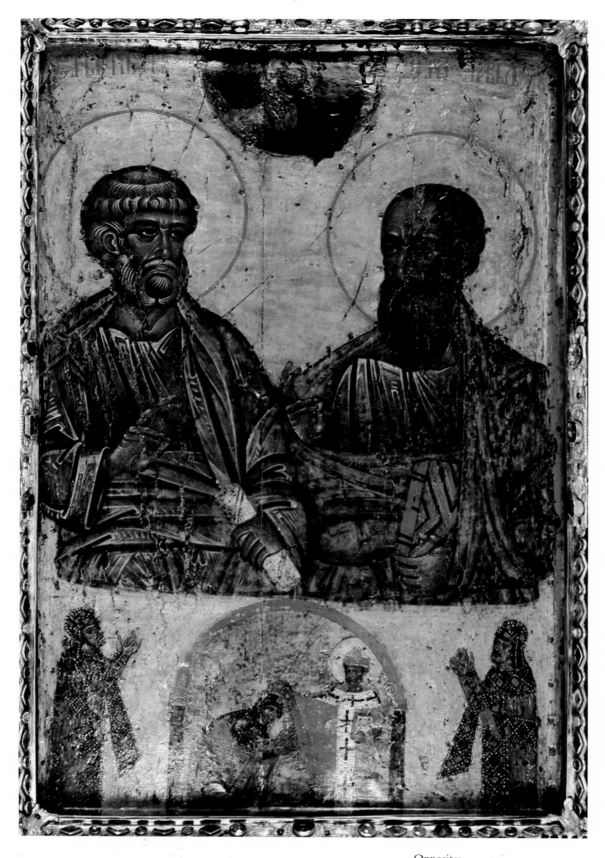

Apostles Peter and Paul with Serbian Kings as donors
Serbian painter
Tempera on wood, 75.5 x 51 cm. (29 ¾ x 20 in.) ; end
of thirteenth century; Treasury of St. Peter, Rome.

Opposite:
*St. Nicholas with Donors, Serbian King Stephen III
Dečanski and His Wife*
Serbian painter
Tempera on wood, chasing; 187 x 132 cm. (73⅝ x 52
in.); 1321–31; crypt of the Church of St. Nicholas,
Bari.

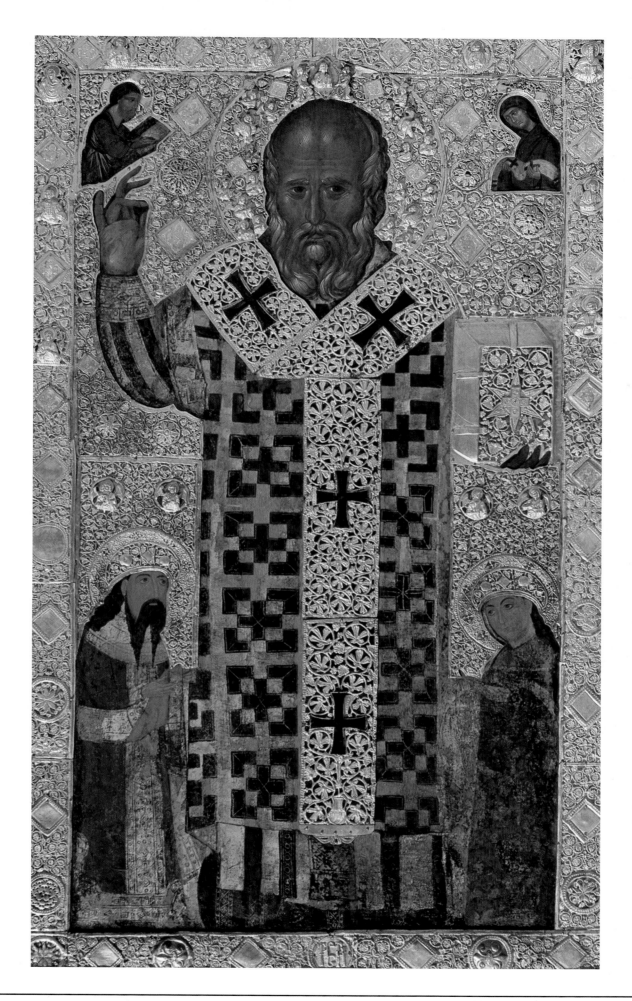

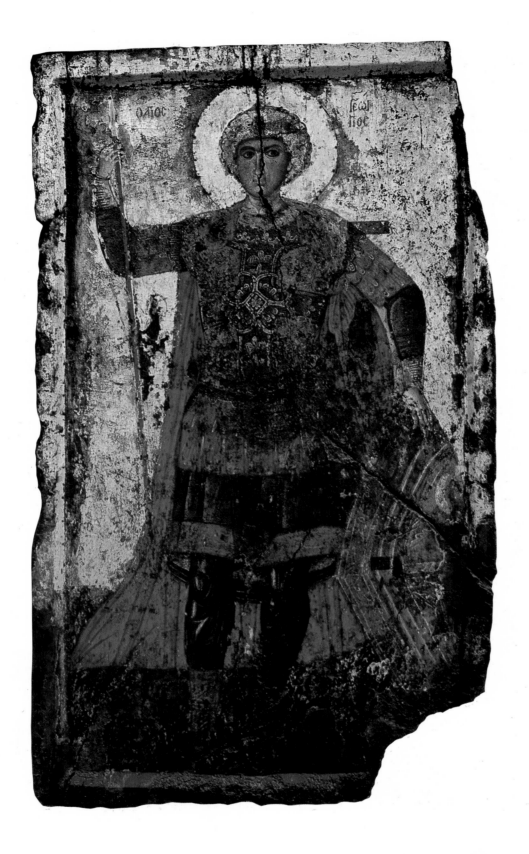

St. George
Painter Jovan (John) working at Ohrid and in
western Macedonia
Tempera on wood, 145 x 86 cm. (57⅛ x 33⅞ in.);
1266–67; Church of St. George, Struga, Macedonia.

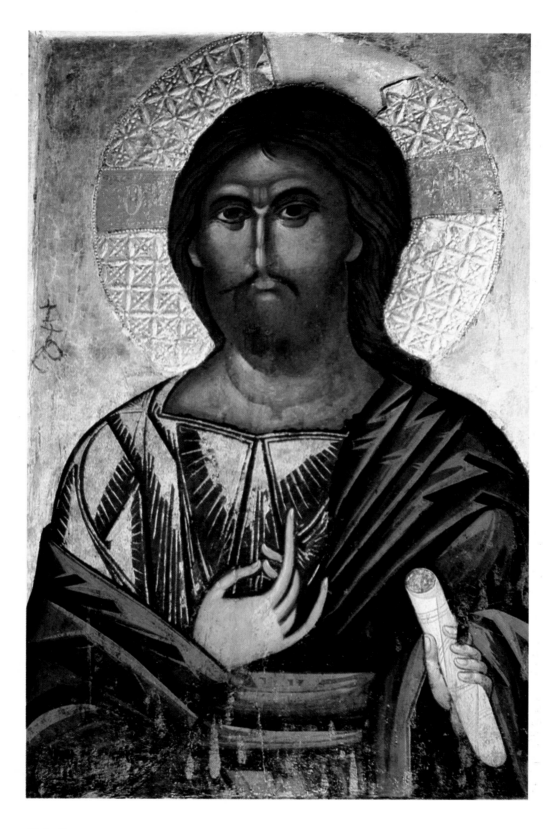

Christ Pantocrator
Greek painter working at Ohrid for Archbishop
Constantine Cavasilas
Tempera on wood, 135 x 73 cm. (53⅛ x 28¾ in.);
1262–63; gallery of icons in the Church of St. Clement,
Ohrid, Macedonia.

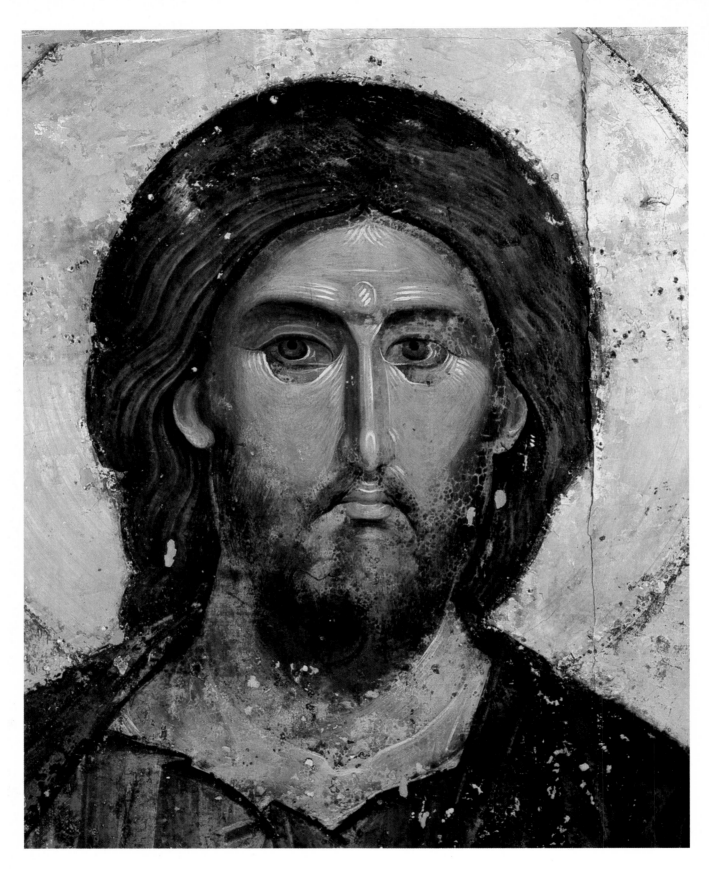

Christor the Savior
An unknown artist working at Chilandari
Tempera on wood, total measurement 120 x 90 cm.
(47¼ x 35⅜ in.); c. 1360–70; Chilandari Monastery,
Mount Athos.

Opposite:
Virgin with Child
Unknown artist working at Chilandari
Tempera on wood (the icon is damaged and without
edges); c. 1360–70; Chilandari Monastery, Mount
Athos.

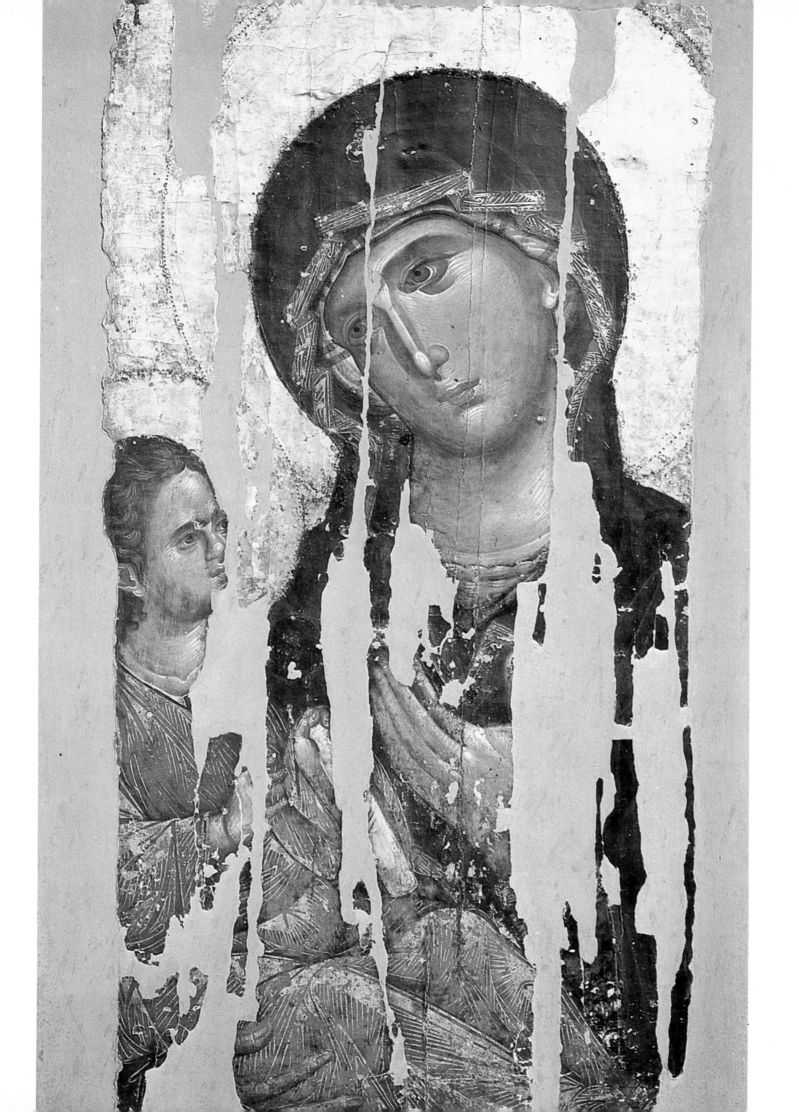

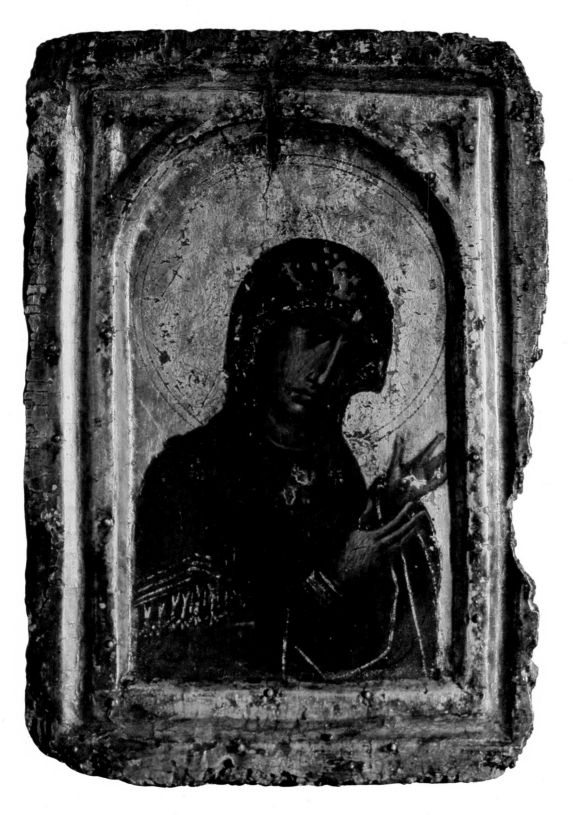

Virgin Paraclesis
Probably a Greek artist working at Ohrid
Left wing of a diptych; tempera on wood, 22.5 x 15
cm. (8⅞ x 5⅞ in.); St. Sophia, Ohrid, thirteenth
century; gallery of icons in the Church of St. Clement,
Ohrid, Macedonia.

Opposite:
Crucifixion
Greek artist working on the Adriatic coast
Tempera on wood, 136 x 80 cm. (53½ x 31½ in.);
Orthodox Church, Senj, Croatia, end of thirteenth
century; Historical Museum of Croatia, Zagreb.

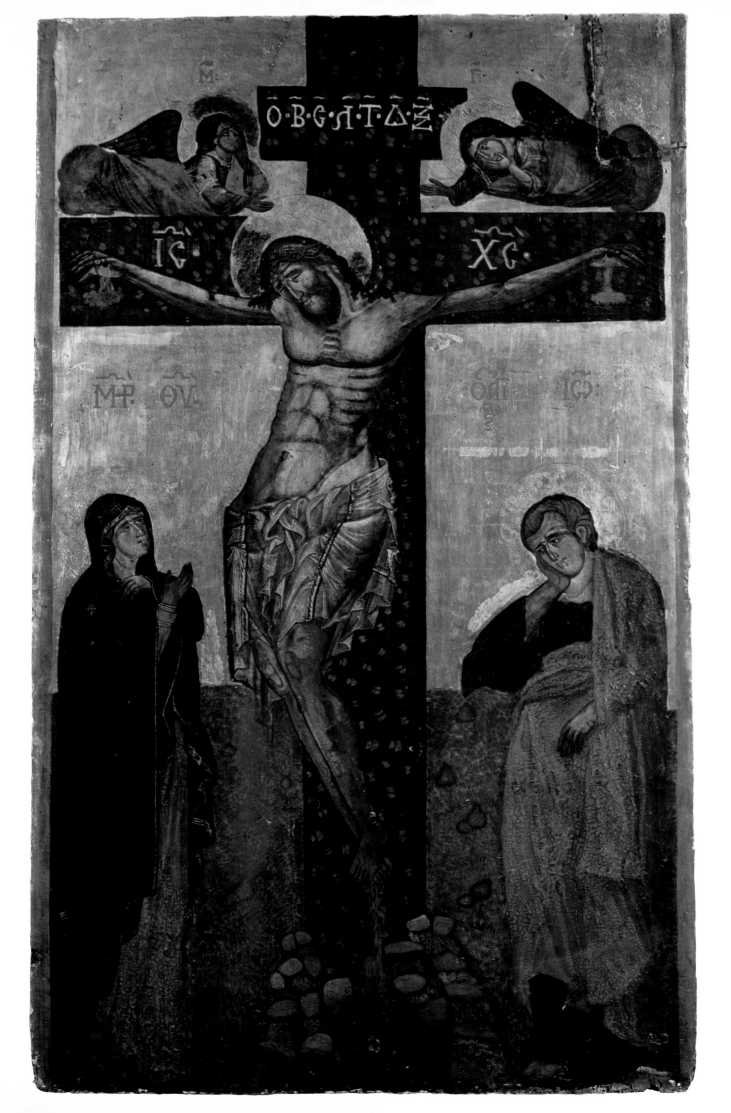

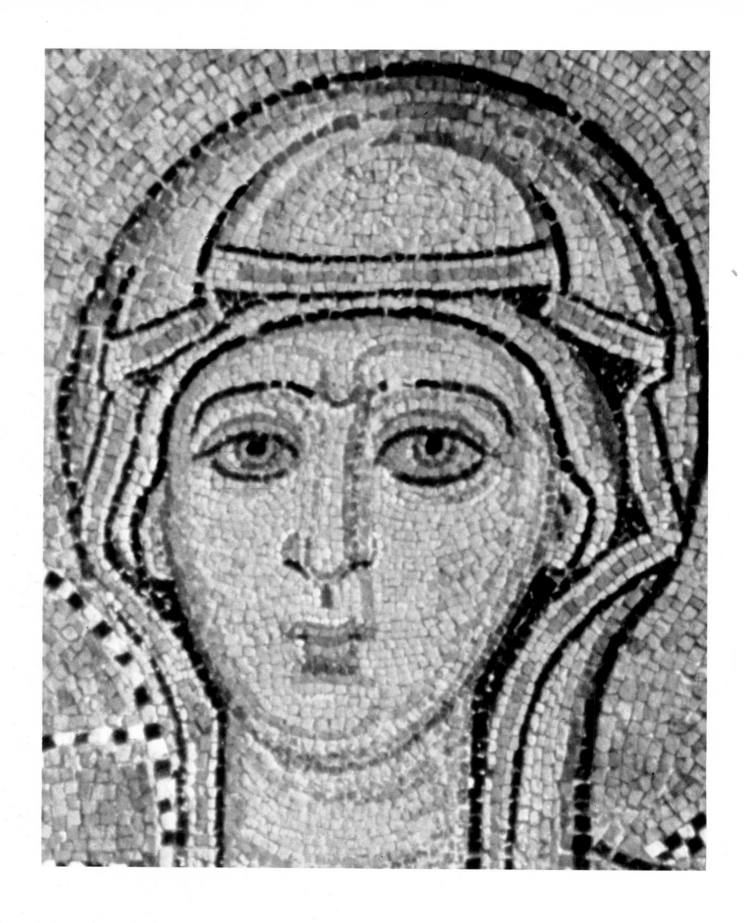

Virgin with Child
Detail: Head of the Virgin

Opposite:
Christ and *Virgin with Child*
Mosaics; Despotate of Epiros, 1285; Church of the
Porta Panaghia, Thessaly.

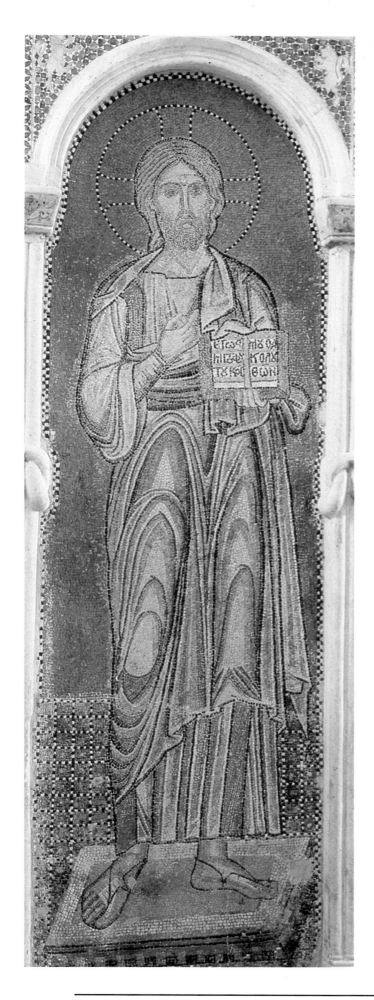
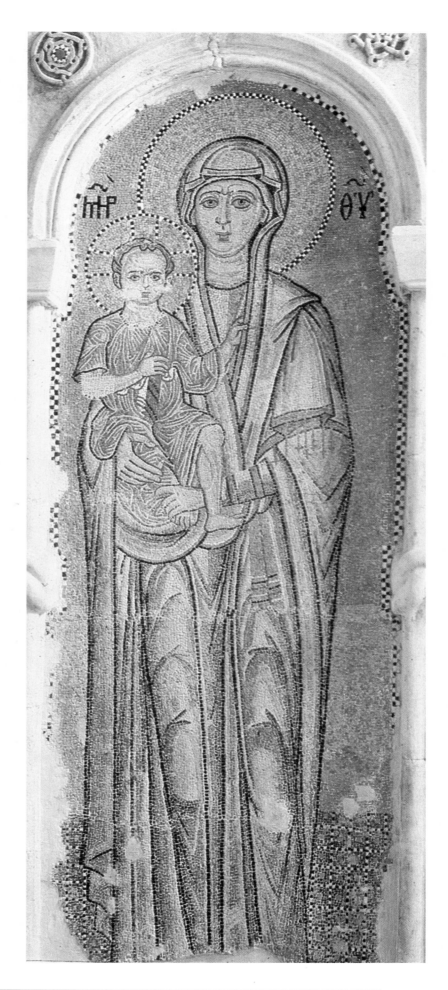

Above left:
St. Barbara
Fresco; central Greece, beginning of
fourteenth century; Church of St.
Thekla, Euboea. (unpublished)

Left:
St. Theodore Tiron
Fresco; central Greece, 1296 (?); Church
of the Transfiguration, Pyrghi, Euboea.

St. Nicholas
Theodore the painter
Fresco; southern Greece, c. 1200; Church of St. Sophia,
island of Cythera.

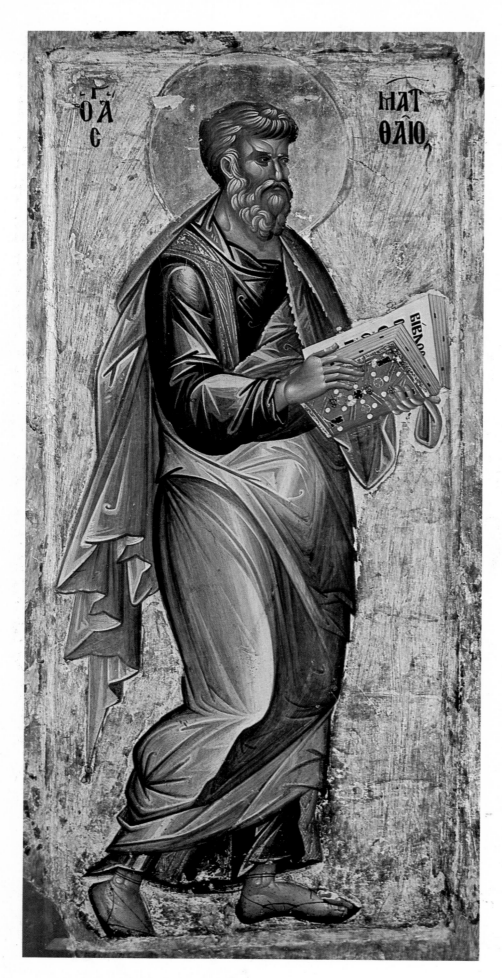

Left:
Evangelist Matthew
Greek painter working at Ohrid
Tempera on wood, 106 x 56.5 cm.
(41¾ x 22¼ in.); c. 1300; gallery of
icons in the Church of St. Clement,
Ohrid, Macedonia.

Opposite:
Ascension
Probably Michael Astrapas or
Eutychios, Thessalonikan painters
working at Ohrid
Tempera on wood, 39.5 x 29 cm. (15½
x 11⅜ in.); Church of the Virgin
Peribleptos, now of St. Clement
(decorated in 1295), c. 1300; gallery of
icons in the Church of St. Clement,
Ohrid, Macedonia.

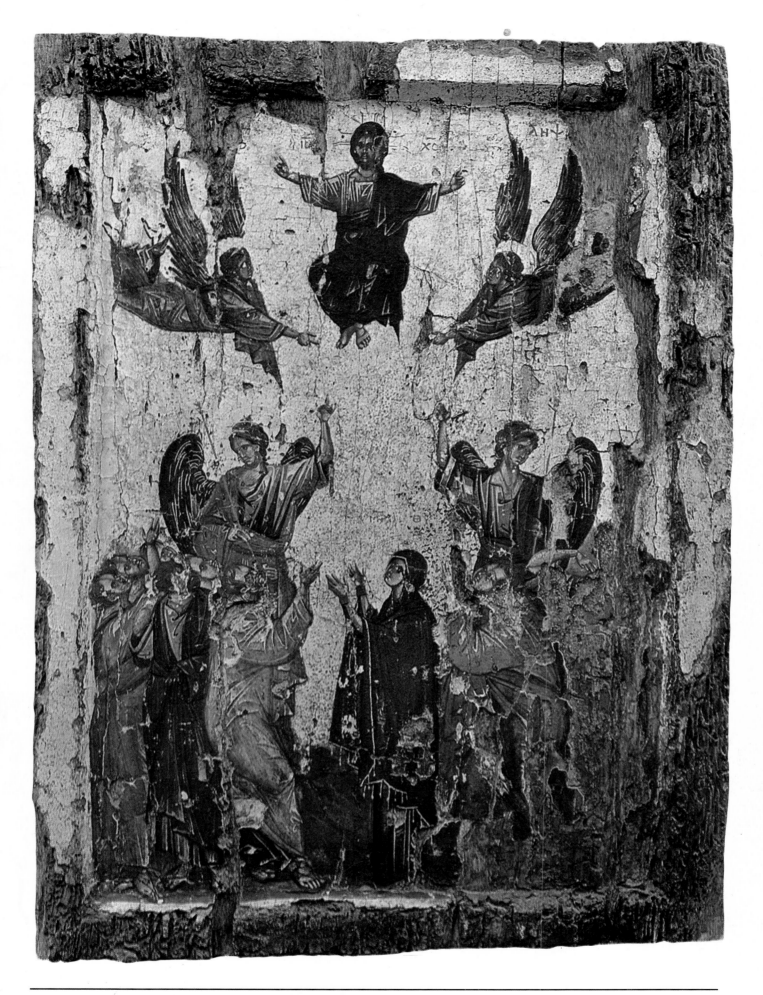

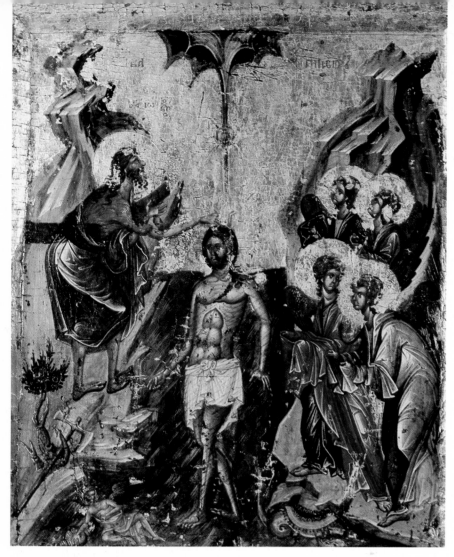

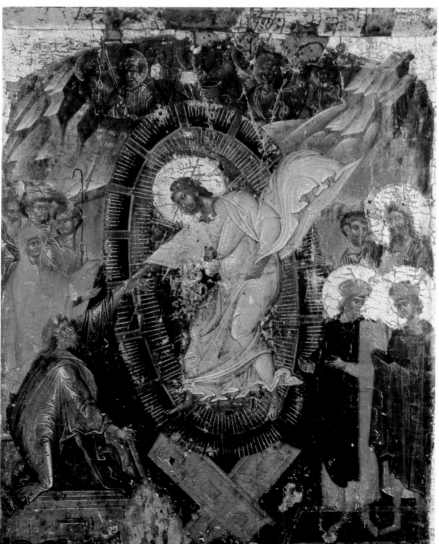

Above left:
Baptism of Christ
Greek painter working at Ohrid
Tempera on wood, 47 x 38 cm. (18½ x
15 in.); Church of the Virgin
Peribleptos, c. 1300; gallery of icons in
the Church of St. Clement, Ohrid,
Macedonia.

Left:
Harrowing of Hell
Greek painter working at Ohrid
Tempera on wood, 46.5 x 38.5 cm.
(18¼ x 15⅛ in.); Church of the Virgin
Peribleptos, c. 1300; gallery of icons in
the Church of St. Clement, Ohrid,
Macedonia.

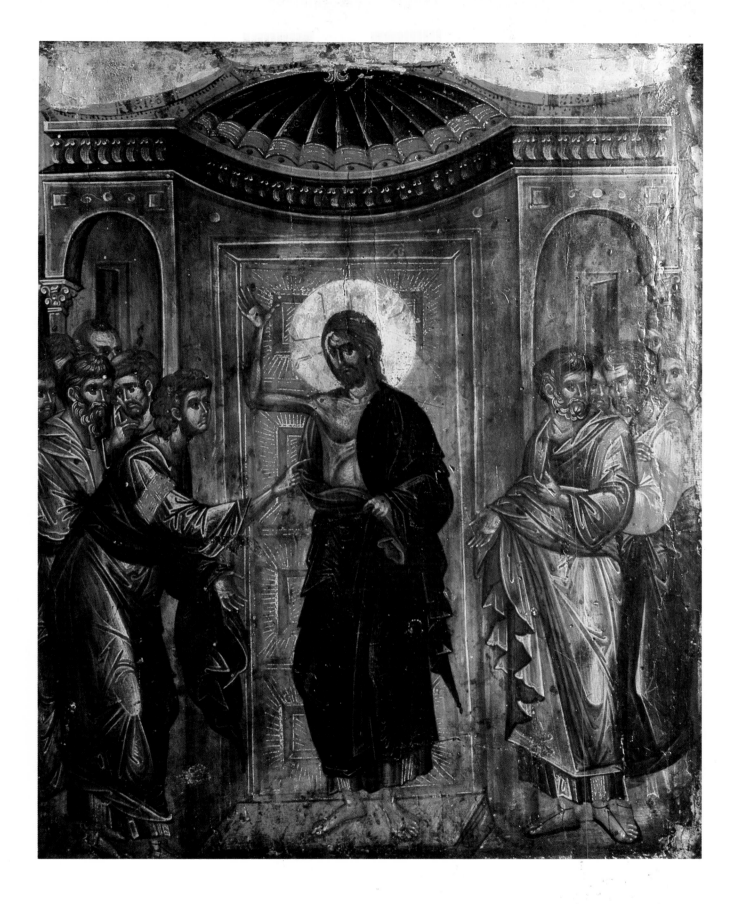

Incredulity of Thomas
Greek painter working at Ohrid
Tempera on wood, 46 x 38.5 cm. (18⅛ x 15⅛ in.);
Church of the Virgin Peribleptos, c. 1300; gallery of
icons in the Church of St. Clement, Ohrid, Macedonia.

Nativity of Christ
Unknown painter working at Ohrid
Tempera on wood, 44.5 x 17.3 cm. (17½ x 6¾ in.);
Ohrid, c. 1300; left half, in the National Museum,
Belgrade; right half, in the Gallery of Art, Skoplje.

Opposite below left:
Nativity of Christ
Detail: Joseph thinking
Unknown painter working at Ohrid

Right:
Baptism of Christ
Unknown painter working in Serbia
Tempera on wood, 40.5 x 32.5 cm. (16
x 12¾ in.); provenance uncertain, c.
1300; National Museum, Belgrade.

Below right:
Baptism of Christ
Detail: Personification of the spring
Unknown painter working in Serbia

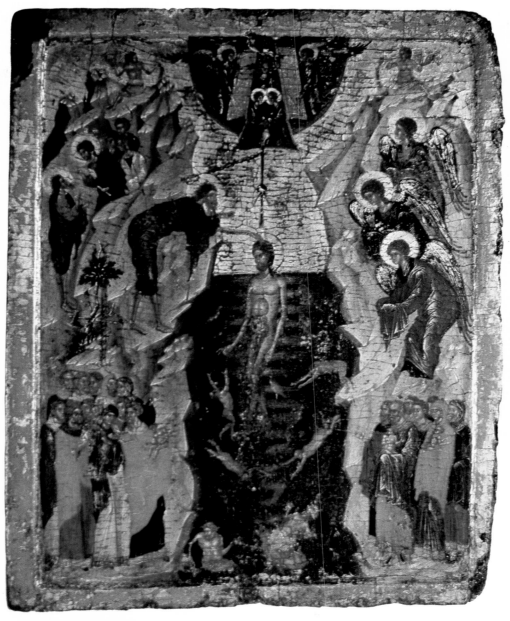

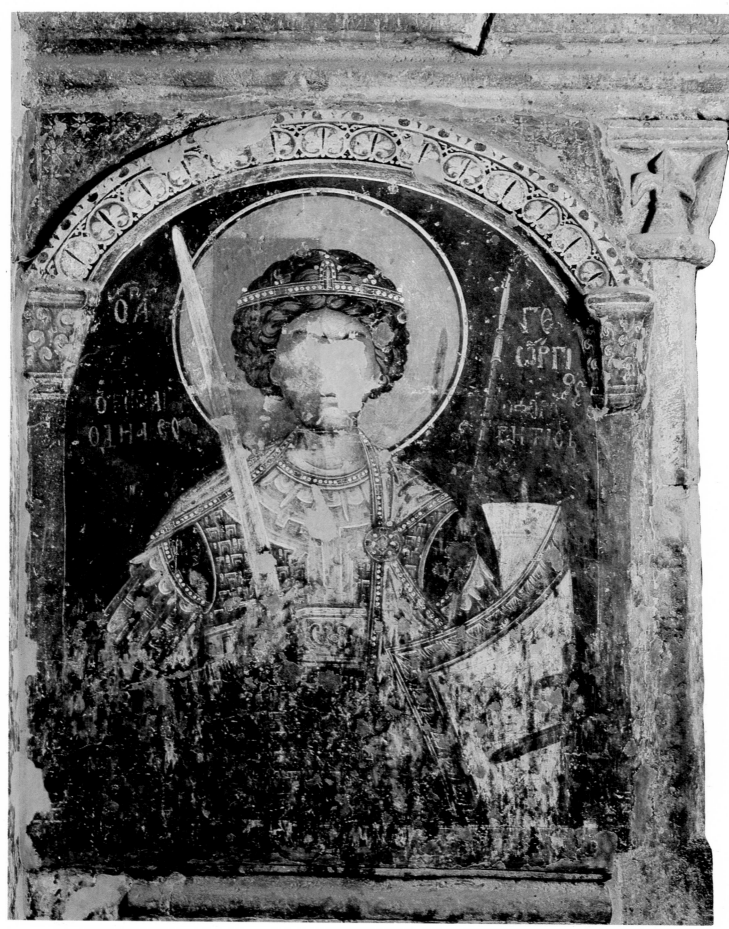

St. George the Tropaiophoros and Diassoritis
Thessalonikan painters Michael Astrapas and Eutychios working in Serbia
Left wing of the altar screen; fresco; 1316–18; Church of St. George, Staro
Nagoričino near Kumanovo, Macedonia.

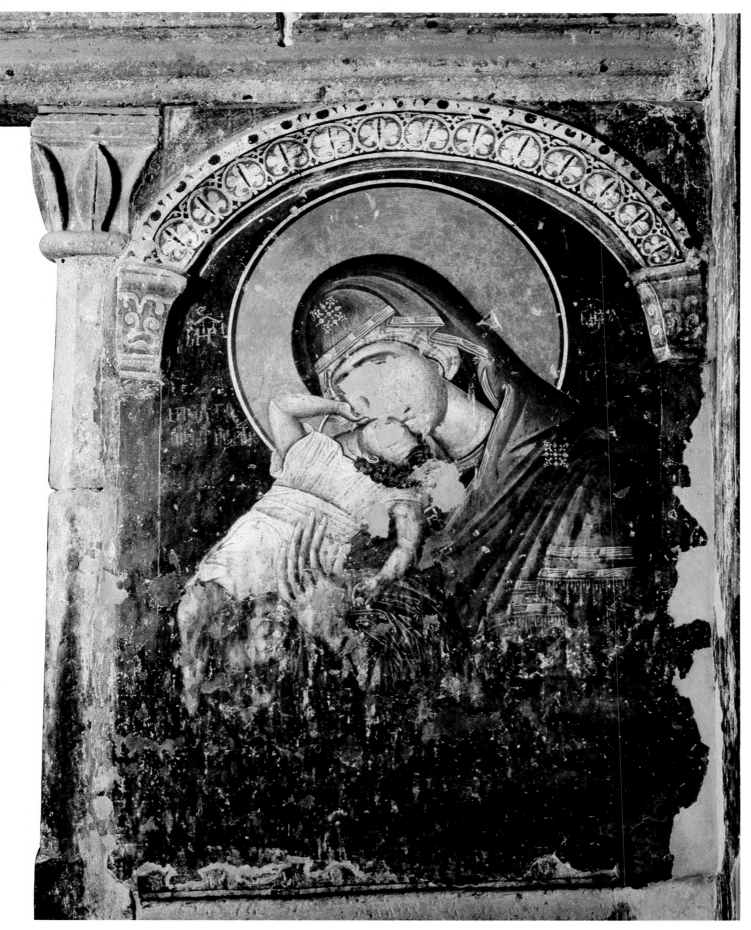

Virgin Pelagonitissa
Thessalonikan painters Michael Astrapas and Eutychios working in Serbia
Right wing of the altar screen; fresco; 1316–18; Church of St. George,
Staro Nagoričino near Kumanovo, Macedonia.

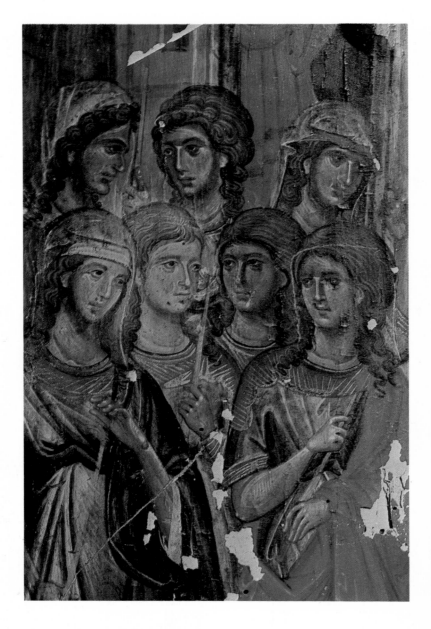

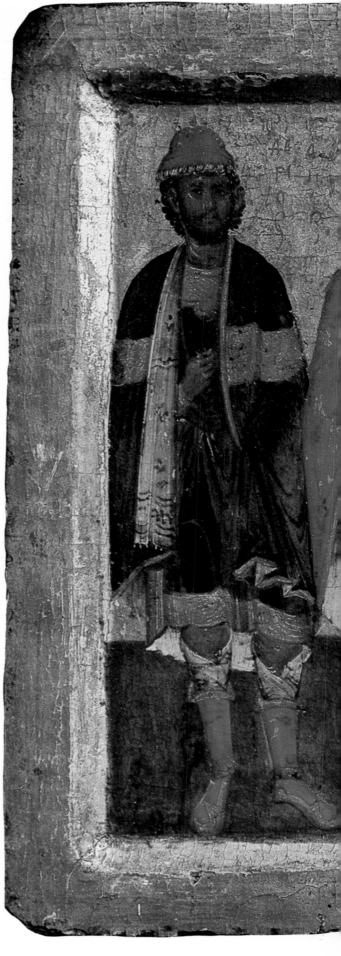

Above:
Presentation of the Virgin in the Temple
Detail: Maidens
Serbian painter working at Chilandari
Tempera on wood, total measurement 109 × 87 cm.
(42⅞ × 34¼ in.); beginning of fourteenth century;
Chilandari Monastery, Mount Athos.

Right:
Martyrs Mardarios, Eugenios, Eustathios, Auxentios, and Orestios
Greek painter working at Chilandari
Tempera on wood, 42 × 33 cm. (16½ × 13 in.);
1350–1400; Chilandari Monastery, Mount Athos.

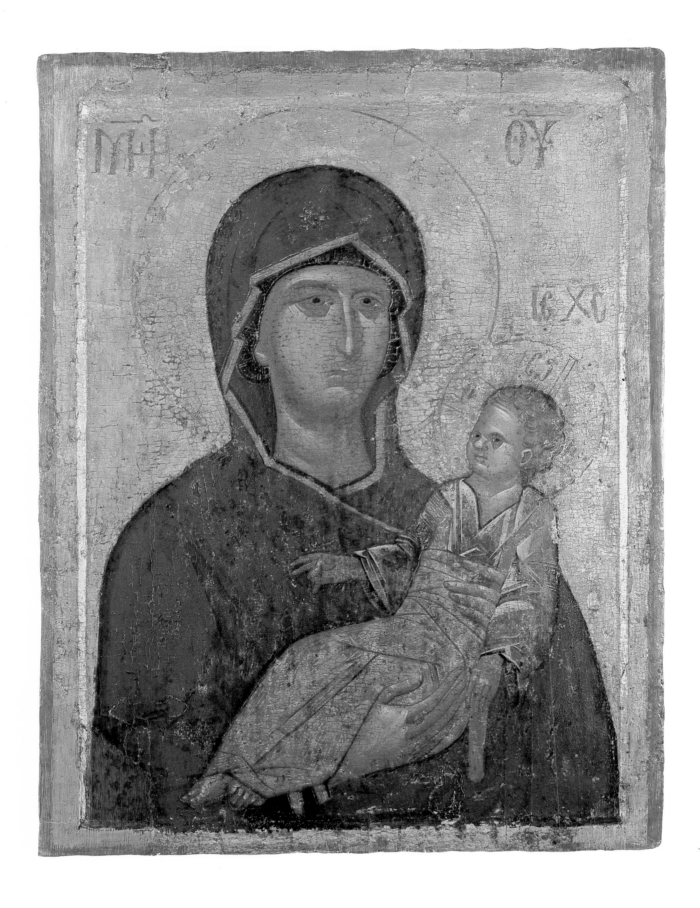

Virgin with Child
Wood, canvas, egg tempera; 85 × 65 cm. (33½ × 25⅝ in.);
formerly in Thessalonike, 1300–1310; Byzantine
Museum, Athens.

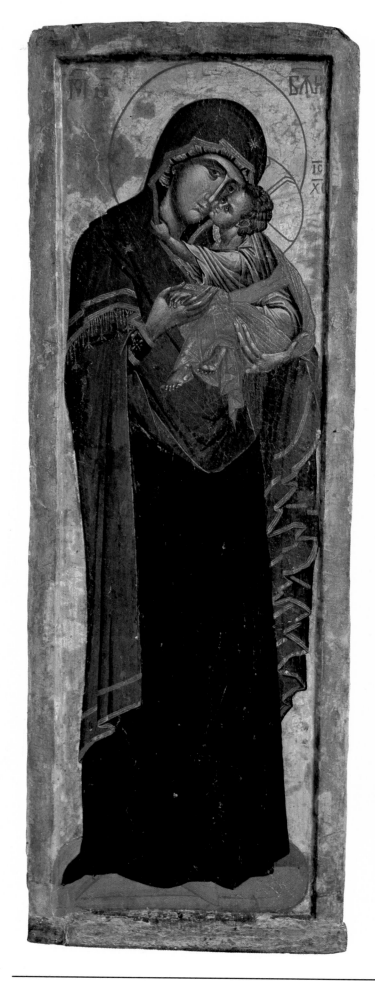
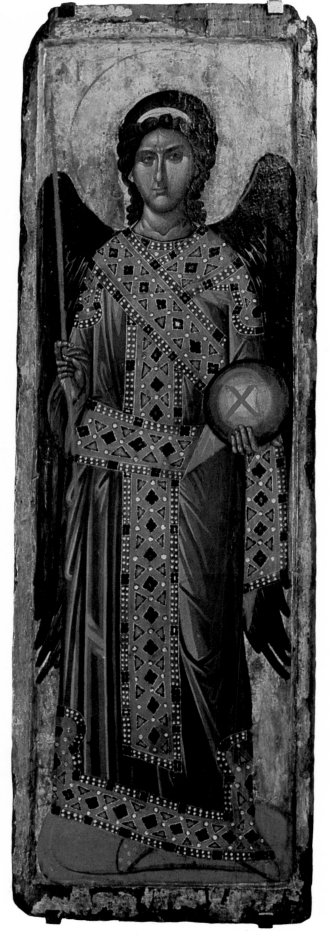

Opposite left:
Virgin with Child
Serbian painter working at Dečani
Tempera on wood, 164.5 x 56 cm.
(64¾ x 22 in.); c. 1350; altar screen of
the catholicon, Monastery of Dečani,
Serbia.

Opposite right:
Archangel Gabriel
Serbian painter working at Dečani
Tempera on wood, 137 x 50 cm. (54 x
19¾ in.); c. 1530; altar screen of the
catholicon, Monastery of Dečani,
Serbia.

Below:
Archangel Gabriel
Detail: Sphaira with the sign of Christ
Serbian painter working at Dečani

Right:
*Virgin with Three Hands (Tricheiroussa)
and Christ*
Serbian painter working at Karan
Fresco; Karan, 1342; on the altar screen
of the church dedicated to the Virgin
at Karan, Serbia.

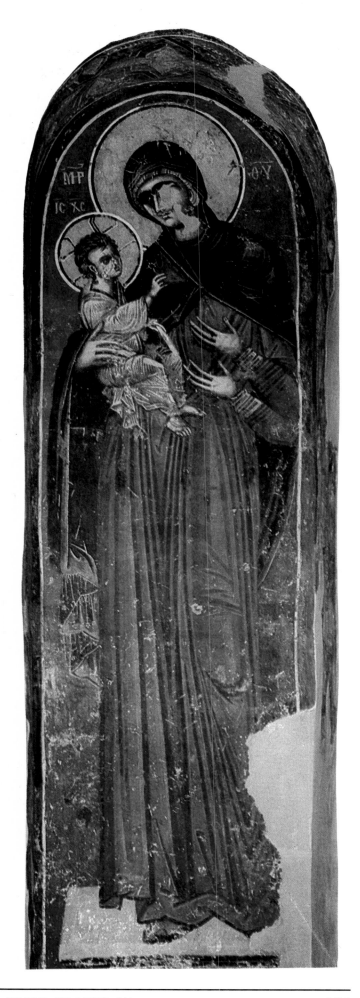

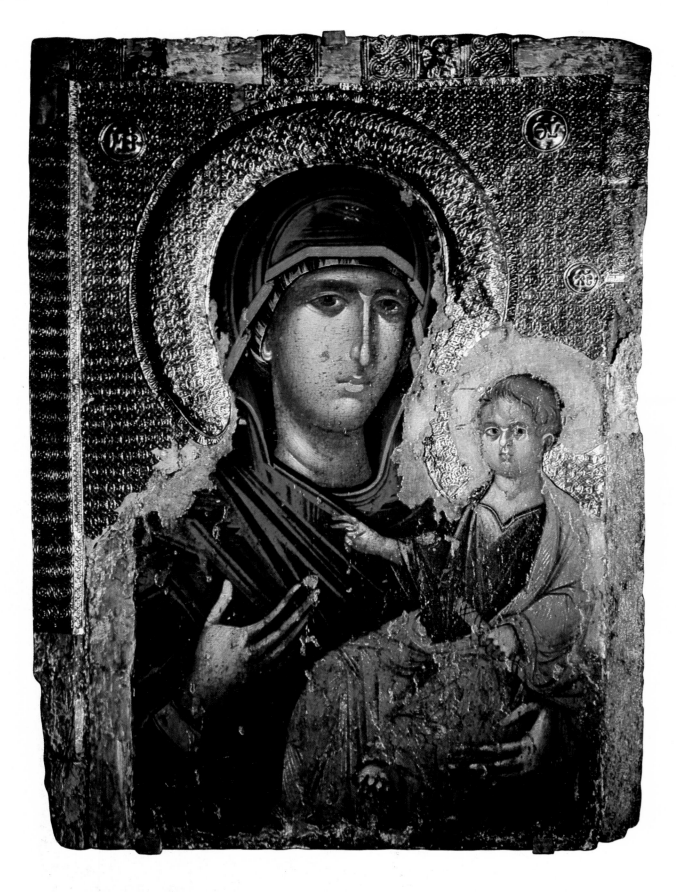

Virgin Hodegetria and Child
Greek painter
Tempera on wood, silver gilt; 99 x 72.5 cm. (39 x 28½ in.); fourteenth century; National Museum, Belgrade.

Opposite:
Virgin with Child
Tempera on wood, 119 x 91 cm. (46⅞ x 35⅞ in.); Thessalonike, 1400–1410; Church of St. Nicholas Orphanos, Thessalonike.

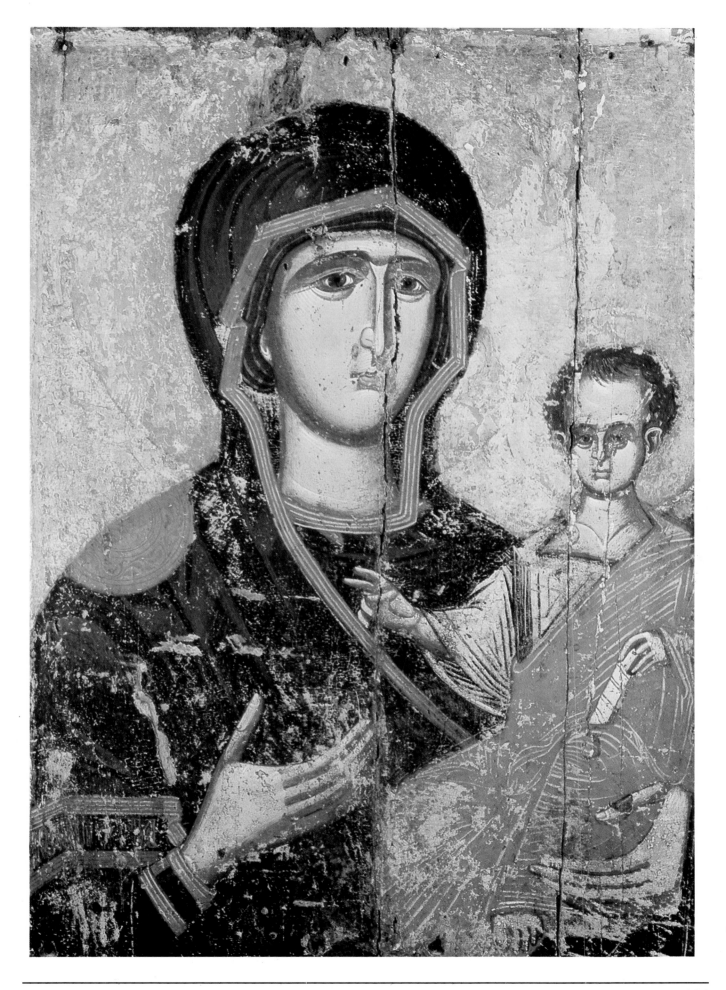

Meeting of Joachim and Anne, the Virgin's Parents
Bilateral icon (reverse)
Serbian painter
Tempera on wood, 39 x 20 cm. (15⅜ x 7⅞ in.);
Ljubižda, near Prizren, Kosovo, Serbia, mid-fourteenth
century; National Museum, Belgrade.

Annunciation
Serbian painter
Tempera on wood, 39 x 20 cm. (15⅜ x 7⅞ in.);
Ljubižda, near Prizren, Kosovo, Serbia, mid-fourteenth
century; National Museum, Belgrade.

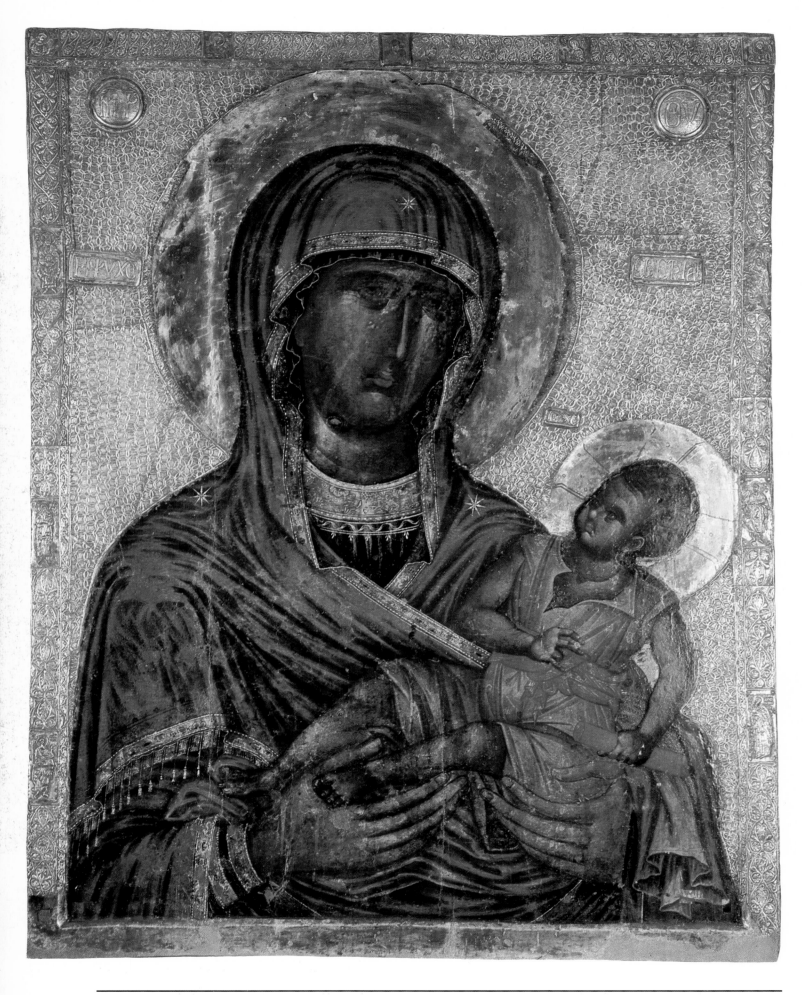

186

Opposite:
Virgin Psychosostria with Child and the Portrait of the Donor, the Serbian Archbishop of Ohrid, Nikola (on the revetment)
An unknown painter working at Ohrid
Tempera on wood, silver gilt; 158 x 121.5 cm. (62¼ x 47⅞ in.); altar screen of the Church of the Virgin Peribleptos, now of St. Clement, mid-fourteenth century; gallery of icons in the Church of St. Clement, Ohrid, Macedonia.

Above left:
Virgin Hodegetria with Child
Serbian painter
Tempera on wood, 74.2 × 44.5 cm. (29¼ × 17½ in.);
mid-fourteenth century; Church of St. Nicholas,
Prizren.

Above right:
Virgin with Child
Serbian painter
Tempera on wood, 122 × 80 cm. (48 × 31½ in.);
Church of St. George, Prizren, Kosovo, Serbia,
mid-fourteenth century; Church of St. George, Prizren.

Evangelist Matthew
Greek painter working at Chilandari
Tempera on wood, approx. 100 × 69 cm. (39⅜ × 27⅛
in.); c. 1360; *Megali Deesis* of the altar screen in the
catholicon, Chilandari Monastery, Mount Athos.

Ο Α ΛΟΥΚΑΣ

Evangelist Luke
Greek painter working at Chilandari
Tempera on wood, approx. 100 × 73 cm. (39⅜ × 28¾
in.); c. 1360; *Megali Deesis* of the altar screen in the
catholicon, Chilandari Monastery, Mount Athos.

Evangelist Matthew
Detail: Head
Greek painter working at Chilandari

Opposite:
Archangel Gabriel
Greek painter working at Chilandari
Tempera on wood, 100 × 64 cm. (39⅜ × 25¼ in.)
(approx.); c. 1360; Megali Deesis of the altar screen
in the catholicon, Chilandari Monastery, Mount
Athos.

Christ the Savior and Giver of Life
Metropolitan Jovan, the painter
Tempera on wood, 131 x 88.5 cm. (51⅝ x 34⅞ in.); Monastery of Zrze
near Prilep, Macedonia, 1393–94; Art Gallery, Skoplje.

Christ, the "Wisdom of God"
Wood, canvas, tempera; 155 × 99 cm. (61 × 39 in.);
formerly at Thessalonike, c. 1360; Byzantine Museum,
Athens.

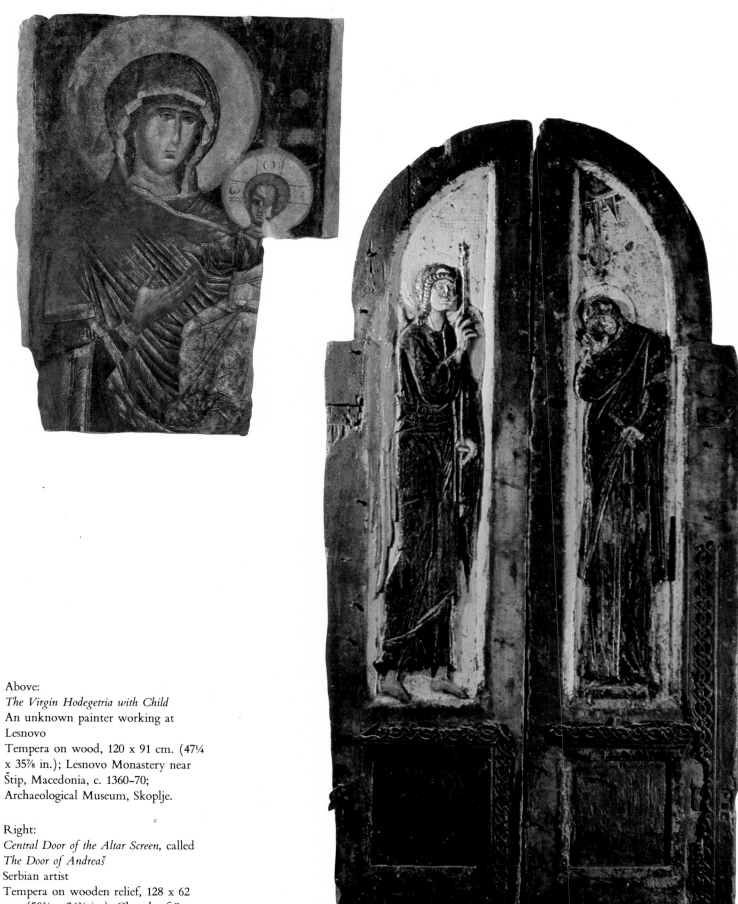

Above:
The Virgin Hodegetria with Child
An unknown painter working at
Lesnovo
Tempera on wood, 120 x 91 cm. (47¼
x 35⅞ in.); Lesnovo Monastery near
Štip, Macedonia, c. 1360–70;
Archaeological Museum, Skoplje.

Right:
Central Door of the Altar Screen, called
The Door of Andreaš
Serbian artist
Tempera on wooden relief, 128 x 62
cm. (50⅜ x 24⅜ in.); Church of St.
Nicholas at Siševo near Skoplje, c.
1360–70; National Museum, Belgrade.

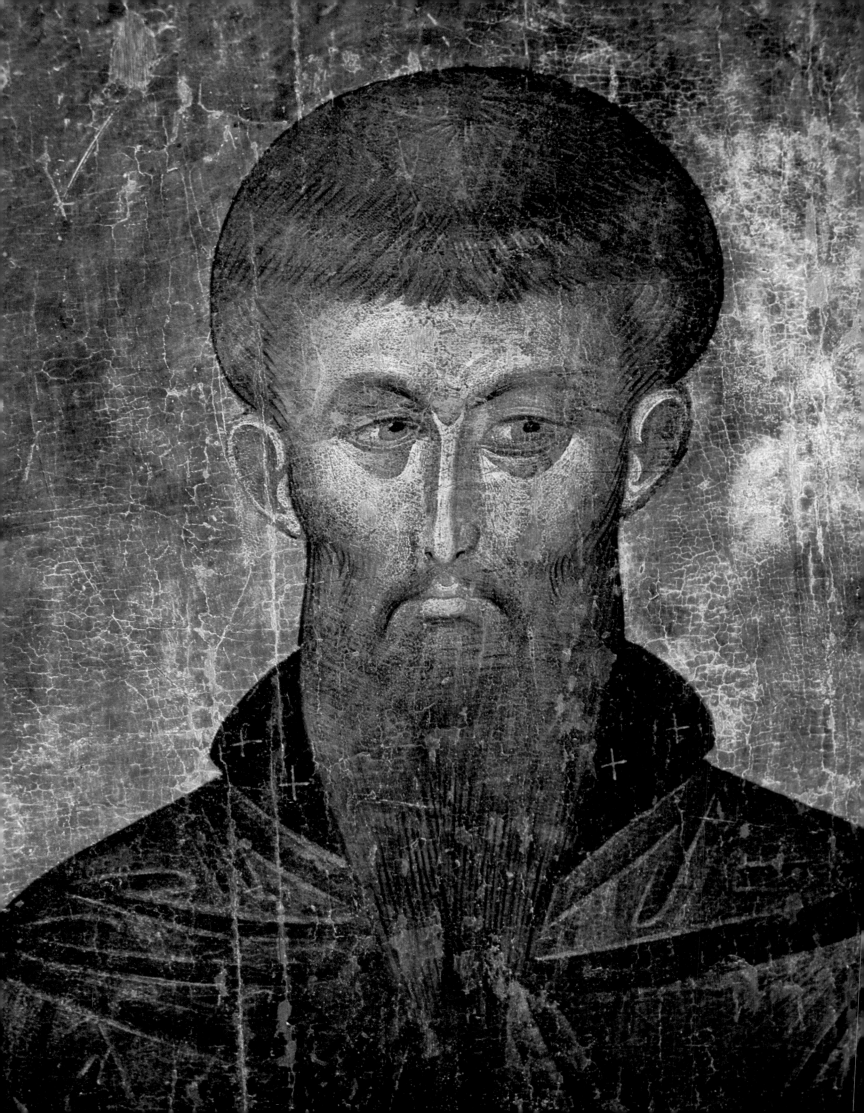

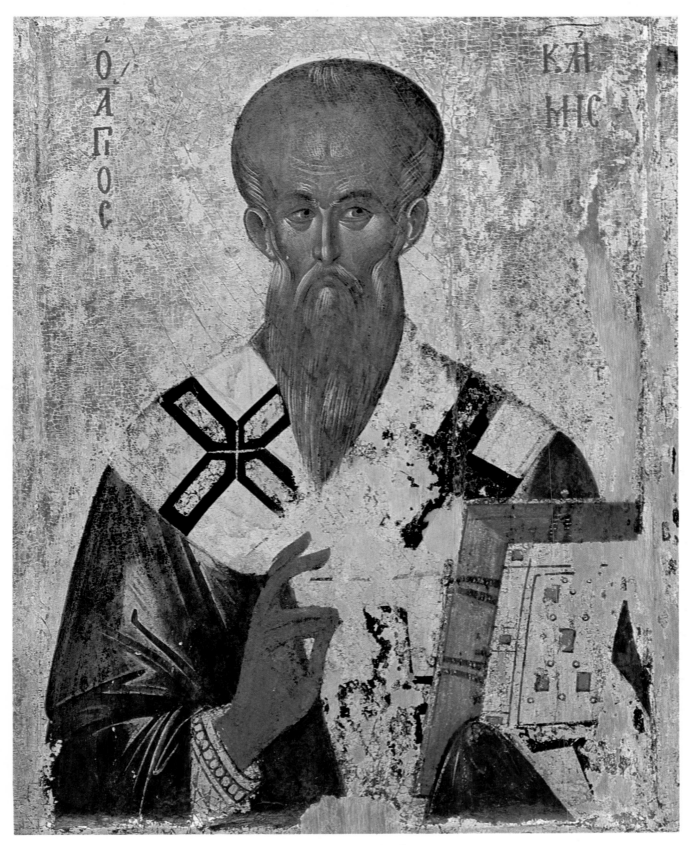

Ο ΑΓΙΟΣ ΚΛΗΜΗΣ

Opposite:

St. Naoum of Ohrid, Detail
Greek painter working at Ohrid
Bilateral icon (reverse); tempera on wood, total
measurement 86 x 65.5 cm. (33⅞ x 25¾ in.); Church
of the Virgin Peribleptos, probably beginning of
fifteenth century; gallery of icons in the Church of St.
Clement, Ohrid, Macedonia.

St. Clement of Ohrid
Greek painter working at Ohrid
Bilateral icon; tempera on wood, 86 x 65.5 cm. (33⅞ x
25¾ in.); Church of the Virgin Peribleptos, probably
beginning of fifteenth century; gallery of icons in the
Church of St. Clement, Ohrid, Macedonia.

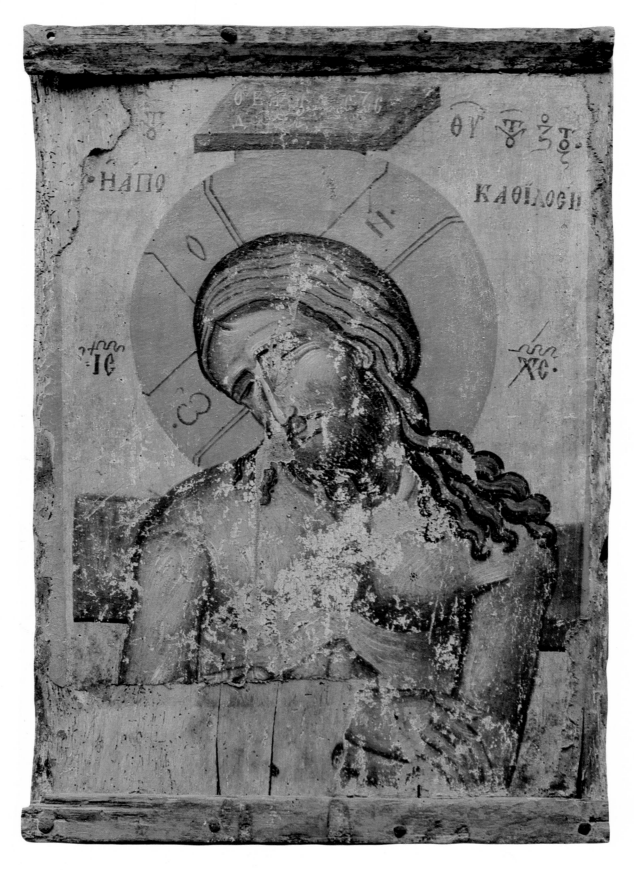

Man of Sorrow
Greek painter working at Poganovo
Tempera on wood, 88 x 61 cm. (34⅝ x 24 in.);
Monastery of St. John, Poganovo, Serbia, probably end
of fourteenth century; Museum of Religious
Antiquities, Nis, Serbia.

Opposite:
Virgin Pelagonitissa with Child, Detail
Makarije Hieromonachos, the painter
Tempera on wood, 134 x 93.5 cm. (52¾ x 36¾ in.);
Monastery of Zrze, near Prilep, Macedonia, 1421–22;
Art Gallery, Skoplje.

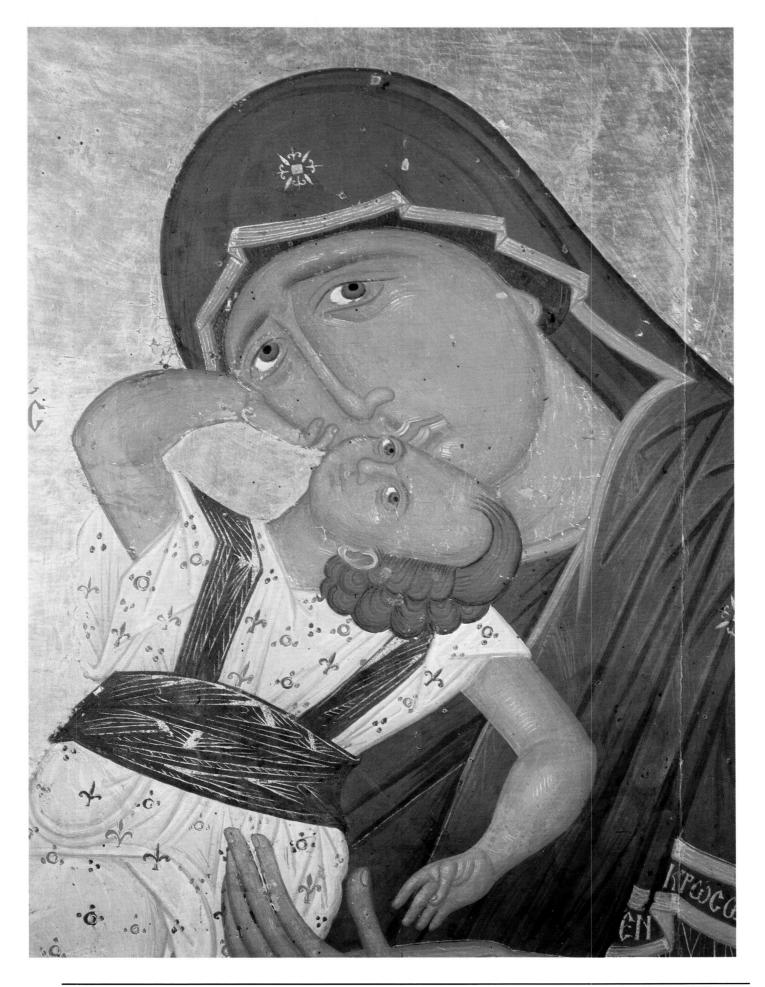

Serbian SS. Sava and Simeon Nemanja
Serbian painter
Tempera on wood, 32.5 x 25 cm. (12¾ x 9⅞ in.);
probably from Chilandari Monastery, fifteenth century;
National Museum, Belgrade.

Opposite:
St. Demetrius of Thessalonik
Greek painter
Tempera on wood, 34.3 x 26.5 cm. (13½ x 10⅜ in.);
probably from Chilandari Monastery, beginning of
fifteenth century; Museum of Applied Arts, Belgrade.

THE ICONS OF THE PERIOD OF THE CRUSADES

Kurt Weitzmann

THE ICONS produced by Latin artists in the Crusader Kingdom became widely known only when the Michigan-Princeton-Alexandria Expedition to Mount Sinai (1956–65) discovered over 120 of these images among the more than 2,000 owned by St. Catherine's Monastery. Outside the monastery a few more such "Crusader icons" have been recognized, but it is on the St. Catherine collection that our study will center. The discovery is so recent that many of the questions it raised are as yet unanswered; our observations must therefore be considered preliminary.

St. Catherine's always had ecclesiastical and cultural ties with Jerusalem. In the twelfth century, Western-style icons came only sporadically to the monastery as gifts; but thirteenth-century examples have been found there in such quantity that we must assume the presence of Latin painters in the monastery itself, for three reasons. First, there are large, coherent groups of icons, which are the products of individual painters and their assistants and pupils. This precludes the possibility that they came as single gifts and suggests the existence of at least temporarily established ateliers in the area. Secondly, there are two iconostasis beams (pp. 222, 223, 229, and 230) which, because of their precise measurements, must have required the actual presence of the artists. Finally, many of the icons have an explicitly Sinaitic iconography (pp. 211, 217, 221, 228, and 235), which presupposes an intimate knowledge of the monastery's many chapels and the holy sites (loci sancti) in the neighborhood.

THE EARLIEST CRUSADER ICON we have been able to identify represents *Christ in Majesty,* blessing and holding an open book on which no text is written—perhaps revealing the artist's indecision whether to inscribe it in Latin or Greek. The style recalls that of the English Channel region. The painter may have been French but was more likely English, considering the similarities between the icon and English miniatures of the same period, the first half of the twelfth century. It is hard to decide whether we are dealing with an import, or whether an English artist

executed this panel in Palestine. The natural proportions of the figure compared to the over-elongation seen in English art of the time make it rather likely that this icon was indeed painted in Palestine, perhaps Jerusalem.

A key work surely made in Jerusalem is a psalter manuscript now in London, produced between 1131 and 1143 for Queen Melisende. Here the attribution problem is the opposite: the Byzantine style is imitated to such a degree that the artist's nationality is difficult to discern. At Sinai there is a stylistically similar icon of about the same period, with a cycle of the Twelve Feasts, executed by an artist undoubtedly Latin but of unknown nationality.

We have assigned to the end of the twelfth century a Crusader icon with six saints arranged in two rows (p. 209). In Byzantium, for the sake of the hierarchic order, the upper row of such a work would contain divine beings, the Deesis (cf. p. 33) or the Virgin between angels; but the Western artist fills both rows with saints, the more important ones in the upper tier. Most prominent is St. James the Greater in the upper center, who takes precedence over St. Paul on his right. This placement may be an indication that the icon was made in Jerusalem, of which St. James, according to tradition, was the first bishop. If so, it may well have been produced before 1187 when the city fell into the hands of Saladin.

On James' left stands Stephen, who was martyred in Jerusalem. Thus, the saints in the upper row point to the Holy Land, while those of the lower are thoroughly Western: St. Martin of Tours in the center is flanked by St. Lawrence on his right and St. Leonard of Limoges, the patron of prisoners characterized by a pair of manacles, on his left (p. 210). The latter two saints are French, but their cults had spread into other Western countries. We believe the artist came from southern Italy, perhaps Calabria, but this must remain an open question. What is significant is his inclusion of saints who are associated with Jerusalem while his style is essentially Western.

It was not until the thirteenth century that Western artists expressed a serious desire to absorb the Byzantine style with sympathy, but once this happened, they sometimes reached the point where it becomes difficult to distinguish them as "Crusader" or "Byzantine." Flourishing ateliers were established by French and Italian artists. The attribution of some icons to French masters is based primarily on similarities to French miniatures produced in Acre, the capital of the Latin Kingdom after the fall of Jerusalem in 1244; for example, a Missal in Perugia, and in the Arsenal Library in Paris a Bible that was made for St. Louis while he was in the Holy Land from 1250 to 1254. An icon of the *Crucifixion* (p. 211) shows the same idiosyncratic gestures as the Crucifixion miniature of the Perugia Missal: the Virgin touching the corner of her mouth with her thumb (p. 214) and St. John touching his nose with his little finger. Most characteristic of the Acre miniatures and the icons related to them are the wide-open eyes with rolling eyeballs—a "trademark" of the French ateliers. The emotional pitch is far more intense than in a Byzantine *Crucifixion*, as can be seen in the weeping angels (p. 214).

The frame of the icon is filled with busts whose general arrangement is clearly inspired by a Grand Deesis, but the Latin artist took a liberty no Byzantine artist would have been permitted. The Deesis group at the top (Christ between the Virgin and St. John the Baptist) is flanked by Moses and Elijah, who take the place which Archangels occupy in the Orthodox scheme, obviously in order to make the icon a Sinaitic locus sanctus image. Then follow, in lateral pairs down the sides of the frame, Peter and Paul as the sole representatives of a full Apostolic collegium and, continuing in the correct hierarchical order, the soldier-saints George and Theodore; two of the Cappadocian church fathers, John Chrysostom and Basil; and the female saints Catherine (the patron saint of the monastery; p. 213) and Irene. Catherine wears the Byzantine imperial garment, the *loros,* and holds the imperial orb of Western tradition. Another Sinaitic reference is the placement of St. Simeon Stylites (p. 212), to whom a special chapel is dedicated in the basilica, at the center of the bottom, a very prominent position. Simeon is flanked by Paul of Thebes, and Onufrius (pp. 212–213), who lived in a cave not far from the monastery. In the corners are depicted Maximus the Confessor and St. Dometius. The artist's familiarity with the "personalities" associated with Sinai suggests that he probably came from Acre but actually worked, at least temporarily, in St. Catherine's.

Another important product of the French workshop is a pair of triptych wings in a style very close to that of the miniatures of the Arsenal Bible. The left wing shows at the top the *Coronation of the*

Virgin, a typical Western theme that was never accepted by the Byzantines. However, below this there is a representation of the *Koimesis,* the *Death of the Virgin* (pp. 215–216), which is in every detail Byzantine, even including the Greek version of the apocryphal story of Jephonias, who tried to overthrow the bier and was punished by an angel who cut off his hands. Again, the agitation of the mourning Apostles reflects the Byzantine tradition (cf. p. 26), while the Western element asserts itself in the humanized Christ, who holds the soul of the Virgin with affection.

The right wing is also organized so that the scene at the top, *Christ Among the Doctors,* reflects Western iconography, while the bottom, the *Lamentation,* follows Byzantine tradition. Christ, instead of sitting in the center of a semicircular presbyter bench amid the doctors, is placed between them and his humbly approaching parents, who are drawn into the scene to humanize the situation (for which we find significant parallels in the contemporary Parisian *Bibles moralisées*). In the *Lamentation* underneath, the painter has adhered more closely to the Byzantine tradition, but here also he makes a characteristic change. The Byzantine model showed Christ laid on a porphyry plaque, the "tombstone," which was a famous relic in Constantinople; here he is depicted in a strangely suspended manner, above an open tomb.

The stuccoed filigree in the background of this scene appears in many icons of the French group. However, the center of the triptych with a *Virgin Enthroned,* and the backs of the wings with *St. Nicholas* (p. 233) and *St. John the Baptist,* were executed by an Italian artist. Such a collaboration is quite understandable in St. Catherine's, where each of the painters is represented by a considerable number of other icons.

Our belief that this workshop was located in Sinai is reinforced by an icon that may actually have been painted by the same French hand. It depicts the Virgin holding the Christ Child suspended, rather than seated, and flanked by three saints (pp. 217–218). This is the type of the *Virgin of the Burning Bush,* though here as in other early representations the burning bush is absent. This Virgin, as is to be expected, occurs in many Sinai icons, and may be termed a locus sanctus image. Following proper Sinaitic iconography, the Virgin is flanked by Moses, who received the tablets of the law at Sinai, and Elijah, who was fed by a raven there. On the right

stands St. Nicholas, the most popular of all the church fathers, to whom a special chapel was dedicated at Sinai. As in all Crusader icons, Moses has a short, shaggy beard, a compromise between his clean-shaven appearance in Byzantine art (cf. p. 65) and his long beard in Western images.

The emotional expression in the faces of the Virgin and the three saints is typical of all the works of the French master and is much stressed also in the bust of the *Virgin Hodegetria,* a variant known as the Dexiokratousa in which she carries the Child on her right arm (p. 219). This is the same type as the Constantinopolitan mosaic at Sinai (cf. p. 64), which quite possibly was the inspiration for the Crusader icon. A comparison reveals clearly that the Western artist attempted to follow his model closely although he did not comprehend the Byzantine Virgin's aloofness. In the French icon the Virgin's head is more inclined, signifying a greater human attachment—a fundamentally different concept of the relationship between the divine and the human.

The normal type of the *Virgin Hodegetria,* full-length and holding the Child on her left arm, is depicted in another icon of the French atelier (p. 221). (The archetype of this Virgin was an image in the Monastery of the Hodegon, one of the holiest of icons. The palladium of the city of Constantinople, it was carried in processions and into battle. According to tradition, it was painted by St. Luke and sent from Jerusalem to Constantinople in the fifth century by the empress Eudocia.) Rendering the Virgin larger than the flanking saints and standing her on a footstool, the artist follows a well-established Byzantine hierarchical concept (cf. p. 45). His inclination toward greater emotionalism is conveyed by Christ's right arm, wrapped affectionately around the Virgin's neck. Flanking her are SS. Peter and Paul, who had a chapel within the walls of the monastery. Despite the artist's endeavor to follow closely a Byzantine model (cf. pp. 70 and 71), their firm stance, greater corporeality, and softly treated garments are signs of the realism evolving in Western art. The two outer saints are monks much venerated at Sinai: St. Euthymius and St. Anthony; to whom an important chapel is dedicated in the monastery. In the spandrels are depicted Moses receiving the tablets and Elijah being fed by a raven. Mount Horeb is portrayed more naturalistically than in Byzantine art, which rendered landscape by accumulated cubes of rocks. Once more the iconography reveals the painter's acquaintance with the

holy sites in the neighborhood of the monastery: a chapel had been built on the spot where the raven stands, two thirds of the way up to the peak of Djebel Musa.

There are other icons we would like to attribute to French artists, icons that do not belong to coherent groups. In one of them, *St. George and St. Theodore on Horseback* are depicted very much in the Byzantine manner (p. 220). The soulful glance of St. Theodore links this icon with the preceding group, but it was obviously made by a different master. The lances with pennants showing a red cross on white ground are a typical Crusader attribute. At the bottom kneels a donor figure, next to whom is a Greek inscription, "Pray for the servant of God, George of Paris"—a Frenchman, probably a pilgrim in the Holy Land, who commissioned the icon from a compatriot.

Of equal importance and even wider range are the icons executed by Italian masters. Their nationality is easy enough to determine by style, but when we try to distinguish localities, the difficulties begin. The most outstanding trading centers with the eastern Mediterranean were Pisa, Genoa, and Venice. We have so far been unable to detect Pisan style among the Crusader icons, and of Genovese painting we know almost nothing. The strongest connection was apparently with Venice, much intensified after the sack of Constantinople by the Venetians in 1204.

We have an iconostasis beam (c. 1256–58; pp. 222, 223, and 224), which is similar in style to one of the few irrefutably Venetian paintings of the thirteenth century, a precious diptych with miniatures under rock crystals made at the end of the century for Andreas III, King of Hungary (now in Bern). The peculiar dotted highlights in the faces and the heavyset proportions, approaching plumpness, of the angels are particularly Italian. The beam was apparently made for a chapel serving Latin monks who had adopted this element of Orthodox church architecture.

The beam contains a cycle of the great feasts in which, to the twelve canonical events, was added a representation of the *Last Supper*. The overall iconographic scheme deviates from the Byzantine tradition by omitting the Deesis in the center. Characteristically, Crusader artists adhered closely to Byzantine models in some feast pictures, while in others we notice the conscious assertion of specifically Western elements. More or less in agreement with Byzantine iconography are the *Annunciation*,

the *Presentation in the Temple*, the *Baptism*, the *Transfiguration*, the *Entry into Jerusalem*, the *Harrowing of Hell*—though in mirror image—and the *Ascension*. On the other hand, strong Western elements appear in the *Nativity*. Here a realistic tendency is noticeable in the remarkable individualization of two of the three Magi (p. 222): one, wearing a fur cap, is clearly a Westerner, and another is unmistakably a Mongol. In 1249, about the time this beam was made, St. Louis sent an embassy to the Great Khan at Karakorum, to engage him as an ally against the Muslims. We should like to identify the third Magus with the Mongol general Kitbuga, a Nestorian Christian who claimed to be a descendant of one of the three Magi.

Also quite un-Byzantine is the figure of Lazarus in the scene of his *Resurrection:* instead of standing in the opening of the tomb, he sits erect on the lid of a sarcophagus. In the *Crucifixion*, the Virgin and St. John are depicted with the typical French gestures, touching chin and nose. The strongest Western accent, however, is seen in the *Pentecost* scene. In any Byzantine rendition of this theme, Peter and Paul, the princes of the Apostles, share the center, but the Latin artist asserts his "Romish" inclination by placing Peter alone in the dominant spot. Also deviating from the Byzantine canon is the representation of the *Death of the Virgin*, the *Koimesis*. Where as a counter-figure to Peter at the head of the Virgin's bier we would expect Paul, the Crusader artist has placed a group of four Archangels. Whenever they occur in Byzantine *Koimesis* scenes, Archangels carry candles, but in our beam they carry orbs, apparently an allusion to the Virgin as Queen of Heaven.

Venice had another style, different from that of the Andreas diptych, which can be seen in two panels, one of *St. John the Baptist* and the other of *St. Andrew*, in the Museo Correr in Venice. It is characterized by the pronounced linear treatment of faces and drapery and by sharp highlights—features of many Crusader icons at Sinai. They form such a large group that we must once again posit an atelier within the monastery. Most striking is a huge bilateral icon with the *Crucifixion* on one side and the *Harrowing of Hell* on the other (pp. 225–226). Bilateral icons are usually thought to have been intended for processional use (cf. p. 72), but our panel is much too big and heavy for such a purpose. Perhaps it was inserted into an iconostasis, with the *Crucifixion* facing the nave and the *Harrowing of Hell* the altar.

This *Crucifixion* is the third example in which the Virgin's and St. John's fingers are displayed ostentatiously. These gestures are almost the "trademark" of Crusader *Crucifixions,* confirming once more the cross-fertilizing influence of artists of different nationalities. In this icon, the Italian temperament asserts itself particularly in the Herculean figure of Christ. Also typically Western is the nailing of Christ's feet with one nail, a detail that originated in northern Europe and was quickly adopted in Italy. This is one of the comparatively few instances in which the painter used Latin rather than Greek inscriptions.

The *Harrowing of Hell,* being the Easter picture, would take precedence over the *Crucifixion* in the Orthodox Church; but our Crusader artist, by setting the *Crucifixion* against a resplendent gold ground and the *Harrowing of Hell* against a subdued dark blue starry sky, has reversed the order of rank. The expressive faces of Adam and Eve (p. 226) reveal a close connection with the two panels in the Museo Correr, supporting our attribution of the icon to a Venetian master. Once more we see an artist who tries intensely to absorb Byzantine influences, without abandoning his Western temperament. The haggard Eve with wrinkled face is in contrast to the youthful Eve of Byzantine art—we are reminded of the gaunt prophetess Hannah in Nicola Pisano's *Presentation in the Temple,* in the pulpit of the Baptistery at Pisa.

A diptych we believe to be by the same Venetian painter is a copy of two much-venerated icons, one of which was an image of *St. Procopius* that was probably housed in a church outside the walls of Jerusalem. Apparently this holy image was of particular splendor, with inlaid enamels not unlike those used for the *St. Michael* icons in Venice (cf. pp. 42–43), a technique clearly reflected in our Sinai icon. The other wing shows a *Virgin with Child* (p. 227) that copies the famous *St. Luke Virgin,* known as the *Kykkotissa,* of the Monastery of Kykko on Cyprus. In certain details—for example, the Virgin's ornamented veil and the sashes over Christ's breast—the Western copyist is more faithful than an eleventh-century Constantinopolitan painter had been to the traditional image (cf. p. 48), but he omits the dogmatically significant motif of Christ receiving the scroll, the *logos,* out of the Virgin's hand. The realistic interpretation foreshadows the future development of Italian art.

The question may be raised why this diptych could not have been painted in Jerusalem, where the famous *Procopius* icon was housed, or at Cyprus, where the *Kykkotissa* was kept. A Sinaitic origin is suggested primarily because of the frames, which are filled with figures and busts like those surrounding the French *Crucifixion* (p. 211). This is particularly obvious in the *Virgin* icon. At the top is a bust of the Virgin before the burning bush, one of the earliest representations of the bush consumed by flames and thus a realistic rendering of the locus sanctus. The Virgin is flanked by the busts of Joachim and Anna, to whom a special chapel is dedicated in the basilica—another locus sanctus. On the lateral frames we see in pairs first Moses and John the Baptist, then Basil and Nicholas, who were all also honored by special chapels (the chapel of St. Nicholas is no longer in existence), and finally St. Climacus, a holy monk of Sinai, and Onufrius, who had lived in a nearby cave. At the bottom is the bust of St. Catherine flanked by Constantine and Helena, to whom again a chapel is dedicated within the basilica. The program could not be more Sinaitic. The frame of the *Procopius* icon also contains saints, most of whom can be connected with Sinai chapels.

The various means by which this remarkable Venetian painter came to grips with his Byzantine models may be demonstrated by a third example that can be attributed to him (p. 228). Here he depicts the *Virgin of the Burning Bush* in the same iconographically exact form—without the bush—as did the French painter (see p. 217). She is flanked by a St. John the Baptist with contracted brows and disheveled hair and by a beardless Moses, both revealing the artist's keen understanding of a Byzantine model. The choice of the Virgin type and the two Prophets is once more thoroughly Sinaitic; but even here the greater corporeality, the sharp design of the faces, and the simplified, more realistic drapery reveal the Italian hand unmistakably.

The most ambitious work of our painter is an iconostasis beam (pp. 229, 230, and 231), which must have been made on-site for a chapel in the monastery. We know that there was a chapel at Sinai called St. Catherine of the Franks, in which the well-known eighteenth-century traveler Pococke was able to celebrate the Latin mass; but we have already seen another Crusader beam (cf. pp. 222–223) and cannot be sure which of the two was made for this particular chapel. Instead of the Twelve Feasts, this second artist painted busts of the *Apostles.* Apparently because of the small size of the chapel, he

was not able to accommodate all twelve and so selected six: Peter and Paul (the one with a scroll and keys and the other with a codex) and the four Evangelists, Matthew and Mark behind Paul and John and Luke behind Peter. In good Byzantine fashion, the artist added two saints, George and Procopius; but in keeping with his Western origins he placed them under Gothic pointed arches.

In one respect this Crusader artist understood the Byzantine tradition better than the other—he placed a Deesis group, omitted in the other beam, in the center of his composition. Nevertheless, he was not free of compromises with the Western tradition. John, for example, who in Byzantine art is usually depicted white-bearded and in Western art beardless, is here quite exceptionally rendered with a dark beard. And it comes as no surprise that an Italian artist, intent on increasing the element of realism in his work, would be rather conventional in his depiction of Christ and the Virgin, but expressive in the depiction of the characterful heads of *St. John the Baptist* (pp. 230–231) and *St. Paul* (p. 229), both drawn with sharply delineated facial wrinkles.

Another Italian artist, who had collaborated with the French painter of the four scenes on the inner sides of the wings of a triptych (cf. p. 215), filled its outer sides with the figures of St. John the Baptist and St. Nicholas. The facial features of *St. Nicholas* (p. 233) reveal the careful study of a Byzantine model that may very well have been the prominent *St. Nicholas* icon painted at Sinai a little earlier in the thirteenth century by a Byzantine artist (cf. p. 67). The Crusader artist placed a mitre on the saint's head and a crozier in his hand, consciously turning the Byzantine Nicholas of Myra into the Nicholas of Bari, whose relics had been claimed by the citizens of that town in 1087. Whether the painter of our Nicholas figure came from southern Italy must, for the time being, remain an open question, but *a priori* it seems quite likely.

Another southern Italian, perhaps of Apulian origin, may be proposed for an icon of *St. Sergius* on horseback (p. 232). The donor is a kneeling woman, wearing a black veil, in attire and posture clearly a Westerner. What distinguishes the rider-saint from Byzantine parallels is the emphasis on the huge pennant on the lance, bearing a red cross on white ground. The artist is so intent on the display of this emblem that he repeats it on the inside of the shield and on the saddle. The pennant, once thought to be the banner of the Knights Templar, must be taken as an emblem for Crusader knights in general. There is also a distinctly Oriental influence discernible in the shape of the quiver, hardly a surprising feature in a product of the Holy Land, the crossroads of so many cultures and artistic styles.

Like so many icons described in this chapter, this is not a stray piece but one of a series, evidence that it was created in the Holy Land, probably right at Sinai. In another icon the artist repeated the figure of St. Sergius on horseback with all the characteristics described above and paired him with St. Bacchus, dressed in the same fashion. This icon is bilateral and depicts on its obverse a bust of the Virgin Hodegetria in a very faithful rendering of a good Byzantine model, though lacking somewhat in spirituality—another of the striking cases where Western and Byzantine elements are uncompromisingly placed side by side.

There exist about half a dozen icons of the same style and size with frontal standing saints, these also probably produced in the monastery. One of them represents in typical Byzantine fashion the three most important soldier-saints: *George, Theodore, and Demetrius* (p. 234). The general impression is much like that of the Comnenian icon of *SS. Procopius, Demetrius, and Nestor* (cf. p. 51). In both panels the saints wear the long tunic and the chlamys, but in the Crusader icon the *tablion* on the chlamys is missing and chain mail is added between the long court tunic and the chlamys, turning Byzantine saints clad in ceremonial court costumes into Crusader knights. In spite of these Western features, the artist (perhaps a Greek from southern Italy), by means of the stiff poses, the lack of a firm stance, and the aloofness of the faces, has caught the Byzantine spirit more convincingly than the emotional French painter (cf. p. 220).

To the same presumably Apulian master can be attributed an icon with the typically Sinaitic *SS. Catherine and Marina* (p. 235). Catherine had become the titular saint of the monastery (originally dedicated to the Virgin) in the tenth or eleventh century, and one of the side chapels of the basilica had been dedicated to St. Marina. The numerous *Catherine* and *Marina* icons at Sinai must, therefore, be considered locus sanctus images. Although the hieratic appearance of the saints, their robes—that of an empress for St. Catherine and of a nun for St. Marina—and the crosses of martyrdom they hold, are all features of the strict Byzantine tradition, there is one detail which reveals the Western influence: the

orb in St. Catherine's hand, an attribute she holds in French and Venetian icons (cf. p. 213) but never in Byzantine. This is one of the many cases in which Western, in this case imperial, iconography is effortlessly infused into an otherwise thoroughly Byzantine image.

OUR EXAMPLES OF CRUSADER ICONS were chosen from three substantial groups, many with a distinct Sinaitic iconography. In our opinion, their origin in the monastery can hardly be doubted. However, there also exist many single icons that were brought to St. Catherine's as gifts. For the most part they were created in the territories controlled by the Crusaders: Palestine, Syria, and Cyprus. It is due to St. Catherine's fortunate isolation in the rocky desert that so much was preserved there while the rest of the Holy Land was exposed to continuous plunder and destruction. Yet there is still hope that when the Sinai material is completely known, additional Crusader icons will be found in other places.

The main point emerging from a discussion of Crusader art is that a clear distinction must be made between the twelfth and the thirteenth centuries. In the earlier period we are dealing with individual icons, probably created by migrating artists. This concept corresponds with what we know about Crusader art in general. The most famous twelfth-century works in the Holy Land are marble capitals of the highest quality made around 1250 at Nazareth by a Burgundian artist. There is no evidence that he and his co-workers established a workshop with the intention of staying. The fact that no other works can be traced to him suggests that after having completed his commission, he returned to France. The same situation seems to have prevailed, as far as our scanty knowledge permits any generalization, for the icon-painters of the period.

The situation is fundamentally different in the thirteenth century. We purposely chose for our study groups of icons that indicate the establishment of large workshops, most of them evidently located within the monastery itself. But there is literary evidence that artists' colonies had sprung up in Acre, and there is every reason to believe that their activities were as lively as those that led to such a variegated production in the monastery. The repeated presence in Acre of St. Louis, the French king, between 1250 and 1254 must have been a great stimulus. He was one of the greatest art patrons of his time, for whom the Bible in the Arsenal Library in Paris was made at Acre. It seems quite reasonable to assume that he was also interested in the panel paintings of the French artists who resided in that flourishing commercial center.

What makes these Crusader icons, painted mainly by French and Italian artists sojourning in the East, look so different from their output at home? The impact of Byzantine art, especially on thirteenth-century Italy, had already been noted by Renaissance critics who had coined the terms "maniera greca" and "maniera bizantina" to describe the Duecento style. Western artists who worked in the East were surrounded by an unlimited wealth of genuine Byzantine art, which they often imitated with such empathy that the work became indistinguishable from the models; while back at home the Byzantine influence was absorbed in the well-established styles of Italy and western Europe. Thus the Crusader icons play an intermediary role between Eastern and Western painting. The emphasis of our brief sketch has been on the adaptation of Byzantine style by Western migrants who were often the equals of their Levantine colleagues. However, many of them had acquired a firmly developed style of their own before they embarked on their adventure, and infused new elements—for example, a pronounced realism in the rendering of the human body—into Byzantine art. The story of that influence has still to be written.

Opposite:
SS. Paul, James the Greater, Stephen, Lawrence, Martin of Tours, and Leonard of Limoges
Tempera on wood, 33.3 x 23.7 cm. (13⅛ x 9⅜ in.); perhaps southern Italian (Calabria ?), 1150–1200; St. Catherine's Monastery, Sinai.

Left:
St. Leonard of Limoges with Manacles as Patron of Prisoners
Detail from *SS. Paul, James the Greater, Stephen, Lawrence, Martin of Tours, and Leonard of Limoges*

Opposite:
Crucifixion and Busts of Saints
French artist working at Sinai
Tempera on wood, 37.3 x 26.8 cm. (14¾ x 10½ in.); mid-thirteenth century.

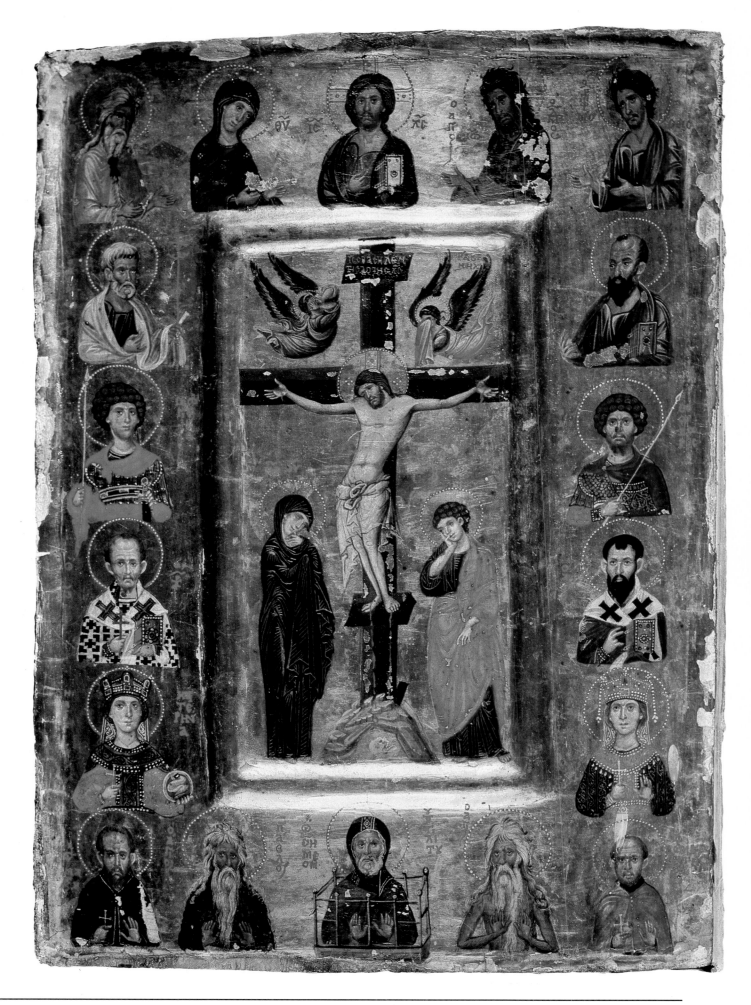

Above left:
St. Onufrius
Detail from *Crucifixion and Busts of Saints*

Left:
St. Simeon Stylites
Detail from *Crucifixion and Busts of Saints*

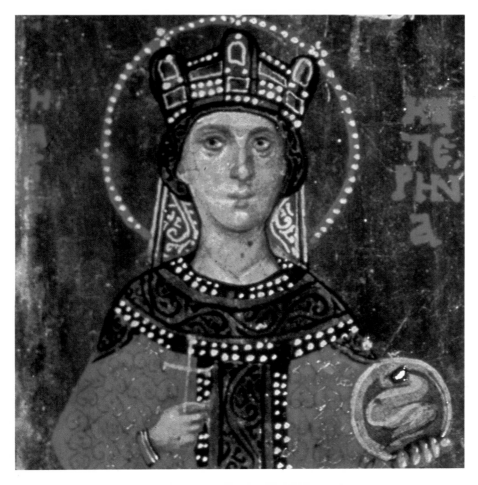

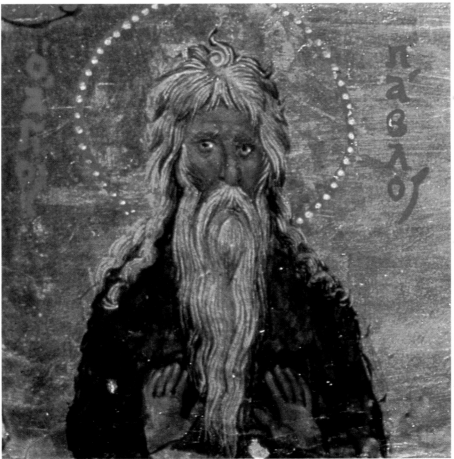

Above left:
St. Catherine
Detail from *Crucifixion and Busts of Saints*

Left:
St. Paul of Thebes
Detail from *Crucifixion and Busts of Saints*

Above:
Weeping Angel
Detail from *Crucifixion and Busts of Saints*

Left:
Virgin of the Crucifixion
Detail from *Crucifixion and Busts of Saints*

Opposite:
Death of the Virgin
French artist working at Sinai
Lower scene of left wing of a triptych; tempera on
wood; triptych: 56.8 x 47.5 cm. (22⅜ x 18¾ in.);
mid-thirteenth century; St. Catherine's Monastery,
Sinai.

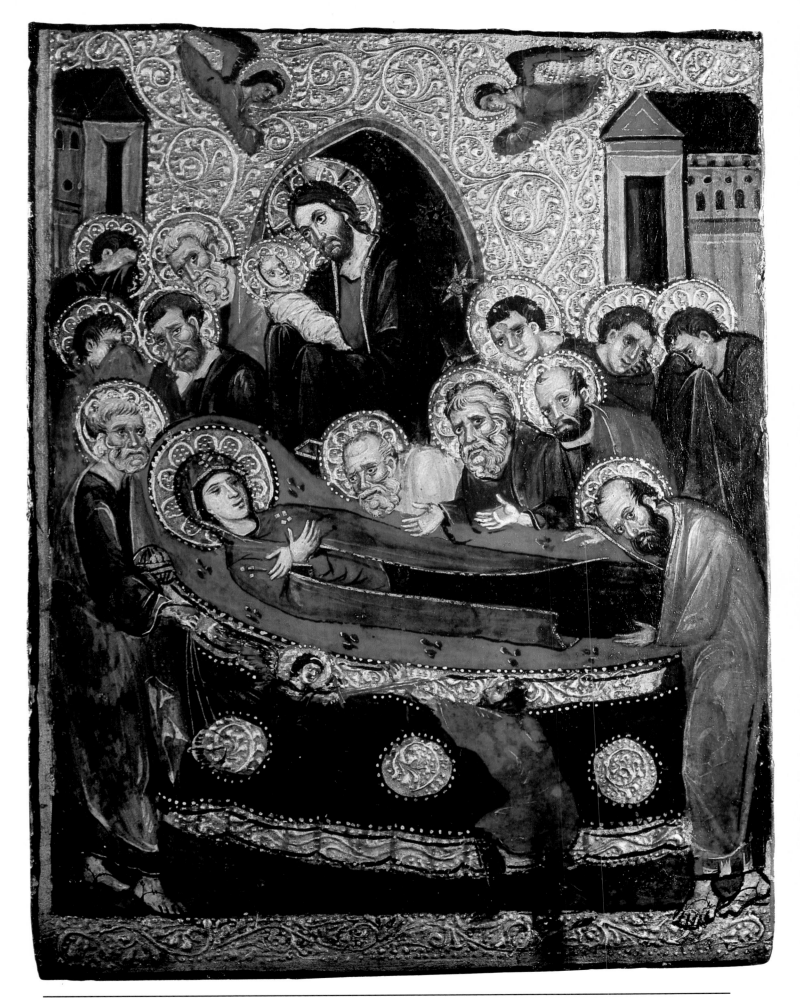

Above:
Mourning Apostles
Detail from *Death of the Virgin*

Opposite:
Virgin of the Burning Bush Between Moses, Elijah, and St. Nicholas
French artist working at Sinai
Tempera on wood, 32.3 x 25.7 cm. (12¾ x 10⅛ in.);
mid-thirteenth century; St. Catherine's Monastery,
Sinai.

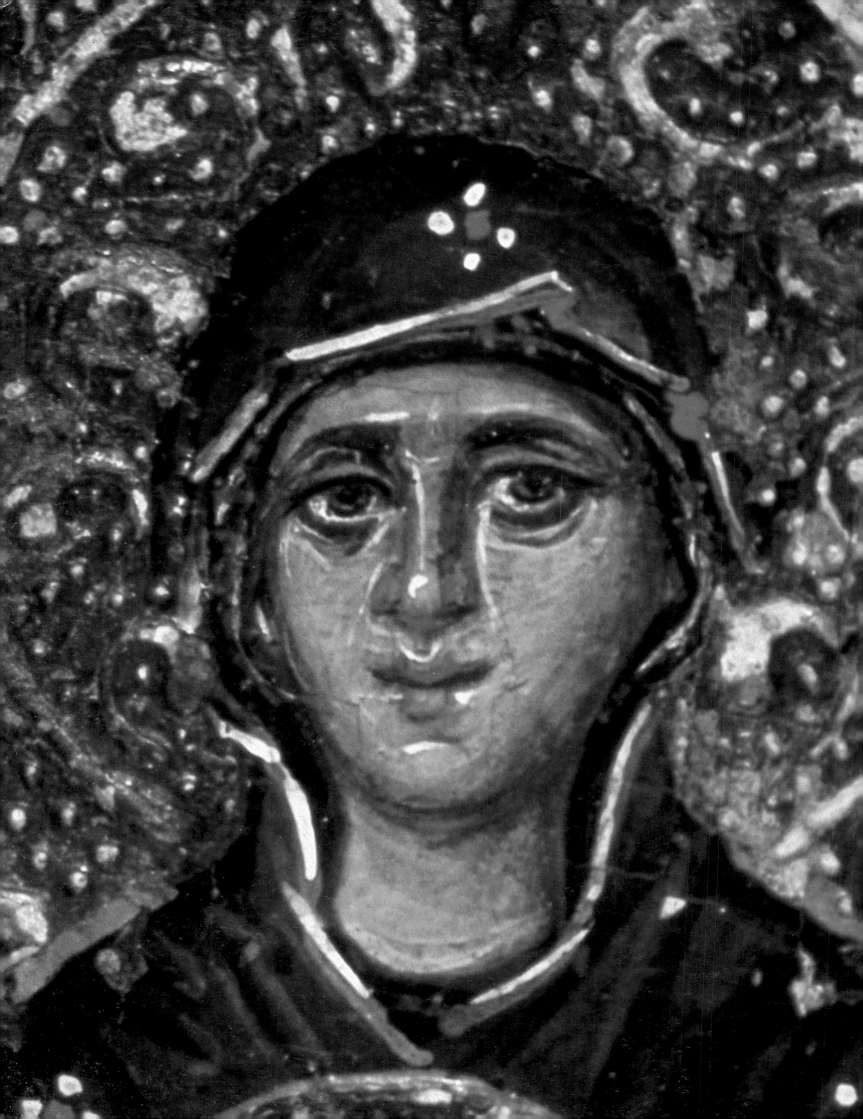

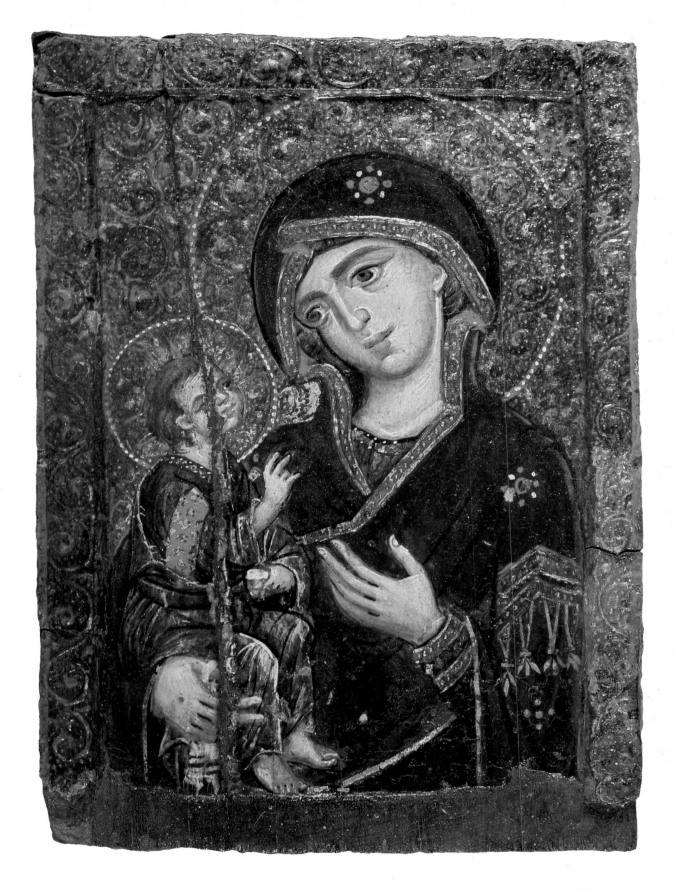

Opposite:
*Virgin of the Burning Bush Between Moses, Elijah, and
St. Nicholas*, Detail

Virgin Hodegetria
French artist working at Sinai
Tempera on wood, 32 x 25.6 cm. (12⅝ x 10⅛ in.);
mid-thirteenth century; St. Catherine's Monastery,
Sinai.

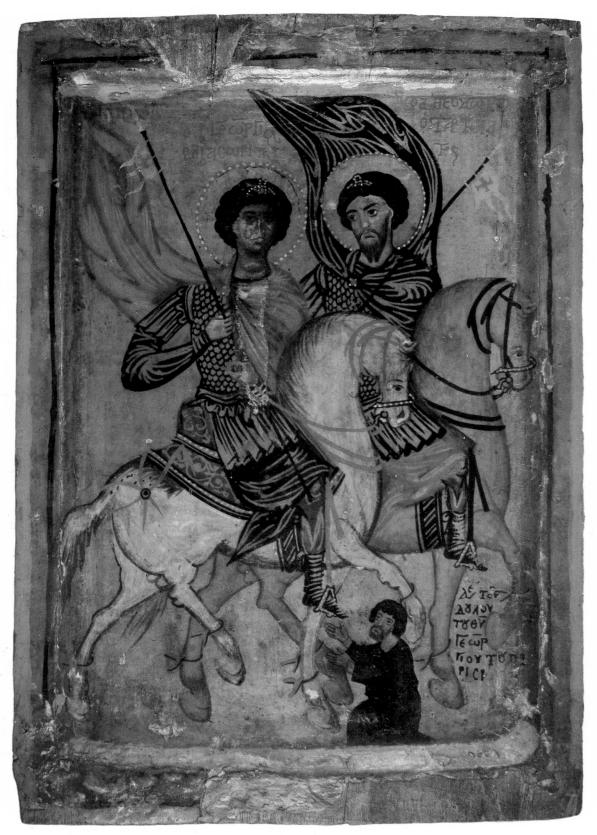

St. George and St. Theodore on Horseback
French artist working in the Holy Land
Tempera on wood, 32.5 x 22.2 cm. (12¾ x 8¾ in.);
1250–1300; St. Catherine's Monastery, Sinai.

Opposite:
Virgin Hodegetria Between Peter and Paul and St.
Anthony and St. Euthymius
In the spandrels: Moses and Elijah
French artist working at Sinai
Tempera on wood, 31 x 24.8 cm. (12¼ x 9¾ in.);
mid-thirteenth century; St. Catherine's Monastery,
Sinai.

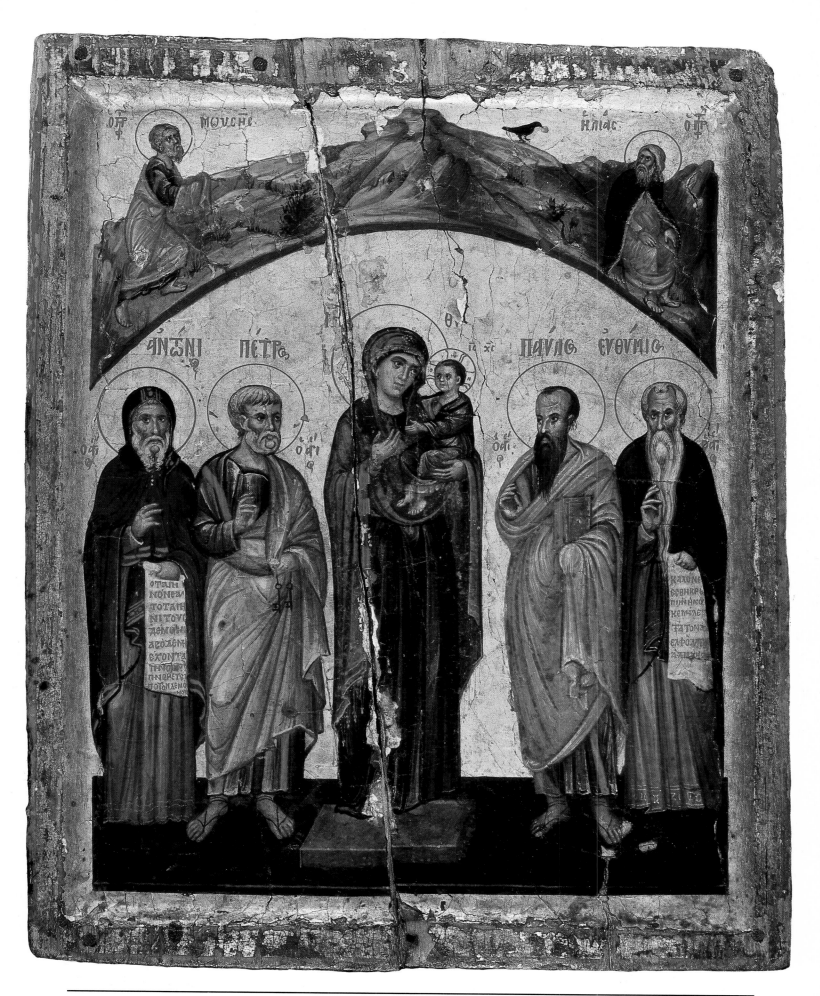

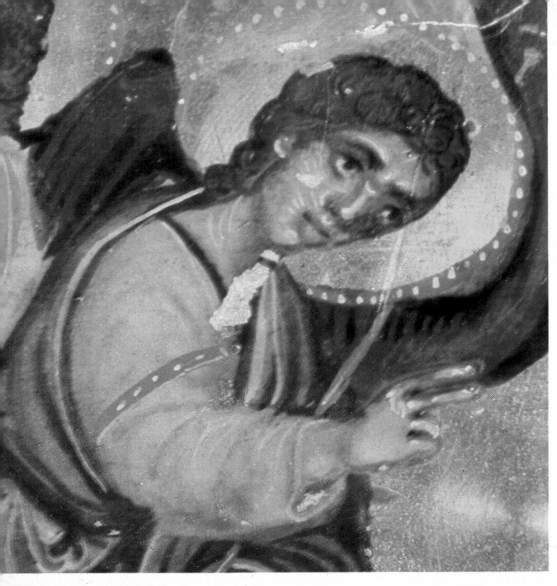

Opposite:
Nativity
Detail of the first of three sections of an iconostasis beam
Venetian artist working at Sinai
Tempera on wood, 28.9 x 68 cm. (11⅜ x 26¾ in.); c. 1256–58 (?).

Above left:
Angel of the Annunciation to the Shepherds
Detail from *Nativity*

Left:
Two of the Three Magi
Detail from *Nativity*

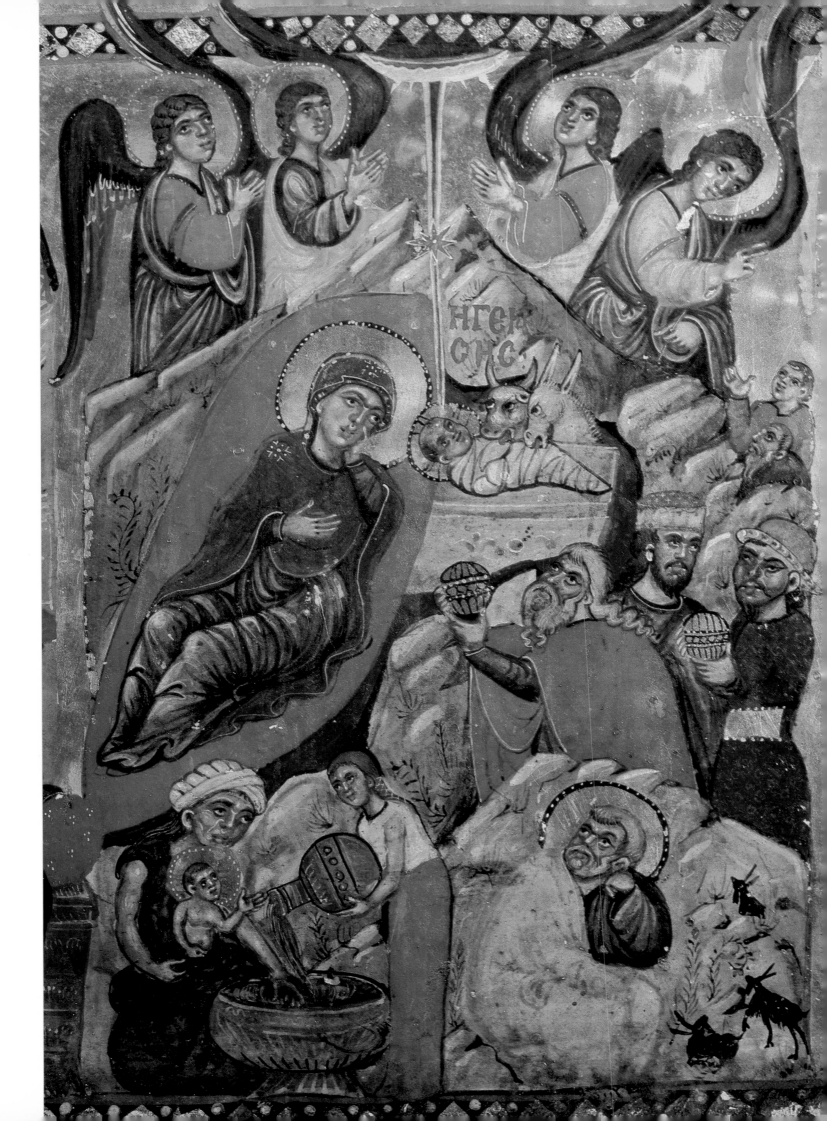

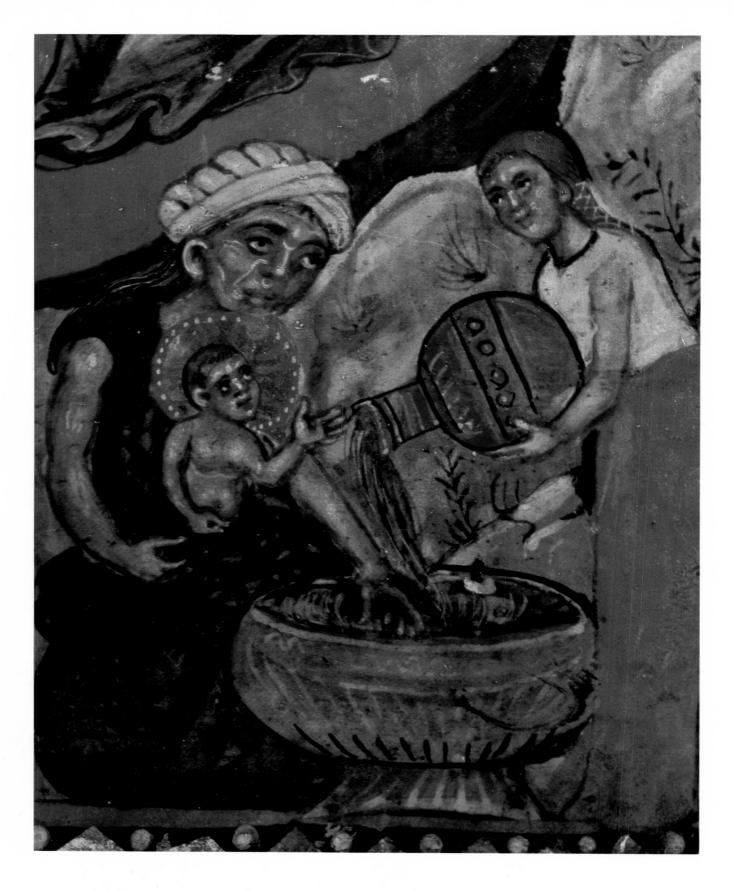

Bathing of the Christ Child
Detail from *Nativity* (see p. 223)

see p. 223

Opposite:
Harrowing of Hell
Venetian artist working at Sinai
Tempera on wood, 120.5 x 67 cm. (47½ x 26⅜ in.);
1250–75.

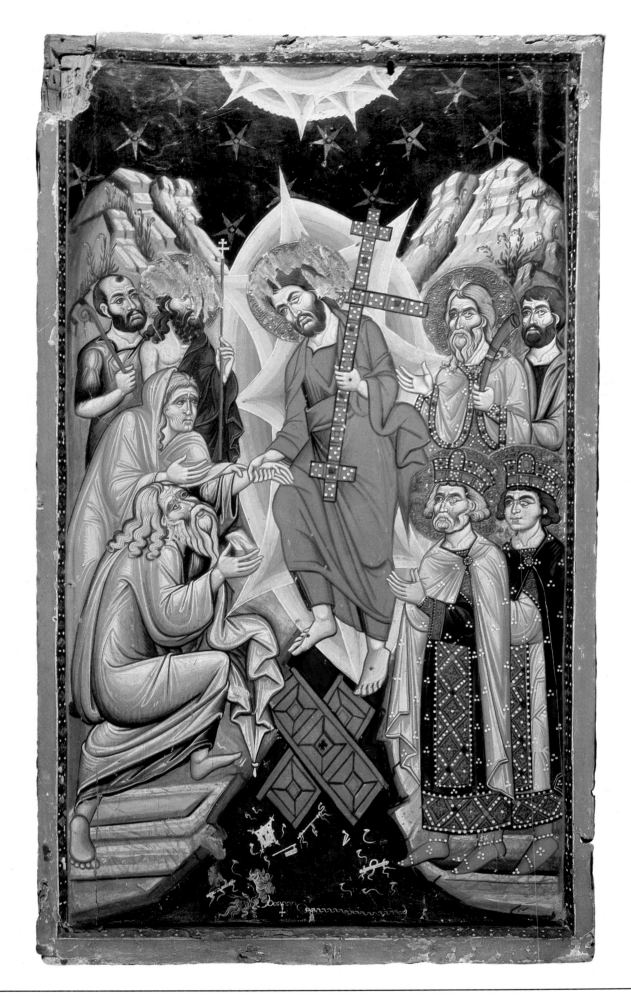

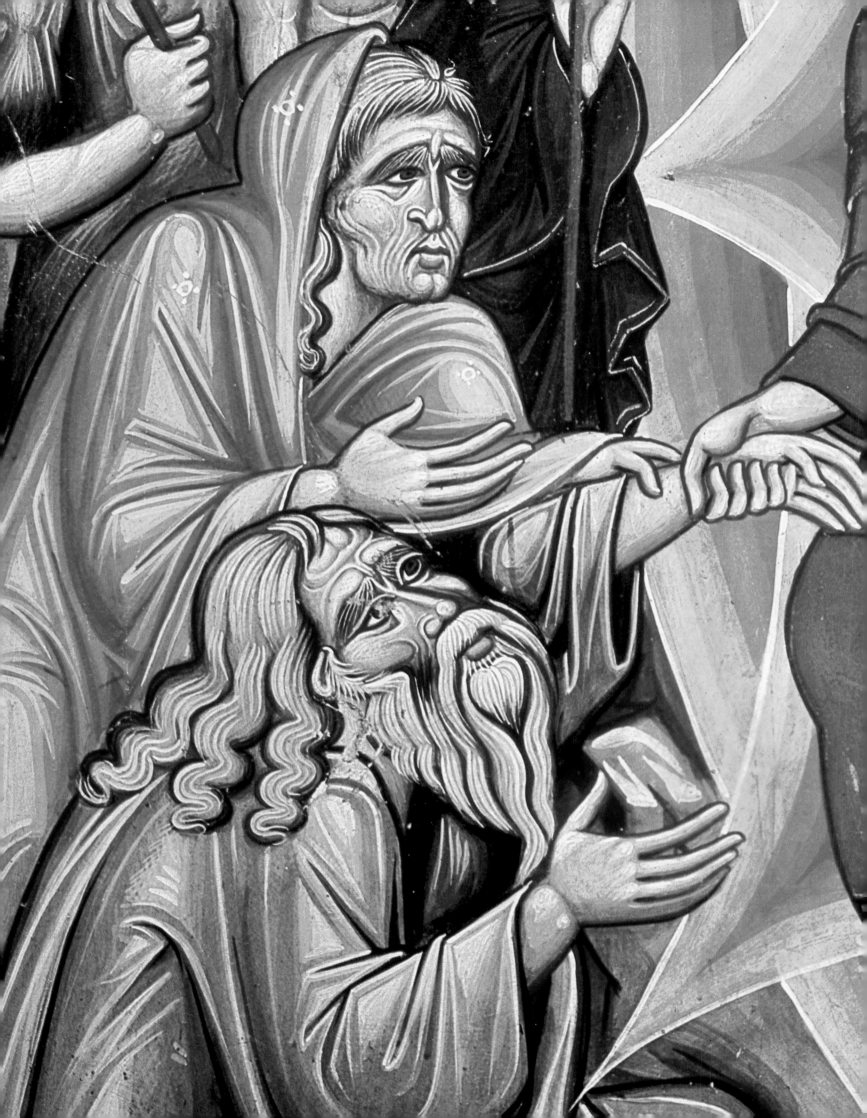

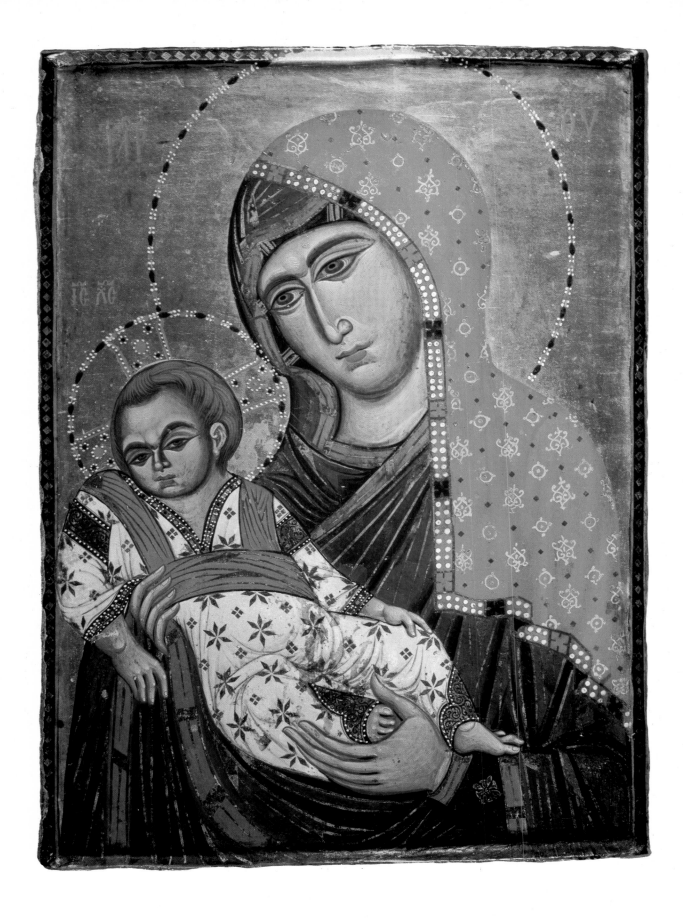

Opposite:
Adam and Eve
Detail from *Harrowing of Hell* (see p. 225)

Virgin with Child, called *Kykkotissa*, Detail
Venetian artist working at Sinai
Tempera on wood, 50.6 x 39.7 cm. (19⅞ x 15⅝ in.);
1250–75; St. Catherine's Monastery, Sinai.

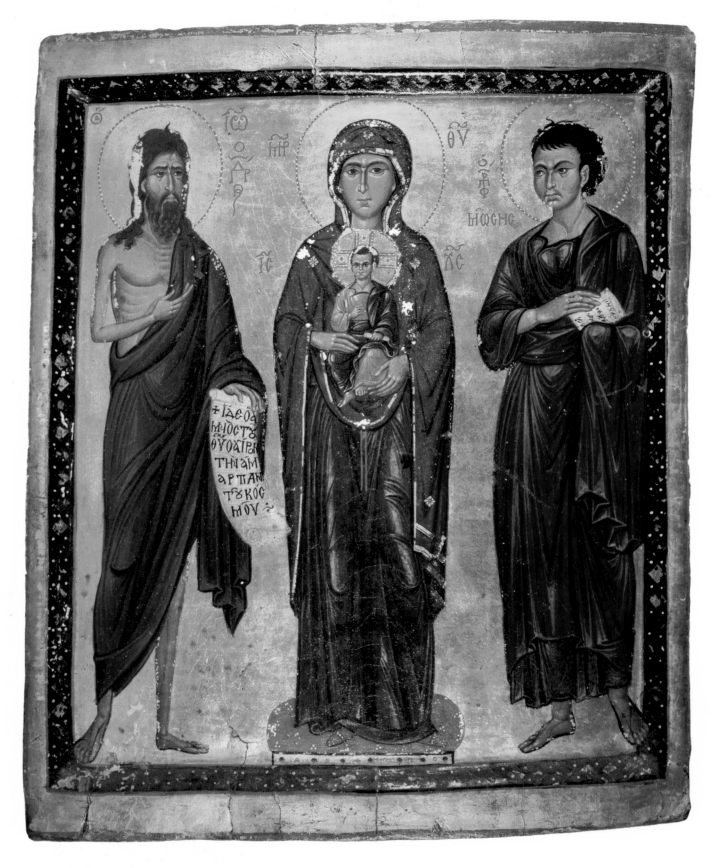

Virgin of the Burning Bush Between St. John the Baptist and Moses
Venetian artist working at Sinai
Tempera on wood, 41.6 x 33 cm. (16⅜ x 13 in.);
1250–75; St. Catherine's Monastery, Sinai.

Opposite:
St. Paul
Detail of an iconostasis beam
Venetian artist working at Sinai
Tempera on wood, 43.3 x 168.5 cm. (17 x 66⅜ in.);
1250–75; St. Catherine's Monastery, Sinai.

Ο ΑΓΙ[ΟC] ΠΑΥΛΟC

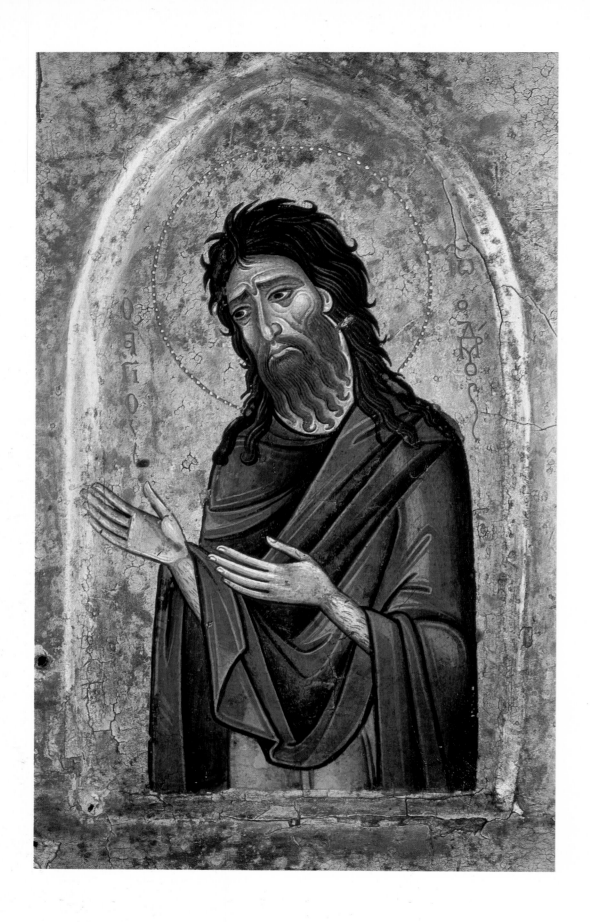

Above and opposite:
St. John the Baptist
Detail of the iconostasis beam shown on page 229.

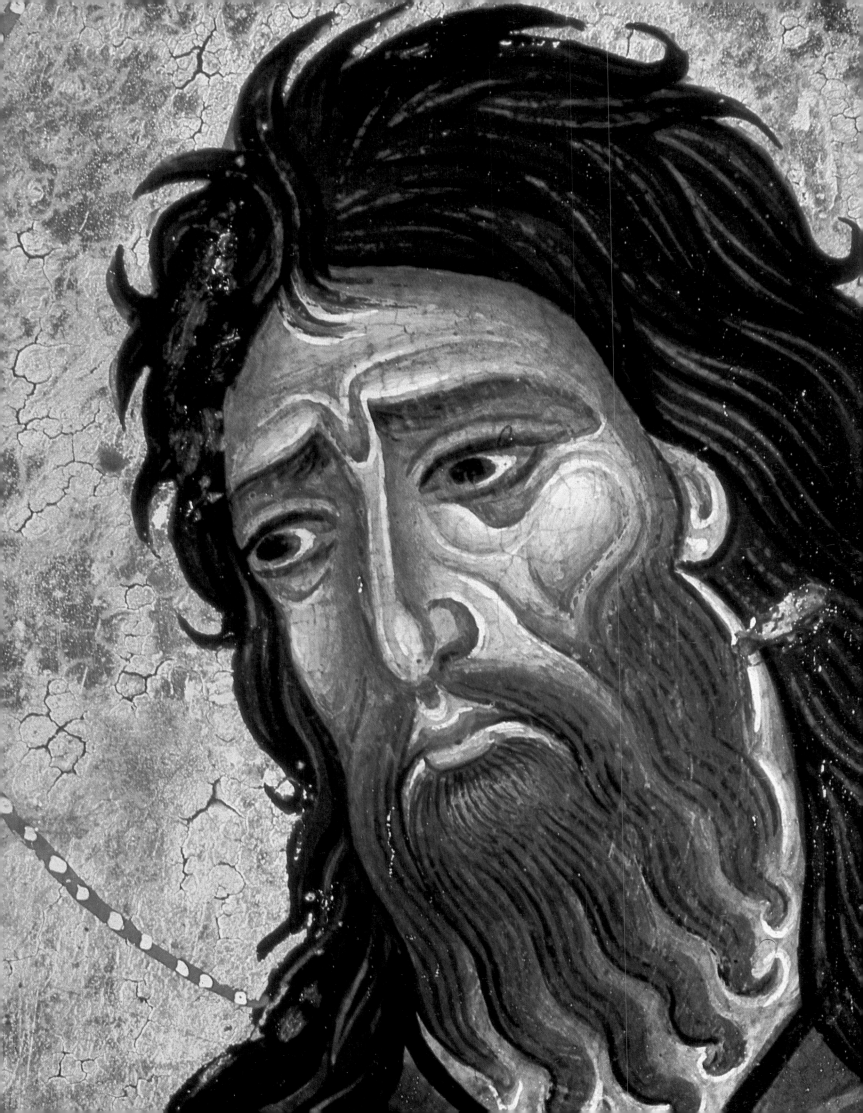

St. Sergius
Italian artist, perhaps Apulian, working at Sinai
Tempera on wood, 28.7 x 23.2 cm. (11¼ x 9⅛ in.);
thirteenth century; St. Catherine's Monastery, Sinai.

St. Nicholas
Outside of the left wing of a triptych
Tempera on wood, total measurement
56.8 x 47.5 cm. (22⅜ x 18¾ in.);
mid-thirteenth century; St. Catherine's
Monastery, Sinai.

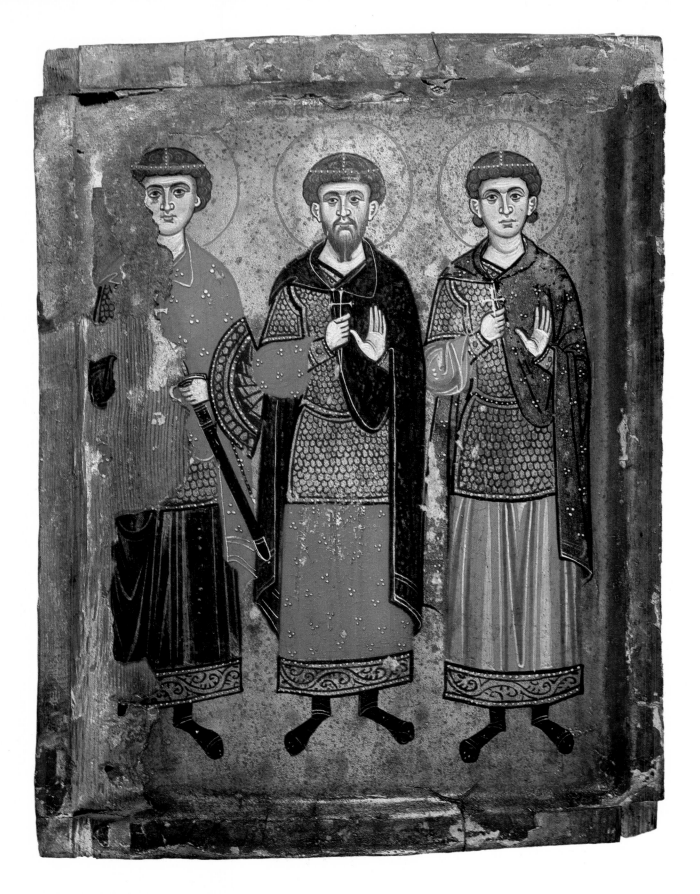

SS. George, Theodore, and Demetrius
Perhaps Greco-Italian artist from Apulia working at
Sinai
Tempera on wood, 34.4 x 25.5 cm. (13½ x 10 in.);
thirteenth century; St. Catherine's Monastery, Sinai.

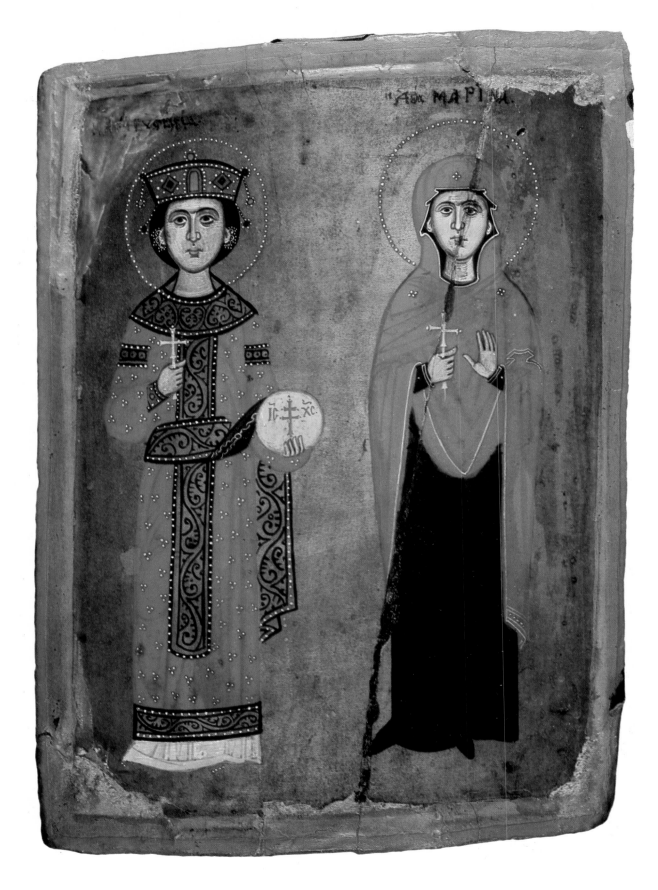

SS. Catherine and Marina
Perhaps Greco-Italian artist from Apulia working at
Sinai
Tempera on wood, 34.6 x 24 cm. (13⅝ x 9½ in.);
thirteenth century; St. Catherine's Monastery, Sinai.

THE ICONS OF RUSSIA

Mihail Alpatov

FROM the time of Peter the Great's reforms to the beginning of the twentieth century, hardly anyone showed concern for or interest in Russian icons. Most of the ancient images were covered with metal mountings, age-old layers of paint, and candle soot, making it impossible to see them properly. The revelation of early Russian icon-painting is a matter of legitimate pride for our century.

Rublev's *Old Testament Trinity* (p. 270) was the first masterpiece to be restored. It emerged in the full glory of its colors, but soon was again obscured by a protective case. Shortly afterwards, I. S. Ostroukhov began the systematic cleaning of the icons in his splendid collection. At the 1913 Exhibition many people had their first look at early Russian, predominantly Novgorodian, icons in all their original beauty.

After the October 1917 Revolution, the collection and restoration of early Russian icons became a responsibility of the state. Lenin's nationalization of artistic masterpieces led to the foundation of the large repositories of early Russian painting at the Tretyakov Gallery in Moscow and the Russian Museum in Leningrad. Scientific expeditions to ancient cities and continuing restoration efforts serve even today to replenish these institutions. The six-hundredth anniversary of the birth of Andrei Rublev was marked by the opening of a museum of early Russian art named after him in the former Andronnikov Monastery in Moscow.

The discovery of icon-painting means more than the identification of hitherto forgotten relics of early Russian art; it is also a recognition of their aesthetic value. Our admiration, once aroused, has not subsided. There is no reason to doubt that in ancient Russia icons were regarded as sacred, meriting reverence regardless of their artistic quality—an attitude that undeniably affected the approach painters took to their subjects. For the modern art historian, however, the icon's aesthetic, rather than cultural, value is of primary interest.

There are some grounds for taking the icon-

ographical approach to the study of icons. Religious artists did not usually invent their own subjects, as secular painters did. They followed an iconographical convention established and developed by custom and the church authorities. Only the choice of colors was at their discretion; in everything else they were supposed to be governed by the traditional canons. This is why icons representing the same subject, even when painted centuries apart, can be so alike that historians may find it impossible to differentiate them.

If we do not limit ourselves to the description and classification of iconographical types, but penetrate to the heart of the matter, then iconology can contribute a great deal to our understanding of these works of art, although it is by no means the sole key. It would be untrue to say that only the approved and canonized conventions prevailed or that artists always obediently reproduced what had been done before. The evolution of Russian iconography was the collective work of many generations, in which the painters played just as important a part as the learned theologians and religious writers. The canonization of iconographical types, the so-called *podlinniki,* apparently occurred comparatively late, a sign of the impoverishment of creative resources and the ossification of tradition.

Many themes in early Russian icon-painting came from the past, but many others were indigenous inventions. We can trace the Russian origin and development of the *Intercession* of the Virgin (p. 297) in icons of the thirteenth to sixteenth century. Fifteenth-century Novgorodian artists were responsible for the iconography of the *SS. Florus and Laurus* images (p. 302). The fine composition *The Battle of the Novgorodians with the Suzdalians—The Miracle Worked by the Icon of the Virgin of the Sign* (p. 275)—was devised in the same period.

The fact that even with all due respect for traditional biblical subjects, painters were always able to add something of their own, to enrich and reinterpret the ancient canons, deserves special attention. The aim of iconology is usually to seek out prototypes in the art and literature of earlier periods; but one should not overlook or underestimate the creative element to be found in virtually every new rendition of an old theme.

The distinction was made in medieval literature between canonical texts and the Apocrypha, folk legends of which the Church disapproved. Icon-painting can be likened to the Apocrypha, not only because artists were often inspired by these legends (for example, the Nativity of Christ or the Dormition), but because the painters themselves frequently created pictorial apocrypha. This is the most poetic aspect of early icon-painting.

RUSSIAN ICON-PAINTING IS a historical phenomenon; therefore, the first task of the scholar is to consider it in the context of history. The first icons were brought to Russia from Constantinople, and the first master painters who worked in the country were Greek. Byzantine icon-painting is distinguished by the finesse of its technique, in some respects bearing the imprint of royal splendor, in others of monastic austerity. It was through the Byzantines that Russian icon-painters came to know the great early Greek tradition, and to follow it.

These foreign roots are worth studying, but one should not forget that purely Russian impulses were of decisive significance in the development of the indigenous style, for example, during the period from the end of the fourteenth to the mid-sixteenth century. Having survived the harsh tribulations of the Tartar invasion, the Russians found the strength to begin fighting for their independence while preserving faithfully the legacy of classical antiquity and Christianity that had come to them via Byzantium. The Russian people, growing progressively more aware of their unity, expressed in their art their hopes and aspirations, their social, moral, and religious ideals. This artistic efflorescence occurred during a period which might be termed a historical prelude, before the emergence of an autocracy that was not unlike the despotism of the Orient. This is why the icons of the epoch display so much that is utopian, elevated, ideal, and incredibly beautiful.

MODERN OBSERVERS CAN only be amazed by the acute contradiction between the cruelty and moral crudeness of feudal Russia and the nobility and loftiness of its art. This does not mean, however, that art turned away from the drama of life. Anyone who holds that the geniuses of that period worked in absolute isolation is transferring

to the past the afflictions of modern art. The Russian people of that day were well aware of contemporary events, but they strove to achieve in art what they lacked in reality.

Every possibility of finding connecting links between the mysterious art of icon-painting and what is reliably known about the world view, beliefs, and superstitions of the people of the time is very important to historians, but this cannot always be done without stretching a point. Such masterpieces as Rublev's *Old Testament Trinity* (p. 270) and the Kremlin Master's *Apocalypse* (p. 294) have a much broader meaning for us than they had for the people for whom they were first created. These icons still have the power to stir us, no less than the marbles of Phidias and Michelangelo. Surely it was not only to defeat heresy that Rublev created his wonderful painting; nor did another artist paint an icon on the theme of a military legend solely to counteract the aspirations of Moscow to the Novgorod lands. The task of the historian is to delve deeply into early art and to find out how it served man's spiritual education, to understand the artistic values of the epoch.

A characteristic feature of early Russian icon-painting, well in keeping with the structure of feudal society, is the existence of two tiers, or strata, "the lords" and "the peasants." There are icons that are distinguished by their splendor and extreme refinement, created by painters from large cities who were close to the upper crust of society; and then there are images painted by *posad*, village craftsmen, which are poorer in material and color and less profound in character. It cannot be said that each class had its special holy relics and looked only to them for assistance. The iconography was universal. Quite frequently, the painters in the cities and villages vied with each other, painting icons on the same theme, on the basis of the same "patterns" or types.

In the thirteenth and fourteenth centuries, the pre-Mongolian traditions of Kiev were preserved and developed in some works, but there was also a new phenomenon: the appearance of the Russian primitives, painters whose works are naive and crude, but captivating in their spontaneity of expression, bright colors, and childlike simplicity, especially in border scenes. Their enforced break with the pre-Mongolian tradition encouraged the emergence of a national Russian school.

At the end of the fourteenth century, a new wave of Byzantine influence spread throughout Russia. Its most prominent representative was the great master Theophanes the Greek (pp. 264–267, 269). His art—passionate, dramatic, wise, austere, at times tragically intense, frequently lofty and splendid—made a deep impression on Russian painters, although the indigenous style continued to evolve according to the principles of its own internal logic.

The work of Rublev and his contemporaries is a phenomenon of the tremendous upsurge of the Moscow school early in the fifteenth century. Rublev broke away from Theophanes' dramatic severity of form, color, and expression. His art is one of the highest achievements of Russian icon-painting (pp. 270–273).

In the fifteenth century, icon-painting also flourished in the free city of Novgorod. Perhaps less contemplative than the Moscow school, the Novgorodian style is no less poetic or refined in taste. The city had no genius equal to Rublev, but as local art patrons set great store on icon-painting, most Novgorodian icons are distinguished by their very high level of execution. Glittering with brilliant, festive colors, incorporating many secular elements, they are close to the spirit of folklore.

Pskov was the "younger brother" of Novgorod. Pskov icons display less artistry in execution than those of Novgorod but convey a greater poetic inspiration. The linear design is hesitant though expressive, and the colors are hot, burning, flaming with an inner fire. There is spontaneity in the faces, passionate feeling, ardent faith.

Certain features of other schools have been defined over the last few years, including the Tver and Suzdal schools. Most clearly expressed are the idiosyncrasies of the Northern school, which was based on Novgorodian traditions but had its own leisurely ambience. This is the art of the village, of the peasants. In it one can discern hints of features of the decorated distaffs that were to come later; there is a simplicity of conception, a rather crude and clumsy draftsmanship, a poverty of color, and at the same time, an appealing sincerity.

Toward the end of the fifteenth century a new star, Dionysius, appeared in the Moscow firmament. He was much indebted to his great predecessor Andrei Rublev, but did not resemble him; this, however, does not mean that he was a lesser artist. His art is mature, restrained in the

expression of feeling, a lofty, contemplative, refined, noble, and profoundly human art. Dionysius was a colorist of great delicacy. His colors are gentle, transparent, forming harmonious chords, especially in solemn, stately scenes involving great numbers of characters. Everything he painted is bathed in a warm effulgence (pp. 286–291).

Dionysius exerted just as much influence on his contemporaries as did Rublev in his time. The poetry of his colors is reflected everywhere in the art of the first half of the sixteenth century. The icons of this time acquired a narrative character, but the literary, didactic side did not obscure the visual attractiveness of the images.

The mid-sixteenth century brought a sharp change. The dogmatic debates over new icons and the affirmation by the Council of the Hundred Chapters of church control over icon-painters put an end to the pious fervor of the artists. The Council upheld Rublev as an example to be followed, but in fact it severed the precious thread that had woven through Russian art since his time. The Stroganov masters attempted to draw on the Novgorodian heritage; in their colors and minute figures there are elements of artistry. For the rest, icon-painting became strictly conventional, canonical, and aesthetically inferior to the work of previous centuries. Only in remote corners of the north, in the work of the village craftsmen, did the vein of free endeavor continue to pulse.

THIS BRIEF SURVEY of the evolution of early Russian painting is necessarily somewhat schematic. It used to be customary to seek a definite linear sequence of development from the medieval conventions to post-Renaissance realism; in actual fact there were peaks of success in almost every period, just as there were setbacks and spells of stagnation. Moreover, Russian art cannot be fitted into the generally recognized scheme of Western stylistic development. Its evolution was highly capricious, with leaps and falls, quickenings and retardations. Only the student who is sensitive to every twist and turn, to every achievement, can discover the grains scattered everywhere which, if they were not always able to put forth shoots, were of enormous value in themselves.

Perhaps inevitably, given the religious and philosophical ideas Russian icons were meant to convey and the ecclesiastical strictures regarding subject and composition, the moral, poetic, and ethical values of these holy images were expressed above all in color.

Canonic types served as a point of departure; true artistry lay in interpretation. Each painter, like a folk singer, told his legend in his own way, adding to it something of his own invention. The art of the Russian icon-painter is to a great degree the art of nuance: even the smallest variation gave an old theme new meaning, new spiritual value. Perhaps the paraphrases of old masters by Van Gogh and Picasso can help us to appreciate the magnitude of this achievement.

An icon-painter, said the Council of the Hundred Chapters, should be "meek, mild, pious, not given to idle talk or to laughter, not quarrelsome or envious, not a thief or a murderer"—but evidently the main requirement was that he show no independence in his work. In reality, Russian icon-painters were people of high ideals with a rich inner life and considerable intellect, profoundly convinced of the moral truth they were proclaiming through their art. Their works show a selfless and undoubting commitment to their convictions, although they were certainly not in the least indifferent to the material quality of their creations.

One precious characteristic of Russian icons, which strikes the eye of the foreigner immediately, can be summed up in Gogol's words: "They have no inordinate rapturousness or exaltation, but are dominated by a calm force.... It is an unusual lyricism born of supreme sobriety of mind." Icons are imbued with a profound conviction, a pure faith, but this never develops into a fanatical passion and does not lead to the loss of a sense of proportion. Their profound humanity lies not only in the characteristic depiction of the ideal, God in human likeness, but also in the fact that everything that is portrayed is within the bounds of man's knowledge, feelings, and emotions, and has come through the cleansing fire of the sensitive human soul; everything is colored with human sympathy. In their striving after higher things, the painters did not lose their ability to consider the world in a kindly, sympathetic way, to enjoy seeing galloping horses, shepherds with their flocks—in short, all the creatures of the earth.

The moral system of the early Russian

icon-painters is reflected in their attitude not only toward virtue but also toward vice and everything that causes man to suffer. From Greek antiquity they inherited the concept of the inevitability of human suffering and tragedy, a prototype of which was the Passion of Christ. But unlike their Western contemporaries, they were not inclined to dwell too long on man's suffering, divine retribution, or the Devil's machinations. These painters of old did not have the sense of original sin and their own damnation that had so troubled medieval men. In this respect they were more pagan than their Byzantine teachers, but this is why they succeeded in overcoming all that was gloomy and forbidding in the Christian legend. The life of Christ, as they understood it, was like the life of any pious, saintly person: a festival, a splendid thing, the final victory of goodness and love over cruelty and evil.

On one thirteenth- or fourteenth-century icon of the *Virgin* (Tretyakov Gallery), the owner inscribed a prayer for the preservation of the lives of the Prince and the Archbishop and delivery from alien invasion—not a prayer evoked by suffering, nor a plea for help at a moment of despair, but a glorious paean to superior forces, the joyous assertion of all living things, born of a conviction of the inevitability of the triumph of justice, a presentiment of the happiness mankind deserved.

The "Life" of St. Sergius tells how he built the Cathedral of the Trinity "that he might vanquish the fear of the hateful strife existing in this world by contemplation of the Holy Trinity." These words apply not only to Rublev's famous image but to early Russian icon-painting in general. The most wonderful icons were created not solely to be worshipped in expectation of aid and healing, but so that man, as he looked at them and their beauty, could find solace, joy, and concord with the world. In its essence the icon is not a sermon, not an exhortation clothed in color. Its moral and educational power is exerted when people, as they gaze at it, give themselves over to artistic contemplation.

Purely factual information about when, where, and who created works of art, under what influence, and what influence they themselves exerted, cannot open up to modern eyes the world of ancient icon-painting. The path of the erudite who are able to quote authorities but are incapable of interpreting them is a devious one in art. We have progressed very far in outlook from the people of ancient Russia, but in one sense they had something we would do well to learn—the ability to contemplate a work of art, to live and feel united with it.

THE SPIRITUAL WORLD of the painters of each epoch to a certain degree influenced the changing representation of man in icons. In the oldest images, the beautiful-eyed youths and women reflect the pagan beauty so esteemed in Greek antiquity. During the twelfth century, an expression of anguished duality—the ideal of holiness—permeates the icon. It is depicted as intensity of will, a sidelong glance, a stern and melancholy gaze. Theophanes the Greek inclined toward the representation of spiritual complexity. But Rublev in his *Savior,* in his *Apostle Paul* (p. 273), and even more in his angels, was able to portray the kindliness, gentleness, frailty, and almost unearthly loftiness that were the recognized acme of perfection in Russia. The faces of Novgorodian icons should also be mentioned—they are almost always restrained in expression, with an intent gaze and impressive ethical strength—and those of Pskov, which look profoundly stirred and anxious, and have a winning sincerity. Dionysius' works achieve that degree of remoteness, that immersion in contemplation, which was looked upon as an expression of the most elevated moral purity a pious being could achieve. Finally, in the sixteenth century, an interest in individual characterization appeared.

WHILE THE ICON cannot be termed a window to the real world, it is often called the window to the other world. The early Russian painters, however, tried to give people an idea of the world as a whole—not as a precise picture but as a likeness. By supplying a minor part, they hoped to enable the viewer to conceive of the whole. The Russian's ingrained inquisitiveness, the need to get to the root and core of everything, was satisfied in medieval times not by science but by myths, legends, poetry, and art, and there is no reason to believe that contemporary artists considered their goal to be purely imaginative. On the contrary, they were deeply convinced that art enabled one

to penetrate to the truth, to touch upon the supreme mystery of life. Such popular legends as "The Dove Book or the Conversations of the Three Church Fathers" give us an idea of the passionate need of people in those days to learn about the order prevailing in the world.

The hierarchical ladder, the pyramid, the pivot, the integrity of the whole and the subjugation of parts—these were considered the bases of world order, the means by which to overcome chaos and darkness. This idea was expressed in the compositional structure of every icon, which was conceived as a likeness of the Christian Church, in turn the model of the cosmos. Modern viewers do not accept the early Russian world view, which for them represents the wishful thinking of antiquity, but even they cannot resist the charm of a harmonious cosmic order triumphant over the forces of dark chaos.

In the world of early Russian icons, the human element is of great importance. True, the main subject of the holy images is the Deity—the Christian Olympus, though invisible and incomprehensible, is ever-present—but the Deity is revealed to the people incarnate, embodied in human form. Christ and the Virgin are ennobled human images. They do not usually surpass mankind in their dimensions; mortals are no smaller than saints. In the universe of the icon, a person does not feel himself lost, as do the Buddhist sages in the boundless spaces of early Chinese landscape painting. In the iconostasis, man finds his place in the heavenly hierarchy, an integral part of the world order, asserting his own dignity.

THE EARLY RUSSIAN ICON-PAINTERS recorded very specific observations of the world when they depicted events in the lives of Christ, the Virgin, and the saints. Striving to penetrate to the true essence of reality, they chose, from the many possible motifs, those that were the most constant, stable, and universally significant: scenes depicting the birth of a saint, showing his exultant, reclining mother; his presentation to his tutor; his solemn ordination; events from his life, devoted to doing good to others; and finally his dormition and entombment. All these are represented graphically but expressively. Every pose, every posture of the saint, his gaze and his restrained gestures help to reveal the soul within.

Among the various traditional themes were several particular favorites, which seemed to express the innermost hopes of the people. One is the image of the Virgin and Child enthroned against the background of a multidomed church, surrounded by an assembly of the people glorifying and exalting them with *"In Thee Rejoiceth"* (pp. 298-299). Another theme of purely Russian origin is the Virgin interceding on behalf of the people, spreading her veil over them. In one case exultant mankind hails the Virgin, in the other mankind turns to her for help and protection. The two subjects are closely related and have common features. These icons may be called convocational, as they depict convocations of many people of various ranks and degrees, representing all mankind; or choral, because their many-registered compositions seem to express in visual terms the harmonies of ancient Russian chant. Certain other subjects, for example, the Dormition of the Virgin and even the Crucifixion, are often given features common to choral icons, making them also representations of joyous intercession and glorification.

In discussing the themes and motifs that were especially dear to the hearts of the people, the Rublev type of the *Old Testament Trinity* (p. 270) should also be mentioned. The three figures, united in sympathy, present a rounded group, portrayed by Rublev with total conviction and charming delicacy. Reproductions of his composition and free variations on the theme are constantly encountered in later icons, especially those by Dionysius.

Everyone agrees that early Russian icon-painting is a symbolic art, but not on how to understand the symbolism. Particular concepts of religious teaching are given visual form by conventionally represented figures or objects (a female figure on a winged throne embodies Sophia, the Divine Wisdom; death is seen as a skeleton with a scythe, riding a beast; a candle burning by a deathbed represents the human soul, and a cup sacrifice), but these are allegories rather than symbols. Symbolism has a much broader foundation and embraces not only the individual motifs but the entire icon. It is founded on the philosophy of late antiquity (Pseudo-Dionysius the

Old Testament Trinity, Andrei Rublev.

Areopagite), the idea that absolutely everything in the world is only a covering which obscures the true meaning, the essence. The concept is a most fruitful one for art, as it assures the artist that by portraying one object he can give an idea of many other things and, what is more important, of the world as a whole.

To the eyes of casual observers, the world of the icon is limited, unsophisticated, even naive. Some notice only the legendary themes, the iconography, while some delve into the theological implications; but others go even further and perceive, beyond what is represented, the artist's vision of the world and mankind. The icon thus possesses several layers of meaning, which makes interpretation difficult but at the same time enriches the work of art. Not infrequently there is an admixture of abstract theological profundity,

but there is actually less of this in Russian icons than in the Gothic stained-glass windows of western Europe. The secondary meaning was not added deliberately but evolved on its own. It is very volatile and elusive, often difficult to put into words. This does not diminish its role. Indeed, its very elusiveness gives it liveliness, profundity, and, at times, a quality of infinity. This remarkable feature of the symbolism of early Russian icon-painting shows that it is born of art, embracing both the theme and the execution. At times it is evoked by the very form of artistic expression.

Angels are widely represented in icon-painting; subordinated to a strict hierarchy in Orthodox dogma, they play an important role in the Christian legend. They appear as the guardians, the helpers of man, and serve as agents between

God and human; they surround the throne of Christ Pantocrator, interceding on behalf of mankind; they sing over the bodies of the innocent martyrs Boris and Gleb; they save humanity when the world's last hour comes. They are winged, but usually they walk the ground. They are an impossible combination of feminine grace, boyish agility, and, occasionally, military valor. Their wings are hidden behind their shoulders or raised in a mighty sweep on either side, as if hinting at a readiness to fly toward the sky.

TODAY ANCIENT RUSSIAN ICONS are exhibited on the walls of museums, but we should not forget that they were not originally meant to be displayed this way. They were supposed to be part of people's daily lives—in the place of honor in their log houses, attached to a pole by the side of a road, carried high above the host when the army set out on campaign. It goes without saying that the majority were placed inside churches, a necessary adjunct to the daily service.

Unlike a secular picture, which tries to hold the attention of one individual viewer, to absorb him or her entirely, icons make their statement not to the individual but to the community. Accordingly, they form a community of their own, a harmonious chorus, without losing their importance in proximity to other icons; on the contrary, they profit by it.

The old Russian iconostasis was an expression of this concept of a pictorial ensemble. Its roots, its first attempts at existence on a small scale, stem from Byzantium and the Balkans. Certain elements of the form can be perceived in a monumental painting of the *Last Judgment* (p. 281), which portrays the theological basis of the iconostasis: the figure of Christ Pantocrator in the center, toward whom the saints turn, eternally praying for mercy and forgiveness for the sins of mankind.

The first Russian iconostases, bearing lifesize figures, date back to the early fifteenth century. From then on, not a single early Russian church was without this beautiful, imposing construction. Many iconostases have reached us incomplete, only a few individual icons surviving, and the modern viewer must strain his imagination to perceive the integral whole of which they were once a part.

As various image cycles evolved (e.g., church feasts, saints' lives), the iconostasis became a kind of church encyclopedia in which biblical stories supported the concept of the joyous state of eternal glory.

The iconostasis represents the two-way visual perception characteristic of ancient Russia. It allows us the possibility of a "dual view" of the painted icon: at close range, where all the details are easily observed and where the basic and literal meaning is most easily perceived; and from farther away, where the first meaning seems to retreat into a second, more universal and general meaning, which can be perceived only from a distance. Among the figures of the Deesis tier, there are not only the recognizable saints but the representatives of all mankind. In their solemn silhouettes, their ponderous movements, their postures and inclined heads, there is something similar to the praying chorus of Greek antiquity. At this distance, the New Testament scenes, the so-called feasts of the Church, are not so much the events described in Scripture as states of triumph and glory in which the viewer also participates.

In fifteenth-century iconostases, the characteristic features of early Russian icons, which had evolved over many centuries, revealed themselves with profound force: clear-cut silhouettes, rhythm and integrity of form, and balanced color areas, alternating regularly and adding to the general decorative effect. Here the icon-painters combined their individual preferences and pictorial methods to create a spectacle that delighted the eye with the harmony of its elements.

Early Russian icon-painting is so unlike the art of our time that the modern viewer may easily succumb to the idea that it amounts to theology in color and nothing more, while at the same time distrusting the aesthetic impression he or she derives from it. Nevertheless, an icon is more easily perceptible to us as a work of art than an object of faith. It is not a ritual mask, not an ancient fetish—it is the product of a superior spiritual culture. The connection between religion and art in Russia was undeniably close, but an icon-painter of genius was not necessarily a pious man; and the beauty of an icon was not limited to pious feelings, its spiritual message not always other-worldly, nor its contemplative aspect the equivalent of prayer. In its finest manifestations, icon-painting was a pure and lofty art.

The early Russian painter knew no contradiction between concept and execution; he did not have to suffer that torture of creative endeavor. On the flat surface of the icon, he laid down bright patches of color and beautiful patterns of outlines, eloquent and strikingly pure notes. What he actually depicted could never be accepted as reality, or only in a very narrow sense. One recognizes the figures of people and objects, but they are transformed and at times not even immediately recognizable. The colors are bright and pure, of a sort one never sees anywhere, except perhaps in the sky at sunset or in a field thickly overgrown with cornflowers. Whatever is portrayed always has an inherent quality of novelty, a sense of the unusual and the unique. At the same time this hitherto unseen, strange, colorful something becomes part of the life of the viewer, part of the space he or she inhabits. In its almost ineffable harmony of color and form lies the icon's incomparable power of persuasion.

In ancient Russia, even in the remote northern regions, no one could pick up a brush who had not at least some elementary idea of painting. The mass production of icons was not known in those times. It was only much later, after the development of consumer markets, that the works of "bad painters" (*plokhopistsy*) began to appear and arouse the anxiety of the church authorities. While modern collectors value all icons, even the least sophisticated of eighteenth- and nineteenth-century works, this is only because an acquaintance with masterpieces has taught them that even in an icon of this kind can be seen the barely perceptible reflection of great art.

BORIS AND GLEB, two of the most revered Russian martyr-saints, were frequently depicted in icons, but never more superbly than in the fourteenth-century image in the collection of the Russian Museum (p. 258). The central Russian artist who painted it must have done so in the most difficult years of the Mongol invasion, but in it he recorded his memory of the glorious Kievan era. He did not invent anything new in terms of iconography: the physiques of the princes, their postures and clothes had been determined by his predecessors. But the familiar, almost identical silhouettes of the ill-fated brothers—innocent victims of the

Saints Boris and Gleb, artist unknown.

internecine strife of the aristocracy—appear in this icon transfigured by the power of art. This is not simply a portrait of two men; they have become signs. The entire icon is invested with the character of a heraldic emblem. The similarity of the two silhouettes expresses their fraternal unity, as does Boris' sword, which stands between them. Gleb's sword is echoed by the cross in his elder brother's hand. No ground is shown beneath their feet, which gives the figures lightness and spirituality, unlike contemporary images of warrior-saints. Nonetheless, the two figures are stable and balanced. The spaces between their bodies is in rhythmic proportion; they are set beautifully in the rectangle of the panel. By virtue of cross-coloring, the hues of the cloaks and kaftans are not so much qualities of the garments as compositional elements of the icon.

All these features are in keeping with the characters of Boris and Gleb. They are not so much warrior-princes or martyrs as examples of moral staunchness and spiritual nobility. The two

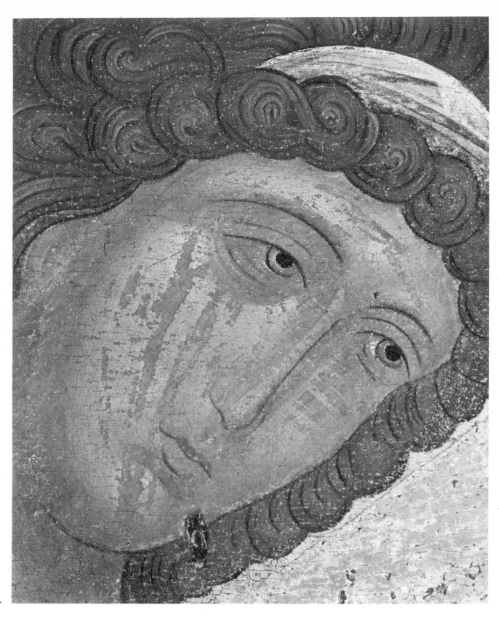

Archangel Michael, Andrei Rublev.

figures comprise an integral whole, anticipating the three angels in Rublev's *Old Testament Trinity.* And when one recalls contemporary Constantinopolitan representations of holy warriors as effeminate fops in the mosaics of Kariye Camii, the loftiness of the moral ideal embodied in the Russian icon is especially striking.

Another *SS. Boris and Gleb* is preserved in their church at Kolomna (pp. 260–261). The modern viewer is impressed by the troubled gaze of these brothers, which hints at a premonition of their tragic destiny. Their bright cinnabar and emerald cloaks, and the touching story of their lives set in border scenes, also rivet the attention.

A Novgorodian icon of the same period shows squat figures so characteristic that it is quite clear they are not Kievan princes but some Nov-

gorod merchant's sons, wearing rich red kaftans.

The *Zvenigorod Deesis* tier painted by Rublev—the *Savior,* the *Archangel Michael* (p. 272), and the *Apostle Paul*—is on a par with the painter's famous *Old Testament Trinity* in terms of aesthetic significance, a truly outstanding masterpiece of early fifteenth-century art. The face of Rublev's Savior commands the viewer's attention, with its kindly, pious, and at the same time open and penetrating gaze, directed straight at the viewer. The face of the Archangel Michael has survived the passage of time better than Rublev's other angels, and its proportions and fine spirituality are closer to pre-Mongol canons. It is hardly surprising to learn from Joseph Volotsky that Rublev spent hours contemplating ancient icons; he did not pray, but looked at and studied them closely,

with utter absorption. In the *Archangel Michael,* everything that is "too human," too carnal and earthy, falls away, is shed as superfluous. We see only the "dissimilar similarity," the pale shadow of humanity. Here we are close to the very essence of human nature, to its "nearness to the divine." We enter a sphere where there is neither grief nor joy, neither sorrow nor smiles, where everything sheds its crude tangibility.

An enormous upsurge of moral power was needed to create such an image. Rublev's *Archangel* will always be profoundly stirring in its spiritual force, but we should not forget that it is also the embodiment of a great artist's special vision and form of expression. The Archangel's features are portrayed so delicately and lightly that they seem to have been incised on the board; contrasts of light and shade disappear, and a luminous golden, all-pervasive hue remains, a glow which expresses heavenly beatitude. The features have a logic of their own. The nose is a slim tree trunk; the eyebrows curve on both sides like the branches of a tree. The arcs of the eyebrows are echoed in the wavy hair, and the rounded outlines become a kind of refrain running through the icon. This is not done demonstratively, only as a hint. A keen study must be made of every feature to appreciate the spiritual beauty inherent in this icon.

Rublev's *Old Testament Trinity* (pp. 270–271) is deservedly the best-known work of Russian icon-painting. It displays the finer points of religious art in its purest form: philosophical depth and conviction, symbolism, technical skill, and profound significance of pictorial form, composition, rhythm, and color. It goes without saying that the icon's significance is not merely that it supplies an irreproachably Orthodox answer to the question of the nature of the Old Testament Trinity, over which heated controversy raged between the official Church and the heretics.

Rublev's solution to the iconographical problem (which aspect of the Trinity was expressed by each of the three figures) was not to show the difference between them but rather to demonstrate their spiritual unity and indivisibility—a point that none of his predecessors was able to make so masterfully. The artist's imagination prompted him to paint the three enchantingly beautiful figures seated around a table, as if for a meal. In this symposium, this friendly exchange, each figure is wonderful and spiritual in

its own way. The slim hands are beautiful, especially the left hand of the angel on our right, holding a staff. There is an expression of love and mutual understanding on the angels' faces. The totality is a harmonious, integral whole, a wreath; set within a circle (or perhaps an octagon), it acquires the rhythmic form of a musical refrain.

In this visual, almost tangible form we divine a higher meaning—the logic of the universe, which seems the highest wisdom attainable by man, the three-in-one, the prototype, the model of the world. Perhaps in his imagery Rublev employed the ancient well-known object-symbols: the wing to denote flight, the bowl as bitter fate, the mountain as spiritual ascension, the tree as the Tree of Life, and architectural details as home-building. But these motifs are seen in such juxtaposition and interrelation as to be part of the pictorial fabric (especially the bowl, the configurations of which are echoed by the space between the figures), in such a way that we derive special pleasure in the very contemplation of it all. We realize that here is an ascent from the particular to the general, to something of significance for all mankind. We can apprehend the ideas behind these objects without losing the beauty, the charm of the pictorial surroundings.

The Ostroukhov *Entombment* (p. 285) deservedly enjoys world renown. We still do not know the name of the painter or his school, although we know the iconographic prototype. The small 1488 icon on the same theme in the Tretyakov Gallery looks like either a preliminary imperfect sketch or a clumsy copy of a common original. Only in the Ostroukhov icon does the image acquire a profound meaning and perfection of form to which nothing can be added, from which nothing can be taken away. The artist gives the traditional type a new interpretation. The upraised arms of the woman cloaked in red express her grief and at the same time an incantation, a ritual gesture. This scene is both a lament for the departed and a solemn rite, a succession of stately figures, bowed and upright. Every participant is finely characterized by gesture and posture; nevertheless, each is obedient to the austere, measured rhythm as if to a law.

The icon keeps to warm tones, brown and orange hues. The only accents are the snow white winding sheet on the body of the dead Christ, and the woman's flame red cloak. Within the context

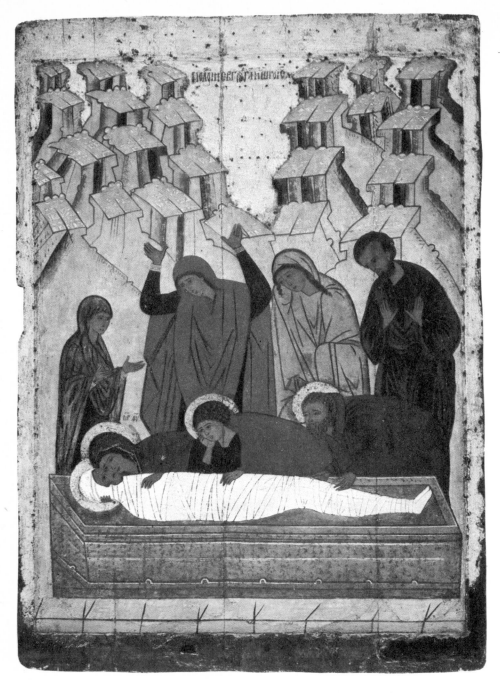

Entombment, artist unknown.

of the whole work, the colors are the vehicle of spiritual expression. The hills in the background repeat the outlines of the woman's arms, but with a downward movement that rivets our attention on what is taking place on earth.

The two large icons of *SS. Peter* and *Alexius,* Metropolitans of Moscow, with scenes from their lives, are masterpieces by Dionysius. The icon of *St. Alexius* (p. 286–287) is especially fine. At first glance the figures of the Metropolitans seem to express only majesty, grandeur, and resplendence; but this is the outward, official aspect. There is another: the moral majesty of the images, the pure poetry of color and form. These icons, painted for the main cathedral in the capital city, were commissioned for the glorification and exaltation of the Moscow principality in the persons of political and ecclesiastical figures.

One of the essential features of Dionysius' poetic design is accentuation of certain elements. In the central panel the face of the saint is shrouded in half-shadow, almost obscured in deep contemplation, while in contrast the richness of his garments is emphasized—the precious brocade of the robe and the white *omophorion* with a design of black crosses. This gives the figure greater

intensity, greater spirituality; the opulent garments seem to fall away, to reveal the saint's spiritual nature. Border scenes telling the story of Alexius' hard ascetic life form a colorful wreath around his image.

In Dionysius' *Crucifixion* (p. 291), the traditional iconography is given a new interpretation. This crucified Christ is a triumphant being, soaring into the heavens, spreading his arms over the world, ready to embrace it. The figures of the intercessors are also light and slim; the whole scene seems to soar rather than stand. But the most remarkable thing is what takes place in heaven. Surrounding the tall, slender figure of Christ are extremely diminutive angels, a contrast which introduces elements of space and depth into the icon. The little figures soaring in the sky form something of a garland around the Tree of Golgotha; they decorate it like flowers; they define the invisible circle which contains the figure of Christ.

It is practically impossible to convey these characteristics of the *Crucifixion* in words; they are hardly perceptible to the eye. It is, however, these barely discernible deviations from the canon that distinguish Dionysius' icon from all others on the same theme.

The *Apocalypse* of the Kremlin Master (p. 294) is an outstanding work in both conception and execution. In this case the painter had no iconographical prototype to follow. Everything was left to his own powers of invention, and he gave the Revelations of St. John a unique interpretation. This is not a story of the grim trials and horrors that will confront mankind at the end of the world, but a glorious dream of the coming kingdom of justice and harmony. True to the finest teachings of Rublev and close in pictorial vocabulary to Dionysius, in this immense icon with its hundreds of figures the Kremlin Master displayed a rare inventiveness and versatility. What he portrays here is not a literal translation of the text into visual form. It is a truly inspired creation: the creation of a new legend and a new myth, about people, about angels, about the appearance of God and the ordeals of mankind.

EARLY RUSSIAN ICON-PAINTING of the golden age spoke with such clarity of language that one would think its creators were straightforward,

simple-hearted people. In fact, icon-painting is a great, mature art, based on a profound understanding and great technical mastery requiring a special comprehension of linear design, composition, space, color, and light.

The purpose of linear design in icons was to convey the outlines of recognizable objects, but it could also help to reveal the relationships between objects. The graphic metaphor is a common element in Russian icon-painting; it is a poetic likening of the human figure to a hill, a tower, a tree, or perhaps to a flower or a slim vase. The delineation may also be pictorially effective; for example, the angels in Dionysius' *Crucifixion* (p. 291), who seem to soar in mid-air, thanks to the linear rhythm.

Almost every icon was thought of as a likeness of the world, and accordingly each has a central axis. The space on either side of the central axis is usually perceived as side wings or leaves, rather like a triptych. The upper part is seen as the sky, the higher ranges of life, while down below is the earth and, in some cases, hell beneath it. This structure influences every composition, whatever the subject, Nativity or Crucifixion, Baptism or Intercession. Besides the three-part structure with emphasis on the central axis there is another, two-part type, in which the central axis is only a divider. In such cases, the figures surround an empty space, and the composition preserves its symmetry of form and meaning. But even where there are deviations from this convention—and there are some—the basic scheme preserves its meaning, reminding the viewer of the necessity of maintaining order and balance in a world where every movement gives rise to a counter-movement.

The Russian icon should not be looked upon as purely two-dimensional art, like the Persian miniature; but it also should not be considered at fault because, unlike Western painting of the Renaissance, it is not strictly consistent in terms of perspective. Elements of spatial depth appear in icons now and then, but the space of the golden age is definitely different in kind from that of the seventeenth century, when Russian painters began to imitate the West. Space is not a definite entity, which is entered or left by the figures. It exists in uninterrupted connection with the figures, is brought into being by them, and is expressed through their movements or positions. It

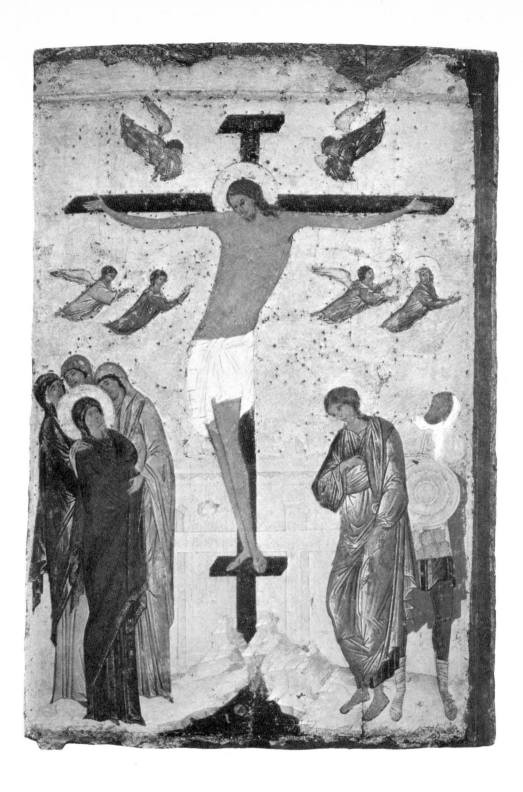

Crucifixion, Dionysius.

is a derivative of the inner life of the icon and consequently cannot be measured.

The accepted critical term "inverse perspective" is misleading, possibly giving the impression that early Russian icon-painters actually aimed at some kind of "inside-out perspective." To understand the way space was organized in the icon, let us study a border scene by Dionysius, the *Discovery of the Remains of Alexius* (p. 286). The artist represents the figures and buildings on three planes, very clearly narrating the action. The saint in his coffin is contrasted to the figures standing beside it. Only the bowed head of the prince and the inclined lid of the coffin convey an idea of what is taking place. But because of the reverse perspective, the sarcophagus seems to be suspended in mid-air. The feeling is conveyed that it now belongs to a different world from the rest of the

figures and the buildings in the background, and the entire scene acquires a highly spiritual character.

The colors of early Russian icons won general appreciation long ago. But the impression of bright joy and rich and varied hues does not exhaust the significance of color to this complex art. Colors in icons are not at all those of nature; nor do they obey conventional symbolism—it cannot be said that each of them has a consistent meaning. But colors are of decisive importance in the creation of images. At times, with just one color a profound characterization is achieved. In the icon of the *Prophet Elijah and the Fiery Chariot* (p. 303), the red of the sky into which the Prophet ascends is as powerfully expressive as his furious gaze.

Early Russian painters inherited the tonal palette of the Byzantines, with its subdued, dull hues expressing a mood of repentance. In the fourteenth century, Theophanes appeared as the master of low-brilliance saturated tints: cherry red, dark blue, dark green, and brown. He had superb control over the interplay of complementary colors and over illumination. In the *Transfiguration* (p. 267), the light falls on bodies cloaked in darkness, like heavenly bliss on sinful earth.

Written texts of the period list the favorite colors of icon-painters—ochre, cinnabar, red, purple, *golubets* blue, emerald green, and others—but in actual fact their palette was much bigger. Besides the pure primary colors, there were many intermediate hues of varying brilliance and saturation, among which are some exquisite shades of red and violet, and others that have no name and cannot be described in words but can be caught only by the eye—colors that glow, shine, sparkle, conveying tremendous joy. In thirteenth- and fourteenth-century icons we can see a love of pure, bright colors, not clouded by highlighting or interrupted by gold hatching. In these early works, the bright glowing cinnabar dominates, as an expression of joy and festivity. The clear colors enable the icons to cast their spell even in the half-gloom of a church interior. Frequently, pure colors are juxtaposed in contrast: red, blue, white, and black. These colors have body; they are solid, almost weighty and tangible, which somewhat limits their radiance; but they impart to the icons an immense power of expression.

Rublev's color range, above all in his *Old Testament Trinity*, possesses a purity unusual in Byzantine icon-painting. His *golubets* burns with a blue flame. The predominance of cold colors, of blue, violet, and emerald green in icons by Rublev and the painters of his school, gives them a character of lofty spirituality. In his *Zvenigorod Deesis* there is not a trace of Byzantine gloom, nor of the carefree, joyous, motley colors of the Novgorodian icons.

In the work of Dionysius and the painters of his circle, colors have one precious new quality: they lose some of their brilliance and saturation but acquire radiance. This marks the final departure from Byzantine tradition. Light is no longer laid over color—highlighting does not break it up. The colors become translucent, distantly resembling stained glass or watercolors. The white gesso ground can be seen through them.

In the icons of the sixteenth and seventeenth centuries, dark tones dominate, at first highly saturated, ringing and noble, later replaced with dull earthy shades, a considerable proportion of black, and dark green backgrounds. Even the golden glow of the Stroganov icons cannot be compared with the radiant colors of Dionysius.

THE RUSSIAN SCHOOL of icon-painting produced remarkable works of art, but what checked its evolution? Was it the desire to emulate the foremost Western countries that led to the sacrifice of the traditions of the Russian past? Even acknowledging the partial accuracy of this explanation in the time of Peter the Great, it is natural to ask whether the art form inherently possessed certain features that rendered it unable to withstand the impact from outside.

A century ago, Fyodor Buslayev reproached early Russian painting for lagging behind the Renaissance in the West, for "lacking the correct draftsmanship, perspective, and color range, rendered intelligible by light and shade." Today, such reasoning carries no conviction. It is clear that early Russian icon-painting had valuable qualities of its own, and was an art form in its own right. But there was something else that robbed it of viability: the efflorescence of art in fifteenth-century Russia was not accompanied by the development of a new and humanistic culture. Long before Peter the Great, the autocrats and the Church sapped religious art of its strength when

they made it a weapon for their own use. Icon-painting lacked the vitality to pass on the traditions of the past to secular art. It began to acquire the features of handicraft. The creative impulse survived only among the mass of the people, in distant places, in the provinces, in peasant art, in icons resembling popular *lubok* prints, in the painted decoration on spinning wheels. This was no longer great art. We cannot say that it absorbed the legacy left by the great masters of icon-painting.

What place in art history should be given to early Russian icon-painting? In Russia it stands somewhere between the art of the Scythians and the Antes and the time of Peter the Great. In the history of Byzantine art it looks like an offshoot of the art of the Comnenian period, and in particular of the Palaeologan style. In the history of European art it is analogous to the autumnal withering of the late Middle Ages. But beyond these external, formal characterizations lies the true significance of early Russian icon-painting: an artistic phenomenon that is unique and of great aesthetic value. Its treasures belong to the world, placed alongside the vases of ancient Greece, Etruscan murals, Byzantine mosaics, Gothic stained glass, Persian miniatures, and the altarpieces of the early Italian Renaissance.

Virgin of the Great Panaghia, Detail

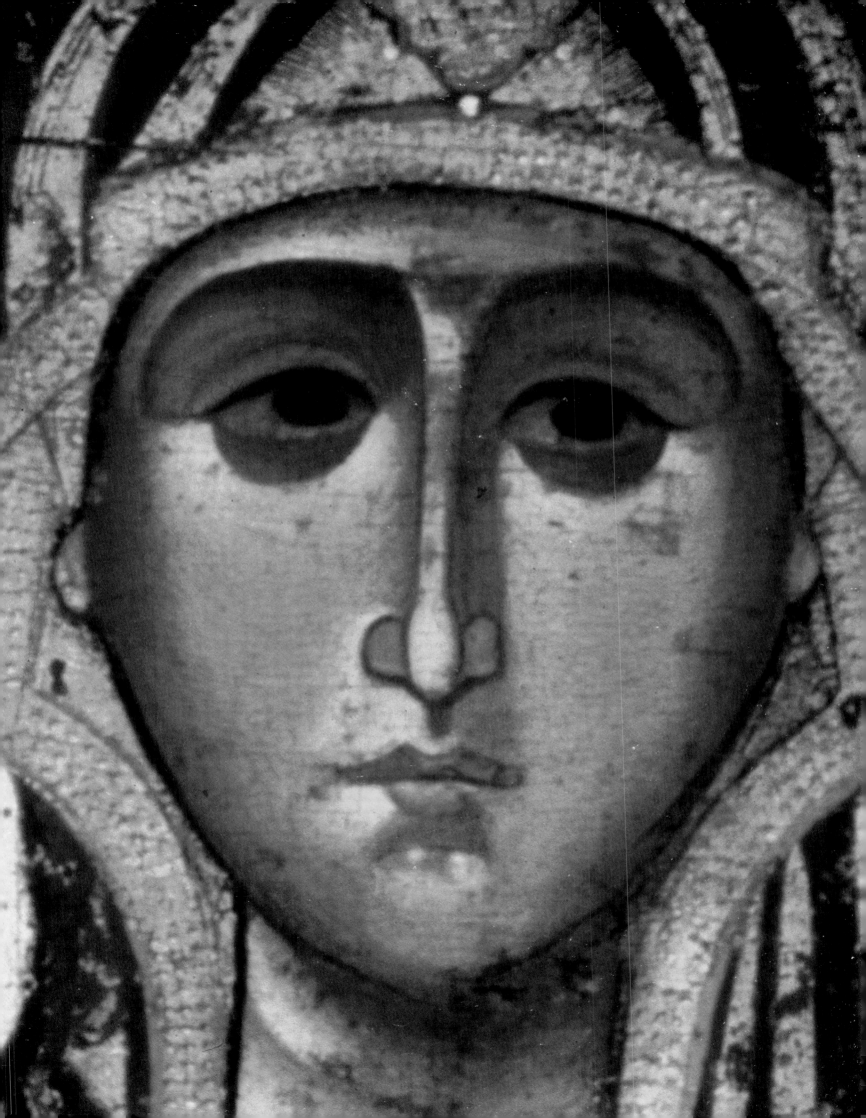

Opposite:
Virgin of the Great Panaghia, called
Virgin Orant of Yaroslavl
Tempera on wood, 194 x 120 cm. (76⅜
x 47¼ in.); Spaski Monastery,
Yaroslavl, twelfth century; Tretyakov
Gallery, Moscow.

Left above and below:
Virgin of the Great Panaghia, Two details

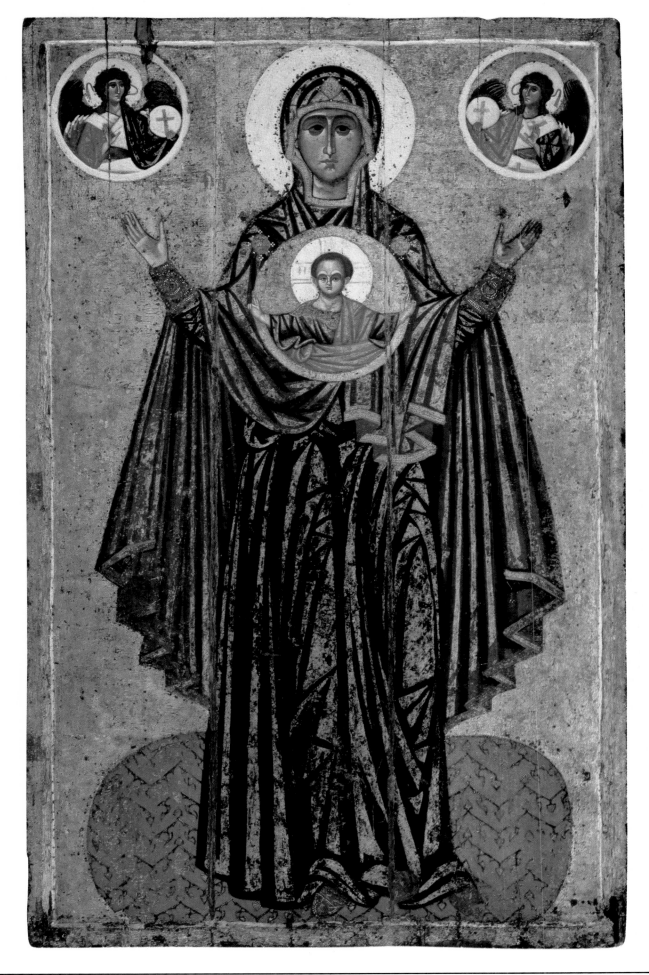

St. Nicholas with Saints
Detail: Head of St. Nicholas
Tempera on wood, total measurement 145 x 94 cm.
(57⅛ x 37 in.); Cathedral of the Virgin of Smolensk,
the Novodevichy Monastery, twelfth century;
Tretyakov Gallery, Moscow.

Opposite:
St. Nicholas, Detail
Tempera on wood, total measurement 68 x 53 cm.
(26¾ x 20⅞ in.); Dukhov Monastery, Novgorod, late
twelfth century; Russian Museum, Leningrad.

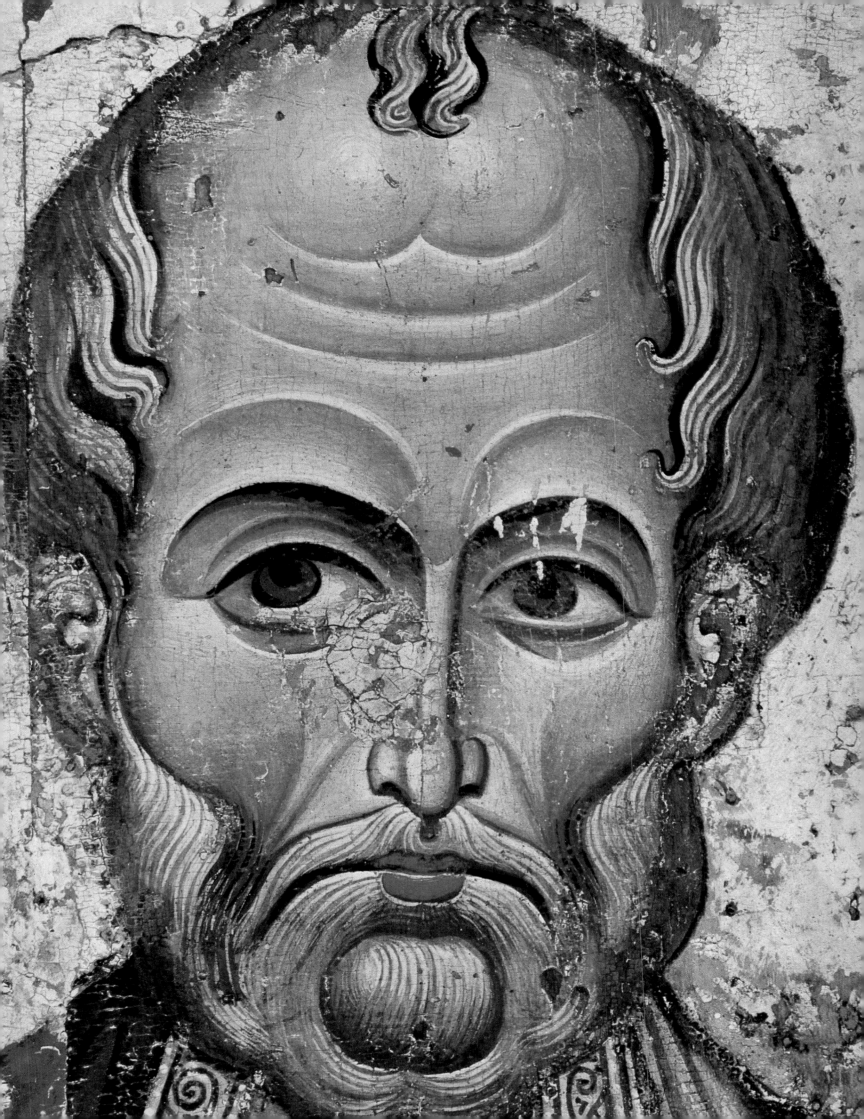

SS. Boris and Gleb
Tempera on wood, 193 x 95 cm. (76 x 37⅜ in.);
central Russian school(?), early fourteenth century;
Russian Museum, Leningrad.

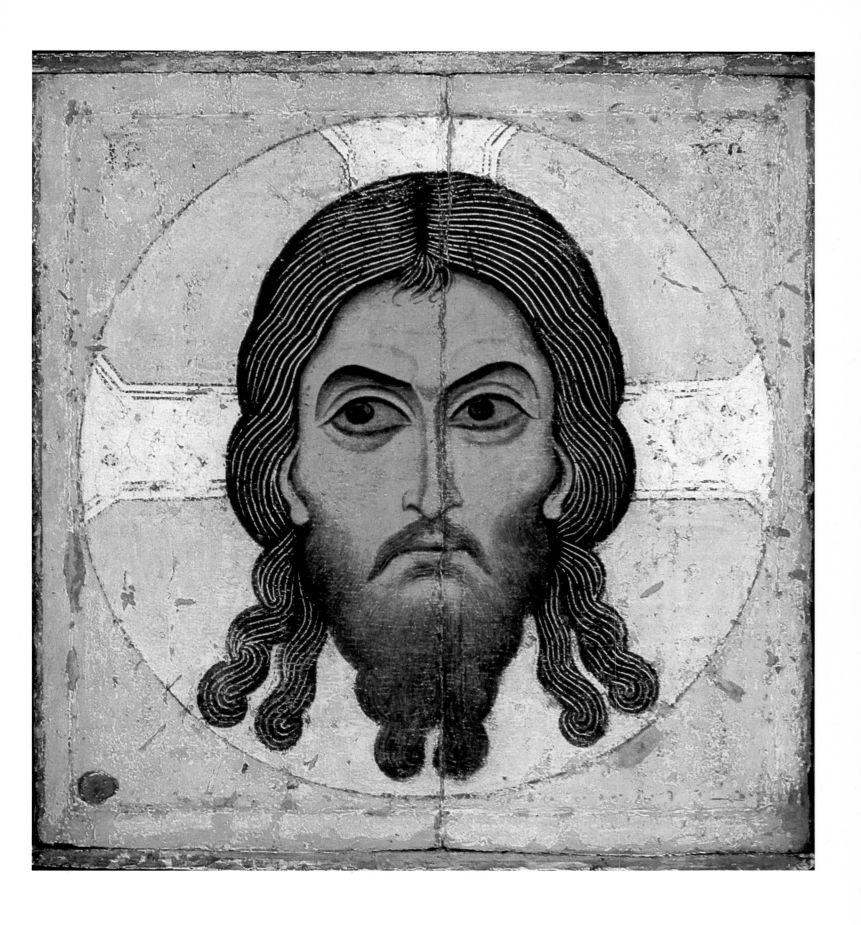

Christ of Veronica
Tempera on wood, 77 x 71 cm. (30¼ x 28 in.);
Cathedral of the Dormition, Kremlin, Moscow,
twelfth century; Tretyakov Gallery, Moscow.

Opposite:
SS. Boris and Gleb with Scenes from Their Lives
Tempera on wood, 134 x 89 cm. (52¾ x 35 in.); preserved at Church of SS. Boris and Gleb, Kolomna, fourteenth century.

Above and below left:
SS. Boris and Gleb with Scenes from Their Lives
Details: Two scenes

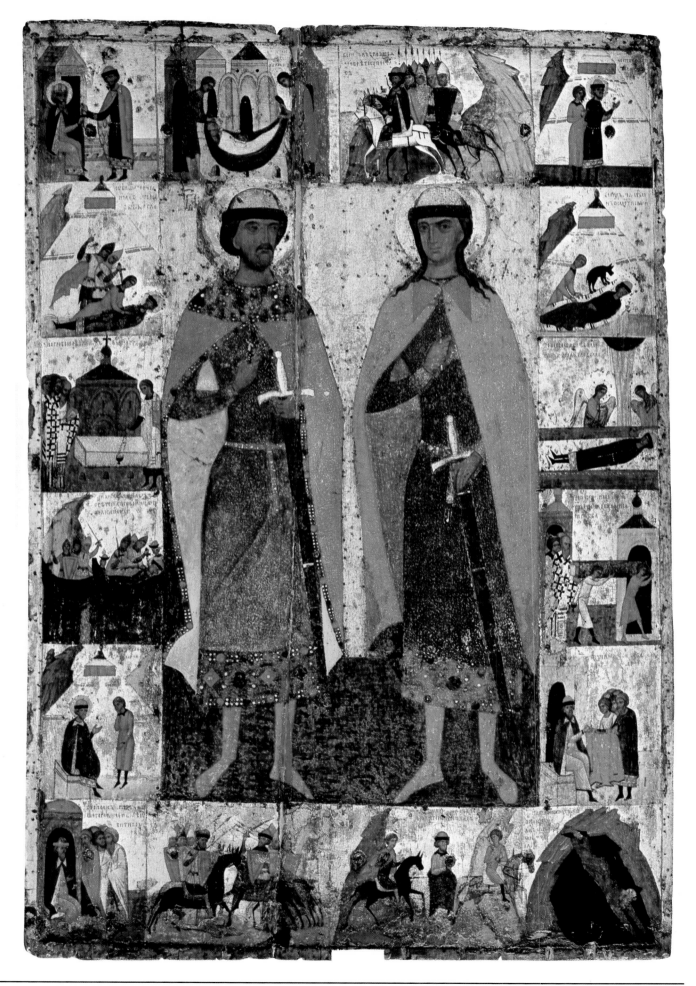

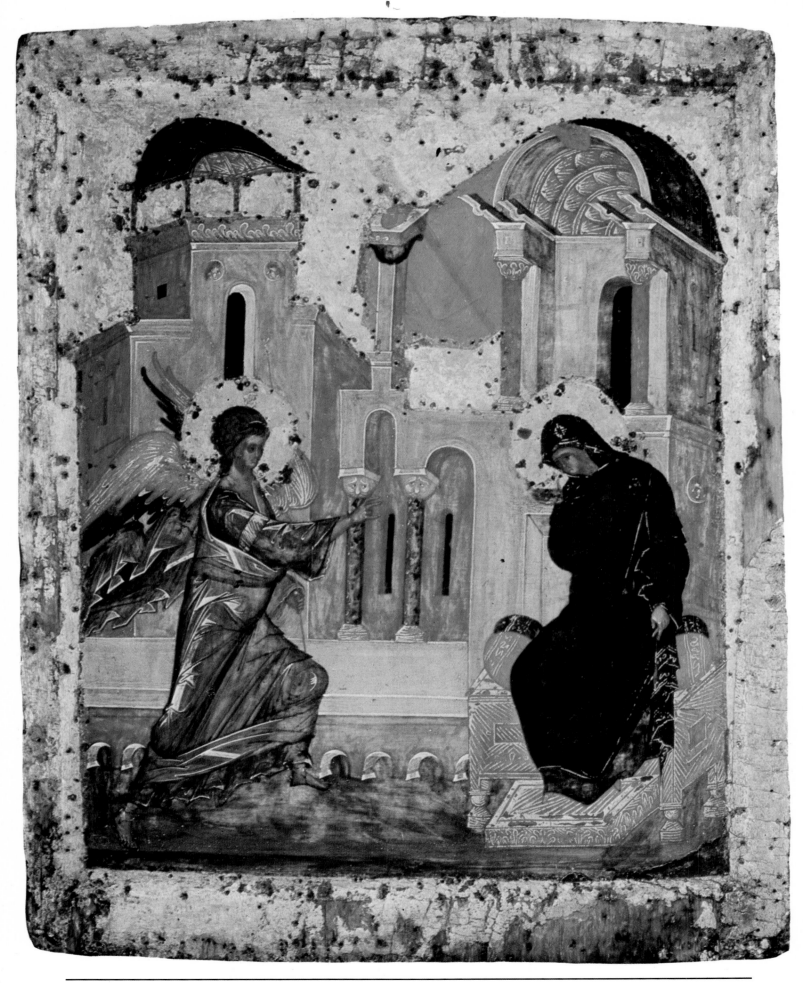

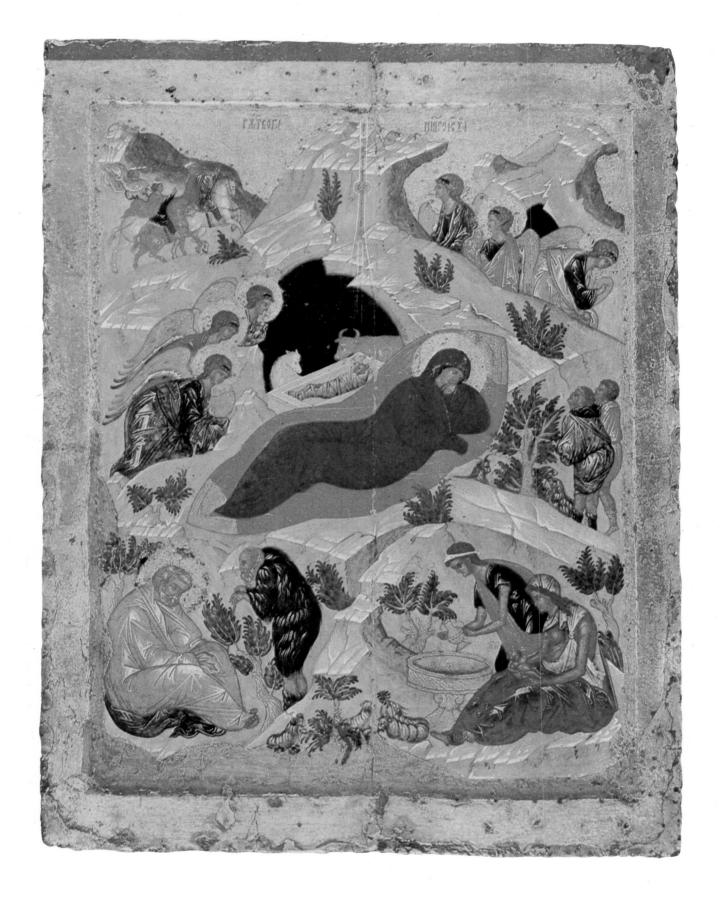

Opposite:

Annunciation
Tempera on wood, 43 x 34 cm. (16⅞ x 13⅜ in.);
Trinity Sergius Lavra, fourteenth century; Tretyakov
Gallery, Moscow.

Nativity of Christ
Tempera on wood, 71 x 53 cm. (28 x 20⅞ in.);
Church of the Nativity, Zvenigorod, early fifteenth
century; Tretyakov Gallery, Moscow.

Above left:
Virgin
Theophanes the Greek
Tempera on wood, 211 x 121 cm. (83⅛ x 47⅝ in.);
1405; from the Deesis tier, iconostasis, Cathedral of the
Annunciation, Kremlin, Moscow.

Above right:
St. Basil the Great
Theophanes the Greek
Tempera on wood, 211 x 121 cm. (83⅛ x 47⅝ in.);
1405; from the Deesis tier, iconostasis, Cathedral of the
Annunciation, Kremlin, Moscow.

Transfiguration, Detail
Theophanes the Greek

Opposite:
Transfiguration
Theophanes the Greek
Tempera on wood, 184 x 134 cm. (72½ x 52¾ in.);
Cathedral of the Transfiguration, Pereslav, early
fifteenth century; Tretyakov Gallery, Moscow.

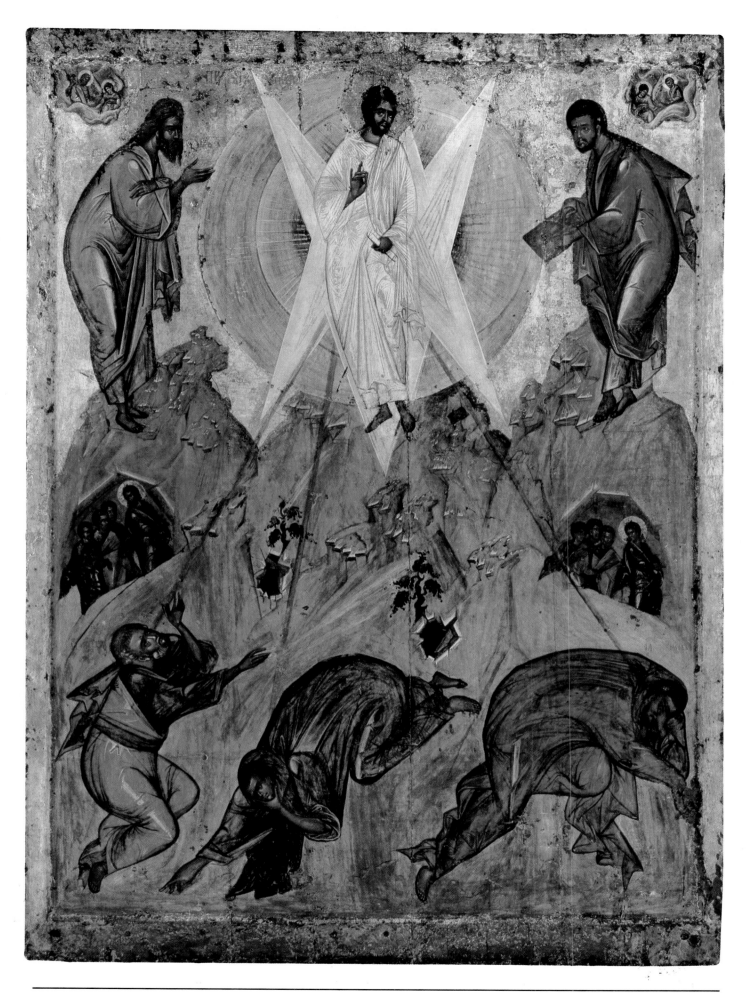

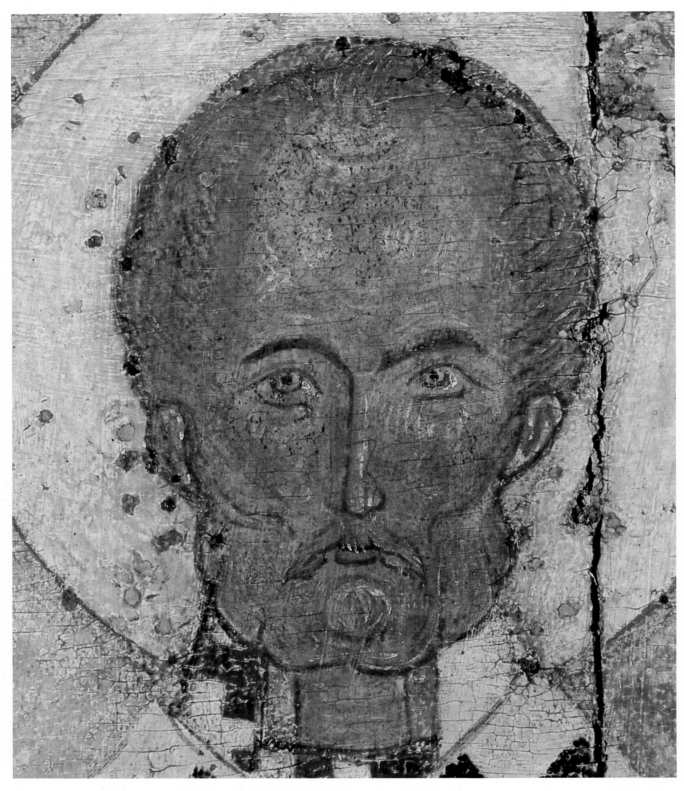

St. Nicholas of Zarisk with Scenes from His Life
Detail: St. Nicholas' head
Tempera on wood; fourteenth century; Tretyakov
Gallery, Moscow.

Opposite:
Virgin of the Don, Detail
Theophanes the Greek
Tempera on wood, total measurement 86 x 68 cm.
(33⅞ x 26¾ in.); Cathedral of the Annunciation,
Kremlin, Moscow, late fourteenth century; Tretyakov
Gallery, Moscow.

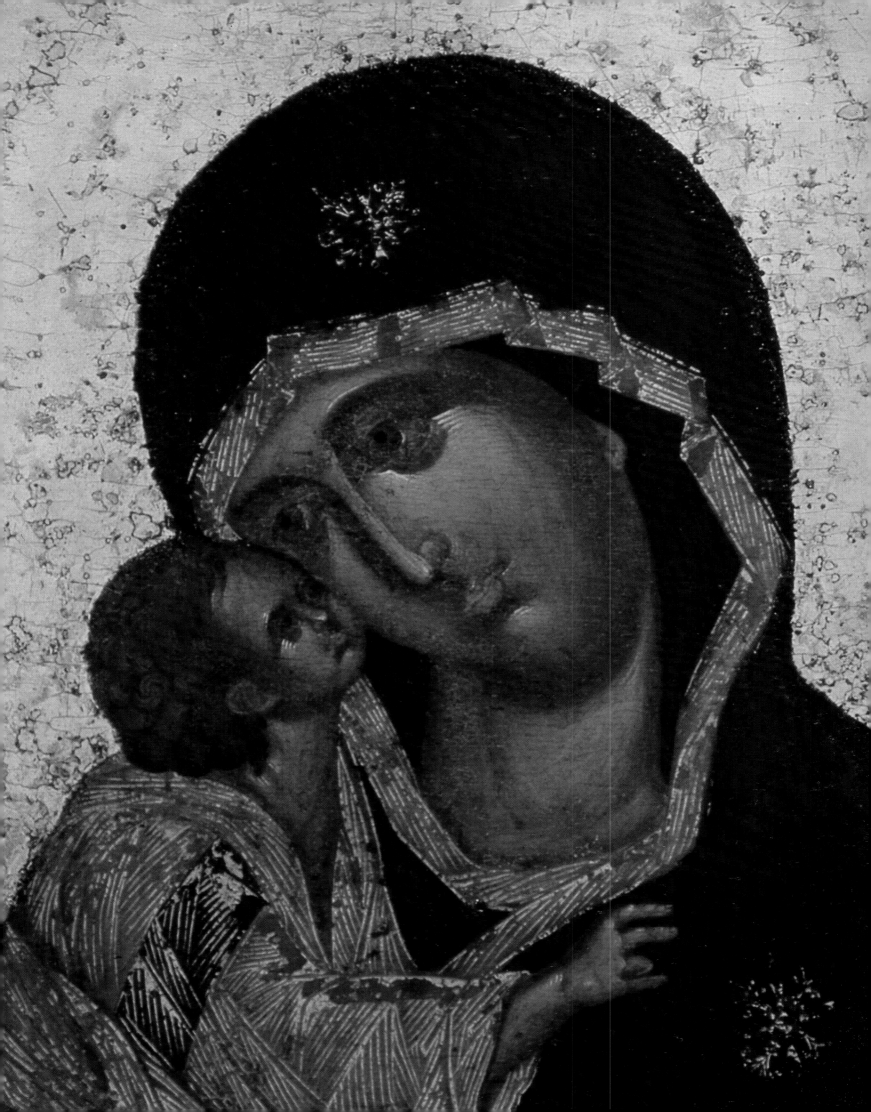

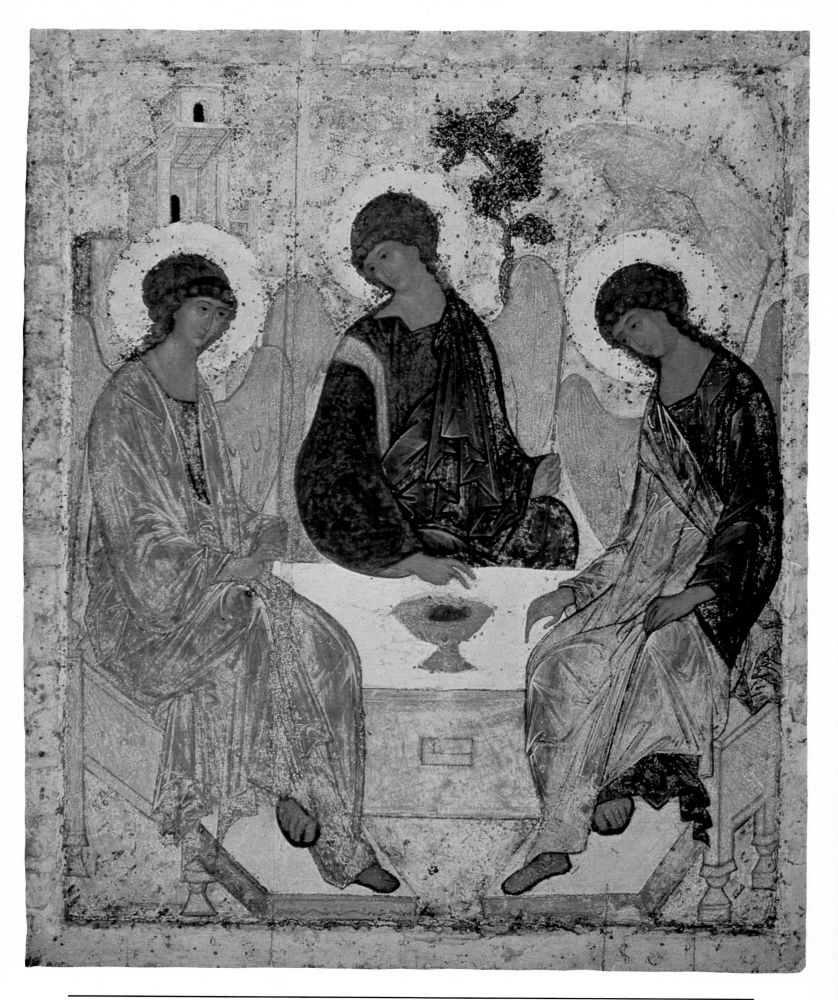

Opposite:
Old Testament Trinity
Andrei Rublev
Tempera on wood, 142 x 114 cm. (55⅞ x 44⅞ in.); Cathedral of the Trinity, Sergius Lavra, early fifteenth century; Tretyakov Gallery, Moscow.

Above and below right:
Old Testament Trinity, Two details
Andrei Rublev

Archangel Michael, Detail
Andrei Rublev
Tempera on wood, total measurement 158 x 108 cm.
(62¼ x 42½ in.); Zvenigorod, fifteenth century;
Tretyakov Gallery, Moscow.

Opposite:
Apostle Paul, Detail
Andrei Rublev
Tempera on wood, total measurement 158 x 106 cm.
(62¼ x 41¾ in.); Deesis tier, Zvenigorod, fifteenth
century; Tretyakov Gallery, Moscow.

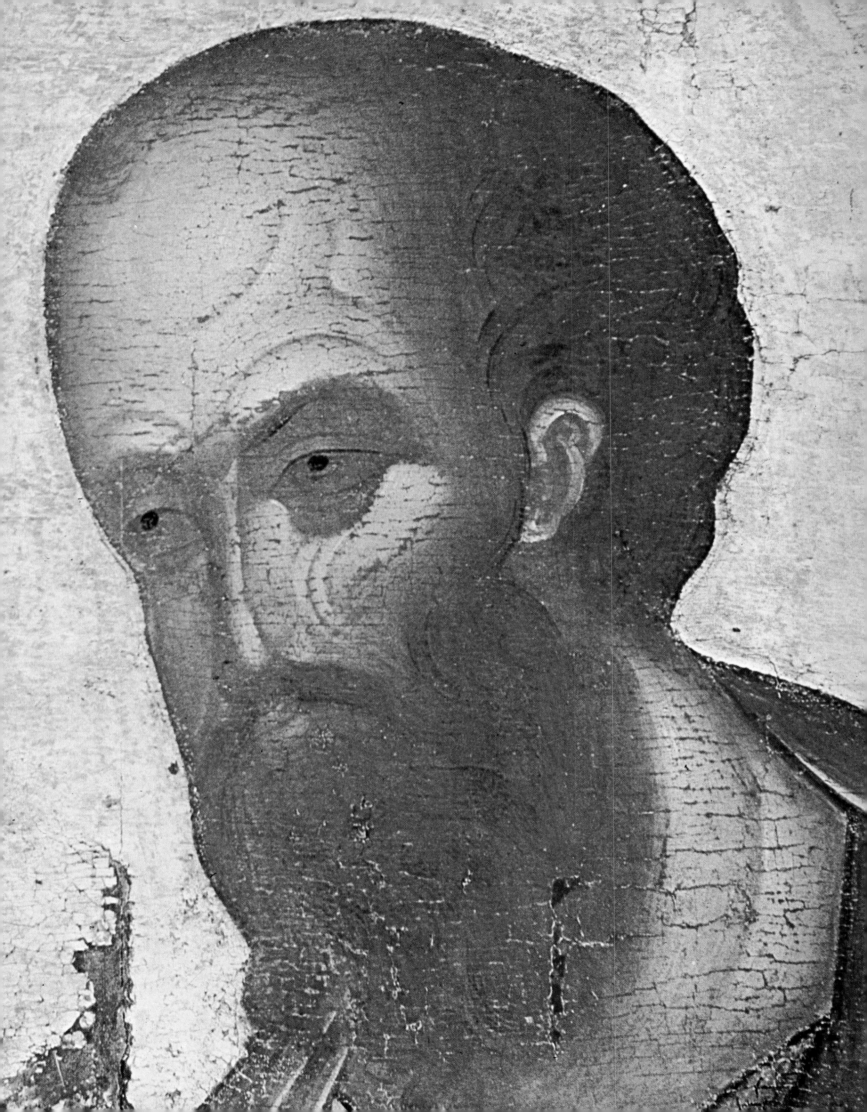

Above:
The Battle of the Novgorodians with the Suzdalians or *The*
Miracle Worked by the Icon of the Virgin of the Sign,
Detail

Opposite:
The Battle of the Novgorodians with the Suzdalians or *The*
Miracle Worked by the Icon of the Virgin of the Sign
Tempera on wood, 126 x 91 cm. (49⅝ x 35⅞ in.);
Novgorod school, mid-fifteenth century; Museum of
Architecture and Ancient Monuments, Novgorod.

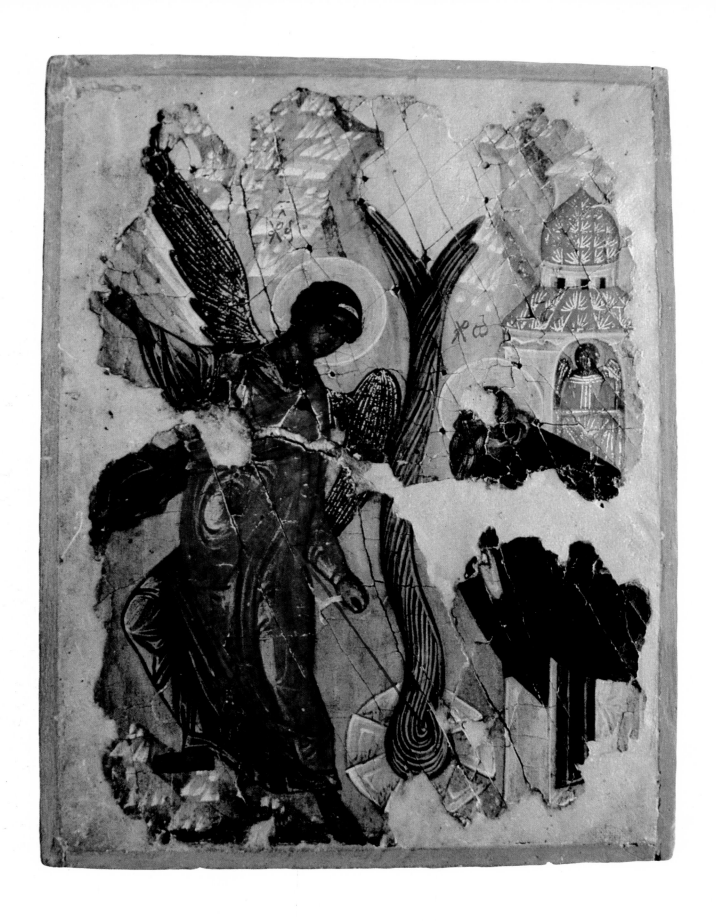

Miracle of *St. Michael at Chone*
Tempera on wood, 20 x 14 cm. (7⅞ x 5½ in.);
Chilandari Monastery, Mount Athos, fourteenth or
fifteenth century; National Museum, Belgrade.

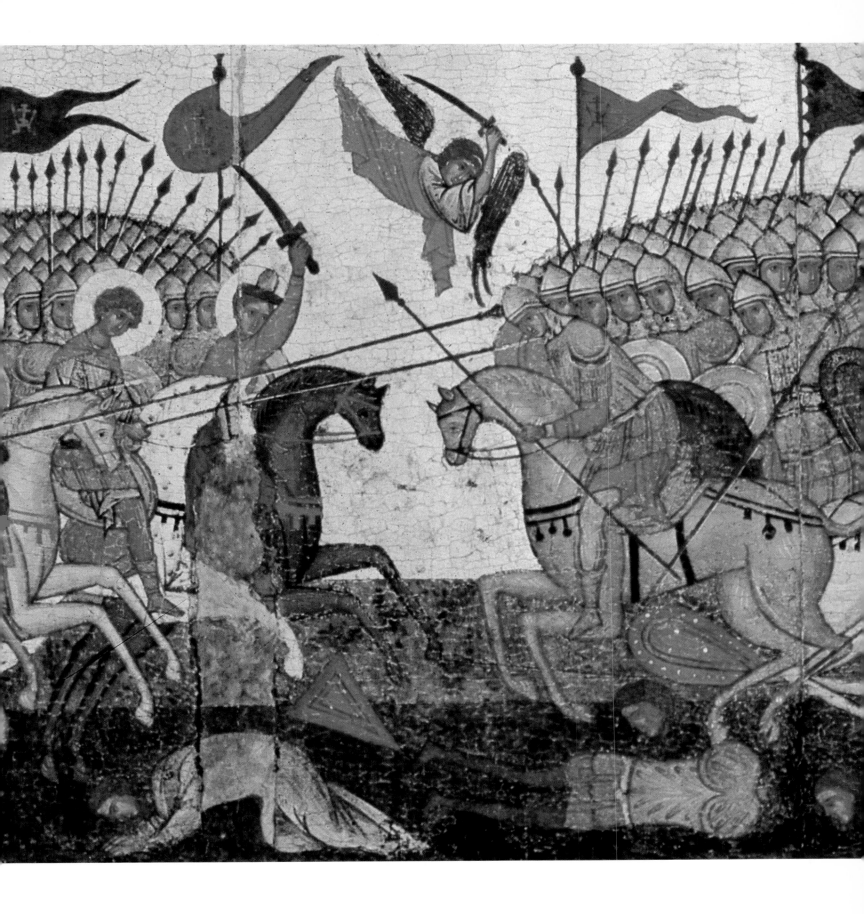

The Battle of the Novgorodians with the Suzdalians or *The Miracle Worked by the Icon of the Virgin of the Sign,*
Detail

Prophets Daniel, David, and Solomon, Detail
Tempera on wood; fifteenth century; Tretyakov
Gallery, Moscow.

Opposite:
Prophet Elijah
Tempera on wood, 75 x 57 cm. (29½ x 22½ in.);
Novgorod school, early fifteenth century;
I. Ostroukhov Collection, Tretyakov Gallery, Moscow.

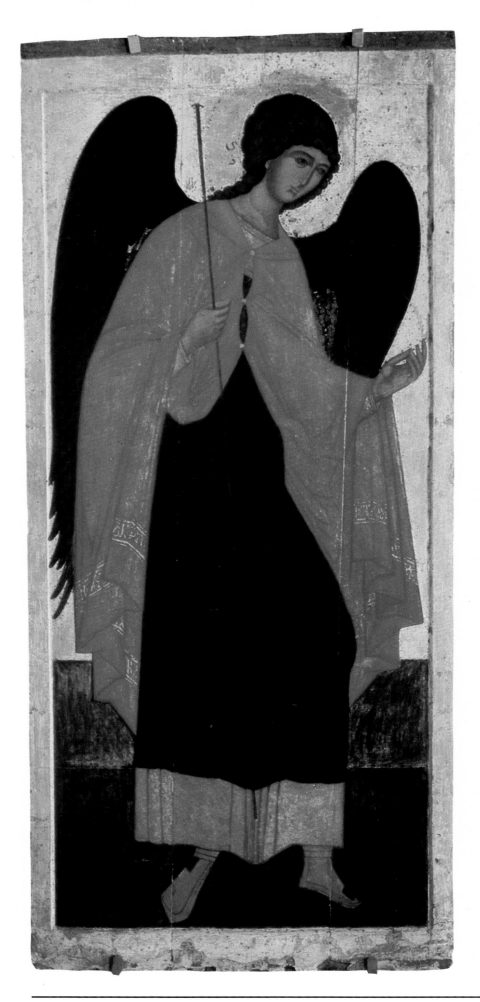

Above:
Last Judgment
Detail: Monks in Paradise

Left:
Archangel Michael
Tempera on wood, 171 x 77 cm. (67⅜ x 30¼ in.); Cathedral of the Spaski Monastery, Yaroslavl, 1516; Russian Museum, Leningrad.

Opposite:
Last Judgment
Tempera on wood, 162 x 115 cm. (63¾ x 45¼ in.); Novgorod school, mid-fifteenth century; Tretyakov Gallery, Moscow.

Incredulity of Thomas
Tempera on wood, 24 x 19 cm. (9½ x 7½ in.);
Cathedral of St. Sophia, Novgorod, late fifteenth
century; Museum of Architecture and Ancient
Monuments, Novgorod.

Opposite:
Harrowing of Hell
Tempera on wood, 91 x 60 cm. (35⅞ x 23⅝ in.); late
fifteenth century; A. Morozov Collection, Tretyakov
Gallery, Moscow.

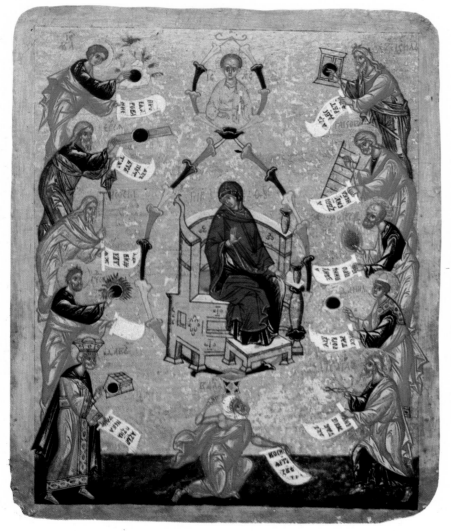

Above left:
Entombment, Detail

Left:
Exaltation of the Virgin
Bilateral icon; tempera on wood, 25 x
10 cm. (9⅞ x 4 in.); Novgorod school,
1450–1500; Tretyakov Gallery, Moscow.

Opposite:
Entombment
Tempera on wood, 91 x 63 cm. (35⅞ x
24¾ in.); late fifteenth century;
I. Ostroukhov Collection, Tretyakov
Gallery, Moscow.

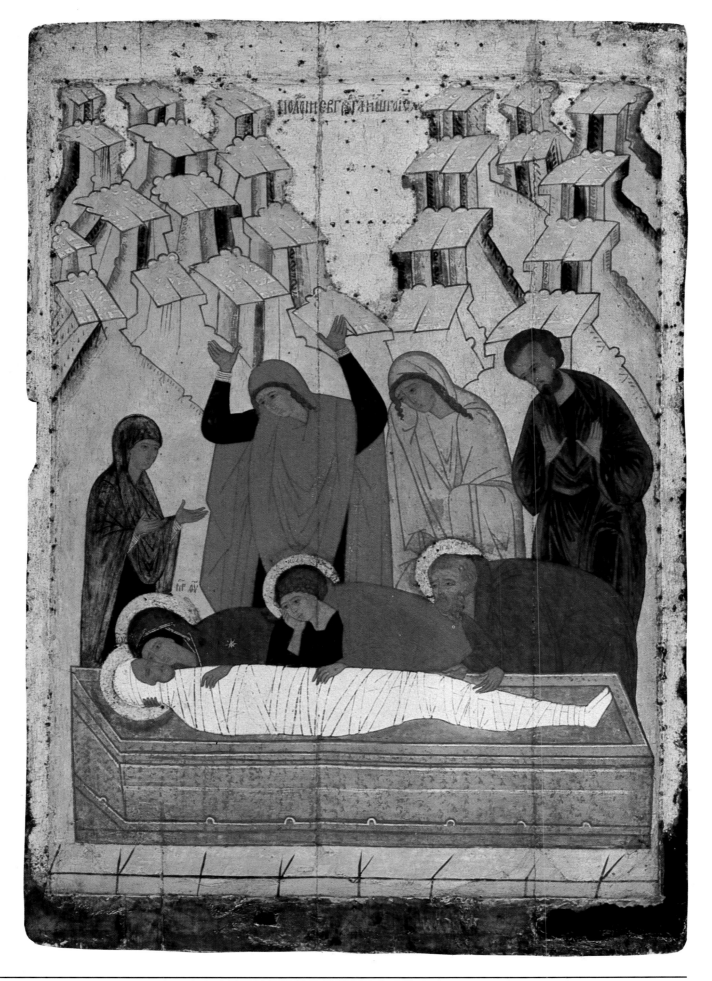

Above left:
St. Alexius, Metropolitan of Moscow, with Scenes from His Life
Border scene: Discovery of the remains
Dionysius
Tempera on wood, total measurement 197 x 152 cm. (77½ x 59⅞ in.);
Cathedral of the Dormition, Kremlin, Moscow, late fifteenth century;
Tretyakov Gallery, Moscow.

Left:
St. Alexius, Metropolitan of Moscow, with Scenes from His Life
Detail of the border scene: Birth of Elevfery-Alexius
Dionysius

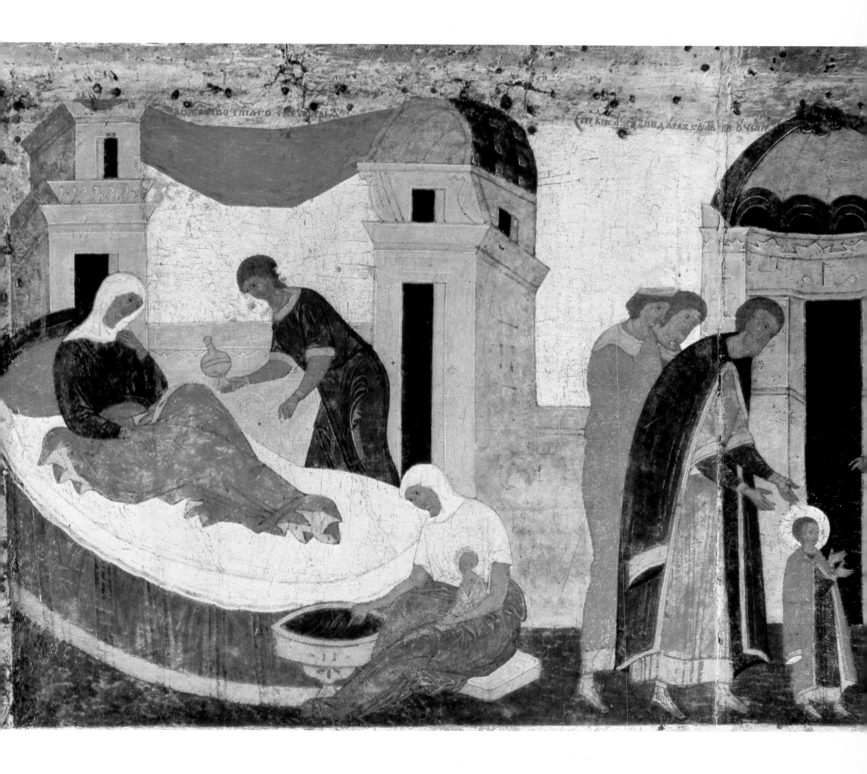

St. Alexius, Metropolitan of Moscow, with Scenes from His Life
Detail of the border scene: Birth of Elevfery-Alexius
Dionysius

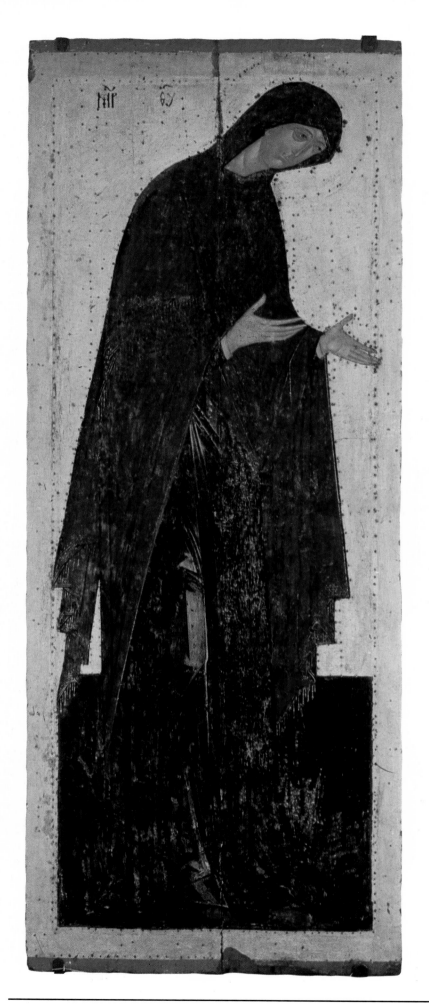

Left:
Virgin
Dionysius
Tempera on wood, 155 x 60 cm. (61 x
23⅝ in.); Church of the Nativity of the
Virgin, Ferapontov Monastery, c. 1502;
Tretyakov Gallery, Moscow.

Opposite left:
St. John the Baptist
Dionysius
Tempera on wood, 155 x 60 cm. (61 x
23⅝ in.); Church of the Nativity of the
Virgin, Ferapontov Monastery, c. 1502;
Tretyakov Gallery, Moscow.

Opposite right:
Apostle Paul
Dionysius
Tempera on wood, 155 x 60 cm. (61 x
23⅝ in.); Church of the Nativity of the
Virgin, Ferapontov Monastery, c. 1502;
Tretyakov Gallery, Moscow.

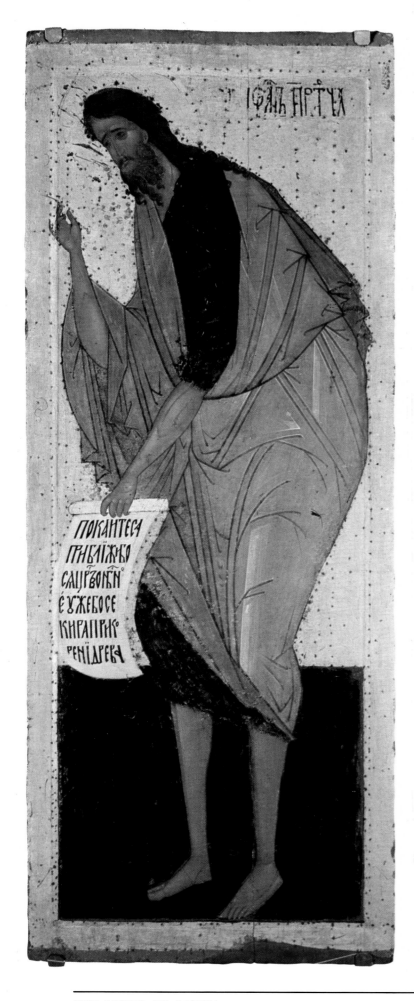

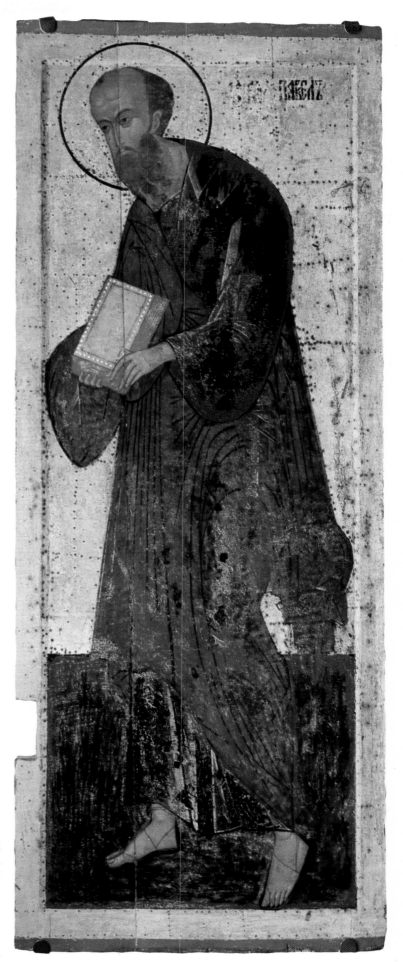

Opposite:
Crucifixion
Dionysius
Tempera on wood, 85 x 52 cm. (33½ x
20½ in.); Trinity Cathedral of the
Monastery of Paul of Obnorski, c. 1500;
Tretyakov Gallery, Moscow.

Above and below left:
Crucifixion, Two details
Dionysius

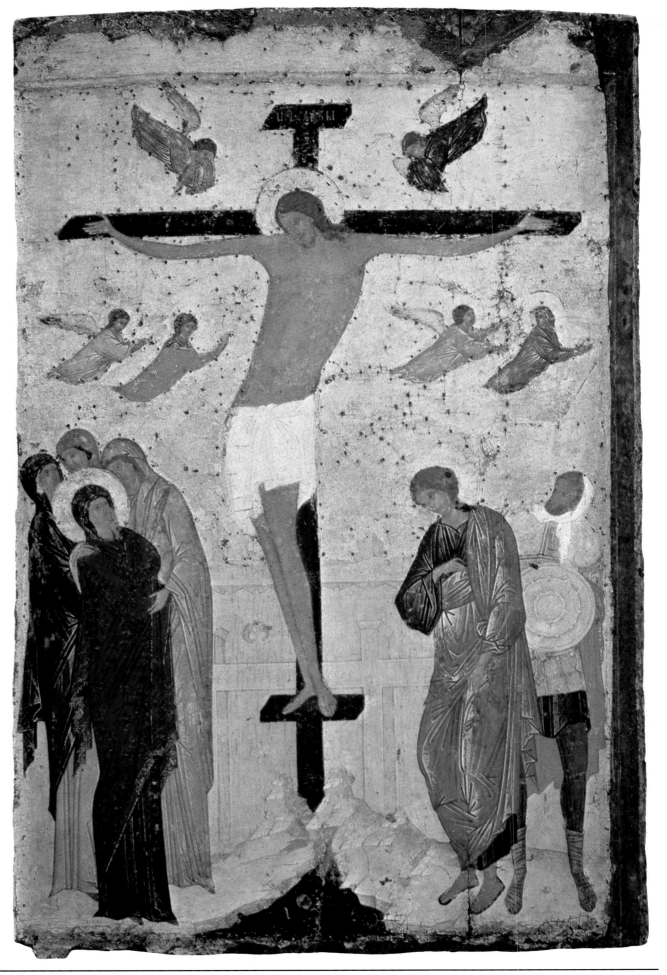

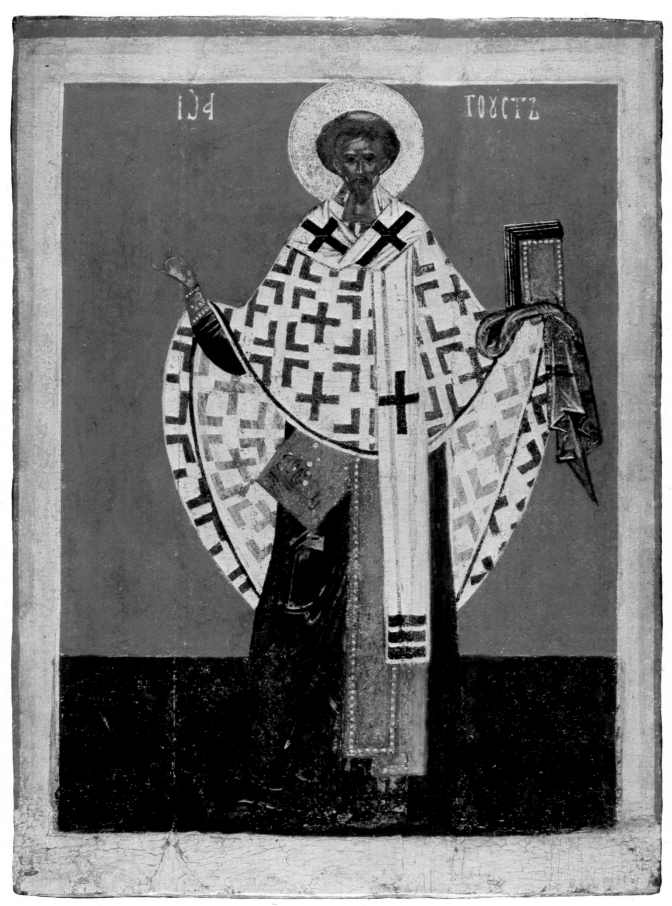

St. John Chrysostom
Tempera on wood, 68.5 × 49.5 cm. (27 × 19½ in.);
the Archangel region, sixteenth century; Museum of
Fine Arts, Archangel.

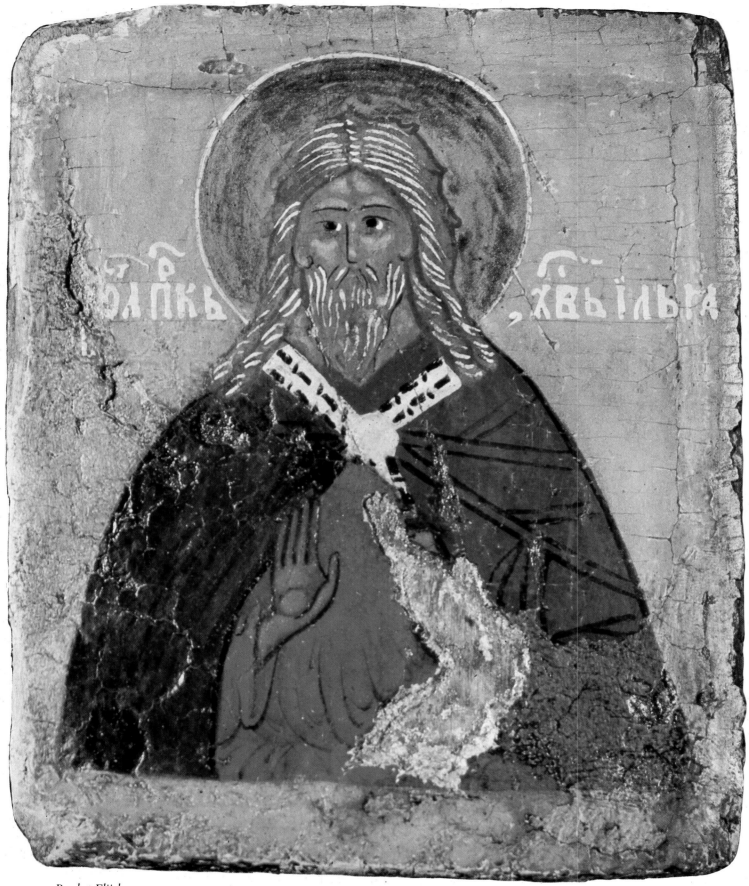

Prophet Elijah
Tempera on wood, 15 x 12 cm. (5⅞ x 4¾ in.);
Keftenitsy, Autonomous Republic of Karelia, sixteenth
century; Russian Museum, Leningrad.

THE ICONS OF RUSSIA

Opposite:
Apocalypse
Kremlin Master
Tempera on wood, 185 x 152 cm. (72⅞
x 59⅞ in.); Moscow school, c. 1500;
Cathedral of the Dormition, Kremlin,
Moscow.

Above and below right:
Apocalypse, Two details

Opposite:
Intercession
Tempera on wood, 117 x 69 cm. (46 x 27⅛ in.);
Moscow school, early sixteenth century; N. Likhachev
Collection, Russian Museum, Leningrad.

Above:
Intercession, Detail

Above and opposite:
"In Thee Rejoiceth," Details
Tempera on wood, total measurement 146 x 110 cm.
(57½ x 43¼ in.); Cathedral of the Dormition,
Dmitrov, early sixteenth century; Tretyakov Gallery,
Moscow.

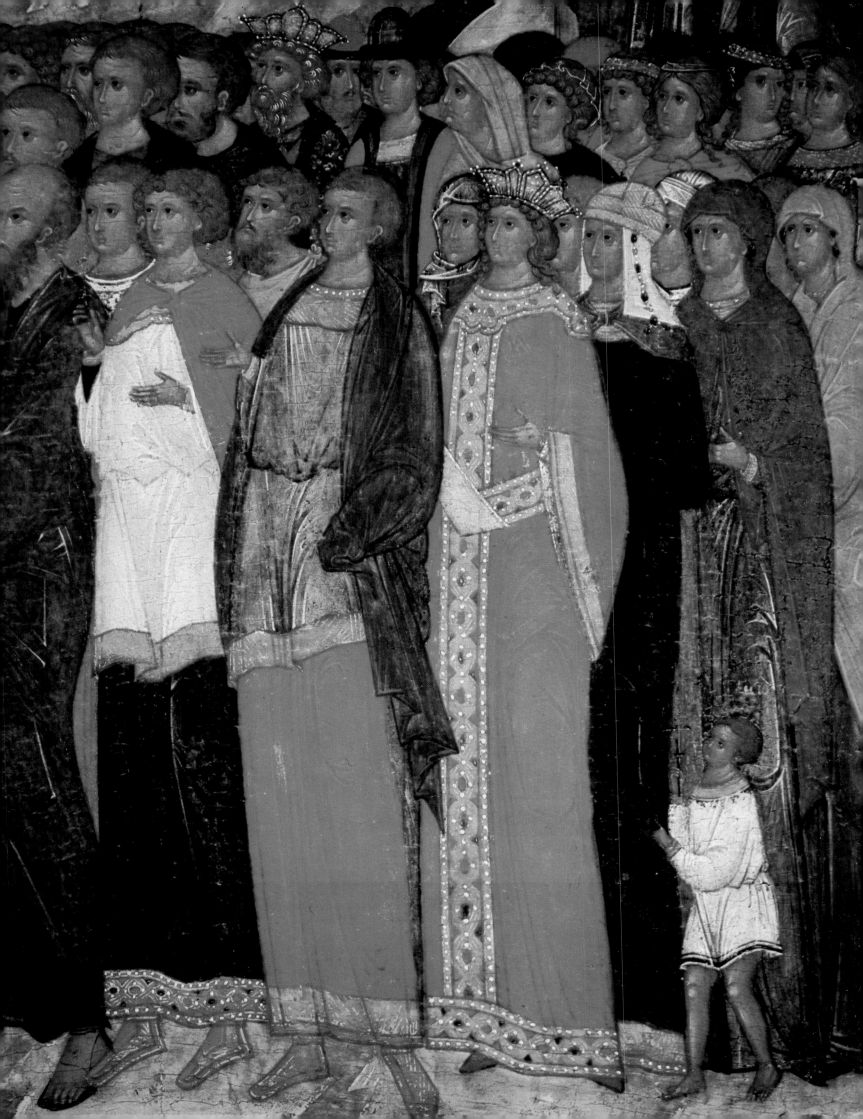

St. Simeon the Pious
Tempera on wood, 31 x 24 cm. (12¼ x 9½ in.);
mid-sixteenth century; I. Ostroukhov Collection,
Tretyakov Gallery, Moscow.

*Prophet Elijah and the Fiery Chariot, with Scenes from
His Life*
Central panel; tempera on wood, total measurement
125 x 107 cm. (49¼ x 42⅛ in.); sixteenth century; I.
Ostroukhov Collection, Tretyakov Gallery, Moscow.

VI

THE ICONS OF THE BALKAN PENINSULA AND THE GREEK ISLANDS (2)

Gordana Babić and Manolis Chatzidakis

AT THE end of the fourteenth and throughout the fifteenth centuries the feudal states of the Balkans were swallowed up one by one by the Ottoman Empire. The rulers of the Mrnjavčević family lost their lands around Seres (1371), Prilep, and Ohrid (1395); Bulgaria fell under Turkish control with the capture of Trnovo (1393); the realm of the Serbian despots vanished with the fall of Smederevo (1459) and the Byzantine Empire with the sack of Constantinople (1453). The same year saw the fall of Athens, soon followed by the Morean states in the Peloponnese (1460). Bosnia was conquered in the next Turkish wave (1463), followed by Herzegovina (1481) and Montenegro (1499). Gone forever were the courts and feudal lords whose patronage had encouraged the arts. But despite temporary crises and setbacks, the art that flourished in Byzantium and was fostered in the late Middle Ages by Balkan Orthodoxy lived on another two, and in some places even three centuries after the fall of Constantinople, as the spiritual expression of people who endeavored, by maintaining their cultural traditions, to preserve their language, history, faith, and art, their awareness of their roots.

Religious and artistic life in the Balkans found vigorous expression among both Slavs and Greeks in the sixteenth century, when the Turks, pressing victoriously northward toward Vienna, demonstrated a degree of toleration for the Christians in their rear. On the Holy Mountain (Mount Athos), extensive restoration work was carried out during this period. Educated and gifted artists gravitated to the churches and monasteries, studied the paintings of the Palaeologan age, and tried to revive this last great and famous style of Byzantine art, which had transmitted the ideas and ideals of Constantinople east to the Caucasus and west to Venice and Italy. Seeking inspiration and instruction in the works of the "Palaeologan Renaissance," the sixteenth-century painters, coming from Greek, Slav, Rumanian, and Mount Athos workshops, were once more united before the same ideal of beauty, and took part in the rejuvenation of Byzantine art. In some places earlier, in some later, they displayed the same faith in the archetypes, in the enduring value of an art whose last widely adopted

and highly regarded style recalled the age when the Eastern Christian world enjoyed prosperity and artistic renown.

SERBIAN LANDS

WHEN ARCHBISHOP MAXIMUS and his mother Angelina, the son and wife respectively of the deposed Serbian despot Stephen Branković, erected their Church of the Annunciation at Krušedol in the Srem region (1509–12), they found a highly educated and gifted artist to paint the *Grand Deesis* for the altar screen, with standing figures of Christ, the Virgin, St. John the Baptist, angels, and Apostles. It is not certain how this anonymous painter reached Srem, but judging by the polished forms in restrained colors and features of the script on the pages of the Serbian Gospels in the hands of the Apostles, he may have been from Wallachia (Rumania), still a rich land at the time, with which Branković's descendants maintained close ties.

In the mid-sixteenth century, Abbot Joakim commisioned an icon of the *Virgin with Child and Prophets* for the same Krušedol church. The artist was an extremely skillful and talented painter, with a perfect understanding of the iconography and technique of the masters of the Palaeologan Renaissance, when artists had been very fond of illustrating liturgical verses inscribed on scrolls held by Prophets, envisioning the Virgin as a gate through which Christ would pass, a bedewed fleece, a burning bush, tongs bearing live coals, the ladder by which Christ descends to earth, and so forth. Old Testament texts had served writers of the liturgy from the sixth to the ninth century as a source for their verses, and inspired painters as early as the Comnenian period to create the iconographic type of the Virgin with Prophets that was to become particularly popular in the early fourteenth century and again in Serbian art of the period we are now discussing (pp. 338, 348, and 350).

A broad wave of religious and artistic revival swept across the Serbian lands after 1557, when the Ottoman Empire permitted the restoration of the Serbian Patriarchate at Peć. The office of Patriarch was held by Makarije Sokolović, a relative of the Grand Vizier Mehmed Pasha Sokolović. Through the efforts of the Serbian Patriarchate, churches were repaired, and frescoes and icons on the iconostases restored, at Peć, Gračanica, Studenica, Banja (near Priboj), Dečani, and elsewhere. After 1557, the paint-

ers gathered in Peć around the new patrons and lovers of the arts, drawing their inspiration from the famous works of the past which they were called upon to restore. The frescoes and icons from King Milutin's reign at Gračanica (1321); those from the time of King Stephen III Uroš Dečanski and his son, King (later Emperor) Dušan at Dečani (mid-fourteenth century); and those from the period of eminent archbishops and Patriarchs at Peć (thirteenth and fourteenth centuries) were still well preserved in the sixteenth century, and served as models for the new generations of painters working under Turkish rule.

Demanding of their painters complete fidelity to Orthodoxy and the principles of the old masters, the learned Serbian bishops of the late sixteenth century stressed the importance of tradition, the beauty of local works of art, and the cult of local saints, recalling in this way the existence of the former state and the original Patriarchate, of which they considered themselves the heirs. By emphasizing the antiquity of the autocephalous Serbian Church, the Peć Patriarchate asserted its moral authority in the struggle against the Ohrid Archbishopric, an institution of the Greek Church that was striving to dominate Balkan Christianity during this period of relative self-government. The prestige of the spiritual center at Peć was enhanced by its organization of the religious, political, and artistic life in the regions inhabited by Serbs. From 1557 on, the Patriarchs assumed the role of national leaders, and Peć became the "capital" of the educated classes, who strove to preserve the language, literature, and art, to restore the ancient monasteries, to safeguard their treasure and further embellish their churches with new works of art.

The most talented and educated of the painters whom we know to have worked in Serbia after 1557 was the Peć monk Longin. A poet as well as an artist, he composed the "Hymn to St. Stephen the First Martyr" (1593). He is known to have been a prolific and dedicated worker, since he signed his paintings. Judging by the number of signed icons and frescoes, his literary compositions and painted textiles for church use, he must have worked tirelessly and unceasingly from 1563 until 1597, after which nothing is heard of him. Many of his works can be seen in the monastery of Dečani, the churches of Velika Hoča (Kosovo), the Bosnian monastery of Lomnica, the Piva Monastery, and the Church of St. Nicholas at Bijelo Polje (Montenegro). During his lifetime, he enjoyed a very high reputation, as is evident from the many commissions he received from the heads of the

most famous monasteries. This reputation survived his death, his works influencing and providing models for the artists who came after him.

Working with great dedication, Longin restored the Dečani iconostasis, painting the main icons of *Christ Pantocrator with the Apostles* (pp. 352–353) and the *Virgin Enthroned with Child and Prophets* (pp. 350–351), and surmounting these with a *Grand Deesis* tier. For the same monastery he did ten small bilateral icons (1572–73), which were displayed in the nave on the appropriate feast days. Some of these are distinguished by an unusual combination of ochre, olive green, and blue, showing Longin's originality as a colorist and his readiness to express through color the dramatic sentiments aroused in him by the eternal sacred subjects. In the icons of famous monks, he replaced the traditional light-toned rocky landscape by brown or bright blue mountains, creating an impression of depth and other-worldliness against which the saints stand out in the foreground. The relationship of bright strong blues and warm reds, which preoccupied Longin for years while he was painting at Dečani and Piva, eventually led him to the powerfully suggestive sonorities of the *Nativity* and *Annunciation* icons at Dečani (p. 341).

Familiar not only with old Serbian painting and literature but also with Byzantine works, Longin embodied in his creations the ideas of the Patriarchate of Peć. His verses celebrated the cult of Stephen the Martyr, patron saint of the Nemanjić rulers, and his paintings fostered the cult of the Serbian martyr-king whose remains were interred in the royal mausoleum, Stephen III Uroš Dečanski (1321–1331).

Defeated by his own father in a power struggle over the Serbian throne, blinded as a rebel, and exiled for seven years to Constantinople, Stephen III Dečanski stirred the imagination of later writers and painters. In the early fifteenth century, Grigorije Camblak, Abbot of Dečani, had written a "Life" of King Stephen which magnified the sufferings of the monarch, blinded in youth and strangled in old age, and portrayed him as a victim of life's injustices and court intrigues. Camblak, who did not make use of historical documents or the contemporary biography of Stephen by the Serbian archbishop Danilo II, wove this veil of suffering around the king's personality in order to enhance the power of Stephen's relics, which had been proclaimed holy as early as the 1330s.

Longin depicted King Stephen in a new light, as a hero-saint, but without straying from the Byzantine iconographic tradition. He placed the ceremonial royal figure in full regalia in the center of the picture, surrounded by seventeen scenes from the king's life. The main theme is the origin of the Serbian king's authority: like the Byzantine emperors of old, Stephen receives the insignia of power from Christ, brought to him by angelic messengers. He therefore rules by divine will, as Christ's emissary on earth.

The well-known conflict between Stephen and his father, King Milutin, did not interest Longin, who began Dečanski's life story not with the historical events—the punishment and blinding—but with the psychological drama of the father watching his young wife, Queen Simonida, slander her stepson, Stephen (pp. 334, 347). (Grigorije Camblak had adroitly justified Milutin's action, drawing on parallels in Byzantine literature and pointing out that Constantine the Great, the first Christian emperor, had believed the false words of his wife and killed his son Priscus.) The compositions of other scenes recall well-known Byzantine pictures on similar subjects: St. Nicholas appears in a dream to King Stephen as he did to Emperor Eulalius; Emperor Andronicus II Palaeologus is shown conversing with King Stephen and a bishop on a *synthronos,* the semicircular bench on which the participants in Byzantine church assemblies sat in many representations; St. Nicholas restores Stephen's sight, as Christ did when performing miracles (p. 243); the Serbian archbishop Nikodim crowns King Stephen at Peć (p. 345) in the presence of bishops, monks, and courtiers, one of whom holds the king's cloak and spreads it out in the manner described in the famous tenth-century Byzantine text "On the Ceremonies of the Byzantine Court," and depicted in paintings of the coronation ceremony in the only surviving illustrated chronicle, by the twelfth-century Greek author John Scylitzes.

Still other scenes—the reunion of Milutin and Stephen, the distribution of alms, and finally, the hero-saint's death—also repeat compositions taken from Byzantine art. These pictorial "signals," which precisely communicated a certain idea or situation, may be thought of as words whose meaning was immediately understood. For centuries Byzantine painters had used this method to expound visually upon biblical, hagiographic, and liturgical texts (and even historical chronicles), enabling the viewer to grasp the meaning of the picture at first glance. Longin made skillful use of the appropriate compositions—"signals"—to convey the significance of the scenes, never forgetting to include as well a detail or two to be found in Camblak or in his own observa-

·tion of the physical world. In the scene of Stephen's coronation, the church in the background with its barrel roof and cupola recalls that of the Holy Apostles at Peć; and in the picture of the king's foundation of Dečani, Longin precisely rendered the higher central section of the basilica, raised between the three-aisled sanctuary and three-aisled narthex. Such details were introduced into a scene when he thought they would help the viewer to understand the meaning of the episode depicted. His principal aim was to convey an impression of credibility by combining the methods and compositions of the old masters with visual associations of contemporary life.

Longin presented this large icon as his gift to the monastery established by the sainted king, hoping to be relieved of the pain of festering wounds which troubled him and filled his mind with visions from hagiographic texts. The real and the legendary, the historical events and the miracles, are intermingled in the icon as in Camblak's "Life." But while many familiar scenes are presented by Longin in the standard Byzantine manner, the composition of the *Battle of Velbužd* (p. 346) surprises us with its vividly drawn cavalry charge through a ravine in a rugged landscape. Dečanski's triumph over the Bulgarian emperor Michael (1330) and the victorious feat of the young king Dušan reveal Longin as a bold painter, who attempted in the broad frieze (and in the landscape, too) to go beyond the usual schematic battle scenes of medieval illustrated chronicles. Battle as the drama of a vanguard winning glory or death, as the clash of nameless participants who destroy themselves and their noble beasts, greatly excited Longin. He dealt with the subject again when depicting the *Battle of Milvium Bridge* in the frescoes at Banja near Priboj.

In 1577, the same year that he painted the icon of St. Stephen at Dečani, Longin painted three large icons for the village churches at Velika Hoča. For the Church of St. Nicholas he executed the main icon of the patron saint (pp. 344–347), to whom the Virgin and Christ are bringing an *omophorion* and Gospels, in the stereotypical Byzantine composition. Longin added an unusual episode at the bottom (as in the predella of a Renaissance altarpiece) to illustrate the local legend of St. Nicholas restoring King Stephen's sight. The portrait of the donor (the Dečani monk George, shown prostrating himself) and the Cyrillic inscription, give a clear picture of the monks' endeavor to glorify their royal saint by spreading his legends.

The gifted artist, incurably ill, spent a long time at Dečani, enthralled by what he learned from the frescoes and old Serbian books, giving himself up to holy visions by which he was inspired to fuse tradition with the present, the wishes of his patrons, and his own religious concepts. His work delighted his contemporaries. Longin's fine draftsmanship recalled the skill of the medieval masters, while his strong colors in complementary and contrasting juxtapositions or delicate gradations of tone revealed him to be an exceptionally original artist. It is for these qualities that he is still admired today.

In the second half of the sixteenth century, several talented provincial artists (and a few who were only mediocre) were at work in the most important Serbian monasteries. At Gračanica, one of the better anonymous painters renewed the doors and icons on the altar screen, following early fourteenth-century models in the large figures of the Apostles. Commissioned by Nikanor, Metropolitan of Novo Brdo, in 1567, an anonymous painter executed the large icon of *Christ with Apostles* and an excellent portrait of the donor prostrating himself. Somewhat later, in 1608, Victor, Metropolitan of Novo Brdo, paid for an icon of *St. Favronia with Scenes from Her Life,* to be painted with a gold background. Both of these are preserved at Gračanica. (The Serbian founders and benefactors of the sixteenth and early seventeenth centuries were mainly church dignitaries and monks, and on a few occasions, groups of peasants.)

From 1596 to 1617, icons were painted for the new iconostasis of Morača Monastery. The large cross customarily placed on top of the iconostasis was made by George, "the cross man," probably a wood-carver, who was paid for his work by Patriarch Jovan of Peć. One icon of this iconostasis was by the celebrated Chilandari monk-painter Georgije Mitrofanović, an accomplished artist who had been trained on Mount Athos and had come to Serbia to work on restorations. Familiar with both the Serbian and Greek traditions, Mitrofanović boldly undertook the complex task of renewing church frescoes and icons at Morača, Dobrićevo, Zavala, Peć, Krupa, and elsewhere.

Although all Mitrofanović's signed works date from 1616 to 1620, he was certainly active before that, but either his earlier icons were unsigned or they have been lost. In 1615–16 he appears to have been working at Chilandari, where he left behind iconostasis doors, richly carved and gilded, depicting the Annunciation; but in the same year he arrived in Serbia. He presented the icon of the *Holy Trinity* (found at Čelebići) to the Church of the Holy Trinity at Pljevlja, and in

1616–17 painted the frescoes on the west facade of the main church at Morača. In the same year he probably finished the large main icon of the Morača iconostasis, the *Virgin Enthroned with Child, Prophets, and Hymnographers* (p. 370), which illustrates the popular liturgical trope: "The Prophets sent word from on high." Plentiful use of gold, a touch of silver, and the harmony of the violet, red, and ochre tones give the well-drawn, serene figures a solemn air. The strong shading on the oval face and very carefully drawn ornamentation of the Virgin's throne reveal Mitrofanović to have been a well-educated painter. As was customary in his time, he made great efforts to achieve plasticity of the human form and precision of detail in incidental objects.

The finest icons of Georgije Mitrofanović have been preserved in his own monastery, Chilandari, where it seems he spent his last days. An experienced muralist, he was responsible for the frescoes in the refectory (1621–22), leaving also an outstanding icon of *Christ Pantocrator* on the richly carved ceiling. In the chapels, he painted several more doors and icons that are signed. The most beautiful are the *Doors of the Chapel of St. Trifun*, a work of his maturity (1620), in which he achieved beauty of proportion and sureness of line, skillful shading of the flesh in delicate gradations of ochre, and a noble sonority of color. The refectory frescoes of the *Acathist (Hymn) to the Virgin*, the *Life of St. Sava of Serbia*, and portraits of former founders and benefactors, all show Mitrofanović to have been fully acquainted with old Serbian literature. Like Longin before him, he used the customary Byzantine language of pictorial "signals" to depict the lives of the famous Serbian saints, selecting and emphasizing scenes linked with the history of Chilandari to adapt the cycle to his monastery and its traditions.

The painter who signed his name in cryptic writing, usually read as Kozma, was invited to Morača in 1645 to paint the large icon of *SS. Simeon and Sava* with *Scenes from Sava's Life* around the border (p. 371). Kozma clearly took as his model the cycle in the Chilandari refectory. Omitting scenes illustrating the saints' activities on the Holy Mountain, the painter shortened the cycle but retained the established compositions. He separated the scenes not with red frames but by giving them different backgrounds, filling them alternately with painted architecture and landscapes. Painting the Serbian saints Simeon and Sava as monk and archbishop respectively, in the central field of the icon, Kozma kept to the traditional composition. A skillful draftsman, he

was already an experienced master when he undertook the Morača icon. He added some quite original scenes: the building of Morača Monastery; Stephen Nemanja (Simeon), founder of Morača, consulting with the masterbuilders; and Stephen's death. He also contributed to some episodes certain distinctive details connected with local traditions and life.

Kozma was a highly esteemed painter, invited to the large monasteries that were renovating their icons. At the Monastery of the Dormition of the Virgin at Piva, he renewed many icons on the iconostasis that had been painted by Longin in 1573–74. When painting a series of feast-day images and main iconostasis images in 1638–39, Kozma closely followed Longin's icons on the *horos* (circular chandelier), repeating the drafting and composition, and trying to emulate the palette of the earlier master. Copying almost identically the Piva church's feastday icon of the *Dormition of the Virgin*, Kozma showed his immense respect for Longin as a teacher; Longin's powerful red-blue contrasts he could not, however, bring off altogether successfully.

It appears that Kozma sought to master his art by copying Longin's icons. But when he undertook the main icon of *St. George*, to whom Christ offers a sword and victor's wreath, and the icon of *SS. Simeon and Sava*, Kozma was already a fully formed painter. In 1638–39 he left at Piva some successful works, unsigned but attributed to him on grounds of stylistic similarity with the Morača icon of the Serbian saints. The mysterious Kozma is also credited with many icons found in churches at Chilandari, Dečani, Podvrh, and other monasteries.

Among the contemporaries of Georgije Mitrofanović and Kozma were some less gifted painters: Father Strahinja of Budimlje; Basil, who worked at Mostaći; Mitrofan, whose works are preserved in churches of the Kablar area; and others. All of them lived and worked in an environment that had refused all knowledge of the artistic activities of western Europe. Isolated in their faith and their rejection of everything that did not spring directly from the pure traditions of medieval Serbia, these talented men found their only consolation and beauty in the distant past of their country's art. Often self-taught, learning the works of earlier masters, their sole aim was to emulate these models.

Andrija Raičević, born in the village of Toci near Pljevlja, successfully carried on the ideals of traditional painters, working in old Herzegovina from 1638 to 1673. He also undertook commissions for the

Patriarch of Peć and other high church dignitaries.

Radul was one of the last of these painters. Judging by the icon of *SS. Cosmas and Damian* (1673–74; p. 369), in which the physician-saints are enclosed in a border of hagiographic scenes, Radul was a well-educated, capable artist. He clearly drew on old hagiographic literature, as can be seen from the long explanations of scenes in the Serbian language. Working at Peć, Radul carried out the wish of Patriarch Maximus to donate an icon to the physician-saints, from whom he expected aid or to whom he owed salvation.

Various motives prompted donors to commission icons of subjects not usually included on the iconostasis: religious fervor, superstition, the desire of church leaders to revive a local cult (such as the icons of the Branković saints [p. 354] at Krušedol); but most often it was the faith of the individual donor in the power of his or her patron saint. The requirements of the cult or the individual, however, never strayed outside the bounds of tradition, to which both artists and donors remained faithful until the end of the seventeenth century.

The great upheavals and terrors of the Austro-Turkish wars of the seventeenth century and the alliance of the Serbs with Austria ended the revival of Serbian medieval art, leading as they did to the vast national migration of 1690. From the southern regions the people, together with the Patriarch, clergy, and monks, moved north across the Sava and Danube rivers into a new homeland. This migration meant a bitter parting from their old hearths and sanctuaries, their fields and the graves of their forefathers. The inevitable encounter with the laws, politics, and religion of Austria, whose subjects they now became, brought the Serbian populace to a spiritual crossroads. The relative material security and rapid adoption of the bourgeois way of life among the Serbs in their new environment resulted in a gradual separation of religious and secular subjects in art, and encouraged talented artists to turn more and more to the painting of portraits and scenes of everyday life.

The long and fruitful period of religious painting among the Serbs, which had lasted from the late twelfth to the end of the seventeenth century, gave way during the eighteenth century to strange, often unsuccessful attempts to reconcile Orthodox tradition with trends in European art, which had been evolving more rapidly and along a different course ever since the fifteenth century. Under the influence of the Baroque style, icons became merely pictures with reli-

gious subjects, while the pure language of the Byzantine iconographer was slowly forgotten.

CRETE

AFTER THE FALL OF CONSTANTINOPLE in 1453, new conditions were established in areas with populations of Greek national consciousness. One basic circumstance was the division of the subjugated Greeks between the Ottoman Empire and the Republic of Venice. Those who lived in Venetian territory were the lucky ones. The economic and professional equality that the Venetians offered their Greek subjects made it possible for them on the one hand to preserve national, religious, and artistic traditions, and on the other hand to come into contact with rejuvenative intellectual and cultural movements in western Europe. These conditions favored the development of an important artistic phenomenon, which was expressed by a parallel efflorescence of letters and poetry, theater, painting, and sculpture (in both wood and stone), in the cities of Crete, especially Heraklion (Candia).

Many scholars and artists who had taken refuge in Crete from the Turkish-occupied territories even before the fall of Constantinople contributed to this blossoming. We can therefore trace from the beginning of the fifteenth century the development of a style which is a direct descendant of the more idealizing and classicizing tendency of Constantinopolitan painting. In Crete, religious painting developed into an independent "post-Byzantine" school. The artists were organized into a guild, the Scuola di San Luca, which in the second half of the fifteenth century consolidated its own artistic principles and iconographic standards in a program of instruction and apprenticeship that gave it continuity and coherence for at least 250 years. Recently, a considerable amount of information, gleaned from archives and icons, has made it possible for us to determine with some precision the formation and development of this school of painting, which is the only one of the Orthodox "schools" that has a legitimate right to the title during this period.

First, we must relate this school to the development of the cities of Crete as important commercial and shipping centers. This explains the presence of so many artists—120 painters were known to be working in Heraklion in the years 1453–1526. From the archives it appears that Cretan painters received many icon commissions from foreign traders, mainly the

Venetians; from Catholic bishops of Greek territories occupied by Venice, for example, Nauplion (Napoli di Romania); from Orthodox monasteries, like those of Sinai and Patmos; as well as from Greek and Venetian nobles and other citizens of the Republic. As a result, the Cretan painters turned almost exclusively to the production of portable icons, abandoning wall-painting. Working for such a diverse clientele, the Cretans became remarkably deft in many stylistic modes. Much of their fame in both the East and the West must be credited to this adroit eclecticism.

Among the significant painters of this period who were active in Heraklion we shall mention only those who are known by their signed works and whose dates are recorded in the archives at Venice. Andreas Ritzos (d. c. 1492) is famous for his large icons of the *Virgin of the Passion*, executed according to Byzantine tradition and schemes. From the Latin inscriptions on some of these works, it is evident that they were destined for non-Greek Catholics who nevertheless believed in the authentic witness of the Greek icon.

To this category belongs the *Virgin of the Passion* at the Church of St. Blaise (p. 318) in the Dalmatic town of Ston. The type of the Virgin holding a Child frightened by the angels' display of the symbols of the Passion had been known in Byzantine painting at least since the twelfth century; but this composition, which represents a prefiguration of the Passion of Christ, was very rare. In the fifteenth century and after, the theme is seen far more often. Since some of the best of these renditions bear the signature of Andreas Ritzos, the invention of the type has been attributed to him. In fact, the composition is undoubtedly Byzantine. Its faultless rendering has an almost academic character, with a closed synthesis and severe structure in the volumes and garments; but it also conveys a restrained tenderness in the moving attitude and gesture of the Child. The coexistence of the two opposite trends is accomplished by clear and bright colors that harmonize well.

Another equally severe, static composition by Andreas Ritzos is a large icon of the *Virgin Enthroned*, made for the iconostasis of the Monastery of St. John the Theologian in Patmos (p. 319). The painter does not hesitate to introduce a marble throne, a clearly Venetian detail that others would later copy. Ritzos must have found it very interesting to seat a purely Byzantine figure with only symbolic volume and no material weight in a well-shaped throne, decorated with inlaid marble, executed with correct perspective.

Punched ornaments, also of Italian type, have been added to the Virgin's nimbus. This example shows the way these painters employed for each image whatever elements they thought useful, from the reservoir of their twofold skill.

The same ease is demonstrated by Ritzos in the handling of themes very close to Byzantine models, for example, in the *Dormition of the Virgin* now in Turin (p. 317). The rather heavy forms indicate that it is perhaps an early work. The group of angels on the left, a common inclusion in this theme during the Palaeologan epoch, does not reappear in post-Byzantine painting in Crete.

Nicholas Ritzos (d. before 1507), the son of Andreas, represents the next generation of Cretan artists. His only known icon, the *Deesis* with ten scenes from the *Dodekaorton* and five saints, is now in Sarajevo (p. 321). It is valuable testimony to the crystallization, around 1500, of certain iconographic types and stylistic principles of the Cretan school. We may well assert that Andreas and Nicholas Ritzos laid the foundations of this branch of icon-painting.

Another contemporary painter, Andreas Pavias (d. after 1504), had many disciples in Heraklion—among others, Angelos Bizamanos, who later settled in Otranto, Italy (cf. p. 326). The style of Pavias, even in his purest Byzantine works, is apparently influenced more by the anti-classical tendency of the latest Palaeologan period, in tune moreover with "Gothic" realism, as reflected in his "Italo-Cretan" works. A good example of this is the *Crucifixion* in the National Gallery in Athens. Even his beautiful Byzantine-style icon at Jerusalem (p. 320) portraying the *Death of St. Efraim the Syrian* differs from other contemporary icons with the same subject. In fact this picturesque theme, with the wide-spread landscape and the crowd of small monastic figures, most of whom stand around the corpse of St. Efraim while a few occupy themselves with handicrafts inside the caves of the desert, must have enjoyed much success at this time. We know of about ten such images, but later they become rather rare. In the *Death of St. Efraim*, Pavias skillfully executes the Byzantine manner he has chosen; but he paints the idyllic motif of two hares and a deer under a small tree in an Italian style.

Nicholas Tzafuris (d. before 1501), a subtle miniaturist, seems to be more familiar with the works of Bellini and other Italians. His *Man of Sorrow Between the Virgin and St. John* (p. 322), which recalls the mosaic in the Santa Croce di Gerusalemme in

Rome (cf. p. 76), is typical of the icons made for Catholics by the fifteenth-century Cretans, who were well trained in the manners and themes of fourteenth-century Venetian art. With its difference in scale between the upright Christ and the Virgin and St. John, denoting the symbolic character of the scene, this icon can truly be called Greco-Italian rather than Cretan.

An unsigned Greco-Italian icon on the same theme is to be found on Mount Athos, perhaps the only one of its kind there. It is close to the scheme of the *Epitaphios* by Lambardos (cf. p. 362), showing additional human figures and angels. More important, however, it has been fully adapted to the style of Cretan painting with its sharp contrasts of light.

Angelos Bizamanos was a disciple of Andreas Pavias in Heraklion in the years 1482 to 1487. Thirty years later, in 1518, he painted a large predella for the Catholic Church of the Holy Spirit at Komolac, near Dubrovnik. Here he adapted several styles and themes, bestowing very Italian characteristics on the picture of St. Martin on horseback sharing his cloak with a poor man (a theme completely unknown to the Orthodox iconographic tradition; p. 326), while employing a more conservative Byzantine style for the image of St. Nicholas.

We would like to assign to the same period the three beautiful icons which are now in the Istituto ellenico in Venice. It is very possible that they were made in Crete, since the few Greek painters of the time, known as "madonneri," could not possibly have created works of such high quality.

The icon of the *Nativity* (p. 324), in its beautiful contemporary frame, is one of four images with the same theme and features (in Leningrad, London, Athens, and Venice). Preserved in these icons is the gracefulness of the many figures and the variety of the landscape levels, distinguished by different colors, which are echoes of the classical Palaeologan formulation of this scene. Everything here has become more tranquil; the composition is more symmetrical, and has a tendency to be two-dimensional. But here too we see the charming deer and the little hare sitting under the tree, the animals we noted in the *Death of St. Efraim the Syrian* by Pavias (p. 320). All these somewhat academic icons of the *Nativity* still retain the perfection and poetic disposition of Palaeologan times. We believe they must have had a common model, a late fifteenth-century work now lost.

We can observe a similar artistic atmosphere in the *Noli Me Tangere* (p. 325)—a composition repeated many times in the succeeding centuries. The tall, lordly figure of Christ, with his expression of peaceful dissuasion, corresponds in an austere and composite structure to the kneeling figure of the blond Magdalene. But the different nature of the two is shown by the contrast between the drapery of Christ's dark garment, geometrically decorated with gold tracery, and the wide, loose, Gothic-style red cape of the Magdalene—a very Frankish attribute of all sinful women in Cretan painting.

The third icon in the Byzantine style is that of *St. George Killing the Dragon* (p. 328), a handsome young man on horseback who spears the black dragon with a rather gentle movement. The richly designed gold tracery on his breastplate is similar to those of the painter Tzafuris, while the luxurious Venetian saddle and the four-footed dragon indicate contacts with Italian art. More specifically, the sturdy horse and the form and posture of the black dragon seem to be modeled on a work with the same subject by Paolo Veneziano. As for the indirect sources of classicism in this icon, it is interesting to note that Paolo is thought to have used the ancient Greek bronze horses of San Marco as his models. Before leaving the icon of *St. George,* let us note also the blazon on the red wing of the dragon—a sign that this, like so many beautiful Cretan icons that are as elegant and precise as jewelry, was undoubtedly made for an aristocrat, whether of Catholic or Orthodox faith.

During the sixteenth century, several Cretan painters were invited by large monasteries in central and northern Greece to decorate their churches with murals and portable icons. As far as we know, the first of these was the monk Theophanes Strelitzas, surnamed Bathas (d. 1559), an important painter who came from Heraklion to Meteora in 1527 to decorate a relatively small church at the Monastery of St. Nicholas Anapavsas. Among the figures in his mural is *St. Euphrosinos,* a simple-minded monk who had been a cook at the monastery (p. 334). The face of the full-length, picturesque figure has a reserved, dramatic expression; the branch he holds in his right hand denotes that he is enjoying the fruits of Paradise.

In 1535, Theophanes executed the murals in the large tenth-century church of the Great Lavra Monastery on Mount Athos, as well as a set of at least fourteen portable icons—the *Twelve Feasts* and the *Despotics*—for the new iconostasis, which was then under construction. One can appreciate in these works both the virtues and the shortcomings of the singularly urbane Cretan school which, even away from its

home base, in the employ of a community of monks, was able to function at a high level of artistry.

In the icon of the *Transfiguration* (pp. 332–333), as in most of the other pieces of this set, we note a repetition of the composition that had been formulated in Crete in the fifteenth century (cf. Nicholas Ritzos, p. 321). But here the synthesis is more compact as it unfolds harmoniously on three levels parallel to the picture plane, from the first, in which the stunned Disciples convey the human drama, to the third, where the Divine Epiphany attains its sacerdotal grandeur. Of special importance here are the delicate harmonies of well-proportioned color on which the composition is based. In these icons, Theophanes proves himself to be an excellent colorist, something which we cannot always ascertain in his as yet uncleaned wall-paintings.

Equally impressive is the *Entry into Jerusalem* (pp. 330–331) from the same set at Lavra. Here, the artist endows the tight and dense composition with a more monumental character, painting bodies of weighty proportions and faces with firmly modeled features.

The iconographic types that Theophanes handled with such skill were copied almost identically not only by his contemporaries but also by the later Cretan painters, up to the end of the seventeenth century. A typical example of this somewhat mediocre, imitative kind of painting is an icon representing the *Raising of Lazarus* (p. 337), now in the Benaki Museum, Athens. The landscape in this composition acquires a certain dramatic character from the arrangement of the sharp converging rocks. The intensity of tone is enhanced by the contrast between the perpendicular figures of Christ and Lazarus and the humbly bowed sisters and laborers.

The large icon at Lavra that depicts the *Apostles Peter and Paul* (p. 336) is painted with the same technique but a somewhat different spirit. The warm embrace of the two tall, stalwart men, constructed on an old Byzantine model, is a symbolic message of peace for the world. The drapery is arranged according to a pure geometric design; with the help of the gradations of light in narrow bands, it glitters almost metallically. The faces, meticulously molded to emphasize their volume, are intensely characterized, resembling in this respect the five icons of a *Deesis* executed in 1542 by the priest Euphrosinos (now in the Monastery of Dionysiou). The Lavra icon's high quality, its expressive heads and faultless design, and the large color-patches that create an intense harmony, are evidence that this image was painted in a

Cretan workshop, not that of Theophanes, but nonetheless also of the sixteenth century.

Theophanes was unquestionably the most influential artist of his generation. After his death, another artist attained a similarly prominent position: Michael Damaskinos of Heraklion. About one hundred of his icons were known in Heraklion, Mount Athos, and the Monastery of Sinai; and also in central Greece, Corfu, Zakynthos, Puglia, and finally Venice, where he lived for a few years while decorating the new church of the Greek community. To satisfy the demands of such a diverse clientele, Damaskinos developed to a very high degree the eclecticism he inherited from his masters. He could paint icons that were very close to the tradition of Theophanes, like the image of *St. Anthony* (p. 355) now in the Byzantine Museum, Athens. This imposing ascetic figure, with its carefully modeled, fleshy face and long, thick beard, condenses the most severe traditions of Byzantine painting of the final period.

In the icon of *St. John the Forerunner* in the museum of Zakynthos (p. 360), Damaskinos returned to the type established since the thirteenth century, painting the Forerunner with wings—because he was considered both an angel and a Prophet—in a three-quarter turn toward the diminutive Christ. Here, however, the ascetic, exotic, exceptionally tall figure has a certain elegance of posture and gesture, with more softly modeled limbs. The rocky landscape has a somewhat rounded contour rather than the usual sharp surfaces, and the bottom of the long scroll is correctly lit. Damaskinos must have borrowed this special motif from the Greco-Italian Virgin icons of the fifteenth century, in which Christ holds an inscribed scroll rolled up in the same fashion. A more personal contribution of the painter is the long and narrow composition, in which each separate form has an attenuated elegance.

It should not come as a surprise to us that Damaskinos was capable of ringing changes on other compositions, like the *Adoration of the Magi* (p. 361), which belongs to a set made for a monastery in Crete. In this well-populated picture, where humans mingle with horses and camels while angels hover overhead, we can easily recognize the elements that he borrowed unaltered from works by the Venetian painter Bassano. Damaskinos followed local tradition in the composition, placing the mountain and angels on the right and the few holy personages on the left in the established Cretan way; but all the secular elements—buildings, people, and animals—he painted in a con-

temporary Italian manner (cf. the *Noli Me Tangere*, p. 325). Some "faults" in the perspective, creating confusion in the rendering of the space, sustain the coexistence of fundamentally different spheres, while the totality exudes the atmosphere of an imaginary world.

An equally well-known contemporary of Damaskinos was the capable painter Georgios Klotzas (d. 1608). More scholarly than Damaskinos, he was interested in chronographical and chrismological texts, which he registered in 1590 in a voluminous codex (now in the Biblioteca Nazionale Marciana), decorated with hundreds of miniatures—the most interesting Greek illuminated manuscript of the period. Klotzas painted very few icons, in a purely Cretan style less attached to tradition than those of Damaskinos. His style is quite personal, as for example in the painting now in the Istituto ellenico in Venice (p. 357). In the upper register he combines the themes of two hymns to the Virgin, the *Acathist* and the *"In Thee Rejoiceth,"* while in the lower he depicts *All Saints.* The hymnographic part of this original design is based on an order of seven concentric circles around the Virgin, each containing many miniature scenes. In the lower area, four dense groups of holy personages gaze at the Celestial City, represented by a Venetian townscape. The artist, as though possessed by the *horror vacui,* loads each scene with detailed and superfluous spectators—an exhibition of excessive skill. In these scenes, it is true, there is not even a trace of the almost geometrical patterns of Theophanes; but the tall, thin figures conform to the manneristic style of the period. Being all of the same physiognomical type, the dozens of characters take on a family resemblance. This picture, despite all its Italian elements, remains essentially Greek and Orthodox in character. Even without a golden background, it is still two-dimensional, with low-keyed harmonies of the usual color tones that are never affected by atmospheric light.

Georgios Klotzas uses the same analytical method in his smaller triptychs, where he shows his technical mastery. In one, in the Monastery of St. John the Theologian on the island of Patmos, he presents many miniature scenes of the Twelve Feasts, the Miracles, and the Last Judgment. The largest central panel is exclusively occupied by the *Finding of the Holy Cross* (p. 359). Its tall, thin figures exist in a space replete with Renaissance or late Gothic buildings in good perspective. In these works of Klotzas we see a new kind of small-scale Greek Orthodox painting, incorporating many elements of Western art but always retaining the Byzantine style in the modeling, drapery, and palette.

These exquisite works of the latter half of the sixteenth century, addressed to the artistic taste of the Cretan urbanites and churchmen who had close ties with Venetian culture, evince a tendency toward the renewal of a traditional expressive vehicle by more modern means, the replacement of the icon's symbolic and representative nature by a more illustrative and narrative character, which includes more elements of the secular world. The important painters of the next generation after 1600, however, opposed these initiatives. In religious painting, they showed the general tendency toward the older traditional forms and styles that we note in the works of artists like Jeremy Palladas, Frangias Kavertzas, and Emmanuel Tzanfournaris. To this group we may also assign the painter who signed himself with a certain assurance only by his first name, Angelos, making it difficult for us to establish his family name and when he lived. Angelos constantly took the works of the second half of the fifteenth century as his models, as we can see in his *Christ Enthroned* (p. 360), now in the museum of Zakynthos. The marble throne in Venetian style reminds us of the Virgin's in the icon by Andreas Ritzos (cf. p. 319).

Angelos often painted St. Phanourios (p. 358), a figure of mysterious origin, depicting him as a slender, graceful youth who wears a lavish warrior's costume and bears a distinctive emblem, a burning candle fastened to the cross he holds. The graceful figure with its light counterpoise, and the carefully designed tracery of the breastplate, associate this and similar icons with a hypothetical model of the time of Andreas Ritzos that must have embodied the "international style."

To this group of conservatives we must also add the priest-painter Ioannis Apakas, who signed the icon of the *Deposition from the Cross* (p. 365), in the Great Lavra Monastery on Mount Athos, in very fine gold letters. This icon is a typical example of the Cretan painters' adaptation of the iconographic scheme of an engraving of the early sixteenth century (by Marcantonio Raimondi) to the current figurative language, just as Theophanes had done earlier in the *Massacre of the Innocents.* By adding certain known persons and a two-dimensional view of Jerusalem (actually a Venetian-style town), the artist made the composition more visually familiar to the Orthodox believer. It is unlikely that Apakas himself introduced this Italian motif, creating a model for many future

icons. From his few surviving works, we know that he was not a painter of much initiative. The *Deposition from the Cross,* however, with its graceful figures, compositional facility, and precise painting, is a small masterpiece in its own right. That it was probably executed for an educated nobleman is indicated by the blazon on the cross.

The true conservatism of this period is represented by two painters of Heraklion who both signed themselves Emmanuel Lambardos. They are known from the archives as well as from a significant number of icons, almost all of which are characterized by a retrogression to the traditional models of Theophanes' time, ignoring the attainments of Damaskinos and Klotzas. In the *Lamentation* (p. 362), or *Epitaphios,* now in the Byzantine Museum in Athens, the artist reproduced with faultless technique and precise draftsmanship a theme which in the post-Byzantine iconostasis had a permanent place above the door of the *Prothesis.* In the large icon of the *Crucifixion with Donors* (p. 363), now in the Church of San Giorgio dei Greci in Venice, Lambardos returned to the severe composition and rather harsher modeling that had been used by Theophanes and the other painters of Mount Athos. But the very delicate proportions of the elegant structures resemble more closely an early work of Damaskinos, lost to us when it was burned in the earthquake of 1953. The two tiny donors of the *Crucifixion,* dressed in Venetian fashion, are named. Residents of the city of Rethymnon, the father was a lawyer and the son a poet. The identification helps us to estimate that the icon was made in the period 1613–18.

An early icon of *St. Anne with the Virgin* (p. 366), now in the Benaki Museum—with Emmanuel Tzanès' signature and the date 1637, both forged—is a fine example of the ability of even mediocre painters to execute large icons according to the Lambardos method. In this work, we observe even more clearly the trend toward monumental composition and tranquil grandeur combined with restrained tenderness, which Andreas Ritzos had taught. Here the symbolism acquires poetic extensions: the flower offered by the Virgin, a mature woman, symbolizes Christ.

Heraklion, the only Cretan town that had not yet fallen to the Turks, finally capitulated in 1669, after twenty years of uninterrupted siege. The disintegration of the social order in the large towns inevitably caused a deterioration of the coherence and vitality of Cretan painting. That is why it is difficult to speak of a "Cretan school" after the seventeenth century.

The most prominent artist of the final generation was unquestionably Emmanuel Tzanès Bounialis (1610–1690), a scholar-priest from Rethymnon. Tzanès must have been very famous in his time, for his output was prolific until the very end of his long life. Faultlessly and steadily, he built his personal style on a concrete technical foundation. All his artistic virtues are evident in the icon of *Christ Enthroned* (p. 367), which he painted in 1664 for a church in Athens, together with an icon of the *Virgin.* Here are revealed the sources of his inspiration, Angelos and Andreas Ritzos. The symbolic animals of the Evangelists, which clarify the meaning of the *Majestas Domini,* were added by the painter-priest. In other subjects Tzanès invented entirely new compositions, which were repeated throughout the eighteenth century, particularly in the Ionian Islands.

Contemporary with Tzanès was Theodor Poulakis (1622–1692) from Chania, Crete, who worked both in Corfu and in Venice. More independent than Tzanès, in some instances Poulakis followed the style of Klotzas; however, when painting biblical stories or other narrative scenes on complete sets of icons, he relied mainly on Flemish engravings, creating a new kind of composition. Using bright and luminous colors, Poulakis at times succeeded in creating a sense of atmosphere—something very rare in the icons of his time.

CENTRAL GREECE

IN THE MID-SIXTEENTH CENTURY, while Theophanes was at work on Mount Athos, an important school of painting appeared in the area of Ioannina. It was active at the two monasteries on the island in the lake of Ioannina, as well as in northwestern Greece, at Meteora in Thessaly, and elsewhere. The artists, most of whom were anonymous, produced a group of wall-paintings of high quality, related in many ways to the work of the painter Frangos Katelanos of Thebes in Boeotia, who in 1560 created the murals in the chapel of St. Nicholas in the Great Lavra Monastery on Mount Athos. The murals in the main church of the Barlaam Monastery at Meteora (1548) are so closely related to those of Lavra that for some time they were attributed to Katelanos. His work, in con-

trast to the classic, quiet style of Theophanes, expressed his disposition to the Baroque, mainly in compositions crowded with agitated figures and many buildings. Nevertheless, Katelanos' relationship to the contemporary Cretan school was very close, especially in his choice of iconographic themes. In his paintings of individual saints, his technical methods were similar to the portable Cretan icons, as we see in the fresco of *Christ Pantocrator* (p. 335). Here Katelanos—or his patron—returned to the older system of iconostasis decoration, painting Christ and the Virgin on the front of the pilasters. The tall and noble figure of Christ has the intelligent features typical of this painter's creations.

The next phase of this school belongs to two other Theban painters, Frangos Kondaris and his brother, the priest Georgios, who worked together in some churches of Meteora and Epiros in 1563 and 1566. (In 1568, Frangos is known to have worked alone.) In these works we note the tendency toward stylization of the figures: the modeling becomes harsher, the drapery more rigid, the colors deeper and their scale narrower. The wall-paintings that decorate several churches in central Greece and Euboea are associated with the art of the brothers Kondaris, for example, the mural-icon of *St. John the Forerunner* in the Galataki Monastery (1566). The saint is framed by a roundel, surrounded by its graceful decorative designs. These are characteristic features of the school, whose style would survive well into the seventeenth century, spreading to northern Greece and neighboring countries.

Dormition of the Virgin
Andreas Ritzos
Tempera on wood, 67 x 44 cm. (26⅜ x 17⅜ in.);
Heraklion, Crete, 1450–1500; Galleria Sabaudo, Turin.

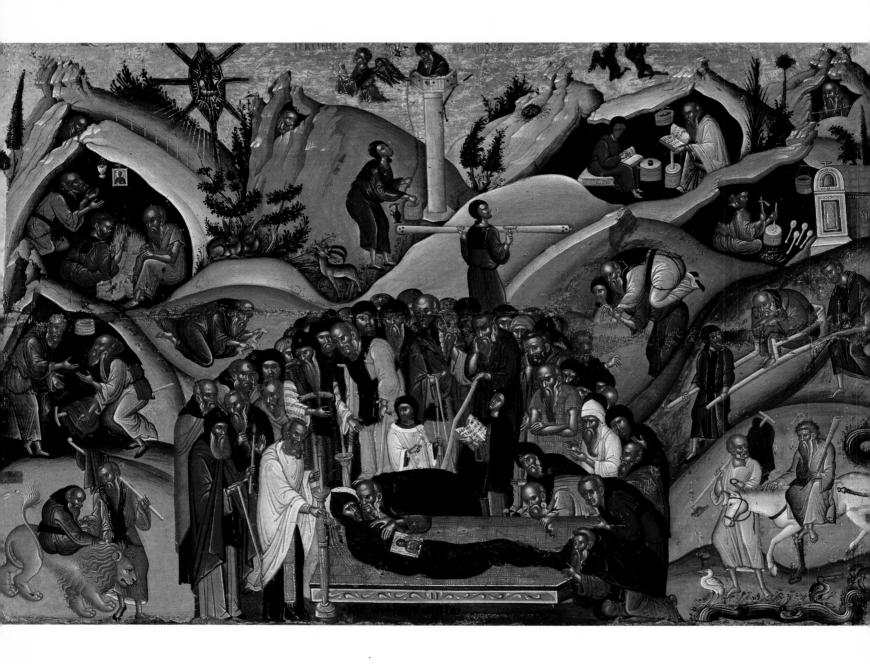

Death of St. Efriam the Syrian
Andreas Pavias
Tempera on wood, 39.5 x 59 cm. (15½ x 23¼ in.);
Heraklion, Crete, 1450–1500; Church of St.
Constantine and Helena, Jerusalem.

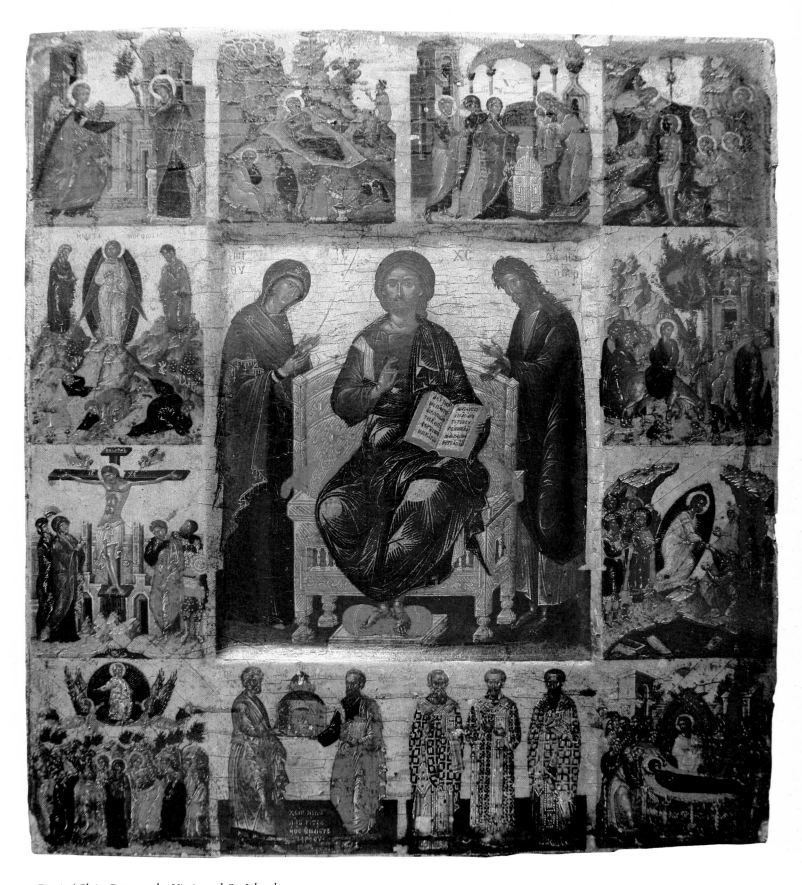

*Deesis (Christ Between the Virgin and St. John the
Forerunner with Twelve Feasts)*
Nicholas Ritzos, son of Andreas
Tempera on wood, 37.8 x 33.4 cm. (14⅞ x 13⅛ in.);
Heraklion, Crete, end of fifteenth century; Museum of
the Ancient Serbian Church, Sarajevo.

THE ICONS OF THE BALKAN PENINSULA AND THE GREEK ISLANDS (2)

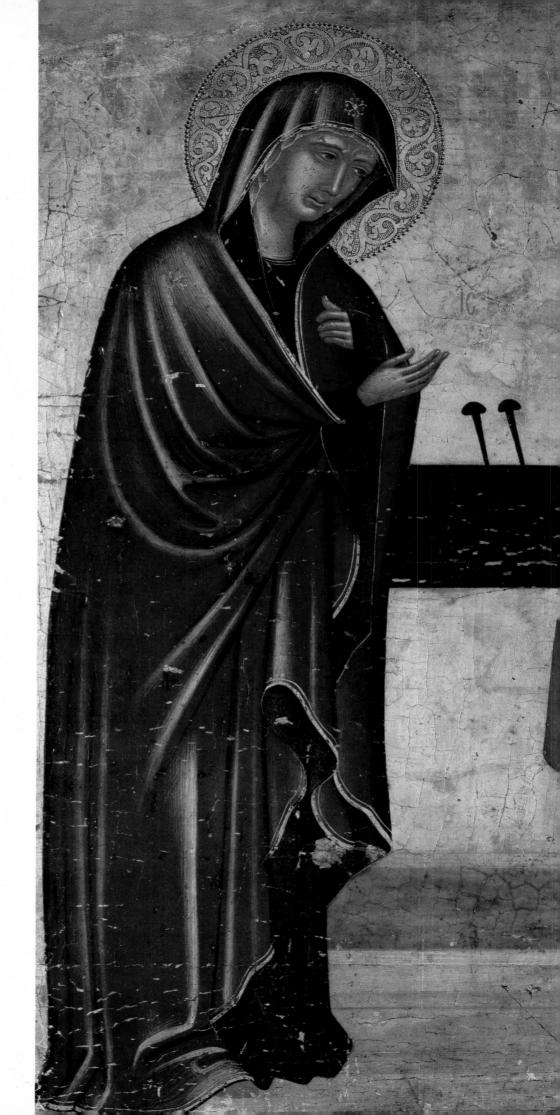

Man of Sorrow Between the Virgin and St. John
Nicholas Tzafuris
Tempera on wood, 59.2 x 76.6 cm.
(23¼ x 30⅛ in.); Heraklion, Crete,
1450–1500; Kunsthistorisches Museum,
Vienna.

322

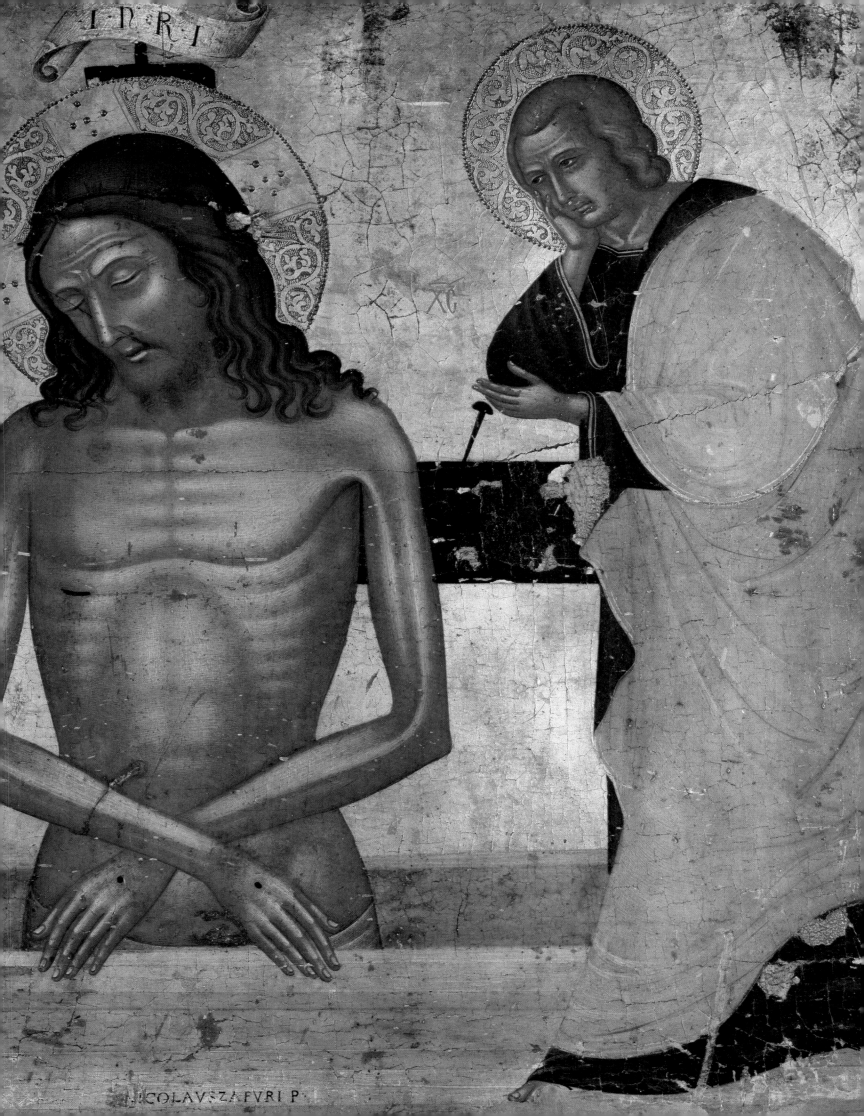

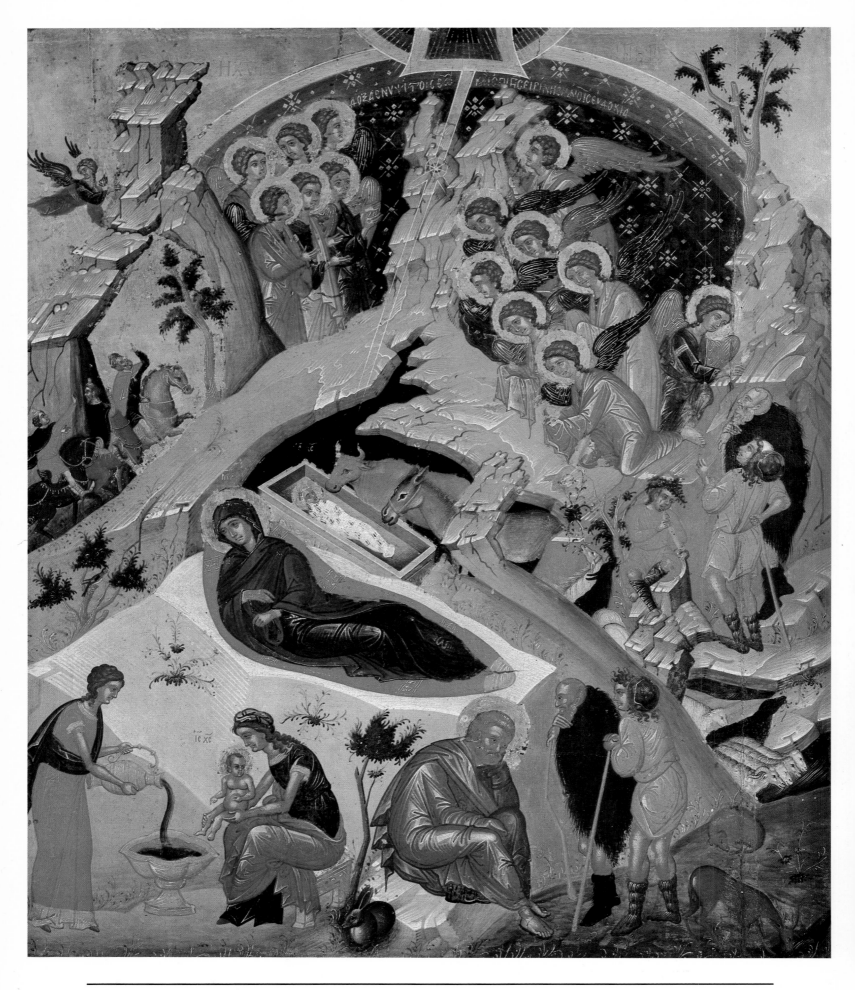

Opposite:
Nativity
Tempera on wood, 57 x 47.5 cm. (22½ x 18¾ in.);
beginning of sixteenth century; Istituto ellenico di studi
bizantini e post-bizantini, Venice.

Noli Me Tangere
Tempera on wood, 57 x 47.5 cm. (22½ x 18¾ in.);
Cretan school, Crete, beginning of sixteenth century;
Istituto ellenico di studi bizantini e post-bizantini,
Venice.

Below:
Predella with Five Saints
Angelos Bizamanos from Heraklion, Crete
Tempera on wood, 31.5 x 168 cm. (12⅜ x 66⅛ in.); Dalmatia, 1518; Church of Komolac, now in the Franciscan Monastery, Dubrovnik.

Above left:
Predella with Five Saints
Detail: St. Jerome
Angelos Bizamanos from Heraklion, Crete

Left:
Predella with Five Saints
Detail: St. Martin
Angelos Bizamanos from Heraklion, Crete

Opposite:
Pietá
Tempera on wood, 50 x 40 cm. (19¾ x 15¾ in.); Italo-Cretan style, Crete, 1450–1500; Monastery of Koutloumoussi.

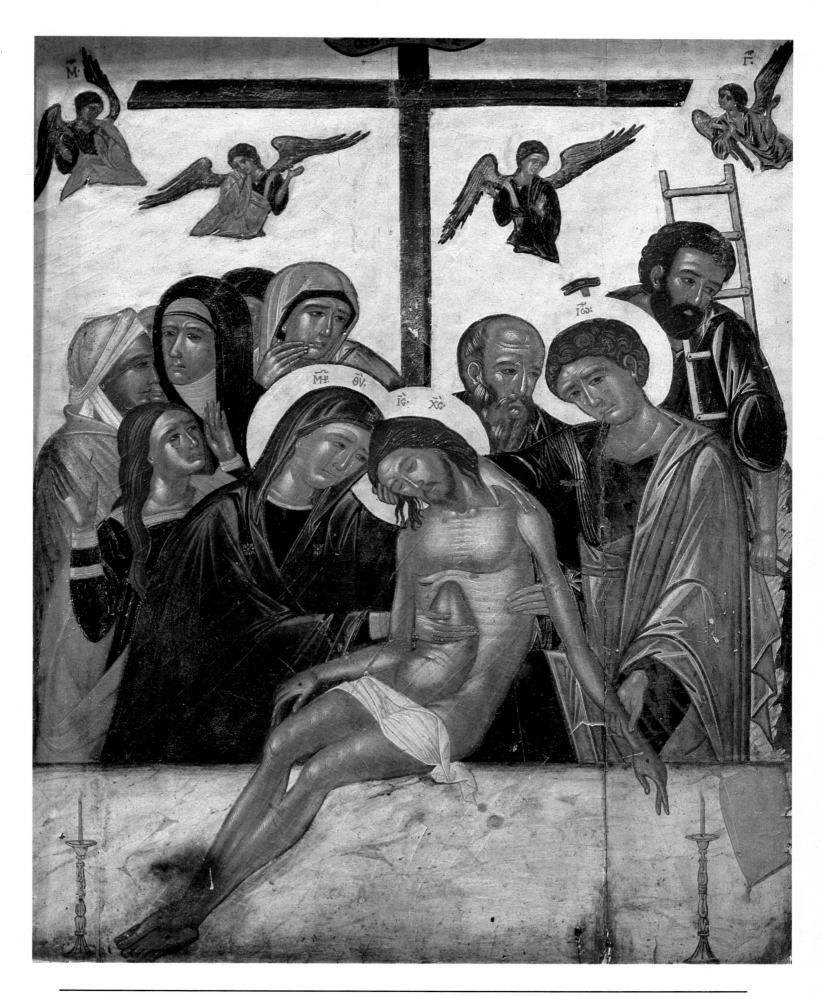

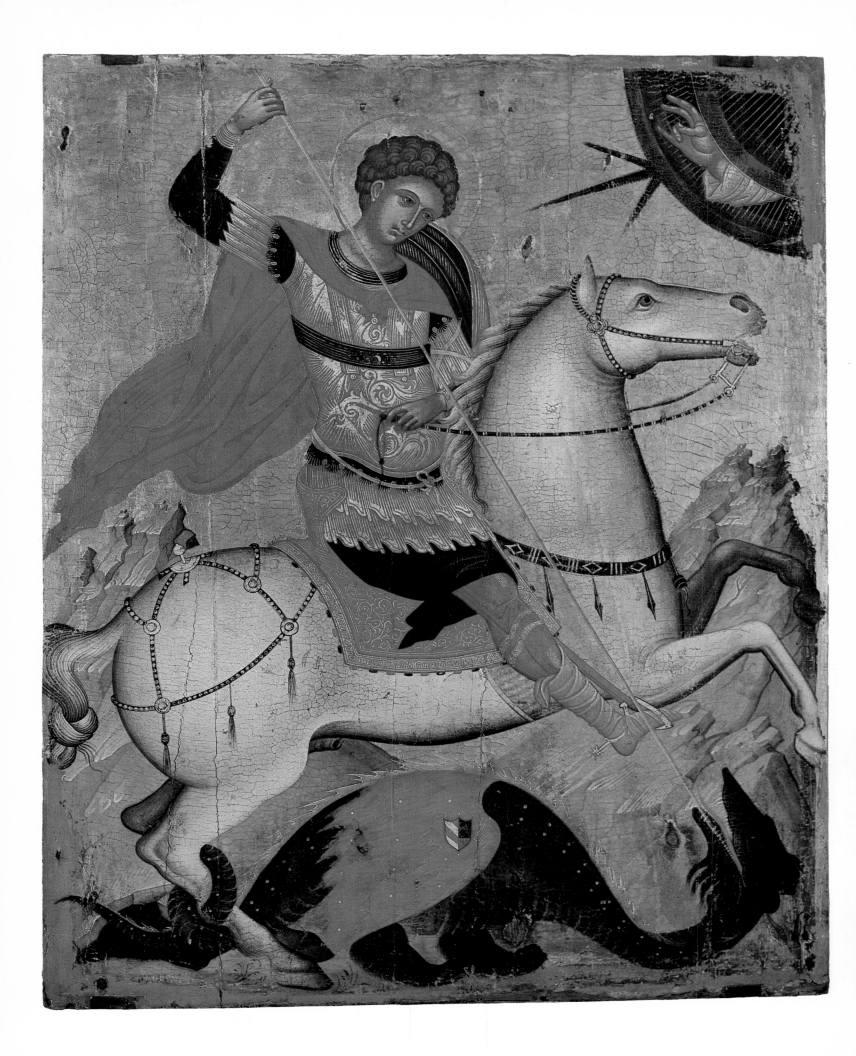

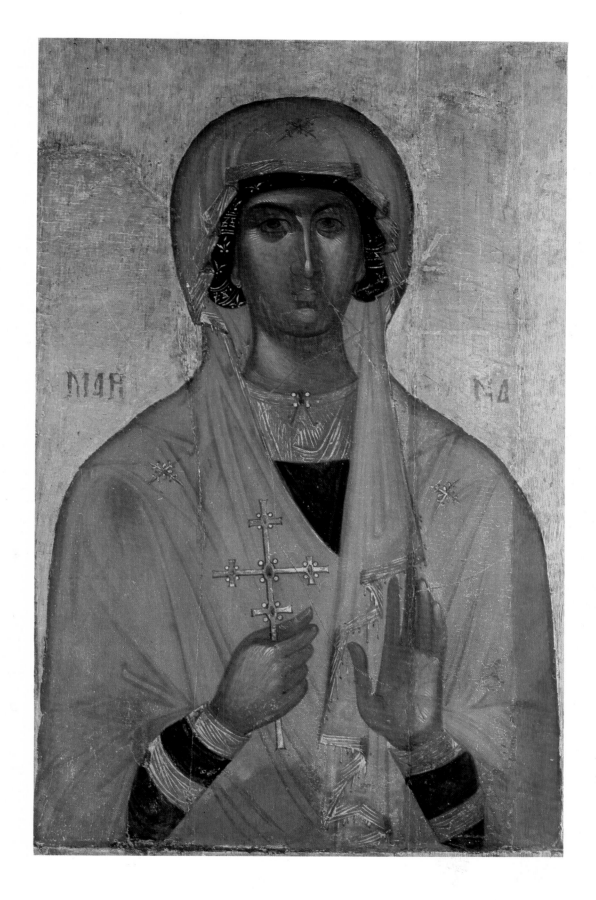

Opposite:
St. George Killing the Dragon
Tempera on wood, 82.5 x 65.5 cm. (32½ x 25¾ in.);
Cretan school, Crete, c. 1500; Istituto ellenico di studi
bizantini e post-bizantini, Venice.

St. Marina
Tempera on wood, 115 x 78 cm. (45¼ x 30¾ in.);
Cretan school, Crete, mid-fifteenth century; Byzantine
Museum, Athens.

Entry into Jerusalem, Detail
Attributed to the monk Theophanes Bathas from
Crete

Opposite:
Entry into Jerusalem
Attributed to the monk Theophanes Bathas from
Crete
Tempera on wood, 64 x 46 cm. (25¼ x 18⅛ in.);
Monastery of the Great Lavra, Mount Athos, 1535 (?);
catholicon of the Monastery of the Great Lavra,
Mount Athos.

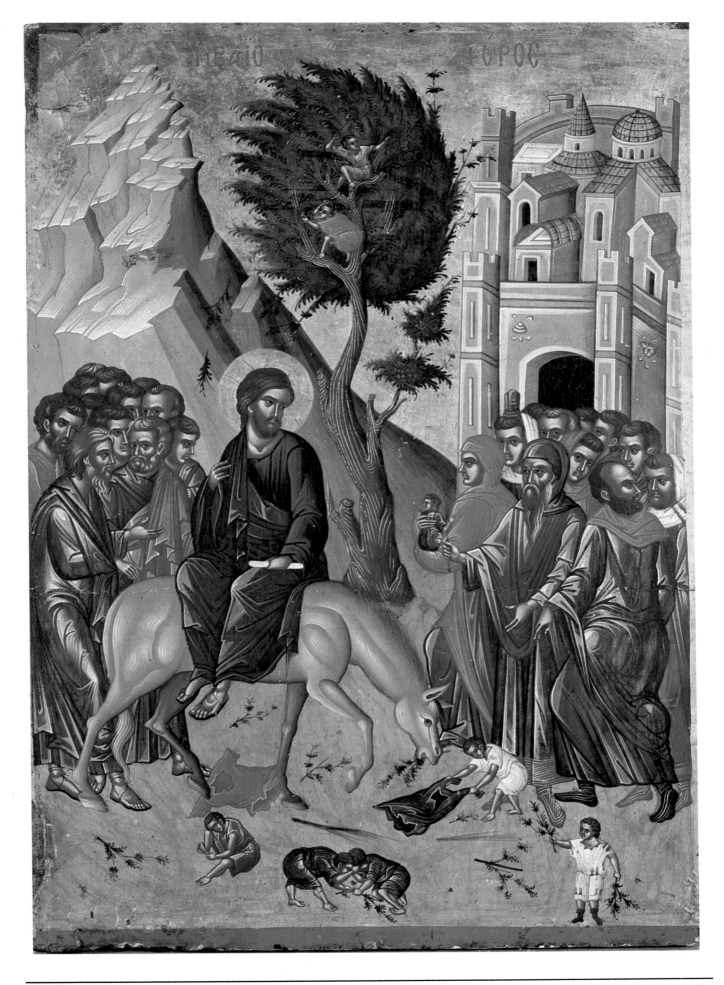

Transfiguration, Detail
Attributed to the monk Theophanes Bathas from Crete

Opposite:
Transfiguration
Attributed to the monk Theophanes Bathas from Crete
Tempera on wood, 64 x 46 cm. (25¼ x 18⅛ in.);
Monastery of the Great Lavra, Mount Athos, 1535 (?);
catholicon of the Monastery of the Great Lavra,
Mount Athos.

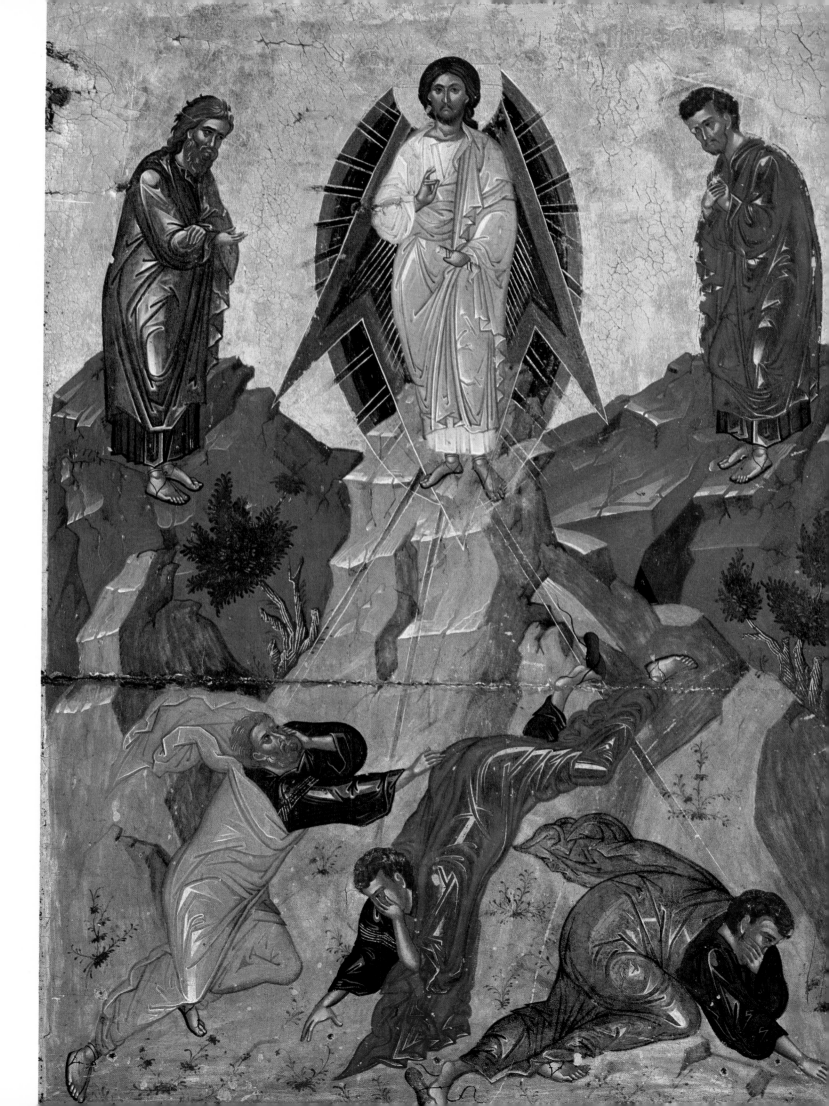

Ὁ Ἅ
ΑΦΡΩ
CΙΝΟC
ΟΜΑΡΤΡ
ΟС

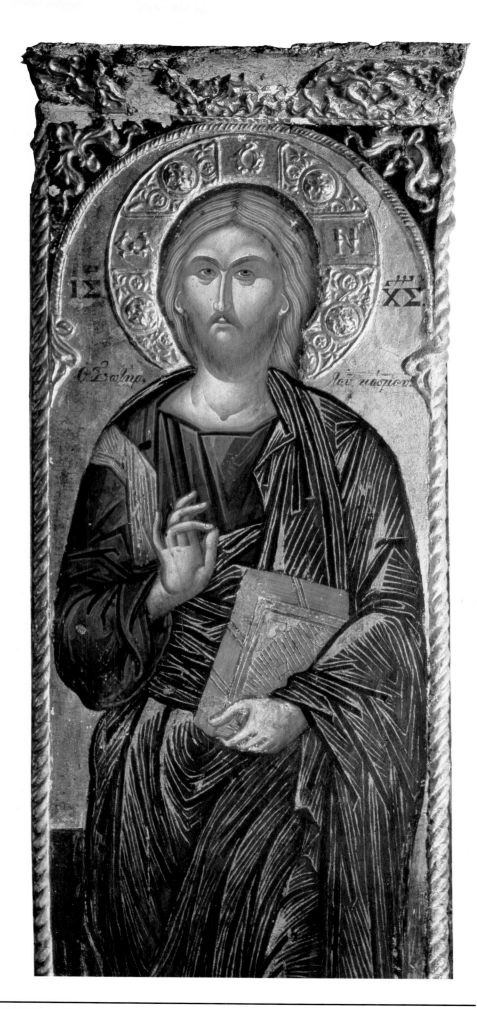

Opposite:
St. Euphrosinos
Theophanes Bathas from Crete
Fresco; 1527; Monastery of St. Nicholas
Anapavsas, Meteora.

Right:
Christ Pantocrator
Attributed to Frangos Katelanos from
Thebes
Fresco; 1548; Church of All Saints,
Monastery of Barlaam, Meteora.
(unpublished)

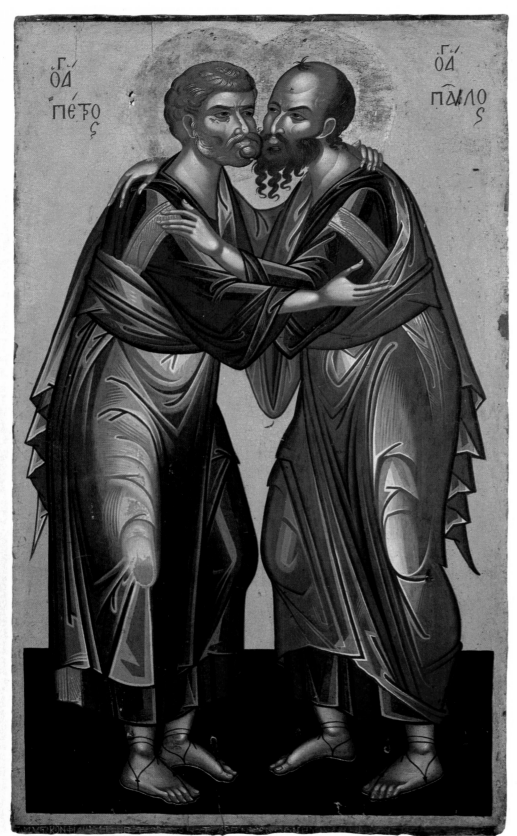

Left:
Apostles Peter and Paul
Tempera on wood, 108 x 63 cm. (42½ x 24¾ in.); Cretan school, Monastery of the Great Lavra, Mount Athos, mid-sixteenth century; Chapel of St. Athanasios, Monastery of the Great Lavra, Mount Athos.

Right:
Raising of Lazarus
Tempera on wood, 37 x 25.5 cm. (14⅝ x 10 in.); Cretan school, Crete, mid-sixteenth century; Benaki Museum, Athens.

Above:
St. John the Forerunner
Fresco; school of continental Greece, c. 1560–70; Chapel of St. John, Monastery of Galataki, Euboea. (unpublished)

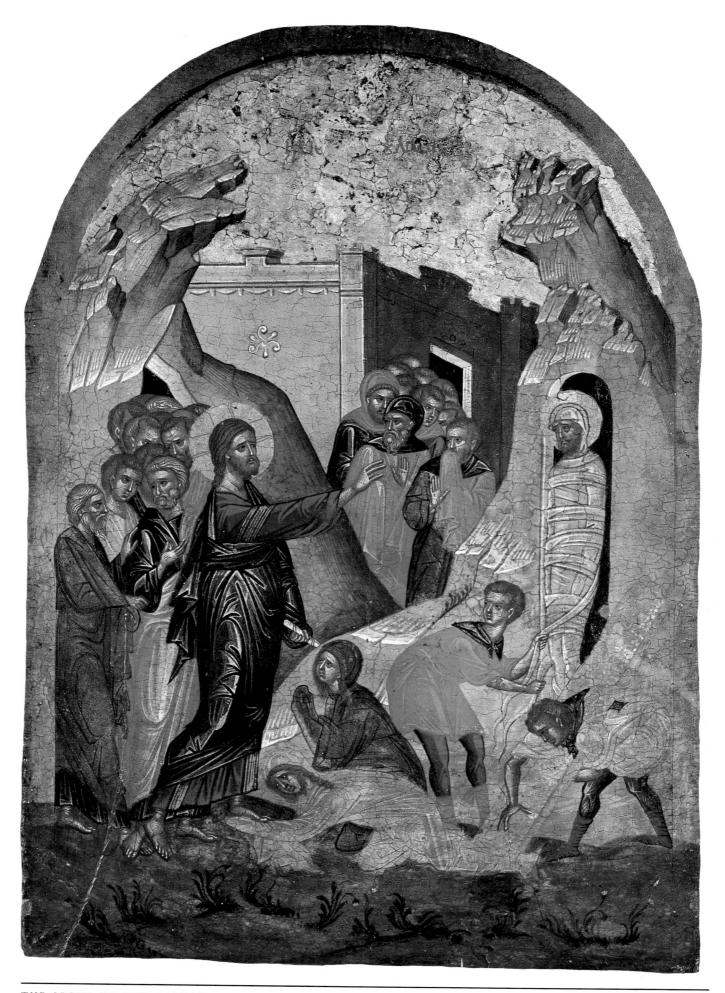

Above left:
Virgin Enthroned with Child, Angels, and Prophets Holding Scrolls with Greek Texts and Pointing to the Virgin's Symbols
Perhaps the Greek painter working at Krušedol
Tempera on wood, 79.3 x 59 cm. (31¼ x 23¼ in.); Monastery of Krušedol, Srem, c. mid-sixteenth century; Museum of the Serbian Orthodox Church, Belgrade.

Left:
Virgin Enthroned with Child, Angels, and Prophets Holding Scrolls with Greek Texts and Pointing to the Virgin's Symbols
Detail: The Donor, Joakim, Hegoumenos of Krušedol, in Proskynesis
Perhaps the Greek painter working at Krušedol

Opposite:
Holy Trinity
Serbian artist
Tempera on wood, 66 x 42 cm. (26 x 16½ in.); end of sixteenth century; Monastery of Dečani, Serbia.

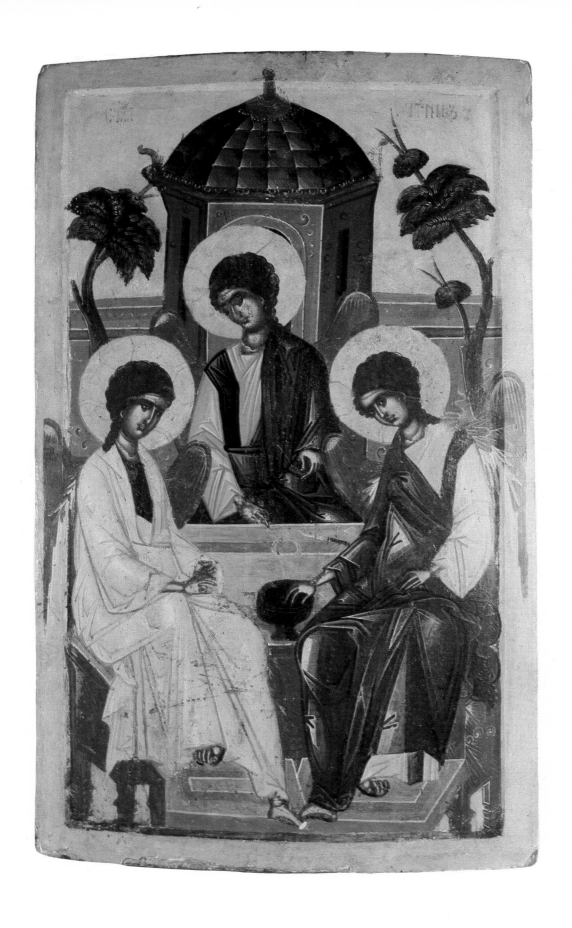

Holy Trinity (*Hospitality of Abraham*)
Serbian artist
Tempera on wood, 101 x 61 cm. (39¾ x 24 in.); c.
mid–sixteenth century; Monastery of Dečani, Serbia.

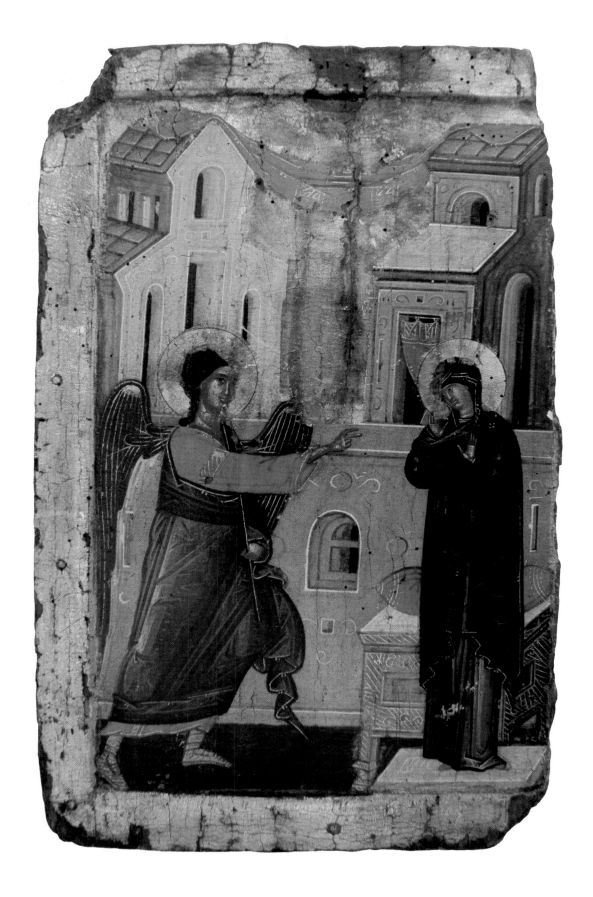

Annunciation
Longin
Bilateral icon with *Nativity* on the other side; tempera
on wood, 44 x 27.5 cm. (17⅜ x 10⅞ in.); 1572–73;
Monastery of Dečani, Serbia.

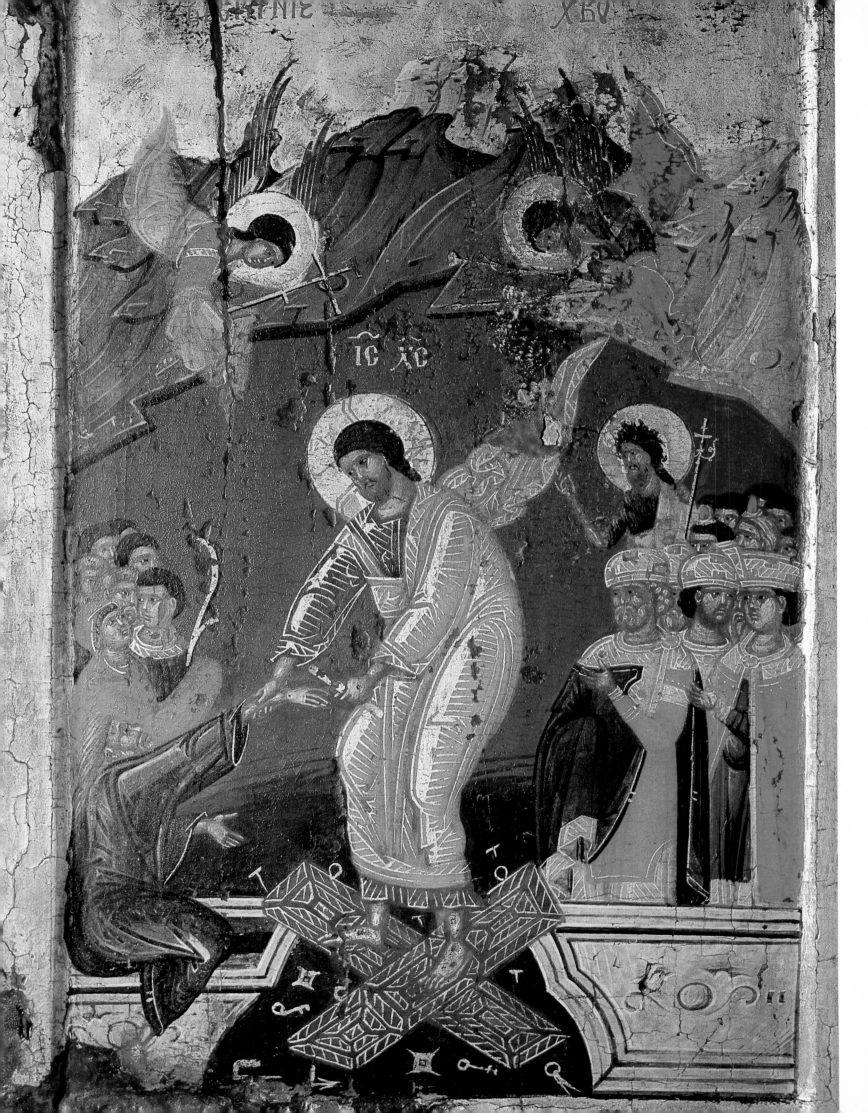

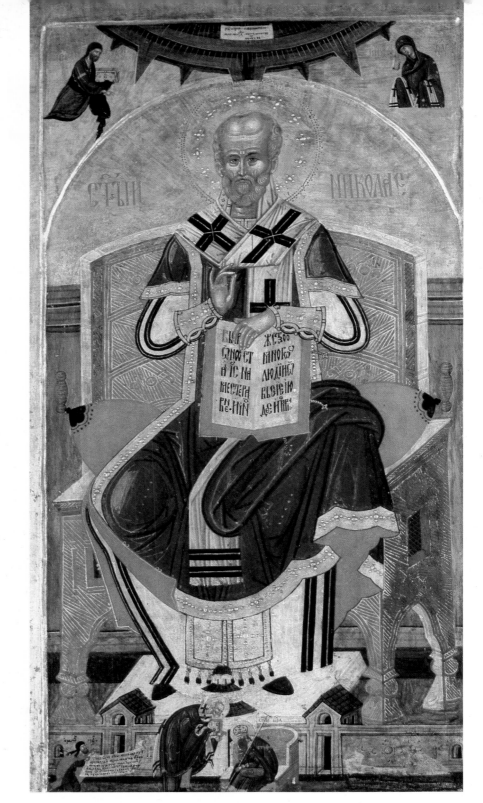

Opposite:
Harrowing of Hell
Longin
Bilateral icon with *Ascension* on the
other side; tempera on wood, 44 x 30
cm. (17⅜ x 11¾ in.); 1572–73;
Monastery of Dečani, Serbia.

Above right:
*St. Nicholas Enthroned, with the Donor
George and One of the Saint's Miracles*
Longin
Tempera on wood, 121 x 68.5 cm.
(47⅝ x 27 in.); 1577; iconostasis,
Church of St. Nicholas, Velika Hoča,
Serbia.

Right:
*St. Nicholas Enthroned, with the Donor
George and One of the Saint's Miracles*
Detail: St. Nicholas healing the
blindness of the Serbian king Stephen
III Uroš
Longin

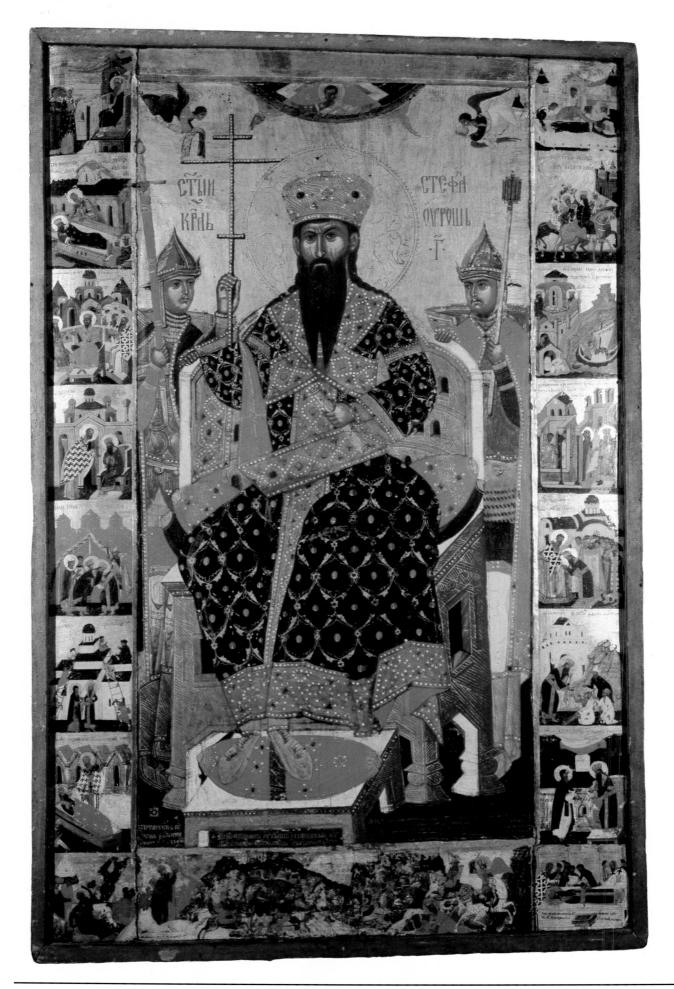

Opposite:
St. Stephen the King Uroš III and Scenes from His Life
Longin
Tempera on wood, 150 x 94 cm. (59 x 37 in.); 1577; Monastery of Dečani, Serbia.

Above right:
St. Stephen the King Uroš III and Scenes from His Life
Detail: The Serbian king Milutin asks for news of his son, Stephen III
Longin

Right:
St. Stephen the King Uroš III and Scenes from His Life
Detail: Archbishop Nikodim crowning the Serbian king Stephen III
Longin

Left above and below:
*St. Stephen the King Uroš III and Scenes
from His Life*
Two details: Battle of Velbužd (1330)
Longin

Above right:
St. Stephen the King Uroš III and Scenes from His Life
Detail: King Stephen and his son, expelled from Serbia, travel to Constantinople
Longin

Right:
St. Stephen the King Uroš III and Scenes from His Life
Detail: Death of St. Stephen
Longin

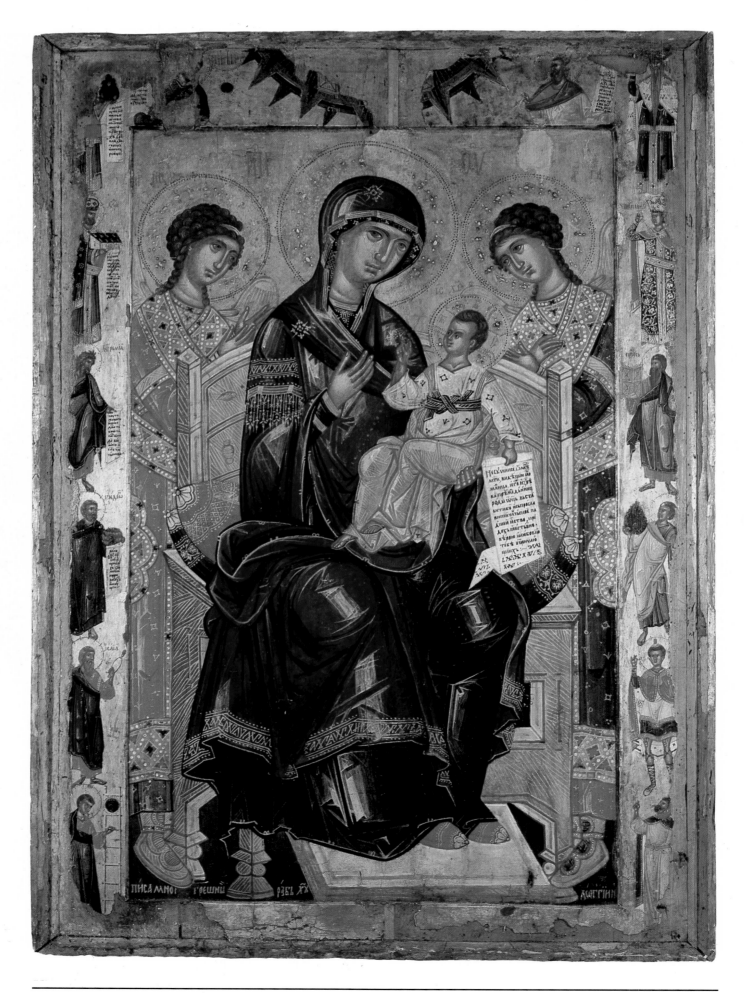

Opposite:
*Virgin Enthroned with Child, Archangels, and Prophets
Holding Scrolls with Serbian Texts and Pointing to the
Virgin's Symbols*
Longin
After restoration; tempera on wood, 117 x 82 cm. (46
x 32¼ in.); 1577–78; iconostasis, Monastery of
Lomnica.

Above left:
St. John Climacos and Communion of Mary of Egypt
Longin
Bilateral icon with *SS. Theodore Tiron* and *Stratelate* on
the other side; tempera on wood, 38 x 27 cm. (15 x
10⅝ in.); 1596; Monastery of Dečani, Serbia.

Above right:
Apostle Matthew
Serbian artist
Tempera on wood, 59 x 23.5 cm. (23¼ x 9¼ in.);
iconostasis, Monastery of Gračanica, mid-sixteenth
century; National Museum, Belgrade.

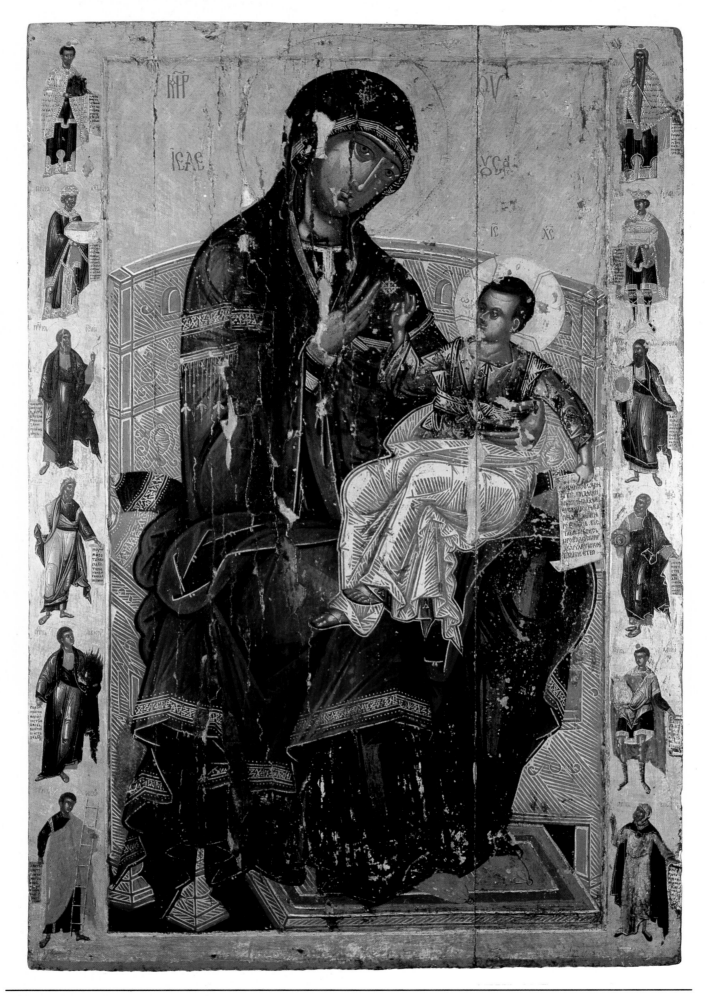

Opposite:
Virgin Enthroned with Child and Prophets Holding Scrolls with Serbian Texts and Pointing to the Virgin's Symbols
Attributed to Longin
Tempera on wood, 174 x 117 cm. (68½ x 46 in.); late sixteenth century; Monastery of Dečani, Serbia.

Above:
Virgin Enthroned with Child and Prophets
Detail: Prophet Moses
Attributed to Longin

Above right:
Virgin Enthroned with Child and Prophets
Detail: Prophet David
Attributed to Longin

Right:
Christ Pantocrator with the Apostles
Detail: Apostle Andrew (see p. 352)
Attributed to Longin

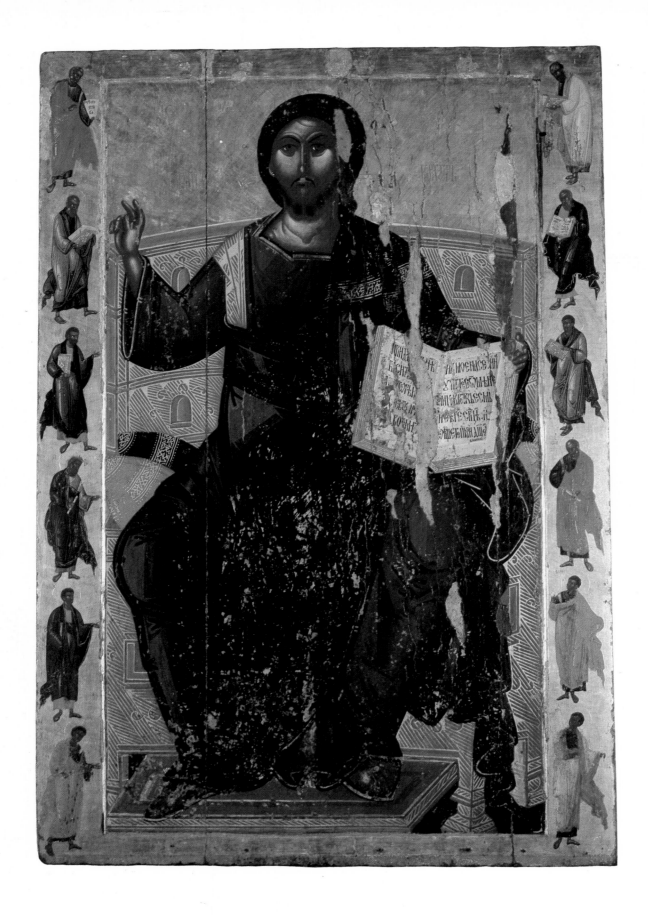

Christ Pantocrator with the Apostles
Attributed to Longin
Tempera on wood, 172 x 115 cm. (67¾ x 45¼ in.);
late sixteenth century; Monastery at Dečani, Serbia.

Opposite:
Christ Pantocrator with the Apostles
Detail: Head of Christ
Attributed to Longin

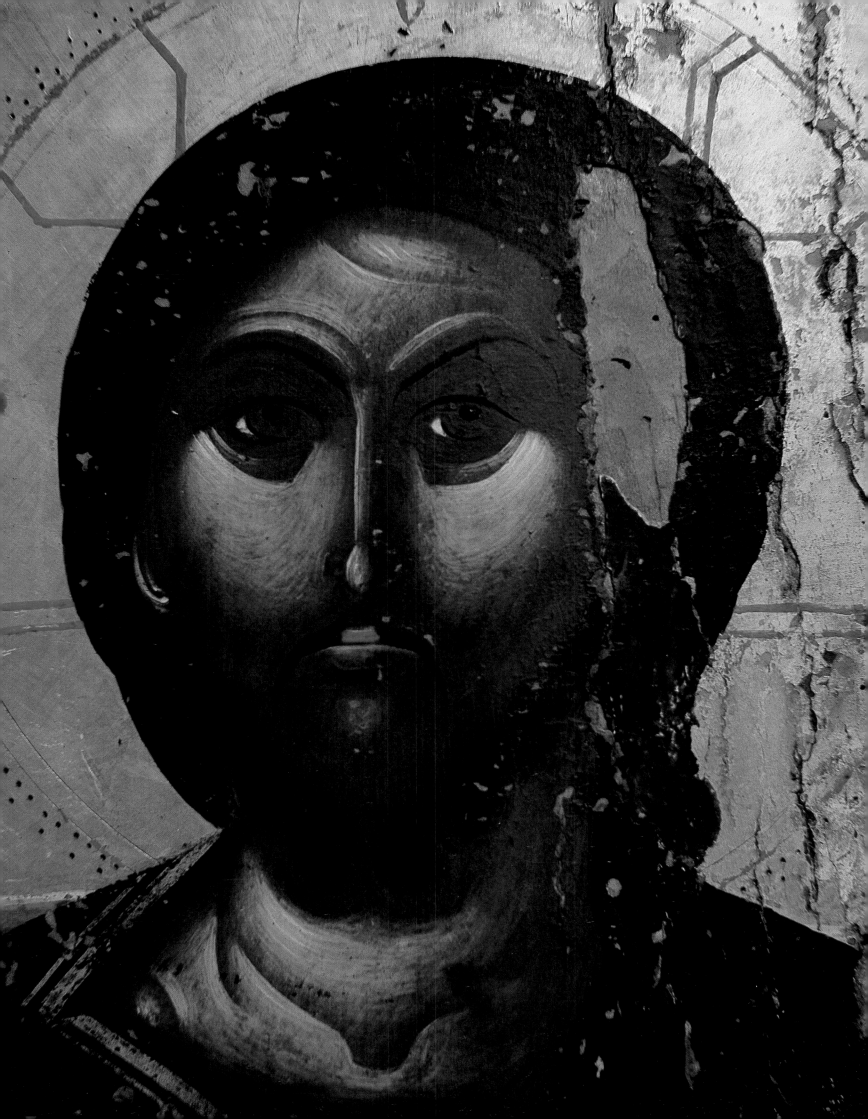

Opposite:
Christ Crowning Serbian Saints (former) Despots, members
of the Brankovic family
Unknown Serbian artist
Tempera on wood, 35.8 x 28 cm. (14⅛ x 11 in.);
Monastery of Krušedol, seventeenth century; Museum
of the Serbian Orthodox Church, Belgrade.

St. Anthony
Michael Damaskinos
Tempera on wood, 86 x 67 cm. (33⅞ x 26⅜ in.);
Heraklion, Crete, 1550–1600; Byzantine Museum,
Athens.

"*In Thee Rejoiceth,*" Detail
Georgios Klotzas

Opposite:
"*In Thee Rejoiceth*"
Georgios Klotzas
Tempera on wood, 71.5 x 47 cm. (28⅛ x 18½ in.);
Heraklion, Crete, 1550–1600; Istituto ellenico di studi
bizantini e post-bizantini, Venice.

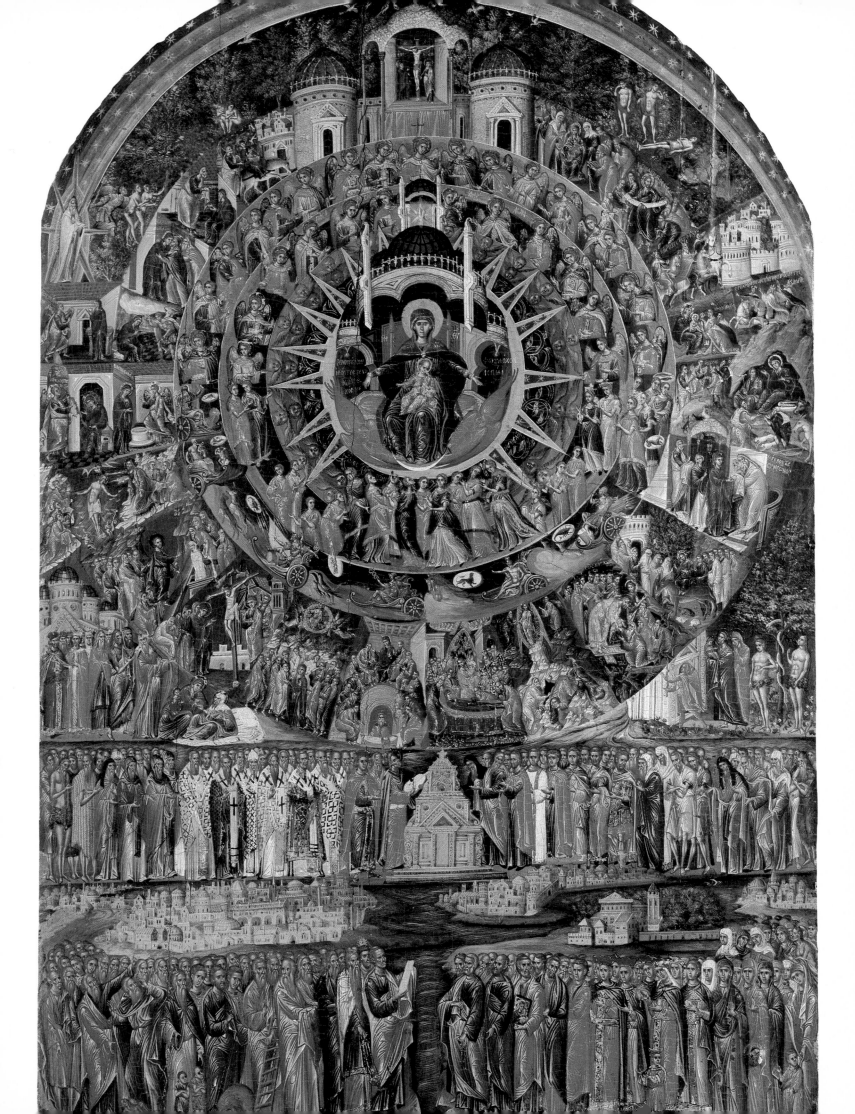

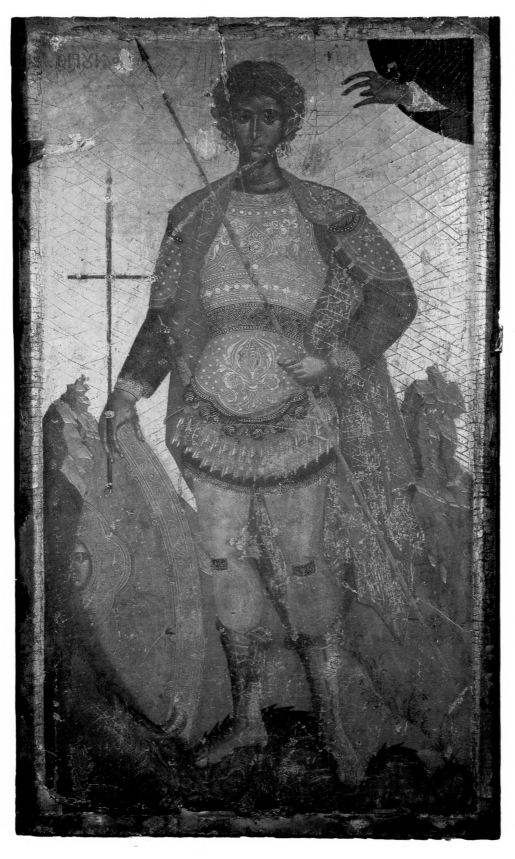

St. Phanourios
Angelos
Tempera on wood, 111 x 62.5 cm. (43¾ x 24⅝ in.);
Heraklion, Crete, c. 1600 (?); Monastery of St. John
the Theologian, Patmos.

Opposite:
Finding of the Holy Cross
Georgios Klotzas
Central panel of a triptych; tempera on wood, 45.5 x
30.5 cm. (17⅞ x 12 in.); Heraklion, Crete, 1580–1600;
Monastery of St. John the Theologian, Patmos.

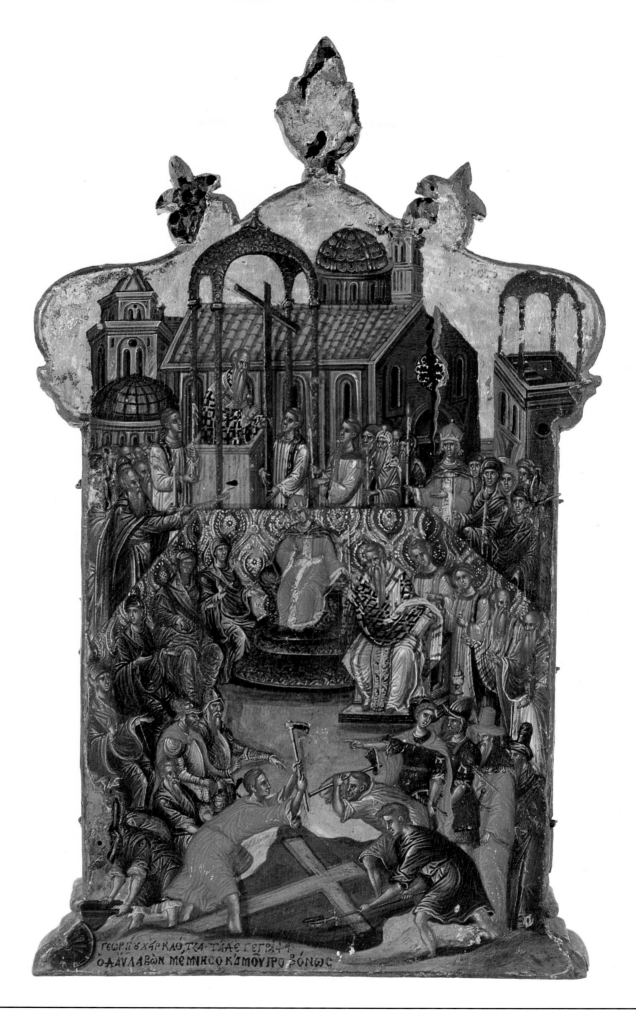

Opposite:
Adoration of the Magi
Michael Damaskinos (the second magus may be a
self-portrait.)
Tempera on wood, 109 x 87 cm. (42⅞ x 34¼ in.);
Heraklion, Crete, end of sixteenth century; Church of
St. Catherine, Heraklion.

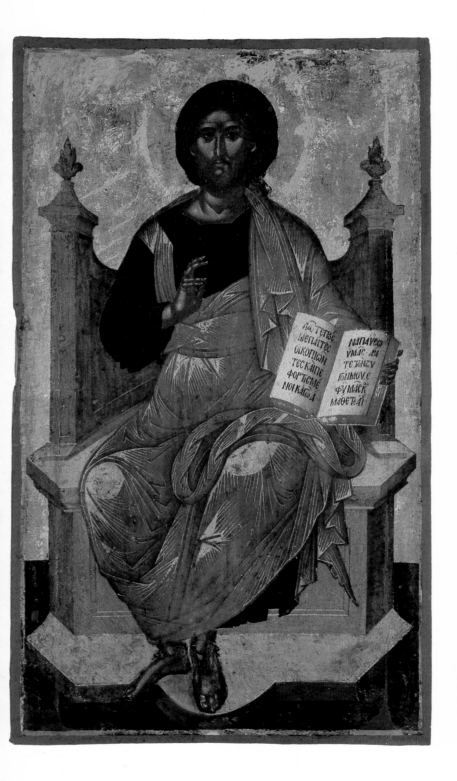

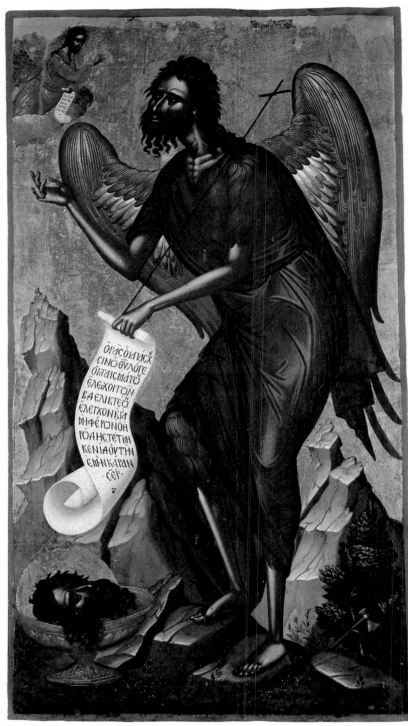

Above left:
Christ Enthroned
Angelos
Tempera on wood, 104.3 x 59.7 cm. (41 x 23½ in.);
Heraklion, Crete, c. 1600 (?); Museum, Zakynthos.

Above right:
St. John the Forerunner
Michael Damaskinos
Tempera on wood, 111 x 60.2 cm. (43¾ x 23¾ in.);
Crete, 1550–1600; Museum, Zakynthos.

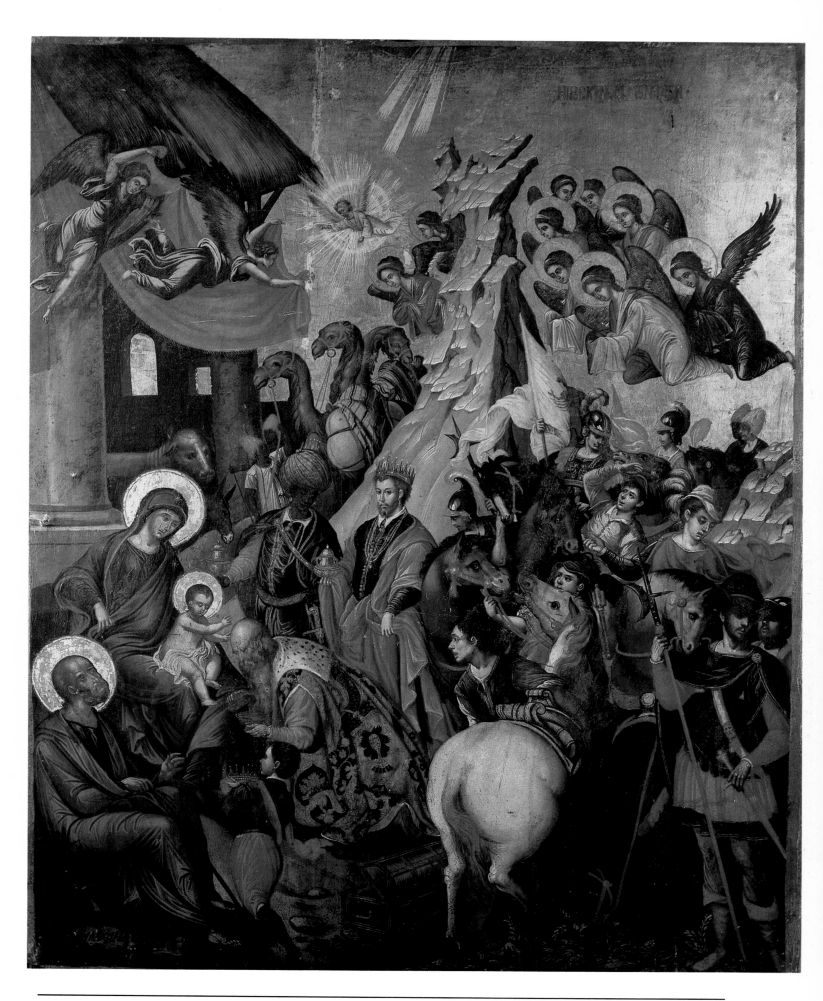

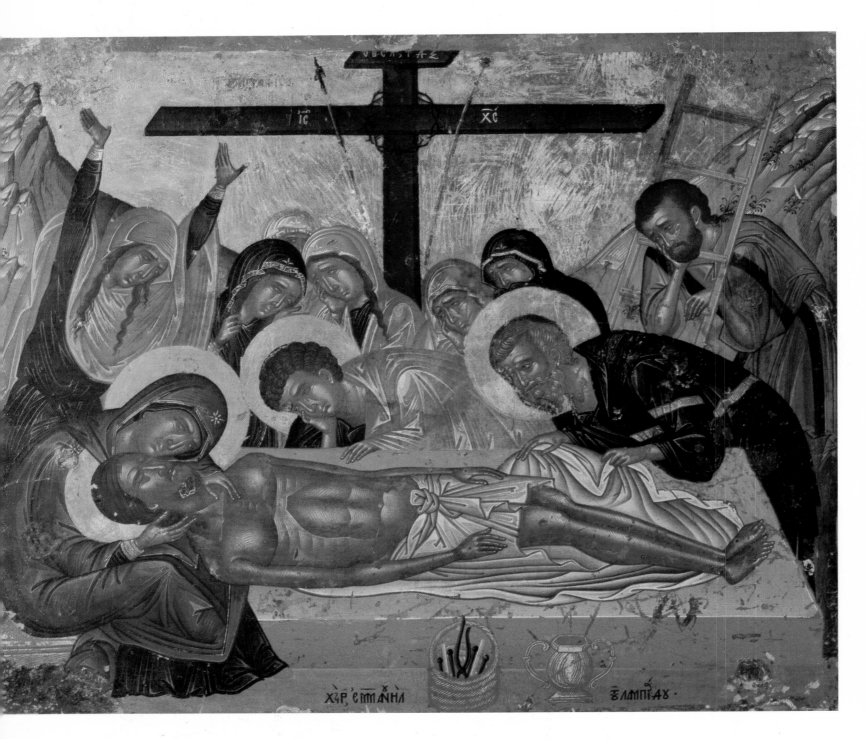

Epitaphios
Emmanuel Lambardos
Tempera on wood, 41 x 52 cm. (16⅛ x 20½ in.);
Heraklion, Crete, c. 1600–20; Byzantine Museum,
Athens.

Opposite:
Crucifixion with Donors
Emmanuel Lambardos
Tempera on wood, 111 x 96 cm. (43¾ x 37¾ in.);
Heraklion, Crete, 1613–18; Church of San Giorgio dei
Greci, Venice.

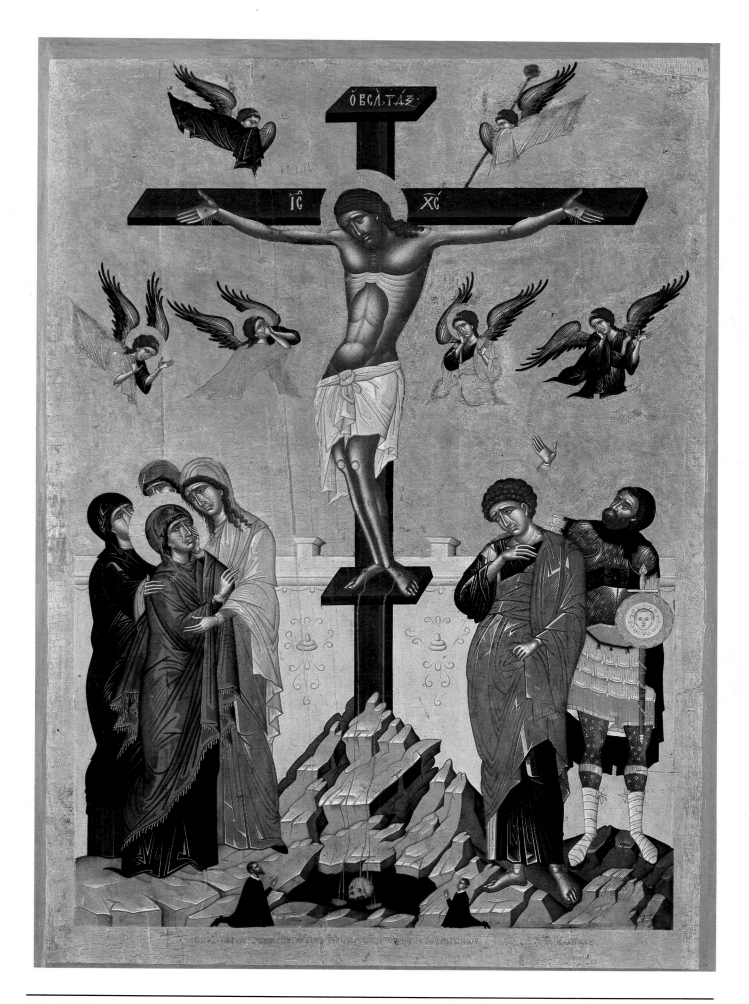

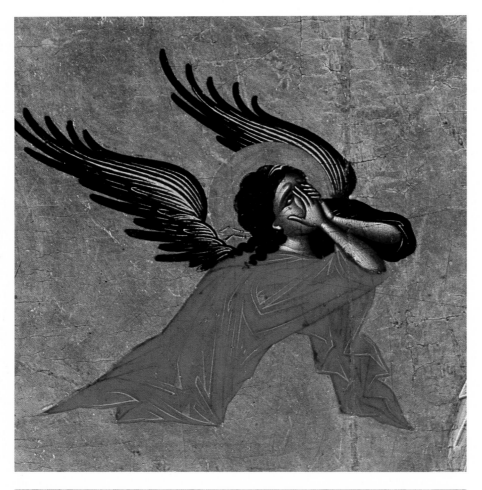

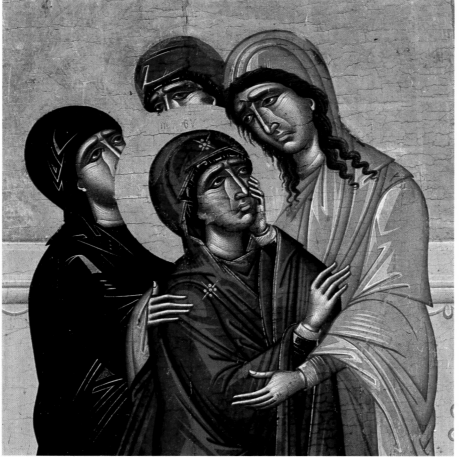

Above and below left:
Crucifixion with Donors, Two Details
Emmanuel Lambardos

Opposite:
Deposition from the Cross
Ioannis Apakas
Tempera on wood, 38.8 x 33.2 cm.
(15¼ x 13⅛ in.); Heraklion, Crete,
c. 1600; catholicon, Monastery of the
Great Lavra, Mount Athos.

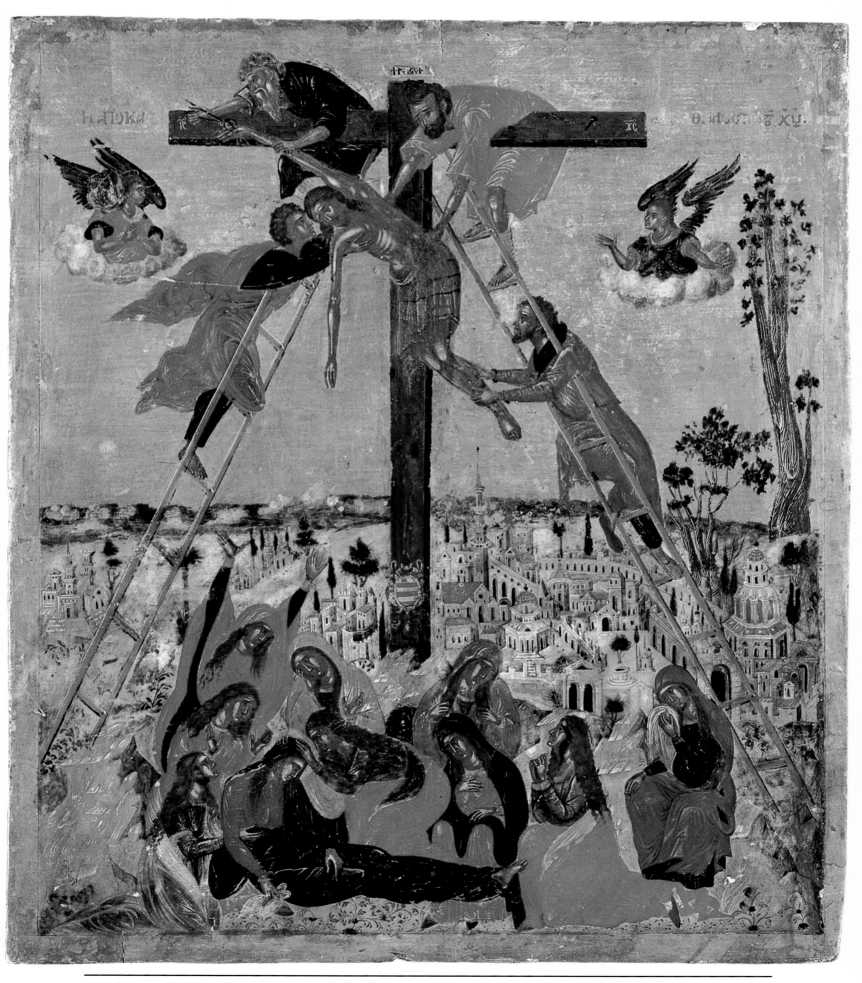

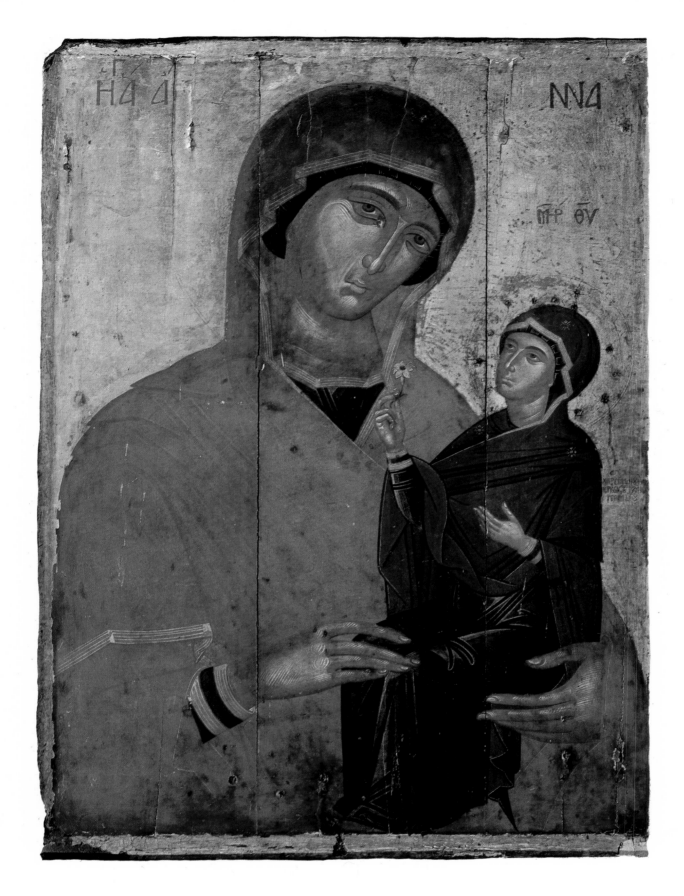

St. Anne with the Virgin
With forged signature and date: Emmanuel Tzanès,
1637
Tempera on wood, 106 x 76 cm. (41¾ x 29⅞ in.);
Rethymnon, Crete; Benaki Museum, Athens.

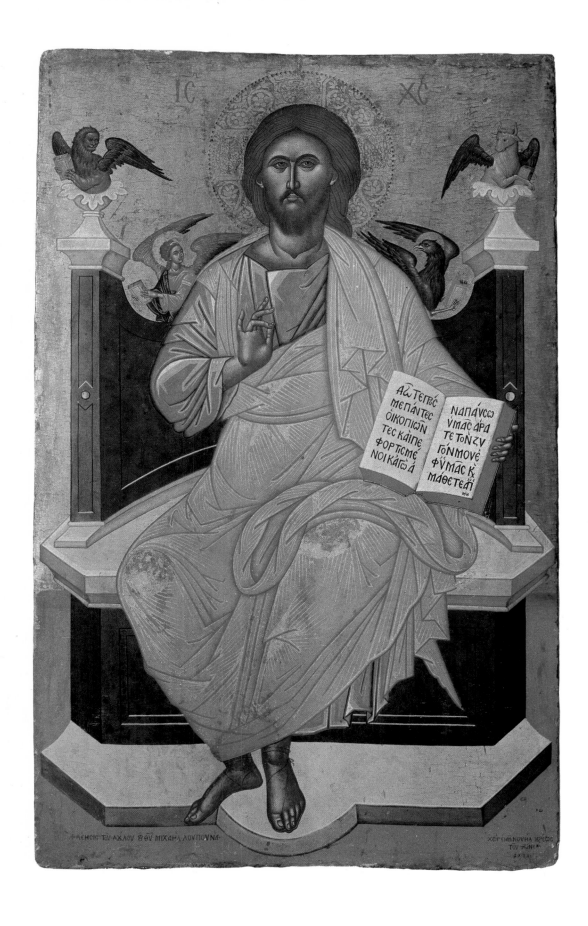

Christe Enthroned
Emmanuel Tzanès from Rethymnon, Crete
Tempera on wood, 106 x 66 cm. (41¾ x 26 in.);
Venice, 1664; Byzantine Museum, Athens.

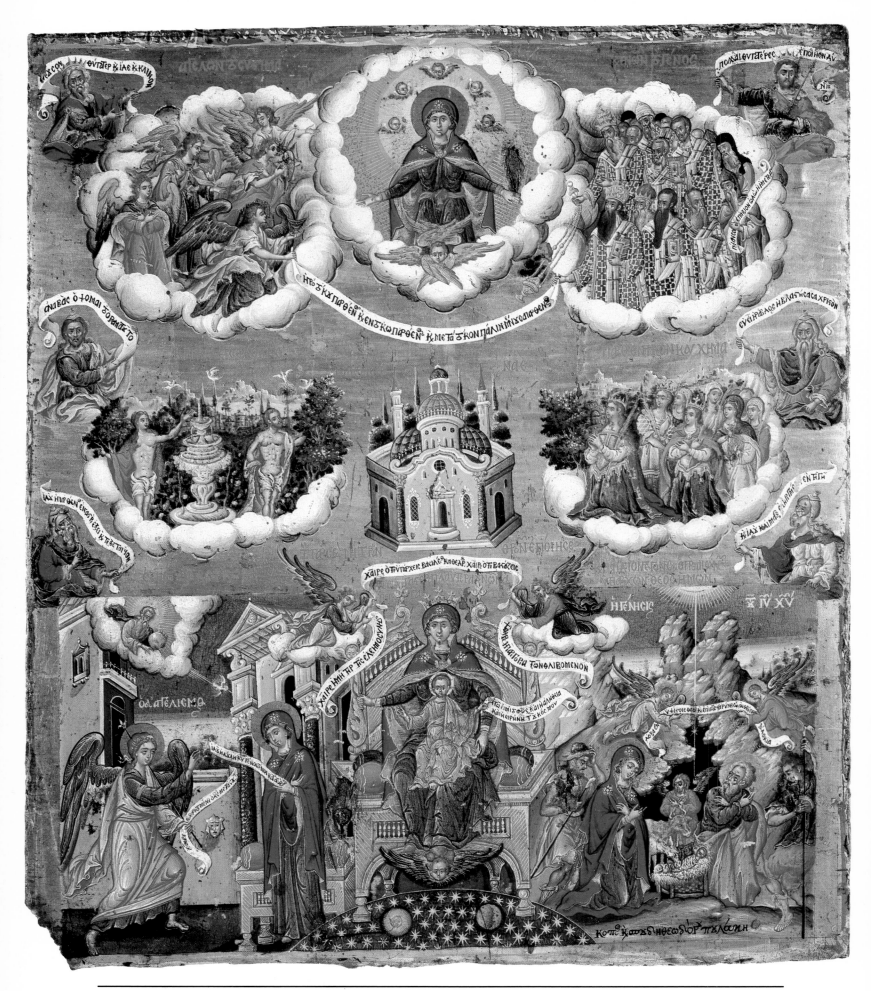

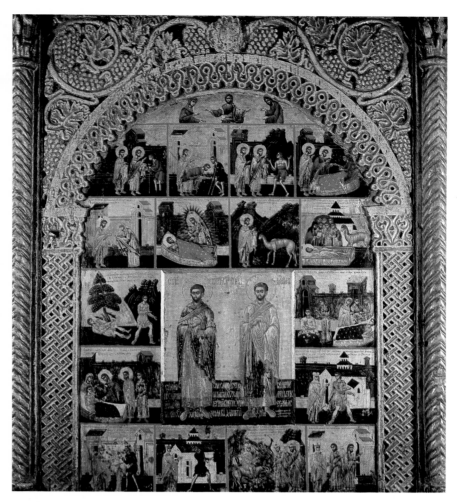

Opposite:
"In Thee Rejoiceth"
Theodore Poulakis (d. 1690) from
Chania, Crete
Tempera on wood, 45 x 38.2 cm. (17¾
x 15 in.); Corfu (?), late seventeenth
century; Monastery of St. John the
Theologian, Patmos.

Above right:
*SS. Cosmas and Damian with Scenes from
Their Lives and Miracles*
Radul of Serbia
Tempera on wood, 98.5 x 85.5 cm.
(38¾ x 33⅝ in.); 1673–74; Patriarchate
of Peć.

Right:
*SS. Cosmas and Damian with Scenes from
Their Lives and Miracles,* Detail
Radul of Serbia

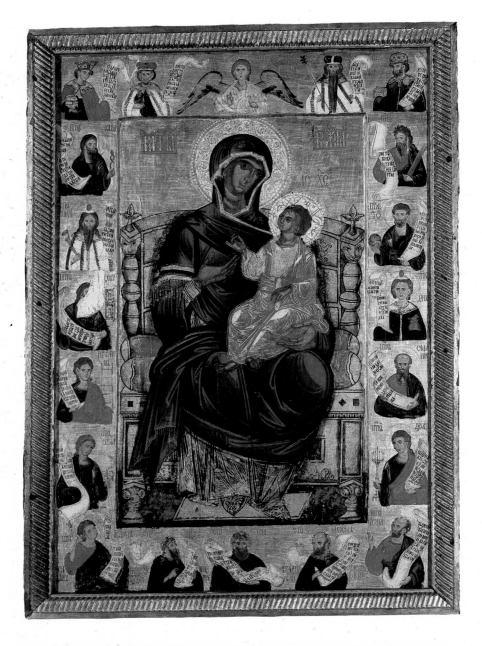

Above left:
*Virgin Enthroned with Child, Prophets,
and Hymnographers*
Georgije Mitrofanović, monk of
Chilandari working in Serbia
133 x 93 cm. (52⅜ x 36⅝ in.); 1616–17;
altar screen, Morača Monastery,
Montenegro.

Left:
St. Luke and Scenes from His Life
Detail: St. Luke painting the portrait of
the Virgin with Child
Unknown Serbian painter
Tempera on wood, total measurement
88.5 x 73 cm. (34⅞ x 28¾ in.);
1672–73; Morača Monastery,
Montenegro.

Opposite:
*Serbian SS. Sava and Simeon Nemanja
with Scenes from the Life of St. Sava*
Kozma
Tempera on wood; 1645; Morača
Monastery, Montenegro.

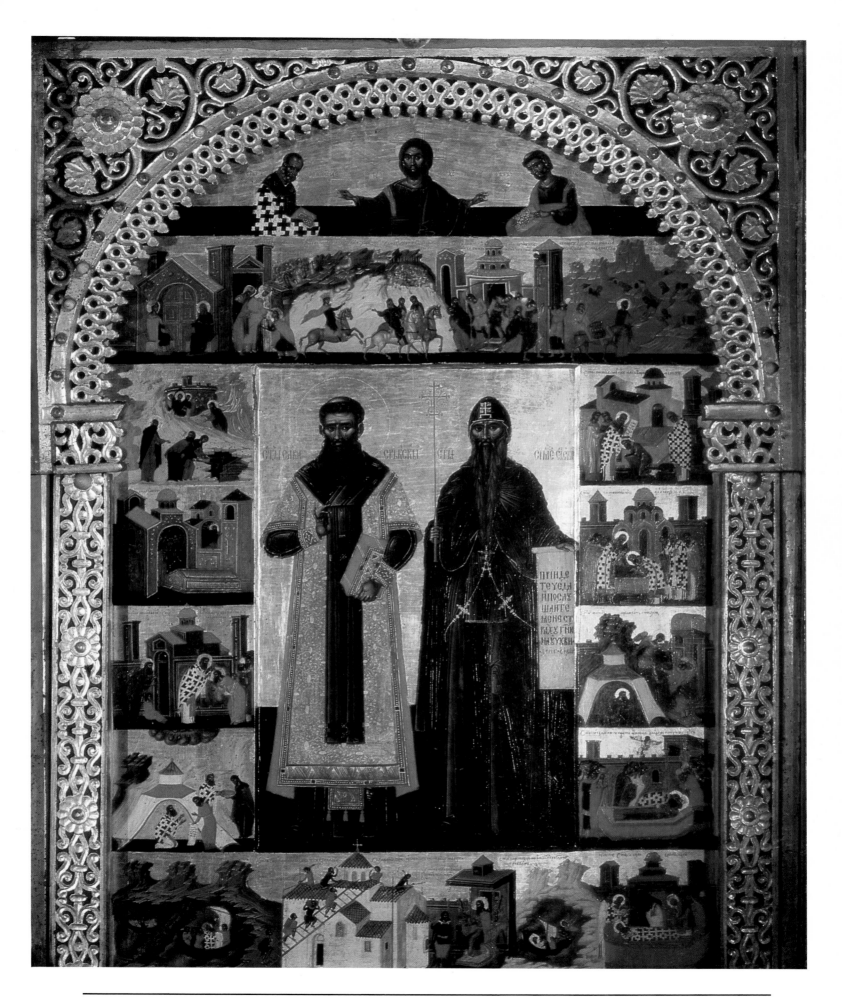

VII

THE POST-BYZANTINE ICONS OF WALLACHIA AND MOLDAVIA

 Teodora Voinescu

Post-Byzantine art, which evolved against the historical and cultural background that preserved the glory of the Byzantine legacy, comprised the artistic experience of all of southeastern Europe. Its birth can be traced to a major historical moment: the fall of Constantinople in 1453. When we examine the factors that stimulated or hampered the development of cultural and artistic life in the aftermath of 1453, we detect both common features and differences in the historical contexts of the various eastern European political entities. The most important point to be made, however, is that the culture of Byzantium survived the conquest of its capital.

Over the past few decades, art lovers and scholars have become very interested in Byzantine and post-Byzantine icons of southeastern and eastern Europe. The absence of a synthesizing work on the subject, accounted for by the scarcity and uneven quality of the research done so far, is nevertheless compensated by a wealth of first-class studies analyzing the artistic expression of various post-Byzantine genres. It is to such studies that we owe our present knowledge of Rumanian icon-painting.

A permanent presence in the cultural background of the Danubian lands, Byzantium was the age-old substratum on which grew the art of Rumania, remarkable from the earliest period for its originality and its exceptional gift for interpreting, processing, and synthesizing. We can distinguish in post-Byzantine Rumanian icons a twofold orientation: on the one hand, the integration of the artistic forms common to the Balkan Orthodox countries in the period so very well labeled, by the historian Nicolae Iorga, "Byzantium after Byzantium"; and on the other hand the tendency to stress, beyond the stylistic diversity with which it came in contact, those elements original and specific to Rumania.

Icons are glimpses of historical, social, and cultural life rendered in suggestive and meaningful forms. Highly valued as art works during the Middle Ages, they satisfied the Rumanian people's need for the beautiful, adding their gorgeousness to the sumptuous interiors of religious monuments. They found their way to lordly mansions, being given a

place of honor amid the furniture, silverware, and tapestries; they embellished beautiful homes and peasant cottages alike. Later, post-Byzantine painters discovered in these icons a precious, exquisite expression of the mentality of the medieval world.

In the period that followed the decay of Constantinople, the emergence of the independent Rumanian feudal principalities stimulated a new efflorescence of art. The enduring autonomy of the principalities, which the Rumanian people defended fiercely, was of paramount importance to the climate of artistic freedom. The role of protector of the arts was assumed by the reigning Wallachian princes, from Neagoe Basarab (sixteenth century) to Constantin Brîncoveanu (late seventeenth and early eighteenth centuries).

In the pages that follow, we hope to determine the place of Rumanian icons in the context of post-Byzantine art and culture and, at the same time, to define their unique qualities. We shall limit ourselves to a discussion only of those works whose beauty entitles them to superlatives, in terms both of local authenticity and true artistic achievement.

THE ICONOGRAPHIC PATRIMONY of Rumania dates back to the end of the fifteenth century and the first decades of the sixteenth, the historical moment when native and foreign artists, in a perfect unity of vision, benefitted from propitious conditions to translate the spirit of the time into Palaeologan nuances that then became their own traditional artistic language. And yet, the birth of Wallachian and Moldavian icon-painting should be traced much earlier. Icons were by no means a spontaneous and isolated phenomenon; they developed in the context of medieval painting, parallel with mural decoration. They appeared from the very earliest emergence of independent Rumanian principalities, in the cultural and artistic environment of the fourteenth and fifteenth centuries, with all the characteristic features of Constantinopolitan art.

The prestige enjoyed by the art and culture of Constantinople throughout the Orthodox world, despite the political and economic decline of the Empire, made the young state north of the Danube receptive to its forms. It became aware of them either through direct contact or via the Serbian kingdom, which had adopted the Palaeologan style at an earlier date. The fourteenth and the first half of the fifteenth centuries witnessed the establishment of successive relations between the Rumanian countries, Byzantium, and the Balkan states. Let us note two manifestations of these contacts: the church of the Basarab voivodas in Wallachia at Curtea de Arges (fourteenth century, or perhaps even earlier, as current research is trying to establish); and the Moldavian churches which, in the time of Alexander the Good (the first half of the fifteenth century), frequently recorded the presentation of ornamental objects, Byzantine manuscripts and icons, commissioned by the rulers of the Empire.

Some of the painters who decorated the interiors of several monasteries in Wallachia and princely churches in Moldavia during this period also painted portable icons. The great number of model notebooks that have come down to us attest to these artists' reliance on traditional iconographic types. Even the large altar icons of the sixteenth century preserve the early Byzantine and thirteenth-century Ohrid conventions, representing the *Virgin Hodegetria, Christ the Savior,* and *St. Nicholas* (in half-figure, surrounded by saints).

Noteworthy for its elaborate modeling is the icon of the *Virgin Hodegetria with Child* (p. 381) from the Monastery of Bistriţa (Vîlcea district), dated 1513. The *Virgin Hodegetria with Child* (p. 385) from the Monastery of Govora (Vîlcea district) is typologically similar. It was executed by order of Father Damaschin, the Superior of the monastery, around 1530, as was another icon, discovered in a nearby hermitage in a deplorable state of conservation.

The iconographic link with Byzantine models is obvious also in the Moldavian image of the *Virgin with Child* (p. 383) in the Monastery of Văratec, Neamţ district. Unlike Wallachian icon-painters, the Moldavian masters employed a wide variety of warm colors, shades of brown and dark red with a predominance of gold.

Contemporary with these works, yet revealing a completely different artistic outlook, is a small panel attributed to the casket which enshrines the relics of St. John the New, brought from Moncastro to Suceava in the fifteenth century—an event that had lasting echoes in medieval Moldavian iconography. The representation of *St. John Brought Before the Diocesan* (p. 384) is rendered in exquisite pictorial images. The main group is depicted in tones of deep red and creamy white against a mild dark brown background. It is a unique example of narrative painting, which corresponds to the skillfully

chiseled plaques of silver gilt framing the reliquary that still contains the remains of the legendary martyr.

At the start of the sixteenth century, Moldavian and Wallachian icon-painting took an original turn, revealed in the images from the princely church at Curtea de Argeş (dating to the reign of the voivoda Neagoe Basarab) and the Monastery of Humor (from the time of the voivoda Petru Rareş and his followers). The Moldavian series is contemporary with the world-famous exterior mural, of unmatched craftsmanship. In Wallachia's generous cultural and artistic climate, illustrious masters such as Dobromir and his team of assistants produced remarkable works (at the Dealu, Argeş, Tismana, and Snagov monasteries; pp. 386–387).

This epoch of spiritual effervescence was dominated by the outstanding personality of Neagoe Basarab, a man well acquainted with the artistic trends of his time. His vocation as patron of the arts and great founder of religious establishments inspired him to encourage an almost international diversity of forms, in as large an artistic area as possible, including icon-painting. Written sources tell us of his commissions and the prices he paid for the Constantinopolitan works that adorned his newly founded church at Curtea de Argeş, standing beside the icons produced by native painters from the prince's own workshop. The few surviving examples of these local works excel in quality everything that had been achieved up to that time. Displaying a great thematic diversity, they feature variety rather than uniformity. Their quality derives from the openness of an epoch that gave its artists opportunities to treat their subjects distinctively and originally.

It is very likely that the ten large bilateral icons which had initially occupied the spaces between the colonnade of the *pronaos* in Curtea de Argeş were executed in the same workshop. Facing the center of the church are figures of anchorite saints, while military saints on horseback, crushing the unbelievers, look toward the *pronaos*. Of this group, only the icons of *St. George Killing the Dragon* and of *SS. Alexis, Barlaam,* and *Joasaf* have been preserved. Besides their functional role, these icons carried a political message, as requested by the prince. The elegance and precision of the draftsmanship, the free expression of the forms, and the brilliant color scheme place this ensemble of remarkable artistry among the outstanding achievements of the early sixteenth century.

The icon of *St. Nicholas* (p. 389), painted in 1512, depicts a white-haired, thick-bearded old man with prominent forehead and cheeks. His hieratic, frontal attitude is reminiscent of an ancient, traditional type. His archaic vestments ornamented with black crosses, and the *omophorion* outlined against the white background of the *saccos,* have correspondences with the hierarch in the altarpiece friezes illustrating the *Melissmos,* which underlines once more the relationship between icon- and wall-painting. This likeness is obvious in other cases, too, such as an icon of *St. Mark and St. Matthew* whose typology and treatment lead us to the *Apostles* (detail, p. 388) surrounding Christ in the *Last Supper* fresco of Tirgşor Church, created presumably in the sixteenth century. Its aspect of depth, the simplicity and sobriety of the frame, and the almost monochromatic colors confer on the icon the specific monumentality of the mural, despite its smaller scale.

Icon-painters attempted iconographic and stylistic innovation by incorporating themes from other genres and schools. Often, they adapted the suggestions of their princely benefactors, investing their paintings with the realities of feudal ideology. Particularly revealing of this new trend is the *Deposition from the Cross with Donors* (pp. 390–391), which shows Despina carrying in her arms her dead son Teodosie, a none-too-subtle parallelism expressing the common grief of the two mothers. This work is visibly influenced by Western art, the result of the coming of Western forms and types from Dalmatia to central Europe, either directly or by way of the itinerant painters familiar with the iconography of the late Gothic style. Obviously, icon-painters in the princely workshops were well acquainted with the artistic vision of Transylvanian painters, most particularly with that of Viet Stoss' followers, one of whom had settled down in Braşov, executing commissions from and paying visits to the court of Wallachia.

The image of *SS. Simeon and Sava,* a frequent theme in Serbian iconography, was commissioned by Neagoe Basarab's wife's relatives in the friendly neighbor country. This is the best-realized icon of the group. The figures are calm, hieratic, ascetic, traceable to the hermit figures in the *pronaos* of the Monastery of Cozia. The color scheme, more free and expressive, with olive green, black, and dark brown in the outline of ample vestment folds, is evidence of the great sensitivity of the painters.

Breaking new ground in the sixteenth century,

icon-painters continued to maintain their pride of place without, however, being able to excel the craft of the Argeş masters.

The icons of the Humor Monastery church (pp. 394–395) give us some measure of the level of Moldavian icon-painting at the moment when a very original style was emerging in mural-painting. Marked by a slight tendency to decorativeness, characteristic of wood carving in the mid-sixteenth century, the Humor icons have a background ornamented with vegetal and floral motifs engraved on the wooden panel and gorgeously gilded. They have certain affinities with twelfth- and thirteenth-century Byzantine works embossed in gilded silver, with sumptuous fabrics and brocades suggested by the background, which is incised or worked in the *méplat* technique of late Gothic altarpieces in Transylvania. Rope-twisted moldings frame the painted surfaces, just as carved rosettes and geometric decorations, in flat relief, enhance the ornamental aspect of the icons. The faces, traditionally drawn, gradually acquire a less severe and more human expression. A narrative tendency brings into the paintings elements of daily life; in the icon of *Archangel Michael*, episodes from the lives of saints replace the busts or full-length portraits of Prophets and Apostles.

The combination of painting, wood carving, and stucco ornamentation, a feature peculiar to Moldavian icons, is found throughout the sixteenth and seventeenth centuries, as for example in the engraved insets of military saints at Suceviţa, the *Virgin with Child* circumscribed by saints (Bistriţa Monastery), and the icon of *St. Paraskeva* from Darmanesti (Bacau district).

Late sixteenth-century Moldavian iconography reveals a great diversity, due largely to the conservation of iconostases carved in wood. Icons representing church festivals become more numerous, for they give artists great latitude in compositional treatment. In the seventeenth-century *Transfiguration* (p. 396), for instance, the painters have boldly resorted to foreshortening to portray the impetuous fall of the Apostles at the bottom. A bright color scheme with warm tones of intense red and mild brown emphasizes contrasts and augments effects.

In the representation of the *Annunciation* on the folding altar doors of the iconostasis at Cîrligi, the figures preserve their monumentality under large halos, richly decorated in stucco relief against the architecture of the background. Delicately colored, with the addition of gilded strips outlining folds and garment accessories, the composition fits perfectly and freely into the arch-shaped wooden panel partitioned by the vertical bar of the folding doors.

Of smaller proportions but closely related to mural-painting is the *Pietá* at the Moldavian Monastery of Bistriţa (Neamţ district). Here the artist stresses the moving drama of the scene, the deeply human relationship between the grieved figure of the Virgin and her resigned, suffering son. The painting is gentle, without intentional emotional effects. The tones of brown, somber but refined, are used with great subtlety. The work reveals a high level of craftsmanship and a vision that reminds us of Cretan iconography.

There are many other works in the collections of monasteries like Putna, Vatra Moldoviţei, and Suceviţa, which round out our general impression of sixteenth-century painting. But no survey of Rumanian icons would be complete without a mention of the achievements of the Transylvanians. Among the major works are the triptychs from Agîrbiciu and Bica monasteries (Cluj district), whose exceptional qualities stand as proof of the artistic unity of the three historical provinces (p. 393). The Transylvanian icon portrays the same traditional types, in more vivid and engaging harmonies of color; compositions are more ample and populous. Transylvanian icons are related to those of Moldavia, revealing Western influences as well.

Icon-painting in the seventeenth century, like Rumanian art in general, entered a new phase marked by other historical, social, and cultural factors, governed by different artistic ideals. Icons in Moldavia began to show greater diversity of style, under the influence of the art of neighboring countries: Poland, Slovakia, and especially Russia, from which Voivoda Vasile Lupu brought painters for his Trei Ierarhi Church. As iconostases grew into high frieze structures, a new type of large tympanum icon developed.

Of a forcefully autochthonous character, obviously touched by folk painting, are the icons produced in local workshops—particularly active in this period—that had evolved around some old monastic centers like Neamţ and Bistriţa: their achievements, despite a certain rustic tinge, are highly authentic expressions, obviously the work of masters formed in the Moldavian ambience. The *Elevation of the Holy Cross* (p. 397) presumably originated in one of the Bistriţa Valley workshops. The creation of a native artist named Grigorie, this icon shows us how pop-

ular among the painters were scenes from the history of Byzantium, especially in the reign of Prince Constantin Brîncoveanu, whose patron saints were Constantine and Helena.

The number of Moldavian icon-painters was steadily increasing. Some, like Ion, Sofronie, and Grigorie from Bierileşti, had been formed entirely in the local artistic tradition, and took as their models the paintings of the fifteenth and sixteenth centuries. Their art reveals a close relationship with the traditional typology of the Byzantine heritage, interpreted in a more personal and freer manner. Gradually, the transcendental character of the old models was lost in favor of local color animated by the narrative and the picturesque. Among these three painters, Grigorie of Bierileşti seems to have been the most traditional. His icons for St. Teodori's Church in Iaşi (p. 401) show that he was much appreciated by his contemporaries. His compositions are echoed in the works of the renowned Wallachian painter Pîrvul Mutu, who had studied in Moldavia. Figures like Grigorie's *St. Teodori* and Mutu's *St. Marina* were equally inspired by Moldavian mural-painting. *St. Teodori* recalls the placement of saints in the ensembles from the churches of Hîrlău and Dorohoi, and St. Demetrius' Church in Suceava. Yet, unlike the models that had inspired him, Grigorie could not escape a certain Baroque mannerism inherent in late Moldavian painting.

Later Moldavian painters were ever more influenced by foreign masters, especially Russians, Poles, and Greeks, representatives of an art contaminated by Western styles. The process of Westernization ultimately led to the end of this school of painting.

In seventeenth-century Wallachia, the reigns of Matei Basarab and Constantin Brîncoveanu stimulated the development of new values. The icons of this period possessed a markedly autochthonous character, infusing the traditional Byzantine forms with· the new synthesis elaborated under the influence of Mount Athos and the Greco-Cretan schools, influences reinforced by the Greek resonance of late seventeenth-century Rumanian culture. We are actually speaking here of two successive periods: the first spanned the reign of Matei Basarab (1632–1654) and his successors; and the second extended from the time of Serban Cantacuzeno (1678–1688) through the whole era of Brancovan painting to the end of the seventeenth and the early eighteenth centuries, when Wallachia enjoyed an epoch of relative historical and cultural calm while Ottoman expansionism concentrated on other areas.

Wallachia found itself somehow isolated and less subject to cultural influences from neighboring lands, which were not themselves in a position to develop and enrich their artistic patrimony. Icon-painting became a prosperous occupation, in response to the ever-growing demands of a newly rising social element, the country boyars. The modest artistic standards of this clientele fostered a rather unassuming indigenous style, which was nonetheless sincere and expressive. Painters borrowed the typology of famous works of the past (for example, the *Virgin Hodegetria* and the *Virgin Eleousa* from Valea and Boda) or transposed subjects and figures from murals, as was the case with the icon of *St. Michael* from Topolniţa, or the *Deesis* from Vălenii (p. 398). This so-called archaicizing tendency, which corresponded to the literary taste of the time, produced a highly personal and sensitive art, despite the persistence of the canons. A bright and lively color scheme of predominantly warm tones of red at Valea, and the glow of the attire and armor of the *Archangel Michael* of Topolniţa, are representative of post-Byzantine painting at the moment when architecture was also being molded into specific Wallachian stylistic forms.

It was a time of very intense artistic exchange with Moldavia, of which the fruit was a number of Wallachian syntheses, best reflected in the icons offered by Matei Basarab to the Monastery of Arnota, founded by him in 1640. These icons are the work of Stroe, a painter from Tîrgoviste. All of them, like those of Moldavia, have gorgeously gilded backgrounds with incised stucco floral ornamentation, gilded halos in stucco relief, and a decorative scheme that augments the more refined sumptuousness of the Wallachian prototypes. The same equilibrium is visible in icons by other painters of the time, for example, those commissioned by Metropolitan Ştefan for his foundation at Bălăneşti and those adorning the country church at Sîmbureşti (Olt district). Some of these icons, for instance the *St. Paraskeva* from Bălăneşti (p. 400), include a landscape which resembles the small, very picturesque genre paintings of the period, whose presence bespeaks the common tendency of the time to cultural Westernization. These timid attempts follow the general trend of renewal through contamination. They are nothing but accidents, and do not go beyond mere impulse.

A few foreign masters were also active in Wal-

lachia at this time, like Mavros, who painted the icon of *St. George* at Viforîta (1631). The artist added to the image elements peculiar to his own training and vision, trying to adapt them to the demands of a public increasingly attached to this type of work.

At the end of the seventeenth century, icon-painting bloomed anew under the influence of a different stylistic orientation. Historical and cultural conditions caused muralists to turn toward Mount Athos for inspiration. The Greco-Cretans who flocked to these regions reflected, in addition to a new typology, Western radiations, filtered, however, through a Constantinopolitan sensibility. The Rumanian icon—steadily developed by an increasing number of local painters—preserved traditional elements but evolved, in tune with the taste of a society ever more receptive to ideas of progress, the forms of a new stylistic outlook.

The last stages of post-Byzantine art were animated by both foreign icon-painters and Rumanian craftsmen recruited and trained in the Rumanian atmosphere. It is to these craftsmen that we are indebted for embellishing the large Brancovan iconostases with correspondingly large icons. Working together in groups or organized teams, in family circles where craft was transmitted from father to son, painting murals and portable icons simultaneously, these men created a number of successful works in the style of their time. From their ranks there emerged, in the first half of the seventeenth century, masters of mural- and icon-painting like Stoica from Brădet, Stroe from Tîrgoviste, Pîrvul Mutu, court painter of the Cantacuzeno family, and the group of draftsmen from the Monastery of Hurezi: Ion, Andrei, Istratie, Ion the monk, and many others. In addition, we should not forget the eighteenth-century painters from rural or monastic environments who worked in traditional Brancovan style, interpreted by a charming, picturesque, and popular vision.

After the expansion of the Ottoman Empire into the Balkans, painters in these areas left their homes to settle elsewhere. This migration led to the establishment of many artistic centers in the cities and around the monasteries of the Rumanian countryside. Foreign masters often placed their skills at the service of local personages who were both rich and influential.

A dominant contribution was made by the Greek painter Constantinos, who settled in Walla-

chia. (He signed his works "Constantinos iconopsis," and once he became the head of the workshop at Hurezi, he liked to introduce himself as "Constantine of Wallachia.") On coming to Wallachia, he found a culture dominated by the voivodas and boyars, who thought that by gaining a place in history they might prove their Byzantinian descent. The erection of rich religious establishments increased their families' prestige. Commissions to foreign painters alone could not satisfy all the requirements of an epoch that was among the most prolific in constructing edifices intended as instruments of internal and external authority in the service of a statecraft depending on Orthodoxy. The contribution of local masters was imperative.

What made adaptation to the new artistic outlook easier was just that common Byzantine substratum which Constantinos found in Rumanian art, despite some infusions of both Western and Eastern elements. The Brancovan icon evolved in courtly, sumptuous forms, appropriate to princely commissions. The entire process of artistic "promotion" was stamped by the personality of Prince Constantin Brîncoveanu, patron of the arts, a supporter of the old traditions but open to the innovations demanded by the cultural ambience. All this favored the emergence of a style bearing his name, whose influence icon-painting could not escape.

An integral part of the Brancovan phenomenon, the icon of the time is neither a Greek (as we might think by the Greek calligraphy of the inscriptions) nor a foreign work. In Constantinos' atelier in the Monastery of Hurezi, where all kinds of craftsmen used to work together, the painters of icons cultivated an art which, like other Brancovan creations, illustrated not only the aspirations of a single personality or a painter, but the general outlook of an epoch conscious of its own needs and goals.

The patron icon in the Church of the Princess, belonging to the ensemble painted in 1683 by Constantinos and his associate Ioan, represents the *Virgin Entering the Church*. Its treatment follows the dimensions and style of genre painting. The features are pronounced: elongated and well-shaped nose, eyes surrounded by a dark, almost black line. The olive complexion is contrasted to tones of red and glowing gold. The same world view informs the iconography on the tympanum of the Voivodal Church in Tîrgoviste and some of the icons preserved today in the monastic complex at Hurezi.

In the icon of the *Virgin with Child* (p. 410),

the type of the Virgin Enthroned has replaced the traditional Virgin Hodegetria. The throne, exceedingly ornate, becomes the major element, turning the representation of the Virgin and Child into a formal painting whose luxuriant vegetal ornamentation, modeled by the brushstroke or by the minute contour lines in fine China ink, expresses in its rich and sumptuous style the potentates' taste for the gorgeous. In other works, like the *Virgin with Child* (p. 402), the *Deesis* (p. 403), the icons of *SS. Constantine and Helena* (pp. 407 and 410) and of *St. Procopius* (p. 406) from Hurezi, the figures look human under their heavy, burdening crowns. But the golden brocade garments, like the background itself, tell of the Byzantine pomp reigning at the court of the great voivodas (pp. 408–409). The aristocratic demeanors, intentionally aulic, in the icons of *SS. Constantine and Helena* are part of the artists' attempt to render (by something more than the brilliant accessories) the likeness between the figure of Brîncoveanu's homonym, the first Christian emperor, and the portrait of the voivoda in votive pictures. This likeness, often emphasized in chronicles and other literature of the time, indicates the great prestige enjoyed by Brîncoveanu. The excess of accessories in the Brancovan icons (pp. 404, 405, and 411) takes on a marked Baroque form, like the faces of the Virgins, increasingly more stereotyped—indications that late Brancovan works could not escape a certain mannerism.

The diffusion of icon-painting after 1700, in the post-Brancovan period, kept the Byzantine tradition alive in iconographic parallels between the waning of the post-Byzantine model and the imposition of Westernizing tendencies. The survival of this phenomenon until the beginning of the nineteenth century compensated for the rather tardy emergence of post-Byzantine painting in Wallachia and Moldavia, as compared to neighboring countries. The icons produced during the eighteenth century by local masters reached the most remote areas, animating rural regions and urban centers alike, illustrating the moral content of religious literature and of widely circulated popular books. Created by an artistic sensibility that fed on the vigorous substratum of peasant production, these works represent the final phase of post-Byzantine Rumanian art in general, and of icon-painting in particular, as the inherited style evolved into a folkloric vision.

Concluding this cycle of icon-painting, which illustrates the survival of Byzantine and post-Byzantine tradition until a very late date, we may say that these painters, who showed a remarkable sense of reality and a robust power of selection and synthesis, receptive to the taste of succeeding epochs, distilled from the vast iconographic repertoire their favorite types and themes. Adding or suppressing details, they enriched and at times even transformed the conventions according to local requirements. Thus they succeeded in maintaining, with a vision apparently diffuse, the artistic continuity of the Rumanian icon along traditional lines.

Opposite:
Virgin Hodegetria with Child
Tempera on wood, 124 x 107 cm. (48⅞ x 42⅛ in.);
Monastery of Bistrita, Vîlcea district, Wallachia, early
sixteenth century; Museum of Rumanian Art,
Bucharest.

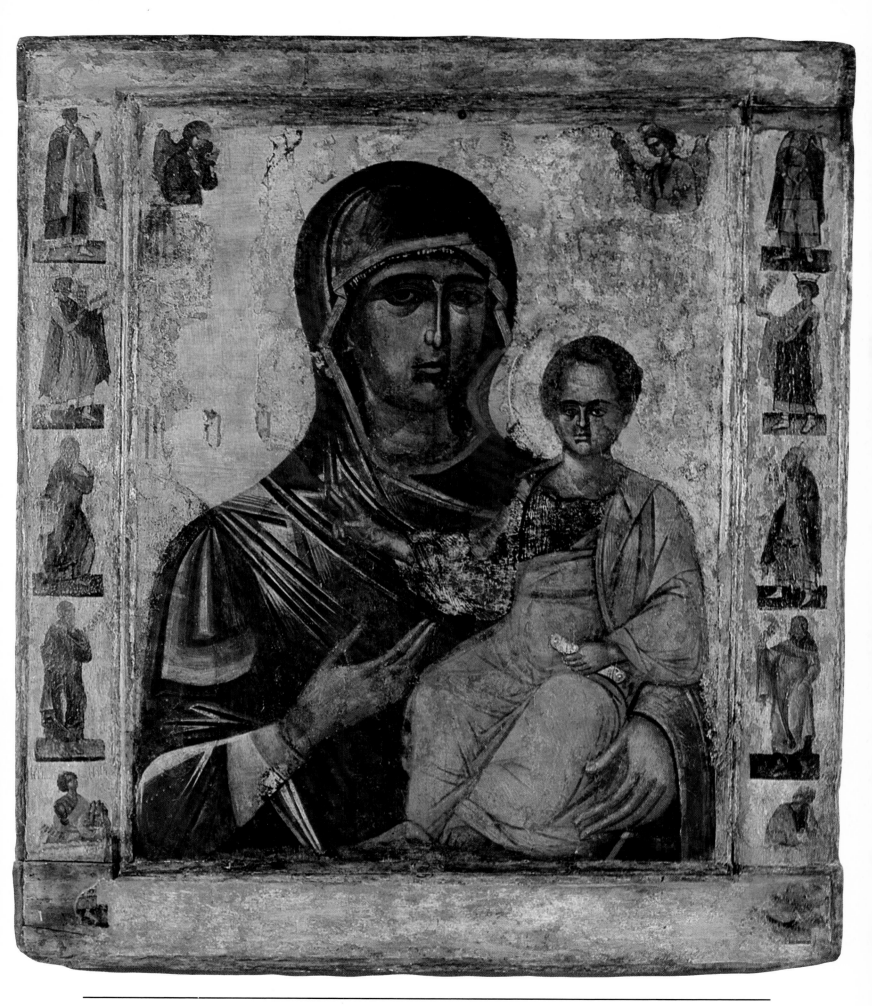

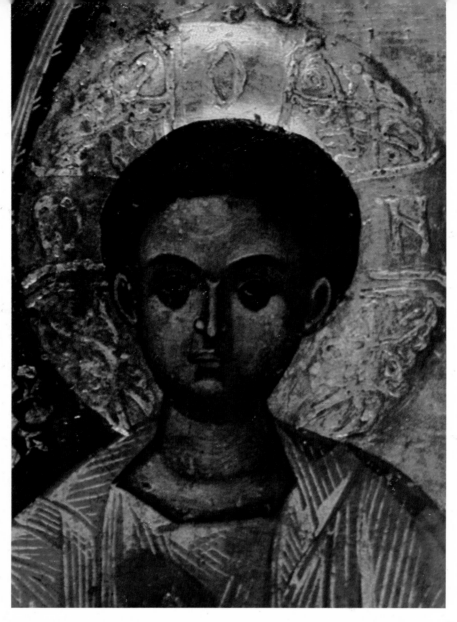

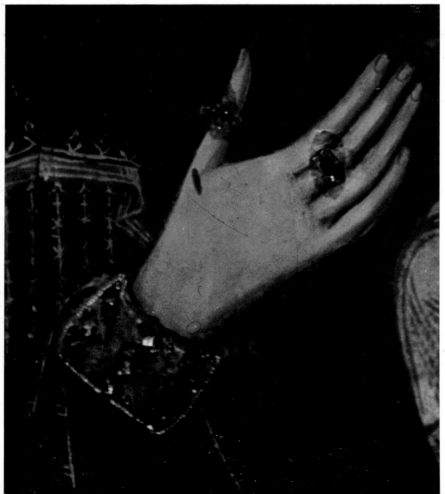

Opposite:
Virgin with Child
Tempera on wood, 92.5 x 72.5 cm.
(36⅜ x 28½ in.); Vălenii, Moldavia,
sixteenth century; Monastery of
Văratec, Neamt district.

Above and below left:
Virgin with Child
Detail: Child

Virgin with Child
Detail: The Virgin's hand

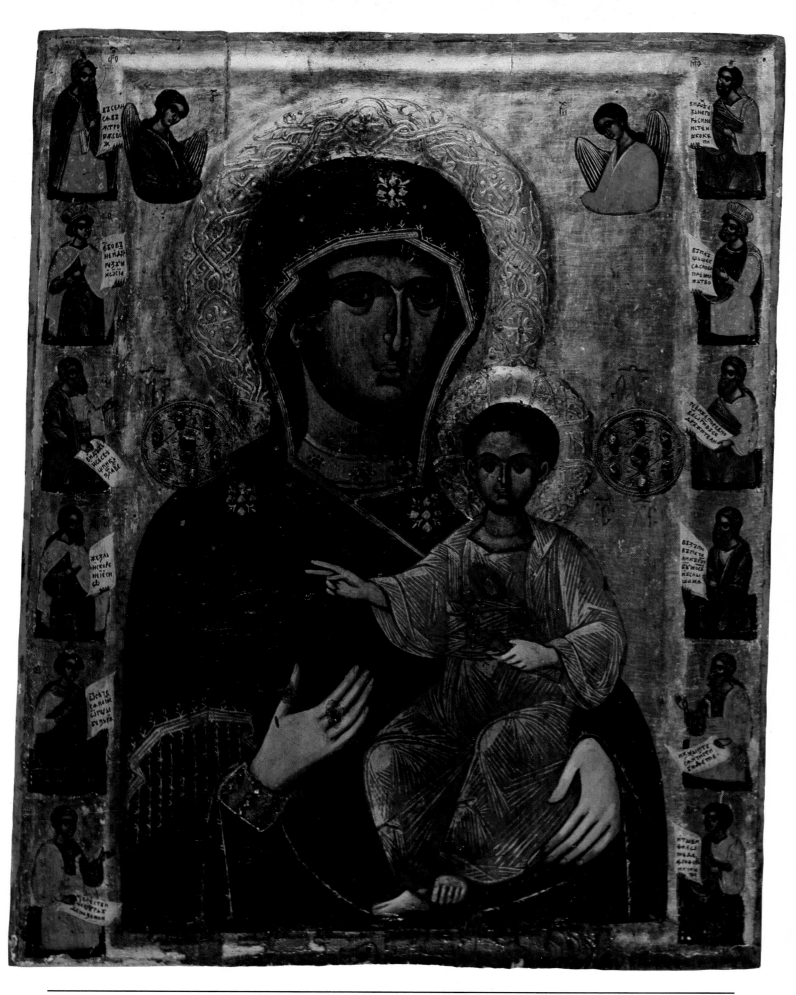

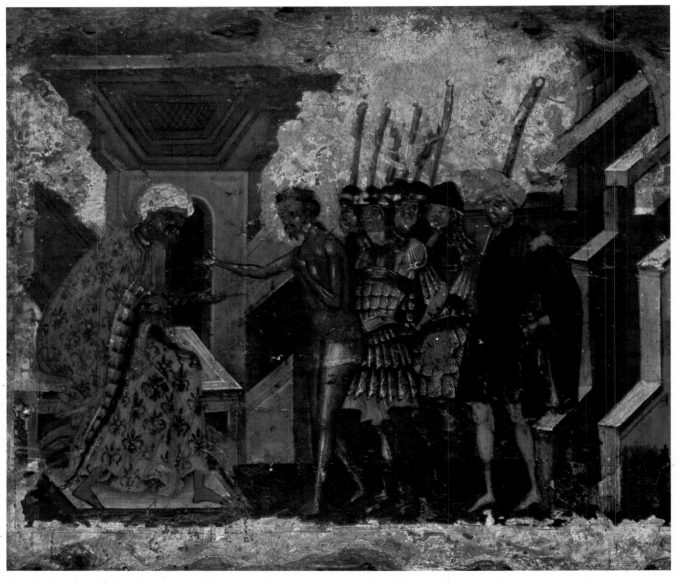

St. John Brought Before the Diocesan
Small panel, perhaps from the coffin that enshrines the
relics of St. John the New, brought from Moncastro to
Suceava in the fifteenth century.
Tempera on wood, 26 x 28 cm. (10¼ x 11 in.);
fifteenth or sixteenth century; Museum of Rumanian
Art, Bucharest.

Opposite:
Virgin Hodegetria with Child
Tempera on wood, 109 x 73 cm. (42⅞ x 28¾ in.);
Govora Monastery, Vîlcea district, Wallachia, c. 1530;
Museum of Rumanian Art, Bucharest.

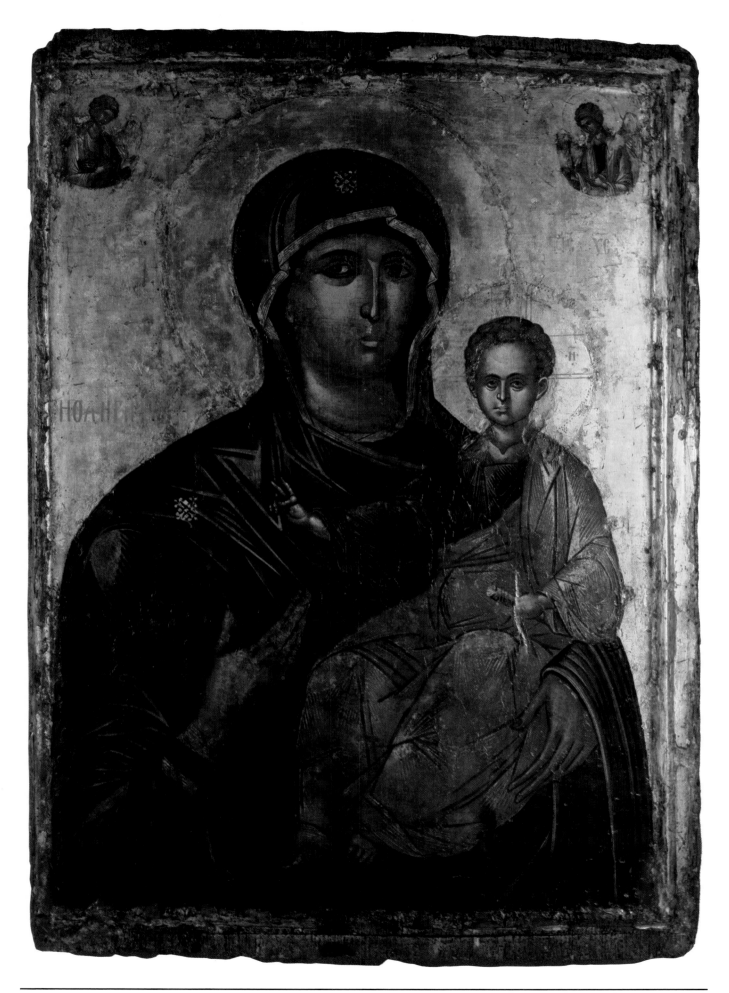

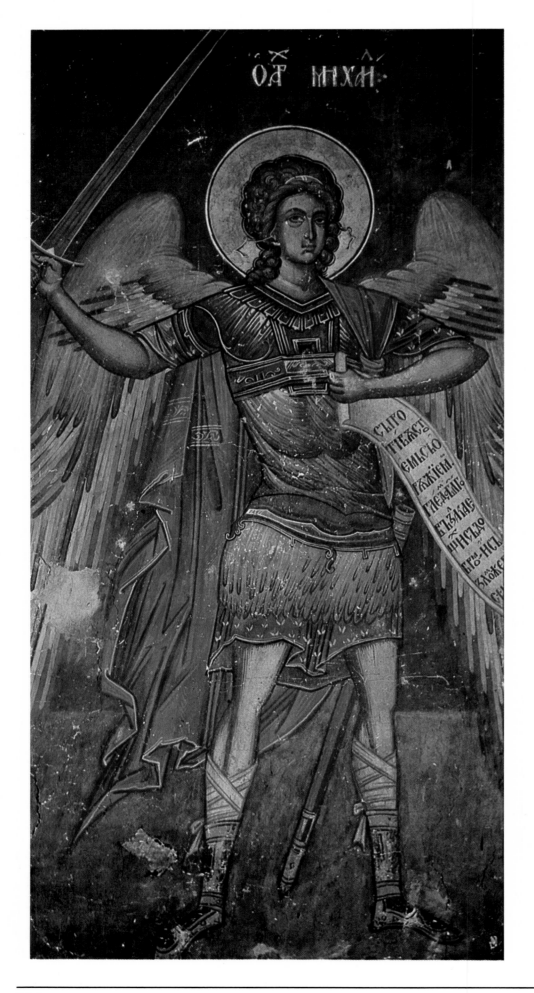

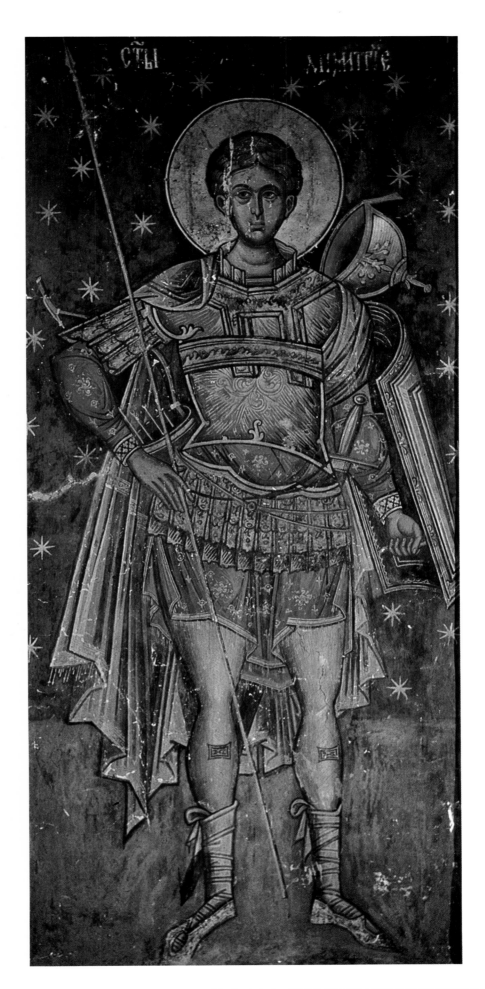

Opposite:
Archangel Michael
Dobromir of Tîrgoviste
Fresco, 256 x 126 cm. (100¾ x 49⅝
in.); Curtea de Argeş Monastery, Argeş
district, Wallachia, 1526; Museum of
Rumanian Art, Bucharest.

Right:
St. Demetrius
Dobromir of Tîrgoviste
Fresco, 265 x 120 cm. (104⅜ x 47¼
in.); Monastery of Curtea de Argeş,
Argeş district, Wallachia, 1526;
Museum of Rumanian Art, Bucharest.

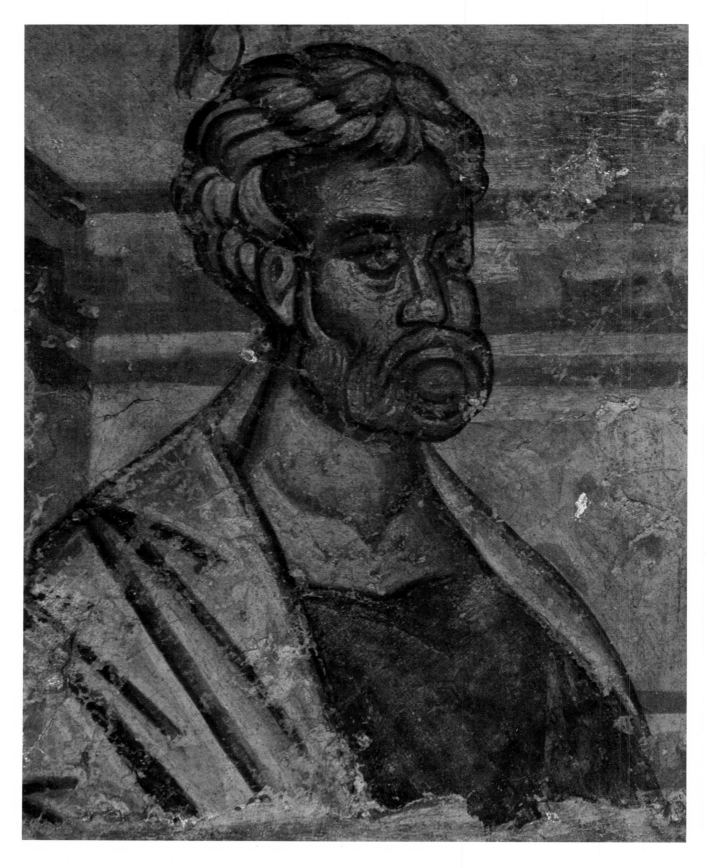

The Apostles, Detail
Fresco, total measurement 62 x 240 cm. (24⅜ x 94½ in.); sixteenth century; Tîrgşor Church, Prahova district.

Opposite:
St. Nicholas
Tempera on wood, 90 x 67 cm. (35⅜ x 26⅜ in.); Monastery of Curtea de Argeş, Argeş district, Wallachia, 1512; Antim Monastery Museum, Bucharest.

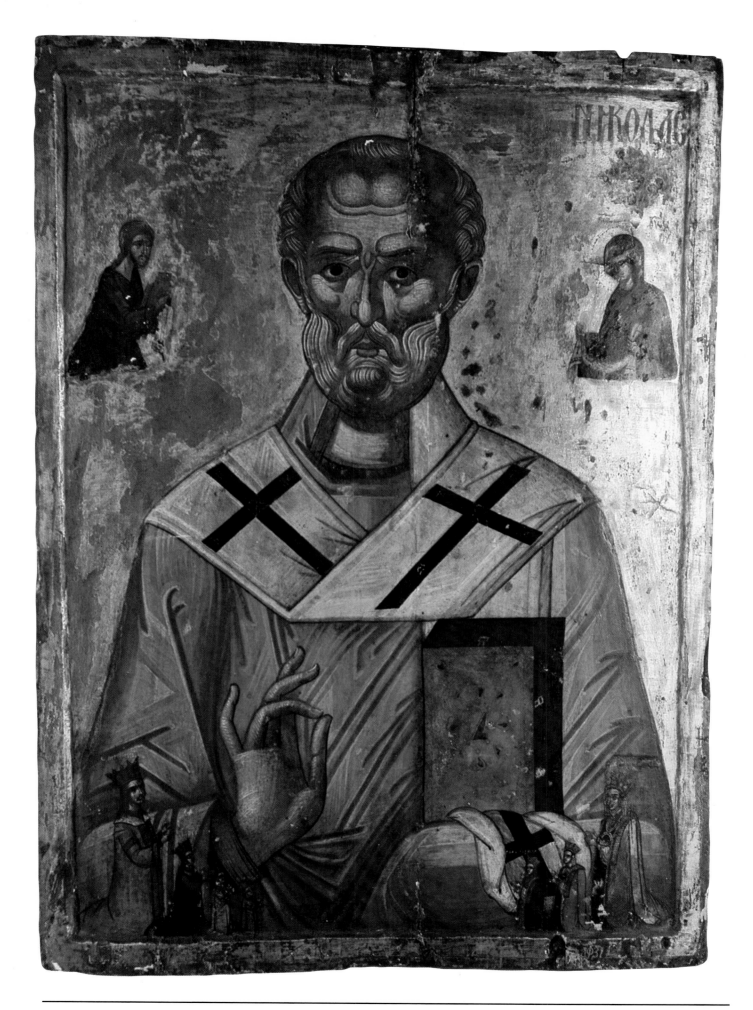

НІКОЛАЄ

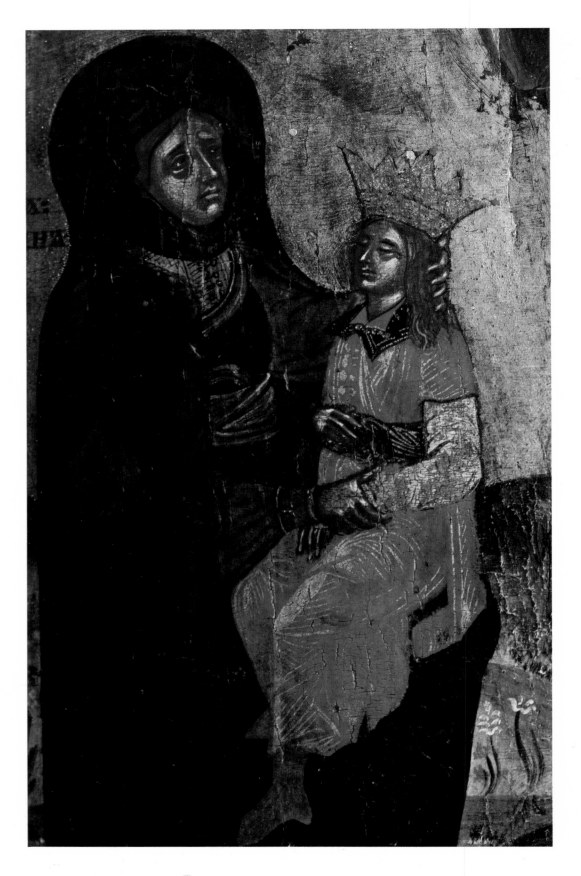

Deposition from the Cross with Donors
Detail: Despina carrying her dead son Teodosie

Opposite:
Deposition from the Cross with Donors
Tempera on wood, 67.5 x 44.5 cm. (26⅝ x 17½ in.);
Monastery of Curtea de Argeş, Argeş district,
Wallachia, early sixteenth century; Museum of
Rumanian Art, Bucharest.

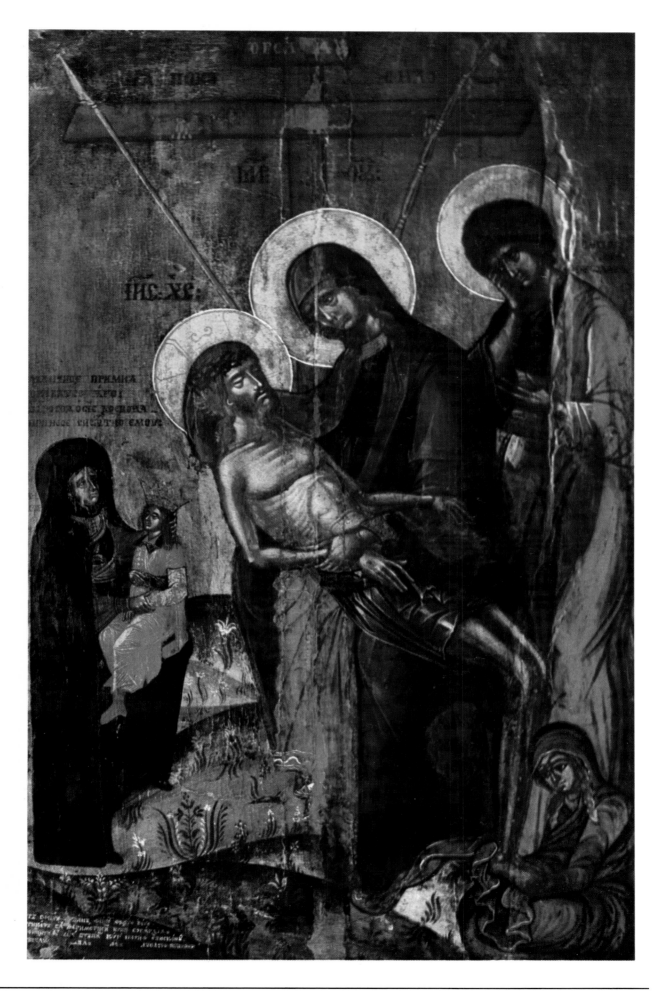

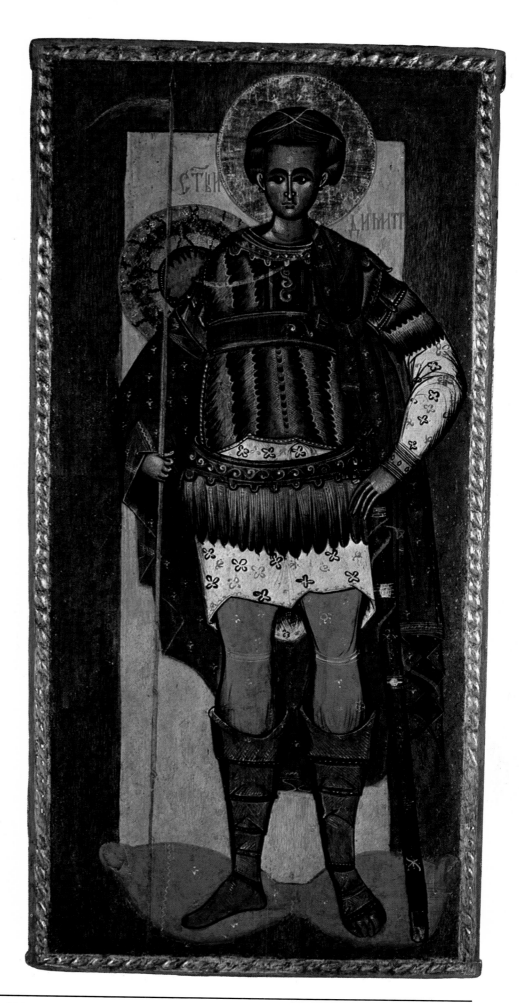

Opposite:
SS. Simeon and Sava
Detail: Despina
Tempera on wood, total measurement
47 x 30 cm. (18½ x 11¾ in.);
Monastery of Curtea de Argeş, Argeş
district, Wallachia, early sixteenth
century; Museum of Rumanian Art,
Bucharest.

Right:
*Triptych from the Church of Bica
Monastery*
Detail: St. Demetrius
Tempera on wood, total measurement
86 x 42 cm. (33⅞ x 16½ in.);
Transylvania, Cluj district, sixteenth
century; Metropolitan Collection of
Sibiu and Alba Iulia.

THE POST-BYZANTINE ICONS OF WALLACHIA AND MOLDAVIA

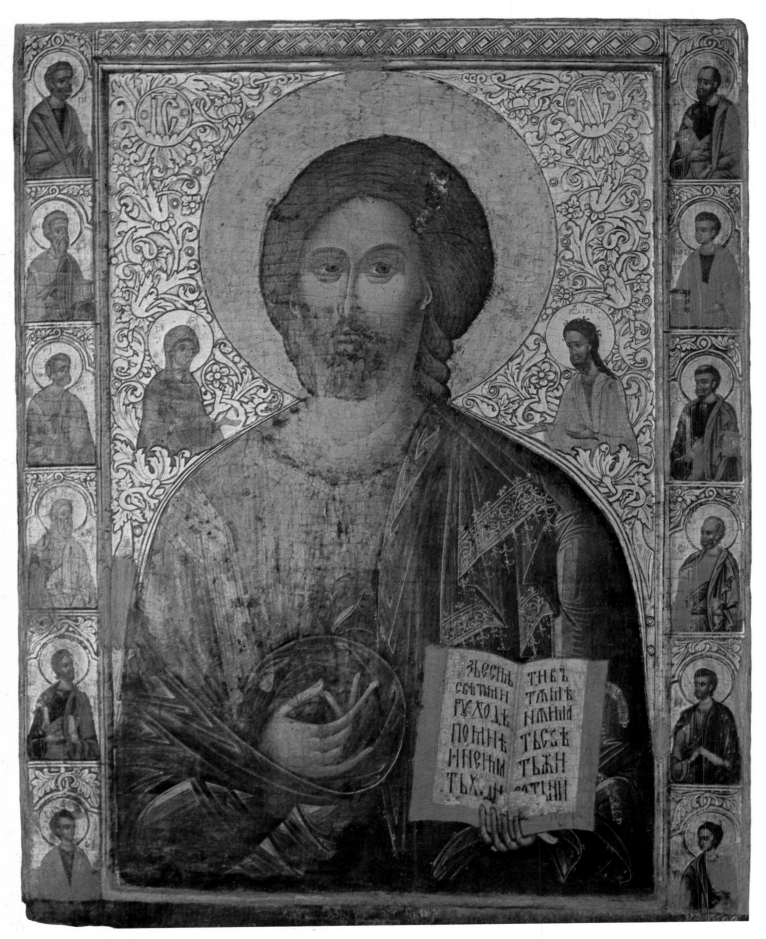

Deesis
Tempera on wood, 106 x 81 cm. (41¾ x 31⅞ in.);
Moldavia, sixteenth century; Monastery of Humor,
Suceava district.

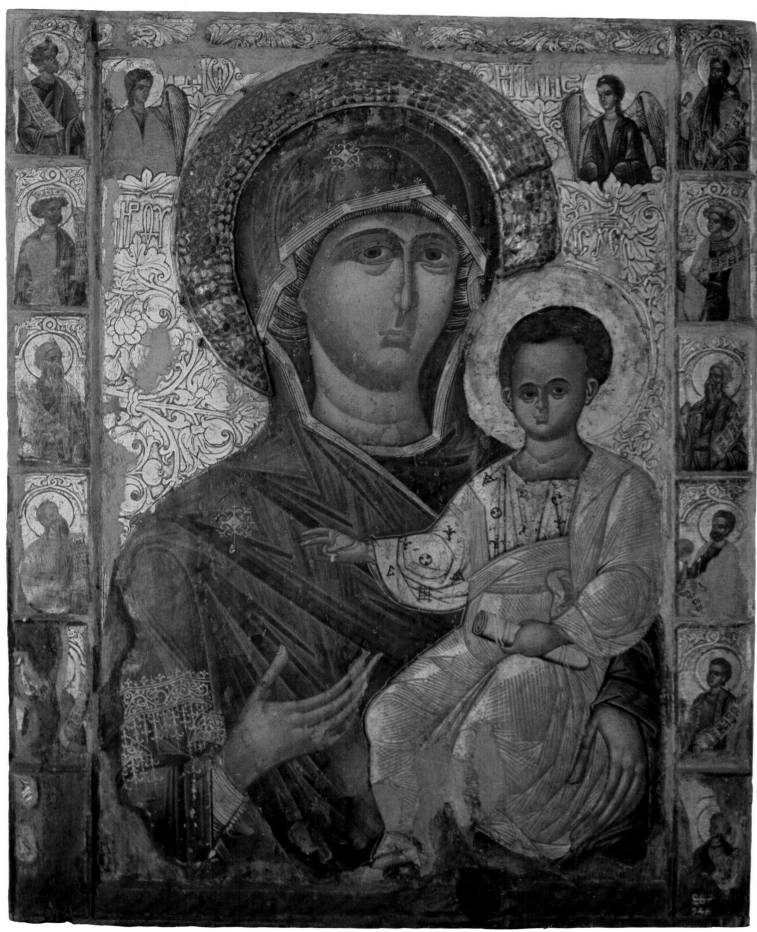

Virgin with Child
Tempera on wood, 106 x 81 cm. (41¾ x 31⅞ in.);
Moldavia, sixteenth century; Monastery of Humor,
Suceava district.

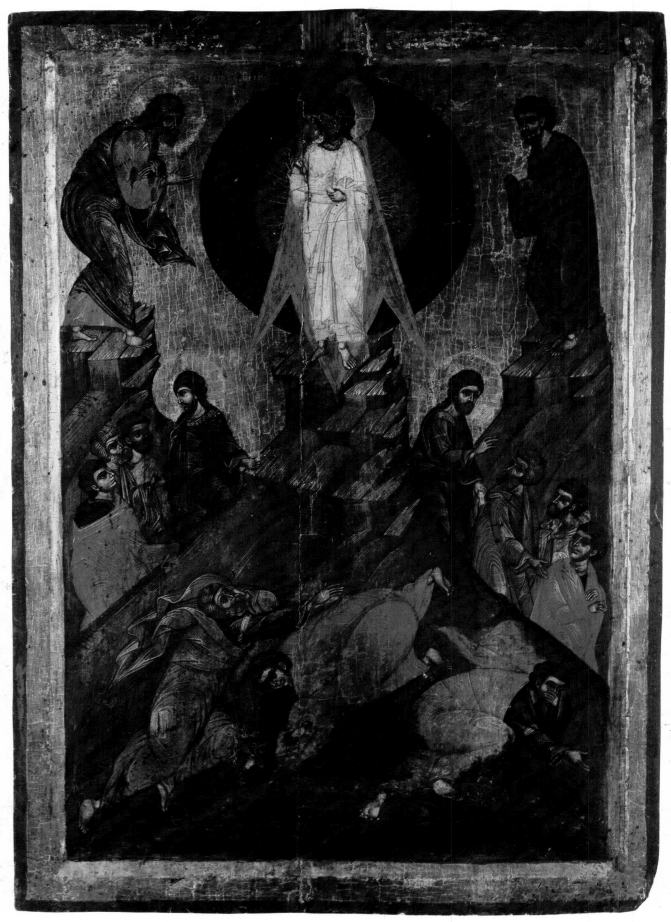

Transfiguration
Tempera on wood, 43 x 35.5 cm. (16⅞ x 14 in.);
Wallachia, seventeenth century; Museum of Rumanian
Art, Bucharest.

Elevation of the Holy Cross
Grigorie
Tempera on wood, 40 x 26 cm. (15¾ x 10¼ in.);
Moldavia, seventeenth century; Monastery of Bistriţa,
Neamt district.

Opposite:
Deesis
Tempera on wood, 72 x 46 cm. (28⅜ x 18⅛ in.); Vălenii, Prahova district, Wallachia, seventeenth century; Museum of Rumanian Art, Bucharest.

Above and below left:
Deesis
Details: Heads of the Virgin and St. John the Baptist

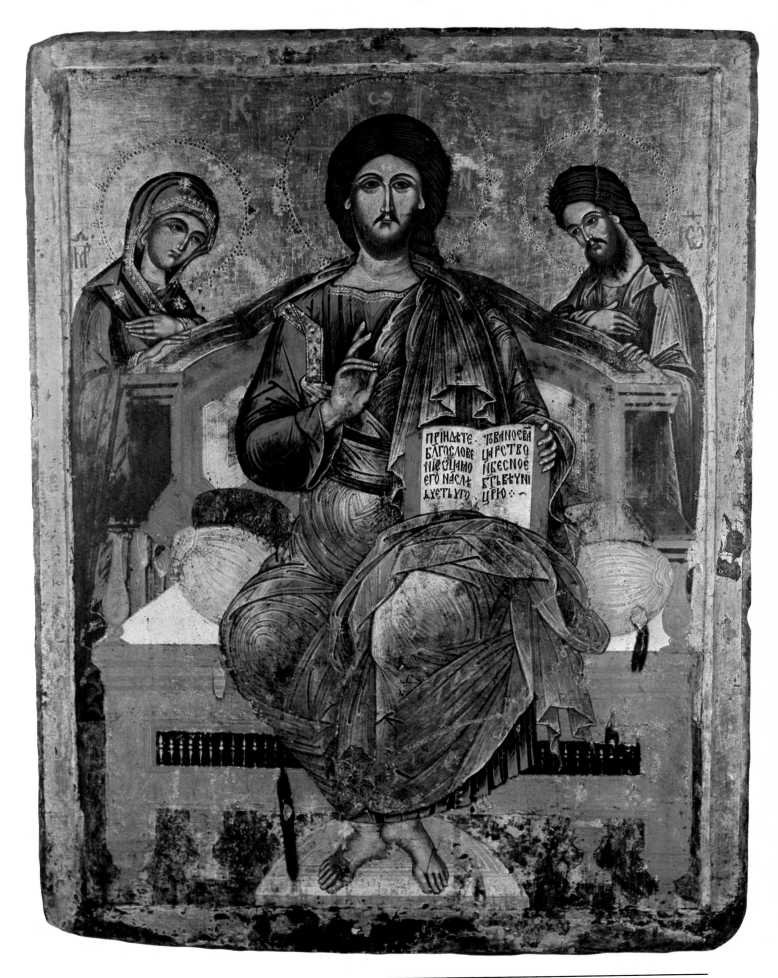

St. Paraskeva
Tempera on wood, 83 x 66 cm. (32⅝ x 26 in.);
Bălănești Church, Vîlcea district, Wallachia,
seventeenth century; Museum of the Monastery of
Hurezi.

Opposite:
Deesis, Detail
Grigorie from Bierilești
Tempera on wood, total measurement 110 x 90 cm.
(43¼ x 35⅜ in.); Moldavia, seventeenth century; St.
Teodori's Church, Iași.

Virgin with Child
Tempera on wood, 112 x 76 cm. (44⅛ x 29⅞ in.);
Monastery of Hurezi, Vîlcea district, Wallachia, end of
seventeenth century; Museum of the Monastery of
Hurezi.

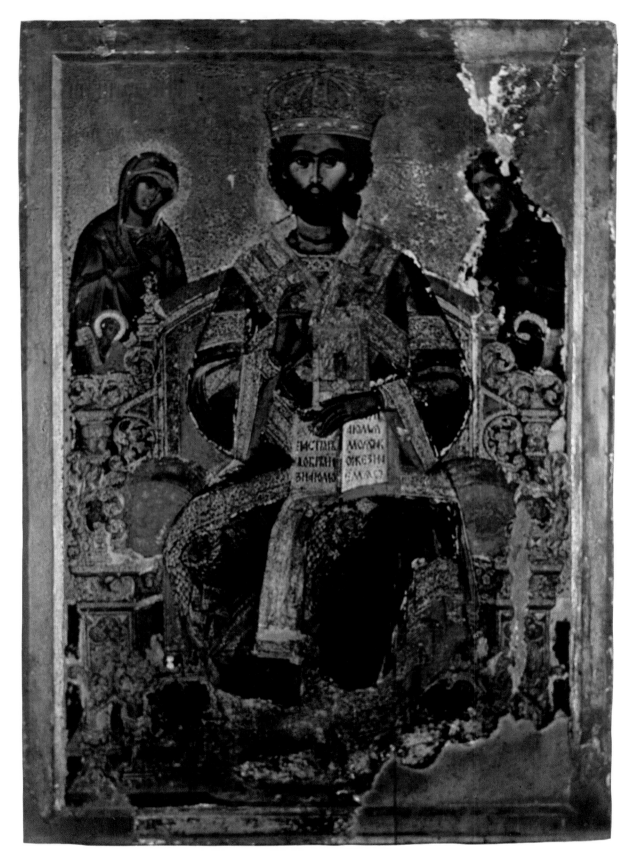

Deesis
Tempera on wood, 112 x 76 cm. (44⅛ x 29⅞ in.);
from the first iconostasis in the church of the
Monastery of Hurezi, Vîlcea district, Wallachia, end of
seventeenth century; Museum of the Monastery of
Hurezi.

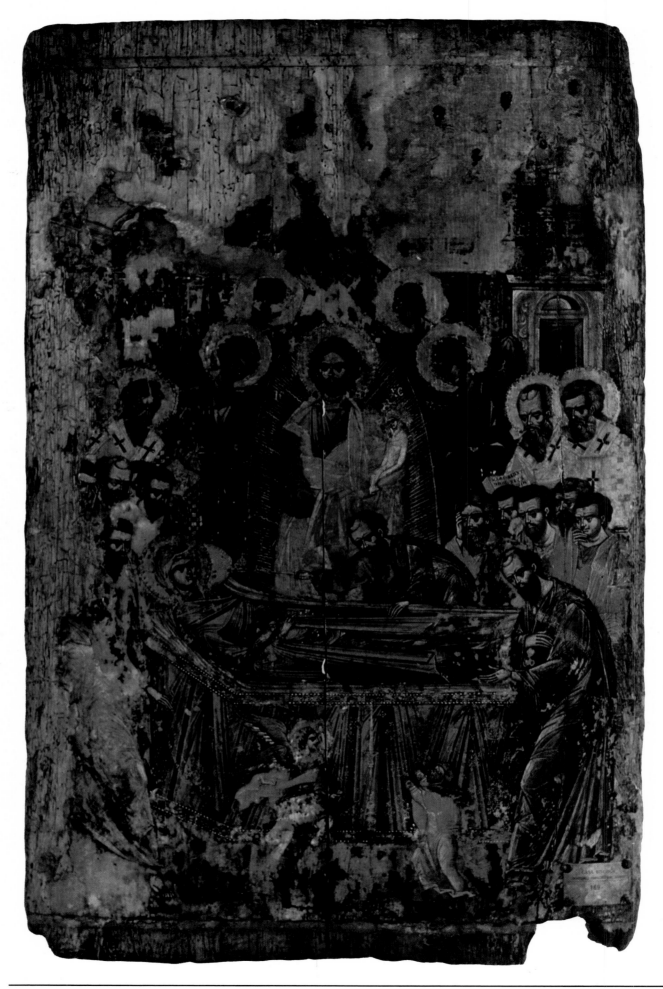

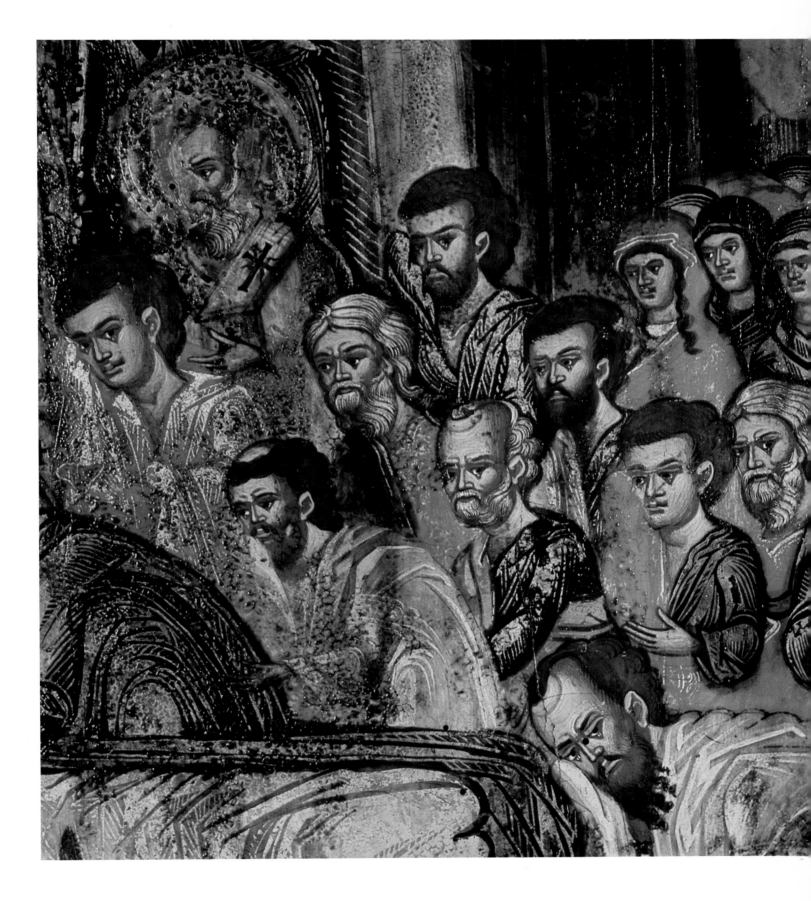

Opposite:
Dormition of the Virgin
Tempera on wood, 86 x 66 cm. (33⅞ x 26 in.);
Wallachia, seventeenth century; Museum of Rumanian
Art, Bucharest.

Dormition of the Virgin, Detail
Nicolae Zugravu
Tempera on wood, total measurement 105 x 78 cm.
(41⅜ x 30¾ in.); seventeenth century; Museum of
Rumanian Art, Bucharest.

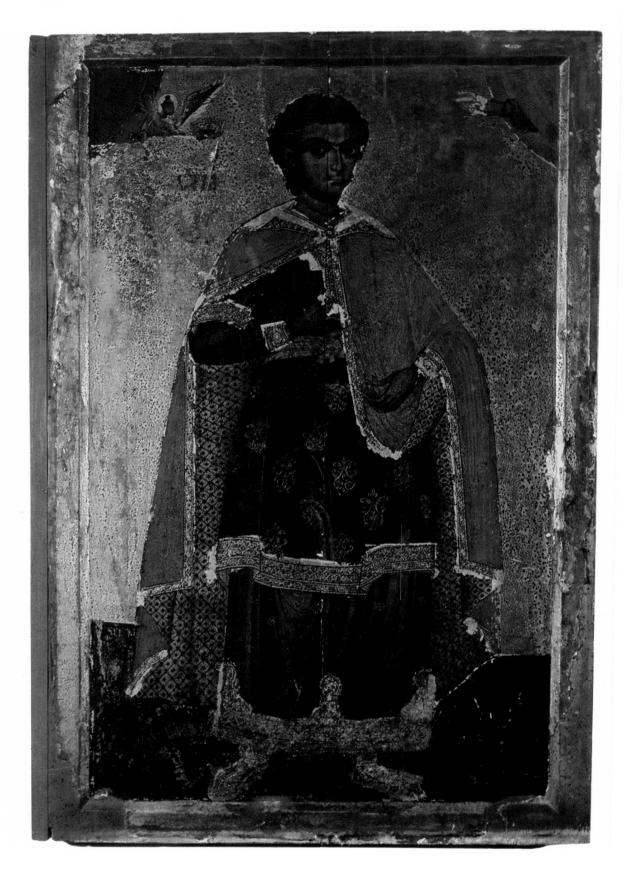

St. Procopius
Tempera on wood, 112 x 76 cm. (44⅛ x 29⅞ in.);
from the first iconostasis in the church of the
Monastery of Hurezi, Vîlcea district, Wallachia,
seventeenth century; Museum of the Monastery of
Hurezi.

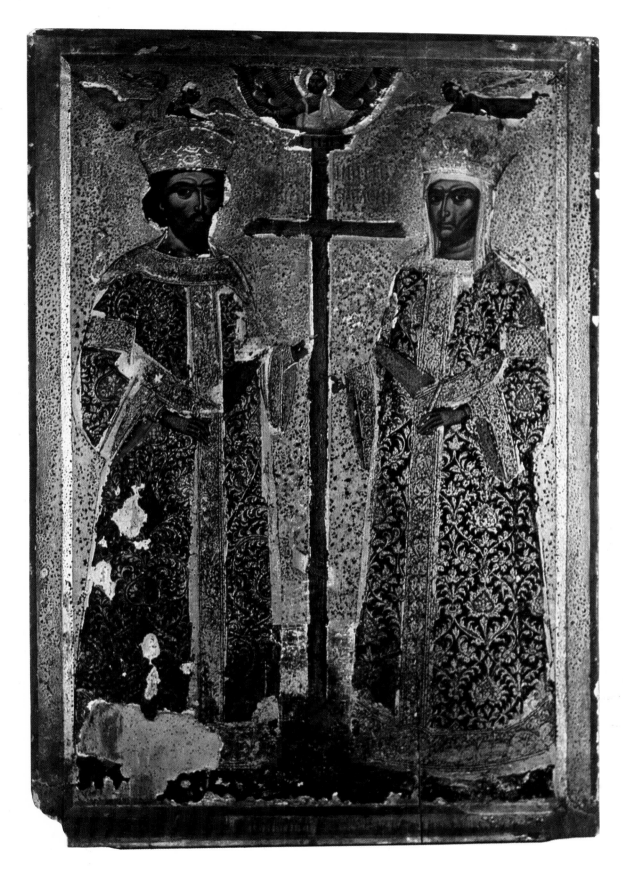

SS. Constantine and Helena
Tempera on wood, 112 x 75 cm. (44⅛ x 29½ in.);
from the first iconostasis in the church of the
Monastery of Hurezi, Vîlcea district, Wallachia, end of
seventeenth century; Museum of the Monastery of
Hurezi.

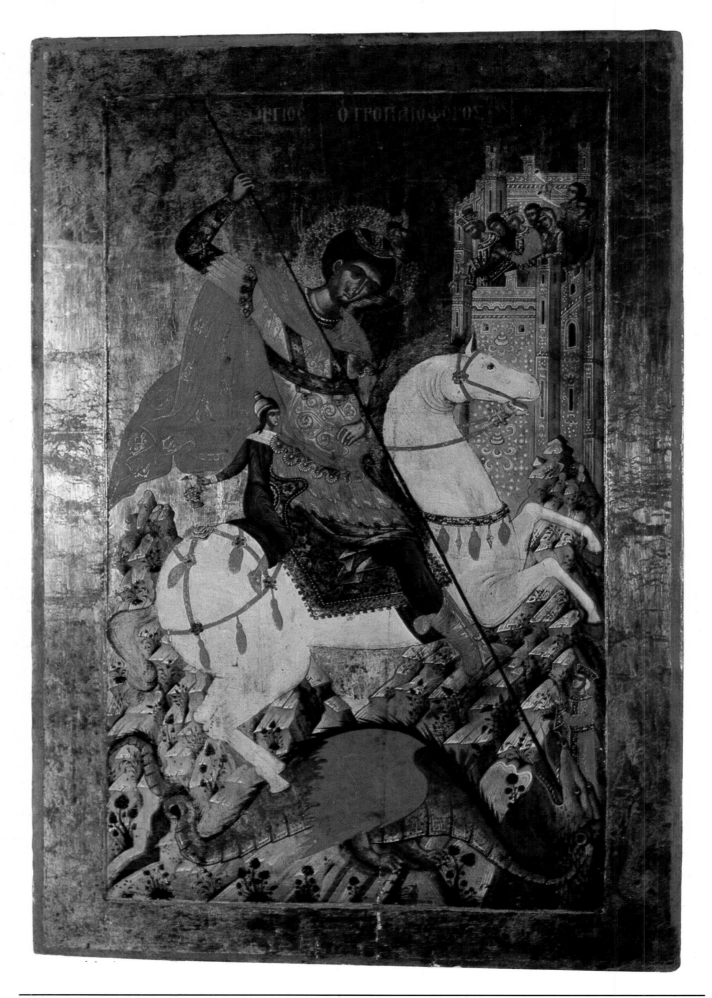

Opposite:
St. George Killing the Dragon
Tempera on wood, 116 x 78 cm. (45⅝ x 30¾ in.); end
of seventeenth century; Museum of Rumanian Art,
Bucharest.

St. George Killing the Dragon
Detail

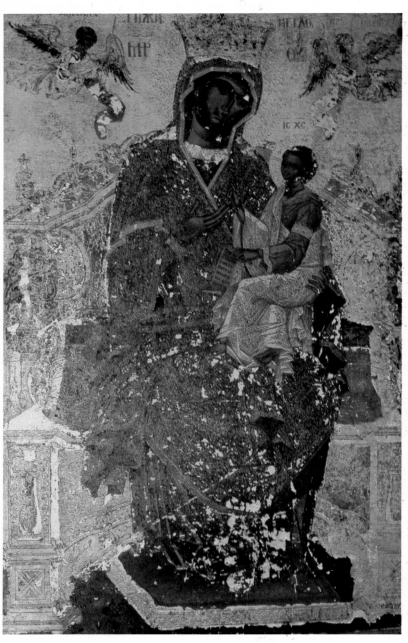

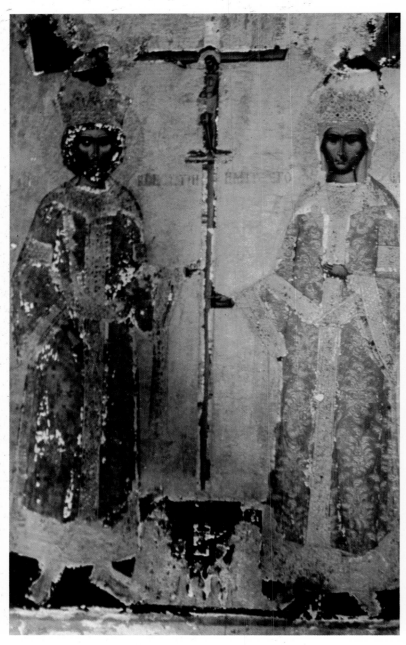

Above left:
Virgin with Child
Tempera on wood, 98 x 62 cm. (38⅝ x 24⅜ in.); c.
1700; Monastery of Hurezi.

Above right:
SS. Constantine and Helena with Donors
Tempera on wood, 98 x 62 cm. (38⅝ x 24⅜ in.);
Wallachia, c. 1700; Museum of the Monastery of Hurezi.

Opposite:
Entry into Jerusalem
Tempera on wood, 36 x 28 cm. (14⅛ x 11 in.); from
the iconostasis of the Metropolitan Church, Tîrgoviste,
Dimbovita district, c. 1707–09; Museum of Rumanian
Art, Bucharest.

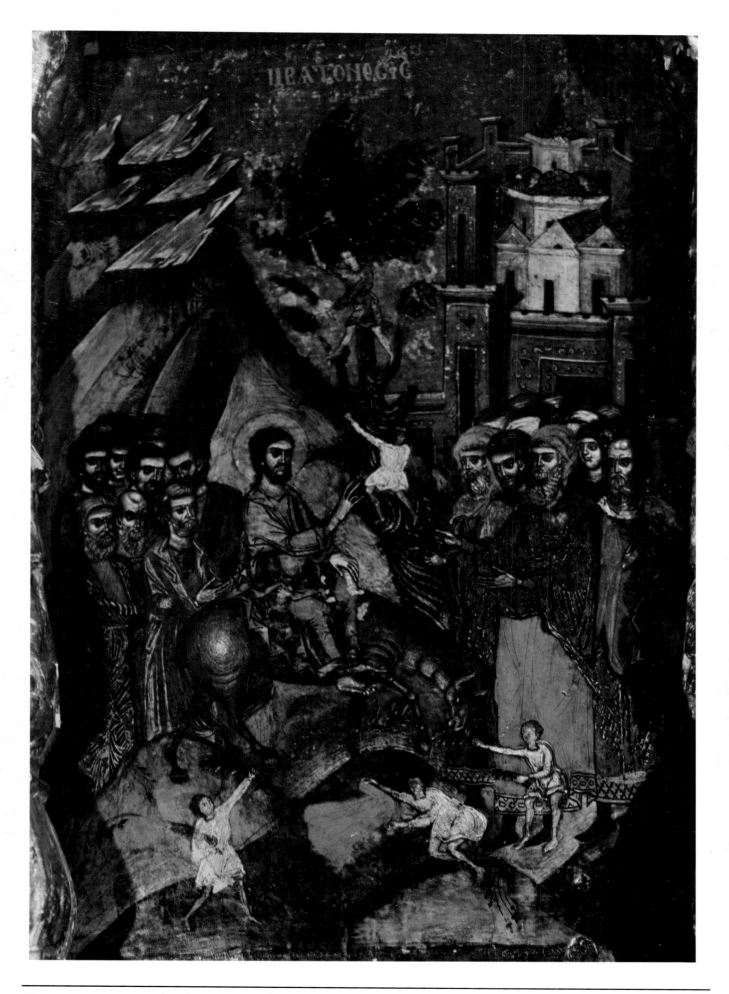

SELECTED READINGS

CHAPTER I, THE ICONS OF CONSTANTINOPLE

A. Bank, *Byzantine Art in the Collections of Soviet Museums*, Leningrad, 2nd ed., 1977.

C. Bertelli, "The Image of Pity in Santa Croce in Gerusalemme," in *Essays in the History of Art Presented to R. Wittkower*, 1967.

O. Demus, *The Mosaics of Norman Sicily*, London, 1949.

V. H. Elbern, *Ikonen aus der Frühchristlich-Byzantinischen Sammlung, Staatl. Museen*, Berlin, 1970.

W. Felicetti-Liebenfels, *Geschichte der Byzantinischen Ikonmalerei*, Lausanne, 1956.

A. Goldschmidt and K. Weitzmann, *Die Byzantinischen Elfenbeinskulpturen des X-XIII Jahrhunderts*, Berlin, 1st ed., 1934; 2nd ed., 1979.

A. Grabar, *Les Revêtements des Icones Byzantines du Moyen Age*, Venice, 1975.

H. Hahnloser et al., *Il Tesoro di San Marco. La Pala d'oro*, Florence, 1956.

————. *Il Tesoro di San Marco. Il Tesoro e il Museo*, Florence, 1971.

R. Lange, *Die Byzantinische Reliefikone*, Recklinghausen, 1964.

C. Mango, "The Mosaics and Frescoes of St. Mary Pammakaristos (Fethiye Camii) at Istanbul," in *Dumbarton Oaks Studies*, XV, Washington, DC, 1978.

S. Mercati, "Sulla santissima icona del Duomo di Spoleto," in *Spoletium*, 3, 1956.

M. C. Ross, *Catalogue of the Byzantine and Early Mediaeval Antiquities in the Dumbarton Oaks Collection*, vol. I, *Metalwork, Ceramics, Glass, Glyptics, Painting*, Washington, DC, 1962.

H. Schnitzler et al., *Skulpturen, Elfenbein, etc. Sammlung E. and M. Kofler-Truniger, Luzern*, vol. I, Lucerne, 1964.

G. and M. Sotiriou, *Icons of Mount Sinai*, Athens, vol. I, 1956 (plates); vol. II, 1958 (text in Greek).

P. Underwood, *The Kariye Djami*, vols. I-III, New York, 1966.

F. Volbach, G. Salles, and G. Duthuit, *Art Byzantin*, Paris (no date).

K. Weitzmann et al., *Frühe Ikonen. Sinai Griechenland, Bulgarien, Jugoslavien*, Vienna and Munich, 1965.

K. Weitzmann, "Byzantium and the West around the Year 1200," in *The Year 1200. A Symposium*, Metropolitan Museum of Art, New York, 1975.

————. *The Monastery of Saint Catherine at Sinai. The Icons*, vol. I, *From the Sixth to the Tenth Century*, Princeton, 1976.

————. *The Icon. Holy Images—Sixth to Fourteenth Century*, New York, 1978.

K. Wessel, *Byzantine Enamels from the Fifth to the Thirteenth Century*, Shannon, 1969.

CHAPTER II, THE ICONS OF GEORGIA

G. V. Alibegašvili, "Works of Medieval Easel Painting of Upper Svaneti," in *Medieval Art (Russia, Georgia)*, Moscow, 1978 (text in Russian).

S. Amiranchvili, *Les émaux de la Géorgie*, Paris, 1962.

————. *The Khakhuli Triptych*, Tiflis, 1972.

R. Kenia, *Chasing in the Icons of the Virgin in the Khakhuli Triptych*, Tiflis, 1972 (text in Georgian).

L. Khuskivadze, *Goldsmiths' Workshops at the Court of Levan Dadiani*, Tiflis, 1974 (text in Georgian).

T. Sakvarelidze and G. Alibegašvili, *Chased and Painted Georgian Icons*, Tiflis, 1980 (text in Russian).

G. N. Tchubinashvili, *Georgian Chasing from the Eighth to the Eighteenth Century*, Tiflis, 1957.

————. *Georgian Chasing*, vol. I (text); vol. II (illustrations), Tiflis, 1959 (text in Russian).

————. "An Ivory Triptych of Racha," in *Voprosy istorii iskusstva*, vol. I, Tiflis, 1970 (text in Russian).

CHAPTER III, THE ICONS OF THE BALKAN PENINSULA AND THE GREEK ISLANDS (1)

G. Babić, "Fresco Decoration of Iconostases," in *Zbornik za likovne umetnosti*, II, 1975 (text in Serbo-Croatian).

M. Chatzidakis, "Icons of the Architraves of Mount Athos," in *XAE*, 4, 1964 (text in Greek).

————. *Aspects de la peinture murale en Grèce au XIII siècle. L'art Byzantin du XII siècle*, Symposium held at Sopoćani, 1965; Belgrade, 1967.

————. "À propos de la date et du fondateur de St. Luc en Phocide," in *Cahiers archéologiques*, 19, 1969.

————. "Classicisme et tendances populaires au XIV siècle," in *Acta of the Fourteenth International Congress on Byzantine Studies, Bucharest 1971*, vol. I, Bucharest, 1977.

————. "L'évolution de l'icone aux XI-XIII siècles et la transformation du templon," in *Acta of the Fifteenth International Congress on Byzantine Studies, Athens 1976*, vol. I, Athens, 1979.

V. Djurić, *Die Byzantinische Fresken in Jugoslavien*, Munich, 1975.

————. "La peinture murale byzantine, XII-XIII siècles," in *Acta of the Fifteenth International Congress on Byzantine Studies, Athens 1976*, vol. I, Athens, 1979.

————. *Les icones de Yougoslavie*, Belgrade, 1961.

A. Grabar, *Les sculptures byzantines du Moyen Age*, vol. II, Paris, 1976.

S. Radojčić, *Icone di Serbia e Macedonia*, Belgrade, 1963.

T. Velmans, "Deux églises byzantines du début du XIV siècle en Eubée," in *Cahiers archéologiques*, 18, 1968.

K. Weitzmann, M. Chatzidakis, and S. Radojčić, *Le Grand Livre des icones*, Paris, 1978; New York, 1980.

K. Weitzmann, *The Icon*, New York, 1978.

A. Xyngopoulos, *Tessalonica e la pittura macedone*, Athens, 1955.

CHAPTER IV, THE ICONS OF THE PERIOD OF THE CRUSADES

G. and M. Sotiriou, *Icons of Mount Sinai*, Athens, vol. I, 1956 (plates); vol II, 1958 (text in Greek).

K. Weitzmann, "Thirteenth-Century Crusader Icons on Mount Sinai," in *The Art Bulletin*, XLV, 1963.

————. "Icon-Painting in the Crusader Kingdom," in *Dumbarton Oaks Papers*, XX, 1966.

————. "Four Icons on Mount Sinai: New Aspects in Crusader Art," in *Jahrbuch der Österreichischen Byzantinistik*, 21, 1972.

————. "Byzantium and the West around the Year 1200," in *The Year 1200. A Symposium*, Metropolitan Museum of Art, New York, 1975.

CHAPTER VI, THE ICONS OF THE BALKAN PENINSULA AND THE GREEK ISLANDS (2)

D. Bogdanović, V. Djurić, and D. Medaković, *Hilandar*, Belgrade, 1978.

M. Chatzidakis, *Icones de St. Georges des Grecs de la collection de l'Institut*, Venice, 1962.

————. "Les débuts de l'école crétoise et la question de l'école dite 'italogreque'," in the volume dedicated to Sophie Antoniadis, Venice, 1964.

————. *Études sur la peinture post-Byzantine*, London, 1976.

————. "Recherches sur la peintre Théophane le Crétoise," in *Dumbarton Oaks Papers*, 1969-70.

M. Ćorović-Ljubinković, *Srednjovekovni duborez u istočnim oblastima Jugoslavije*, Belgrade, 1961.

V. Djurić, *Les icones de Yougoslavie*, Belgrade, 1961.

————. "U potrazi za delom slikara Andrije Raičevića," in *Starine Crne Gore*, I, Cetinje, 1963.

A. Kajamaković, *Georgije Mitrofanović*, Sarajevo, 1977.

————. "Kozma-Jovan," in *Zbornik za likovne umetnosti Matice srpske*, 13, Novi Sad, 1977.

D. Mazalić, *Slikarska umjetnost u Bosni i Hercegovini u tursko doba*, Sarajevo, 1965.

L. Mirković, "Ikone manastira Dečana," in *Starine Kosova i Metohije*, II-III, Priština, 1963.

————. *Starine fruškogorskih*, Belgrade, 1931.

S. Petković, "Delatnost popa Strahinje iz Budimlja," in *Starine Crne gore*, I, Cetinje, 1963.

M. Potamianou, *The Monastery of Philanthropists and the First Phase of Post-Byzantine Painting*, Athens, 1980 (text in Greek).

S. Radojčić, *Ikonen*, Herrsching, Ammersee, 1975.

————. *Majstori starog srpskog slikarstva*, Belgrade, 1955.

A. Skovran, "Ikonostas crkve Svetog Nikole u podvrhu i njegov tvorac," in *Zograf*, 4, Belgrade, 1972.

M. Teodorić-Sakota, "Zograf Longin, slikar i književnik XVI veka," in *Srpska književnost u književnoj kritici*, vol. I, *Stara književnost*, Belgrade, 1965.

T. Liva-Yanthaki, *The Wall Paintings of the Monastery of Dilios*, Giannina, 1980 (text in Greek).

A. Xyngopoulos, *Sketch for a History of Post-Byzantine Painting*, Athens, 1957 (text in Greek).

CHAPTER VII, THE POST-BYZANTINE ICONS OF
WALLACHIA AND MOLDAVIA

A. Dojanski and V. Simion, *Cultura bizantină în România*, Bucharest, 1971.

————. *Arta în epoca lui Vasile Lupu*, Bucharest, 1979.

A. Efremov, "Icoane de la Bistriţa Craioveştilor, in *Revista Museelor*, 5, 1971.

————. "Probleme ale cristalizării stilului în pictura de icoane din secolul XVI, 'oenouă icoană din epoca lui Neagoe Basarab'," in *Bul. Mon. Ist.*, 3, 1971.

————. "Primul peisaj du conceptie occidentală în pictura de icoane din Tara Românească," in *Monumente istoriee si de artă*, I, 1974.

N. Iorga, *Istoria Artelor Plastice in România*, I, 1968; II, 1970.

————. *Les arts mineurs en Roumanie*, I, *Icones*, Bucharest, 1934.

————. *Byzance après Byzance, Continuation de l'histoire de la vie byzantine*, Bucharest, 1935.

E. Lazarescu, "O icoană putin conuscută din sec. XVI şi problemele pronaosului bisericii mănăstirii Argeşului," in "*SCIA*," *Seriă arta plastică*, XIV, 2, 1947.

C. Niculescu, *Icoane vechi româneşti*, Bucharest, 1976.

R. Theodorescu, "Despre cîţiva 'oameni noi', ctitori medievali," in "*SCIA*," 24, 1977.

V. Vătăsianu, *Istoria artei feudale în Tările Române*, vol. I, Bucharest, 1958.

T. Voinescu, "Scoala de pictură de la Hurezi," in *Omagiu lui George Oprescu cu prilejul împlinirii a 80 de ani*, Bucharest, 1961.

————. *Pîrvul Mutu zugravu*, Bucharest, 1968.

PHOTO CREDITS

The abbreviations t, b, r, l, refer to the position of the photo-
graph on the page (top, bottom, right, left).

ACKNOWLEDGMENTS

The editors wish to thank the following for their courteous assistance:

Archaeological Museum, Skoplje
Manolis Chatzidakis, Athens
Church of St. Blaise, Ston
Church of St. George, Prizren
Church of St. Nicholas, Prizren
Franciscan Monastery, Dubrovnik
Desanka Milošević, National Museum, Belgrade
Dečani Monastery
Morača Monastery
Studenica Monastery
Museum of the Ancient Serbian Church, Sarajevo
Museum of Religious Antiquities, Nis
Museum of the Orthodox Serbian Church, Belgrade

All of the icons of the Monastery of St. Catherine of Sinai are published by the kind permission of the Michigan-Princeton-Alexandria Expedition to Mount Sinai.

The Italian edition of THE ICON was an editorial project of Snezana Pejakovic and Lorenzo Camusso, was designed by Gradimir Avramov, Vittorio Merico and Giorgio Munari, and coordinated by Francesca Agostini.
The design of the British edition was adapted from the Italian edition by Christine Aulicino.